DANCE ACROSS
THE USA

DANCE ACROSS THE USA

ISBN 978-0-692-95370-9
Library of Congress Control Number: 2017916093

Cover Design by Tri Widyatmaka
Interior design and layout by Jonathan Givens
Copy Editing by Robrt Pela
All photos by Jonathan Givens

To purchase prints, specialty items, bulk book purchases, or make media inquiries,
contact DATUSA at www.danceatusa.com

To my wife Leigh-Ann

Of all the beautiful things I got to see and experience for this project,
you are, by far, the most beautiful of them all.

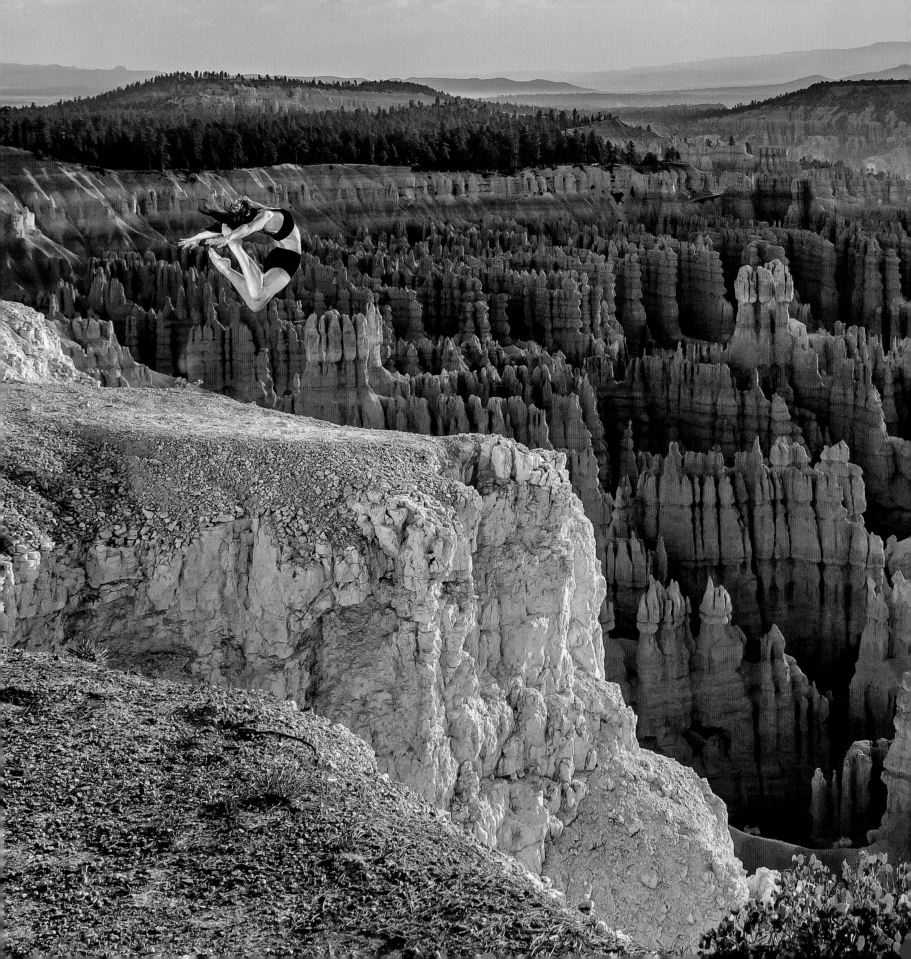

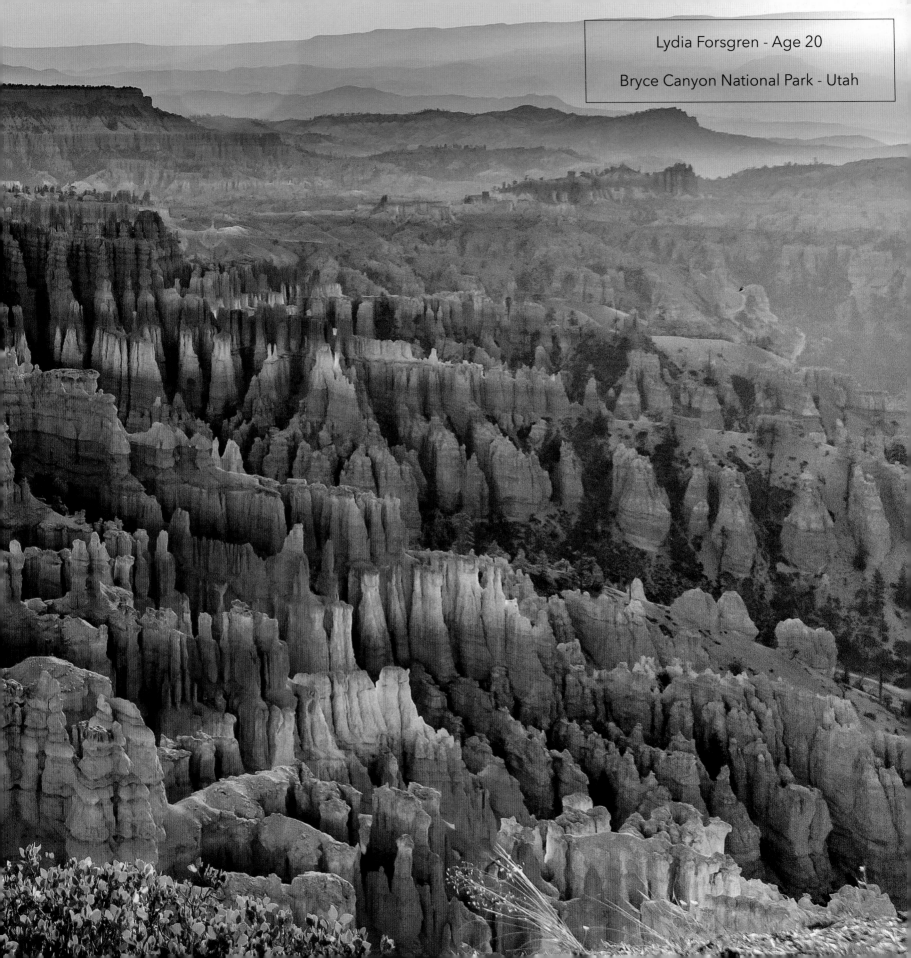

Lydia Forsgren - Age 20

Bryce Canyon National Park - Utah

Contents

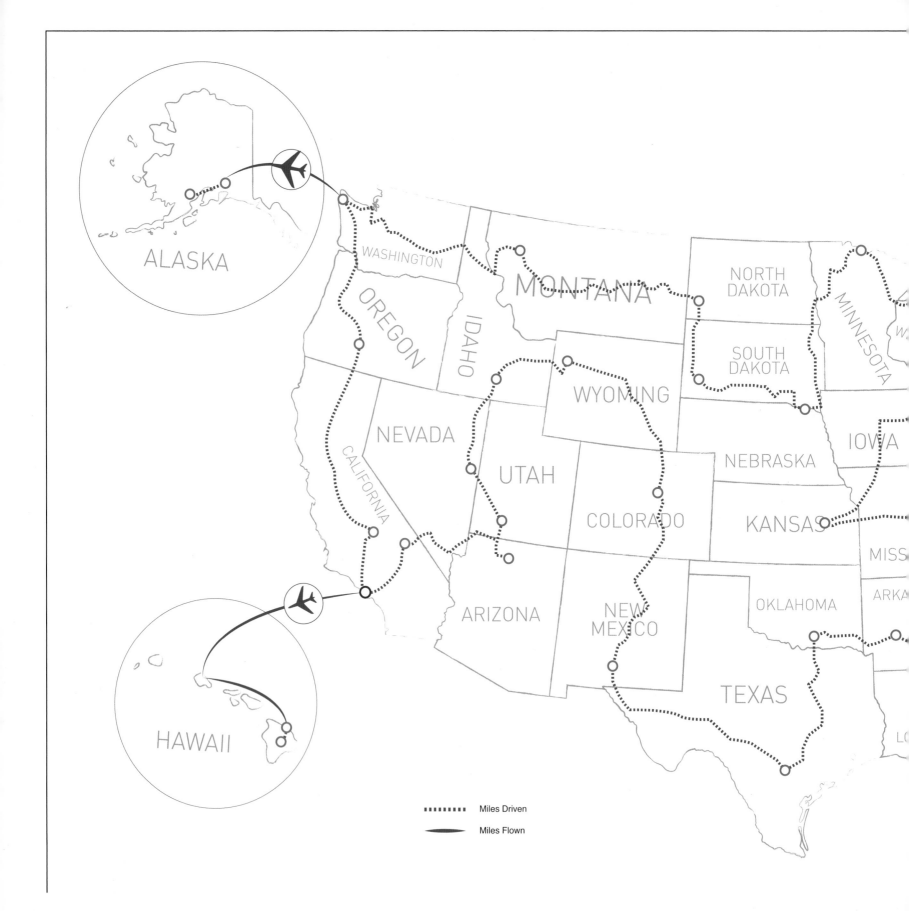

Miles Driven

Miles Flown

90 DAYS | DANCE ACROSS THE USA

22,264 Miles Driven - 8436 Miles Flown

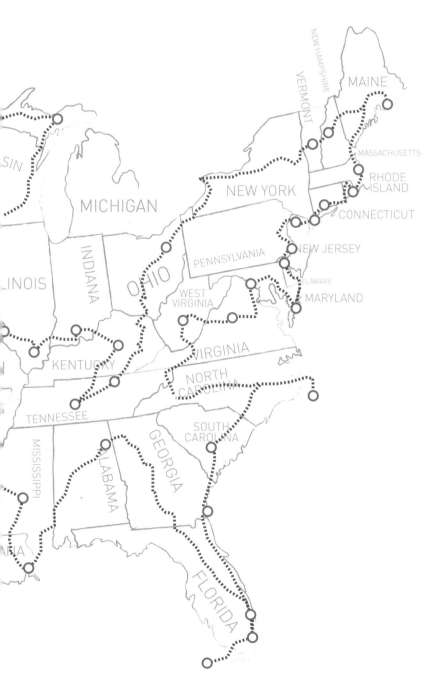

1. Biscayne National Park, Miami FL

2. Dry Tortugas National Park - Dry Tortugas, Florida

3. Little River Canyon National Park – Alabama

4. The French Quarter – Louisiana

5. Cypress Swamp Natchez Trace - Mississippi

6. Hot Springs National Park – Arkansas

7. Chikasaw National Recreation Area – Oklahoma

8. The Alamo – Texas

9. White Sands National Monument – New Mexico

10. Garden of the Gods – Colorado

11. Grand Teton National Park - Wyoming

12. Craters of the Moon National Monument – Idaho

13. Great Basin National Park – Nevada

14. Bryce Canyon National Park – Utah

15. Antelope Canyon – Arizona

16. Dumont Dunes (Death Valley) – California

17. Hawaii Volcanoes National Park – Hawaii

18. Kings Canyon National Park -- CA

19. Crater Lake – Oregon

20. Olympic National Park (Ruby Beach) – Washington

21. Hatcher Pass – Alaska

22. Glacier National Park – Montana

23. Theodore Roosevelt National Park – North Dakota

24. Badlands National Park – South Dakota

25. Missouri National Recreational River – Nebraska

26. Voyageurs National Park – Minnesota

27. Apostle Islands National Lakeshore – Wisconsin

28. Pictured Rocks National Lakeshore – Michigan

29. Effigy Mounds National Monument - Iowa

30. Tallgrass Prairie National Preserve – Kansas

31. The Gateway Arch – Missouri

32. Camel Rock, Garden of the Gods - Illinois

33. Pioneer Mothers State Forest – Indiana

34. Cumberland Falls - Kentucky

35. Natchez Trace - Tennessee

36. Big South Fork River – Tennessee

37. Cuyahoga Valley National Park – Ohio

38. Marsh-Billings-Rockefeller National Historic Park - Vermont

39. Franconia Ridge, White Mountains – New Hampshire

40. Acadia National Park - Maine

41. Boston Harbor Islands – Massachusetts

42. Brenton Point State Park – Rhode Island

43. Gillette Castle State Park – Connecticut

44. & 46 Grand Central Terminal – New York

45. Statue of Liberty - New York

47. Buttermilk Falls, Delaware Gap – New Jersey

48. Independence Hall – Pennsylvania

49. First State National Park – Delaware

50. Assateague Island National Seashore - Maryland

51. The Lincoln Memorial & Washington Monument – Washington DC.

52. Stony Man Mountain - Virginia

53. Babcock State Park - Glade Creek Grist Mill – West Virginia

54. Cape Hatteras – North Carolina

55. Congaree National Park – South Carolina

56. Cumberland Island National Seashore - Georgia

Introduction

Begin at the Beginning...

I would say I am a risk taker. I have always tended to jump in feet first, and then figure out what I found myself in. So on a fine, South Florida December morning in 2015, I came across a map. The plan was created by Randy Olson, a Ph.D. candidate at Michigan State University. Using a fancy computer algorithm he created, he came up with a cross-country journey.

DANCE ACROSS
THE USA
www.danceatusa.com

The Mighty Buford - Age 3

This route would be the most efficient way for visiting all 48 contiguous states. I liked the idea of an epic road trip! I've been to every state already, but never in one go. But why? Why take on a trip like this? To do something good! Like what? Help people. Help people get out and care about our country. Help grow our culture, our sense of community, and... something more. Parks! Support our big beautiful natural spaces. Oooh, history! Can't forget the history. Culture, nature, and history. Sounds good. But what can I do? I make a swell potato salad! Nope. I'm a great carpenter... CHAIRS FOR EVERYONE! Wrong again. I'm pretty good with a camera, I'll take pictures! Photos of dancers in these cool places. Dancers of all shapes, sizes, ages, creeds, cat or dog lovers, anyone! Then I'll put it all in a book, to raise money to donate. Works for me. Thus, *Dance Across the USA* was born.

So there it was, I had the base idea in place. I called my wife Leigh-Ann to tell her my fancy new idea. Her question was "When do you think you'll do this? A couple years?" Naw... six months or so. This summer!

She was so excited.

That would be sarcasm, folks.

While she was not jumping for joy about this idea, she was supportive as ever. She's got my back, I never doubt that. So I began the planning of this trip. Which I quickly discovered was WAY more complicated than I first thought. The basic premise was that I would drive to every state, to a location I had chosen in advance, to photograph dancers. There were some obvious choices to be made: Where? When? Who will the dancers be? How do I get permission for this? How long will this all take? I'm a big fan of lists, so I started one on what I had to plan.

- Locations
- Route from place to place
- Logistics
- Dancers
- Permission
- How to fund it
- What to do with it

I began with the route. Taking the plan I had found on social media, I used that as a base. I did some internet searches to look at locations, and tried to visualize what a dance photo shoot would look like at each place. There is so much you can see from Google, it's ridiculous. I created an initial list of locations in each state, and then mapped out the route. What was the fastest I could get from place to place? How long could I drive until I needed to rest? Where to sleep? The list of to do's was getting longer and longer. Again, this is why I love lists.

Once I had created an initial list of locations, I decided 12 hours was all I wanted to drive in a day. So I based the schedule around that - from location to location, no more than a 12 hour drive. One day off a week, so I could get some computer time, sleep a bit more, do laundry, grocery shop, etc. This led into the logistical portion of the project. I was going to drive, and the natural choice was to take my van, the Mighty Buford. I would need to turn him into a mobile workstation, rv, basically my source for everything. I would need power, food, the ability to cook, a place to sleep, get clean, repair anything as necessary, and have him be the advertisement for what I was doing. So I built him out to handle everything I could think of, and stocked him for every conceivable situation.

At the same time I was sorting out Buford for the trip, I was wrangling dancers to join me in this crazy adventure. I posted a notice on social media, about how I was looking for dancers across the country. All types, ALL ABILITIES, all ages. We had over 3000 dancers apply to be a part of DATUSA (The acronym for Dance Across the USA). We narrowed it down to 300, and then asked for more information. From there we went down to 153 - three per state, plus Washington DC. That ended up growing to 163, after we added double locations in a couple of states. Dancers, check! Men, women, boys, girls, old, young, professionals, amateurs, teachers, and students. A little bit of everything.

Now came the getting permission part. Unlike some folks who think it doesn't Matter (ahem), I believe in following the rules. I don't want to run from the police, or open myself or the dancers up to any legal trouble.

I want the police to help! In most places, if you want to have a photo shoot, you need a permit. Which typically costs money. However, even if the permit is free, you still need them.

Since I had decided to make a book of the images, that made this a commercial venture. Which made the permitting process much more complicated and expensive. I quickly found that there is no uniform method of getting permits for our locations. Every park I went to had their own system, their own fee structure, payment method, and their own set of rules. Some would only accept mailed submissions, and required a six to eight week review period. Add into that the other type of locations: Cities, overlapping jurisdictions, Bureau of Land Management locations, national forests, state parks, and private property. We really ran the gamut. Some places simply refused. Some places said OK, but at astronomical prices. In the end, the cost to cover the permits and related costs for the locations was over $22,000!

The reaction from the locations varied as much as the locations themselves. Some of them were so excited we had decided to use their location for this project. A notable standout there was Tallgrass Prairie National Preserve in Kansas. They could not have been nicer, or more helpful. Others were downright uncooperative. One park wanted to charge us over $3000 to have a two-hour photo shoot in their park. My head exploded at that one. And this park makes millions every year. They simply had no interest in being helpful, and in the end, we decided against those locations. Usually, the reaction we got was one of "You want to do what, now?" Dancers, with your location as the background. "Like a concert? A show? A flash mob?" It became very clear I needed some visual aides.

I decided a test session was in order. So I took a couple of dancers out into the Everglades to do some test shots. Ginger is a fantastic dancer, and most importantly, someone who is not afraid of bugs! Ginger and her mother (who is a world champion ballroom dancer) ventured out into the 'Glades so we could test my theory on portability and compactness for the gear.

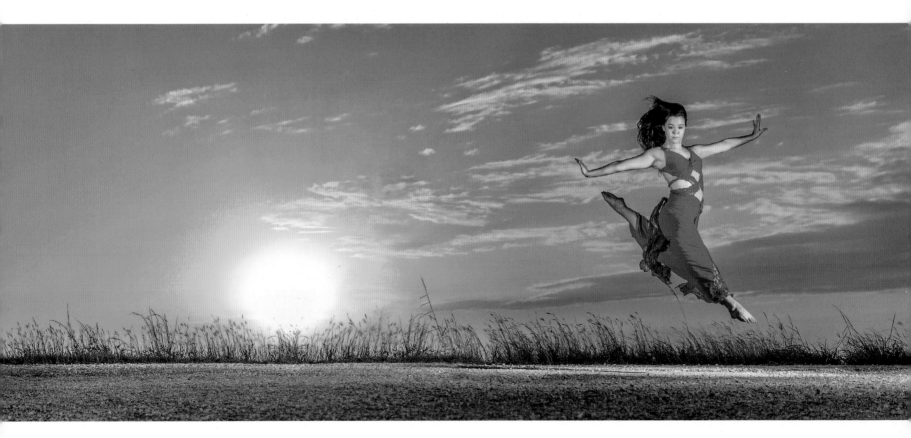

Ginger LeNoir - Age 15 **Everglades Wildlife Management Area, FL**

After my test with Ginger went well, I realized I needed to test another level of abuse — I had to get things wet. Knowing where I wanted to go on the trip, water was going to be a recurring issue. So back into the Everglades with another dancer, this time to get into the water.

Funny thing about the Everglades (which I knew going in, FYI): Unlike most places in the US, there are a whole bunch of things that want to eat you lurking in the water. Keeping an eye out for such wildlife, we plunged ourselves into the water. Off in the distance, I saw something in the water, but couldn't quite tell what it was. Experience has taught me that it's better to err on the side of caution, so I went with the assumption that it was some sort of creature checking us out. And as the moments passed, the object got closer and closer, until it was about 10 feet away — at which point we got out. It was an alligator. See in the background next to Sara's right foot?

We didn't go back in the water after that.

So with these sessions done, I now had some decent examples of what we would be doing at each location, to help them visualize what we were trying to accomplish. With this, I was able to put together an introductory letter to each location, showing the example of what I had in mind. The whole submission packet was the permit request, our liability insurance (yes, you need that, too) the test shots, and a nice letter from us explaining what and why I was doing this.

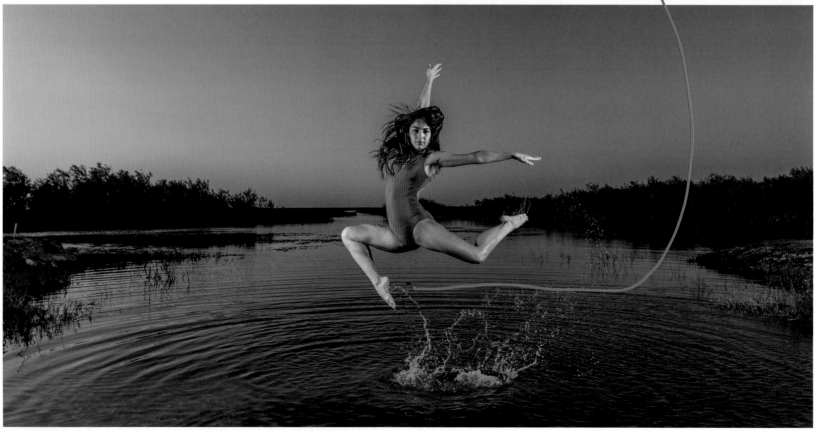

Sara Franco - Age 21 **Francis S. Taylor Wildlife Management Area, FL**

The permitting lasted up until the last week of the trip! There were times when it came down to the wire. One in particular, where the permit finally came through AS WE ARRIVED TO THE LOCATION FOR THE SHOOT. It was simply the sheer force of will of my team that made all of this happen, a huge part of this being my wife. She was doing double duty of both her job (she works for a cruise line), and supporting me while I was out on the road. I simply could not have done this without her. Full stop. Thank you, my love!

With everything else falling into place, the focus then turned to the financial needs of DATUSA. It was clear early on that a fund raiser was going to be the best way to make this happen. We used a site called Crowdrise, and created a page to raise all the monies needed for this trip — everything required from the permits and ranger fees (yup, I had to pay for rangers to watch me as well), to fuel and food. I knew I had to limit expenses as much as possible, which meant sleeping in Buford as much as I could, rather than getting hotels. This was NOT a luxury trip, by any stretch! The hotels would be limited to when I was away from Buford (Hawaii or Alaska), or times when I knew I would need internet because of the remoteness of the location. This is where people really showed how awesome they are! I had several people open their homes for me to stay, do laundry, and have a home-cooked meal. Some businesses donated rooms at their facility (thank you Cumberland Falls!). At the back of this book, you can see the list of all the people and businesses who gave to support DATUSA. It's quite a list, and in the end, we ended up raising almost $44,000! It seems people really believe in this like I do.

A note about the rangers. In several of the parks, they required us to pay a ranger to come around with us. A little more than half of the locations required this. I hope you all get the experience to work with these people. They were some of the nicest, kindest, most dedicated people I have ever come across. These people are doing work that they really believe in, often away from their loved ones for extended periods of time. They want to keep you safe, as well as preserve their park for everyone. There is a lot of pride in being a ranger, and they certainly have my respect. Without

their help, we could not have had the access we did. Several rangers brought us to locations not publicly accessible - special places that they enjoy. After our original location was a bust due to weather, we had rangers who then took us to an alternative site, because they believed in what we were doing as well. Again, it pays to follow the rules, kids.

So now, we have gone through the whole process, and you are holding the results of all the effort. There are literally hundreds of people responsible for this becoming a reality. Strangers, well wishers, old friends, new friends - they all came together to create this work of art. So enjoy the fruits of our labor. While these are all my photographs, none of these could have happened without the Herculean effort of everyone involved. So come on, and watch us *Dance Across the USA!*

Just putting it out there so there is no confusion. Every one of these images is real. The dancers really did what you see. There are no camera tricks or digital manipulation of these photos, save for the occasional removal of something gross from the background. I used Canon 600 EX-RT speedlites to provide the light, which were placed just out of frame. When you see a dancer someplace that looks dangerous, I did shoot it in an attempt to make it look as dramatic as possible, but we were not foolish or irresponsible. In many of our locations, we had rangers and / or supervisors making sure we did not do any damage to ourselves or to the location. And trust me, I was right there with them, usually in much deeper water/higher cliffs/muddier puddles/stinky-er gutters than anyone else was. I didn't have to stay looking nice!

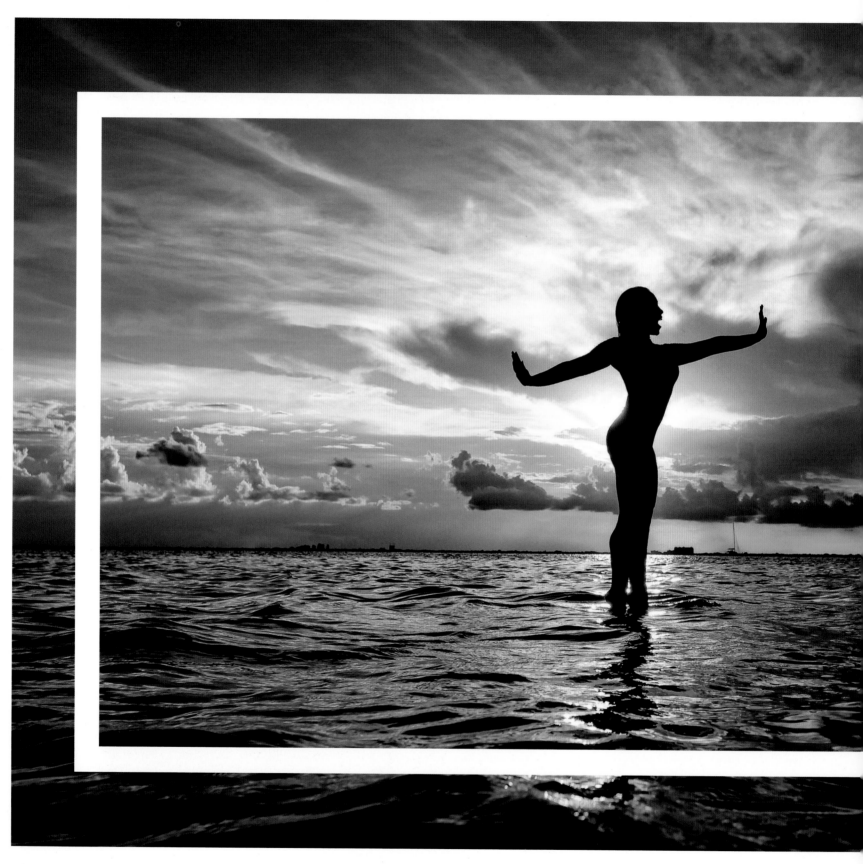

Melissa Blandon - Age 14 **Biscayne Bay Aquatic Preserve, FL**

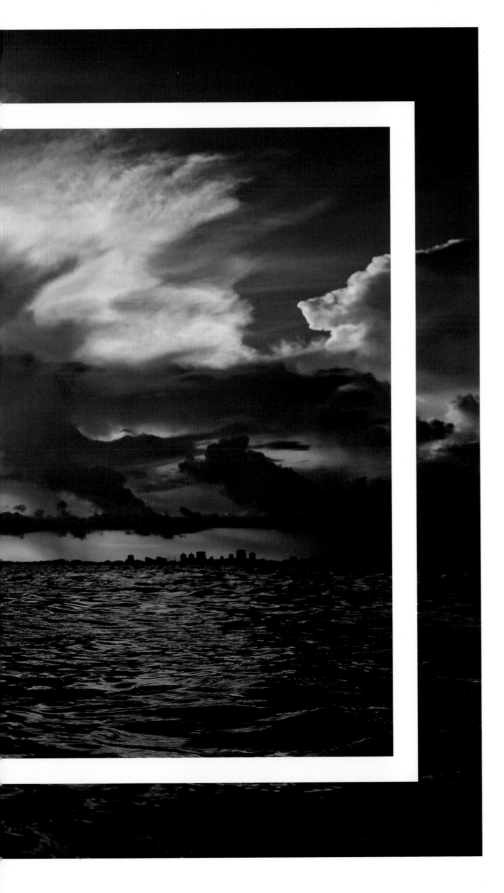

FLORIDA

Biscayne Bay Aquatic Preserve
DAY 1
LOCATION 1
JUNE 28, 2016
MILES ON BUFORD: 36

For our very first location, I wanted to start somewhere close by - just to make sure that my plans would all actually work! I decided on the beautiful Biscayne Bay, a place teeming with life and a big challenge to cover. My vision was to find a sandbar out in the middle of the bay at low tide. This would not be the first time my vision had to adapt... call it foreshadowing!

I hired a boat and a captain to take us out to a place where the sea charts indicated sandbars. We decided on a day when low tide was going to coincide with sunset, so we would have the best shot at finding shallow areas that most people would want to avoid, but for a photo shoot in the middle of the ocean would be perfect. I met the dancers at the pier, and we headed out. When we arrived, the water was much deeper than expected - who knew sand bars moved and changed shape? But, as I'm a big planner, I came prepared with a platform to submerge, so the deck would be just under the water level. *Violà*! Instant sandbar!

Biscayne Bay, surrounded by Miami and Miami Beach, was first settled by the Tequesta tribe around 300 BC. Today, the Miami metro area has a population of 5.5 million people. The bay itself is home to large coral reefs and is full of sea life, which includes manatees, sea turtles, alligators AND crocodiles, as well as over 30 additional threatened or endangered species. There are many ways to visit this area, but it is best seen from underwater. If you happen to make it to South Florida, make this part of your visit!

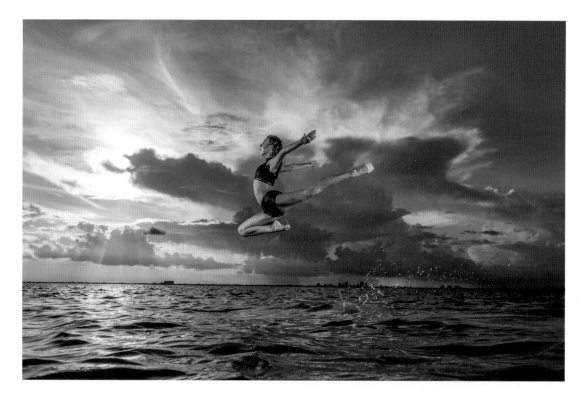

Jasmine Santos - Age 15 **Biscayne Bay Aquatic Preserve, FL**

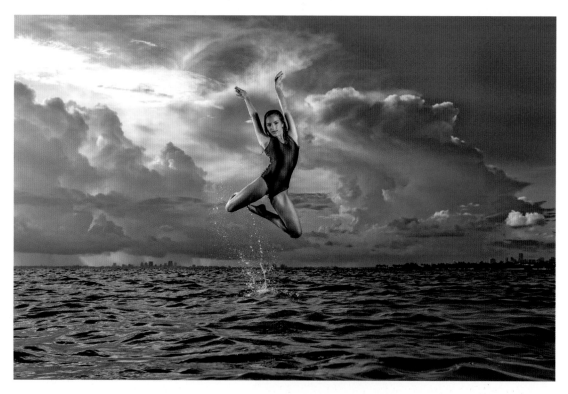

Sydney Vazquez - Age 12 **Biscayne Bay Aquatic Preserve, FL**

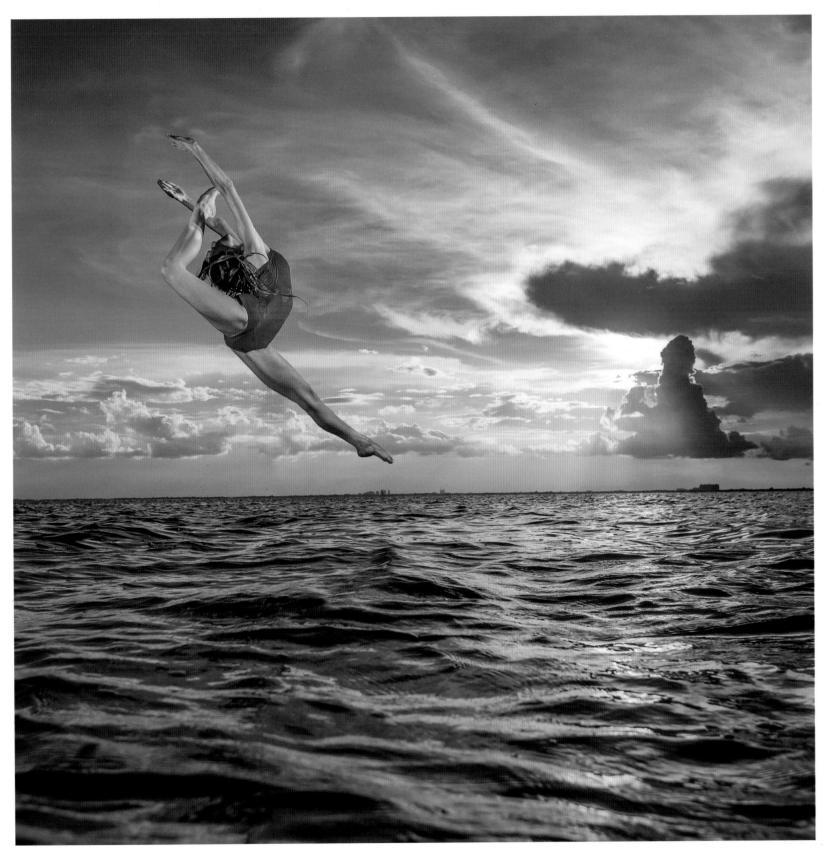

Taylor Richie - Age 16 **Biscayne Bay Aquatic Preserve, FL**

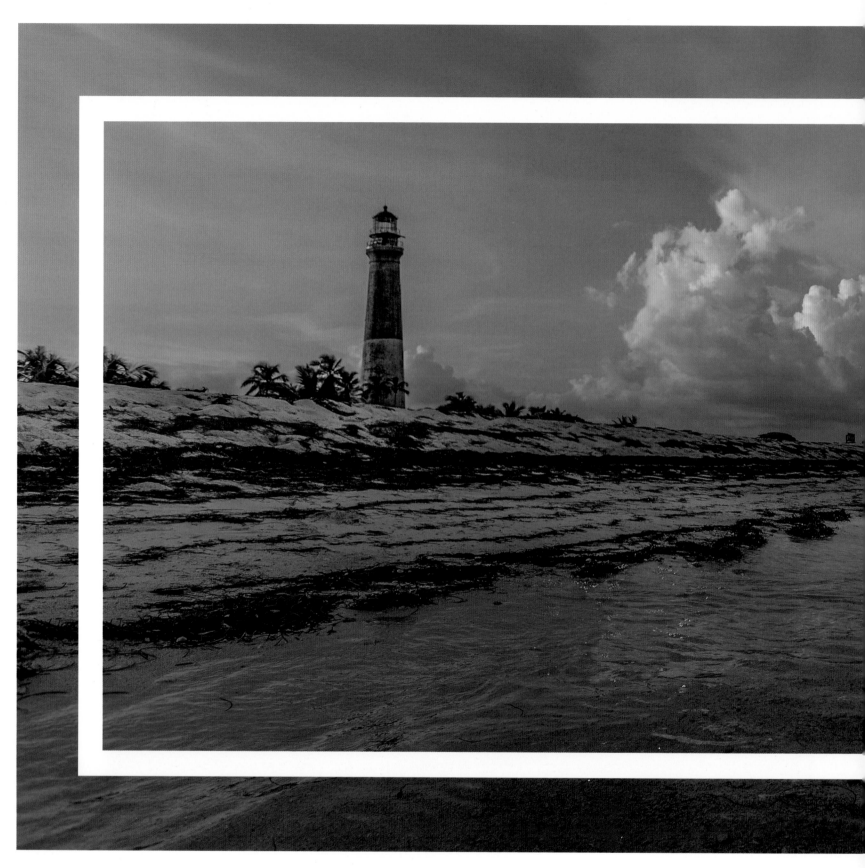

Sara Franco - Age 21 **Loggerhead Key, Dry Tortugas National Park, FL**

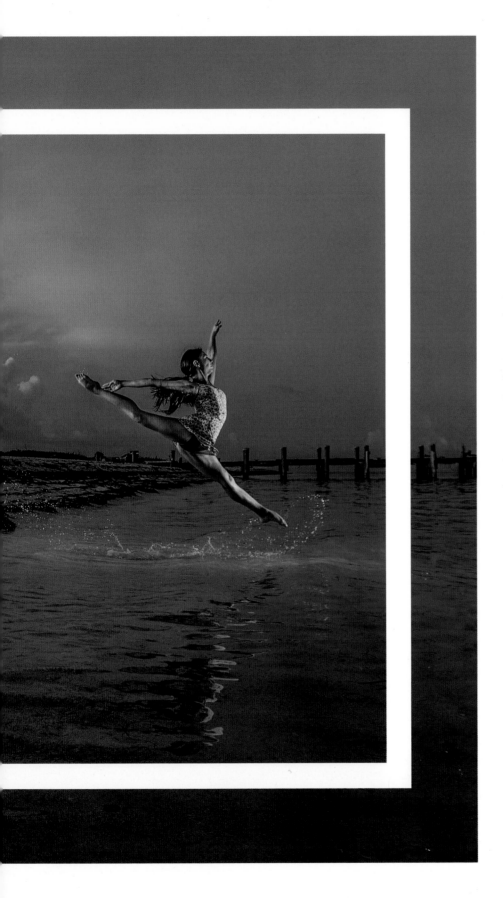

FLORIDA

Dry Tortugas National Park

Day 5

Location 2

July 2, 2016

Miles on Buford: 290

Dry Tortugas National Park is one of those places that is on many a park visitor's bucket list. It is difficult to visit due to the fact you can only get there by boat or sea plane (it is located 70 miles west of Key West), so not many actually make it. Over the past 10 years, the average annual attendance was only 63,000 people, while the most attended National Park received over 10 million! The park is made up of seven islands (or keys), but is 99% water. Garden Key is the location of Fort Jefferson, the largest masonry structure in the western hemisphere. Construction on the fort began in 1846, but was never actually finished.

For us to get the images I wanted, we had to stay overnight. Because of the ferry schedule, we ended up having to stay for two nights, camping on the beach. Camping on the island is fairly rough. There is no water, no electricity, and no real shade, save for the fort itself. You can swim in the ocean, which we did often, but during the middle of the day it was pretty brutal. It wasn't until we were sailing out to the island that Shannon, one of the dancers, realized what this meant. Her face turned pale, and she yelled, "Oh no, my Snapchat streak!"

The rangers here were especially helpful! They brought us over to Loggerhead Key in one of their "fast boats," and were very supportive of the project. We truly enjoyed our time here, but were also very thankful for the showers once we got back to the mainland! Key West marks the farthest south you can drive to in the US. A month from now, we'll be on the opposite side of the country! Go Buford!

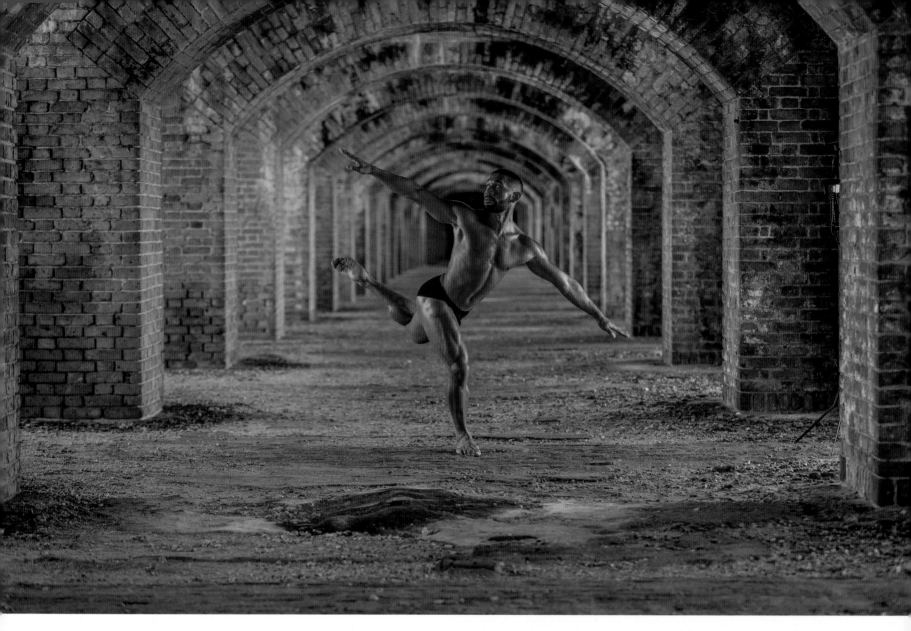

Anthony Velazquez - Age 28 **Fort Jefferson, Dry Tortugas National Park, FL**

One of the coolest things about staying here overnight were the stars at night! Being out in the middle of nowhere with no artificial lights to disrupt your view, the night sky explodes into a show only a few get to see. It was literally breathtaking, standing alone looking up at the night sky. I was so enjoying the view I just sat and watched the night go by for a while, reveling in the sounds of the waves crashing against the fort and hearing the random sea creature surface in the distance. Being able to enjoy our planet and the universe in which we live is something I hope everyone gets the opportunity to experience. So get out there!

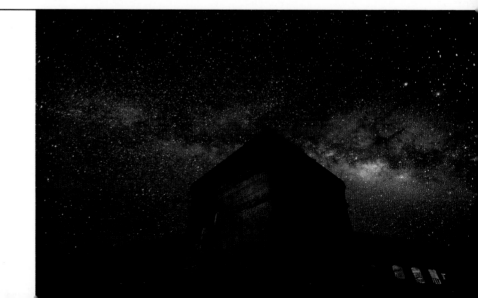

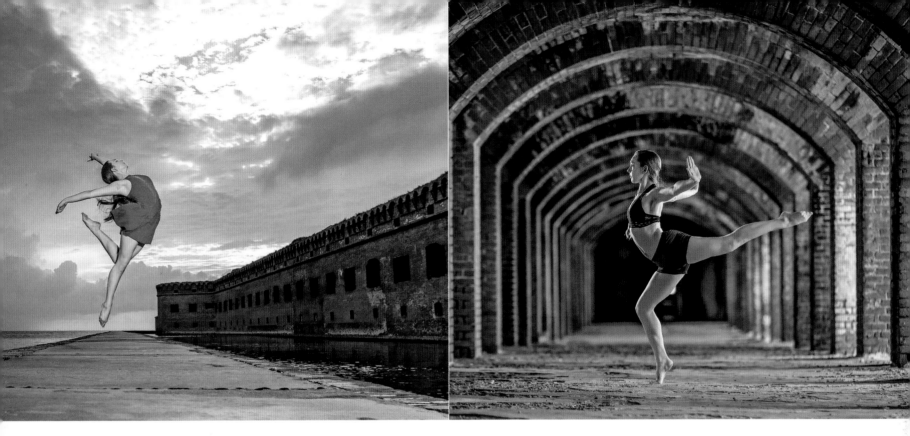

Shannon Wichmann - Age 17 **Fort Jefferson, Dry Tortugas National Park, FL**

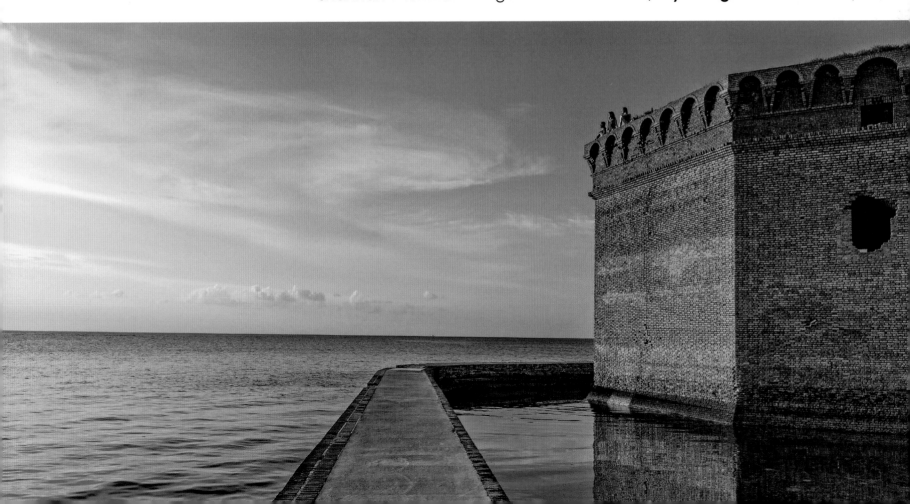

ALABAMA

Little River Falls National Preserve

DAY 9

LOCATION 3

JULY 6, 2016

MILES ON BUFORD: 1282

Our first real road trip of the project! Buford and I headed up to Alabama, leaving Florida behind. We would not see it again until we returned in September. The drive up north is one that I have made several times, up the Turnpike to Interstate 75 from Ft. Lauderdale to Atlanta, then north to Rome, and over into Alabama. Our first "on the road" location was Little River Falls National Preserve. Made part of the National Park system in 1992, it is a beautiful location where you can really enjoy nature, including the many swimming holes that have been a part of life for locals in the area ever since the area was first settled.

When we arrived, we checked in at the ranger station, then headed out to the falls. What a wonderful place! We wandered around the top of the falls for a while, shooting in the peaceful morning air. For the afternoon, we met again a little further downstream at Lynn's Overlook, a place the ranger drove us to so we could again get into the water. We had a great time, jumping off of the falls into the pools below, and by the end of the day we were all soaking wet, and definitely ready for some shut-eye! I slept in Buford in a Walmart parking lot, until early the next morning when it was time for my drive to Louisiana.

A fun little side note: Just northwest of the falls is the town of Fort Payne, AL, home to the band Alabama. The band was formed here in 1969, originally called Wildcounty. Driving through town, there are statues and plaques all over the place, as well as the headquarters of the band's fan club. As a fan of the band myself, I enjoyed this little discovery!

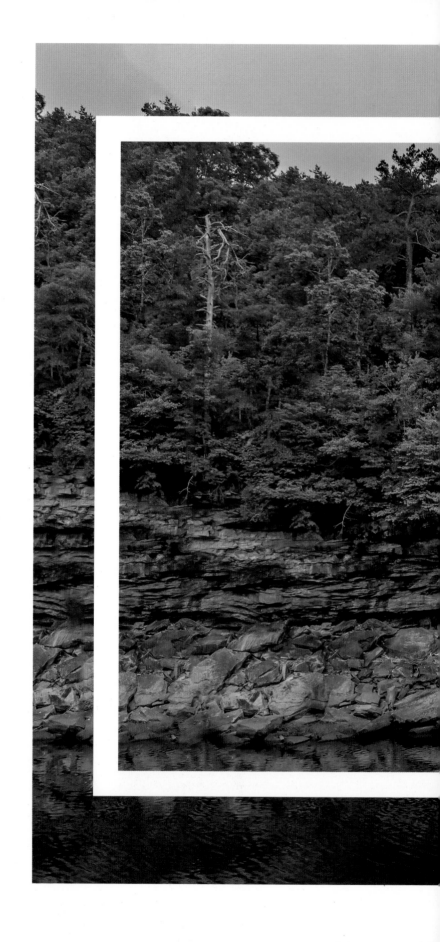

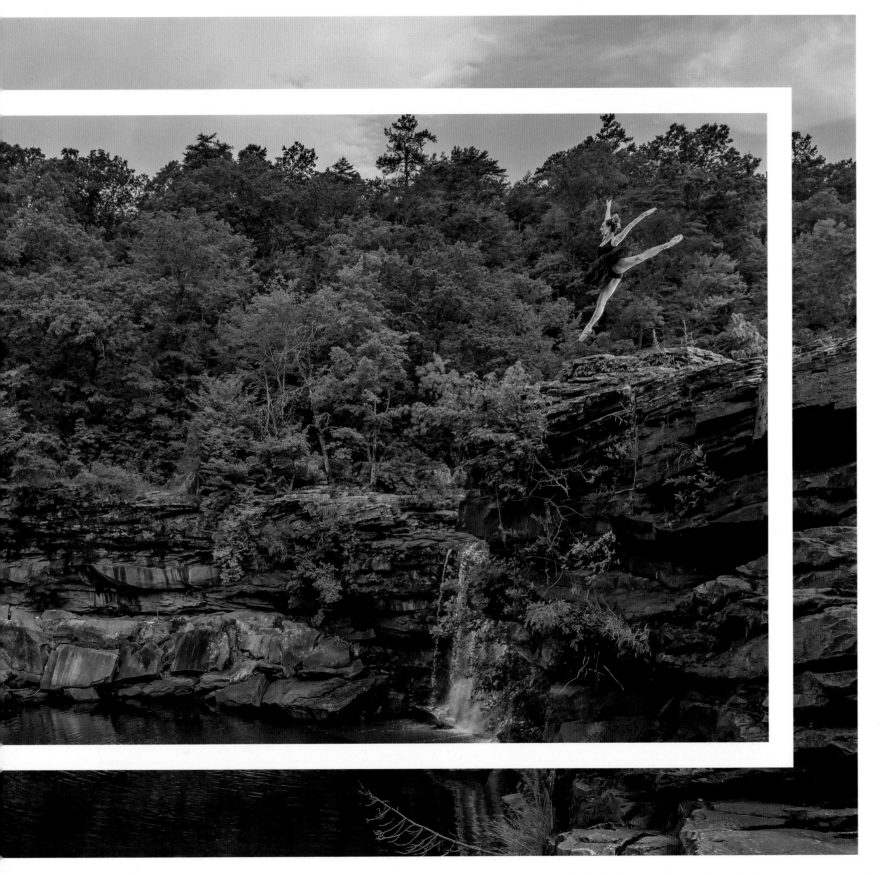

Amanda Martina - Age 24 **Little River Falls, Little River Falls National Preserve, AL**

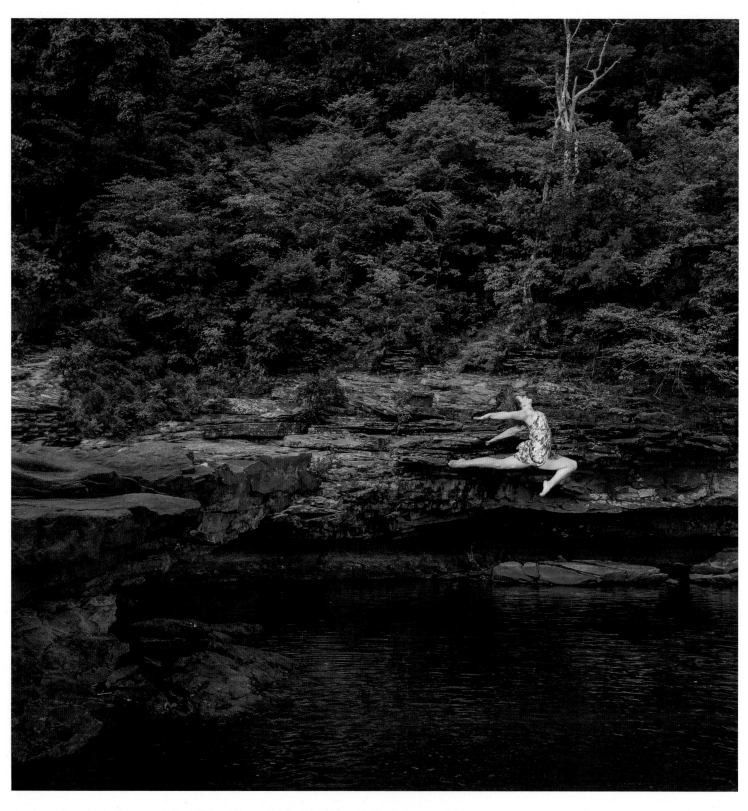

Jenna Tucker - Age 16 **Little River Falls National Preserve, AL**

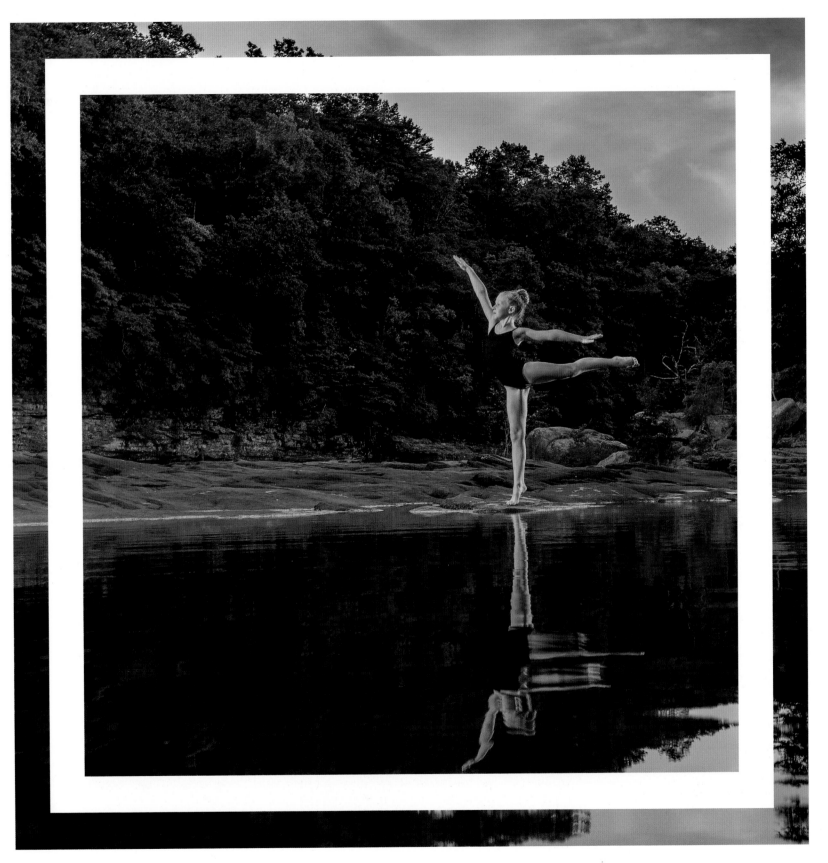

Lily Lary - Age 9 **Little River Falls, Little River Falls National Preserve, AL** 27

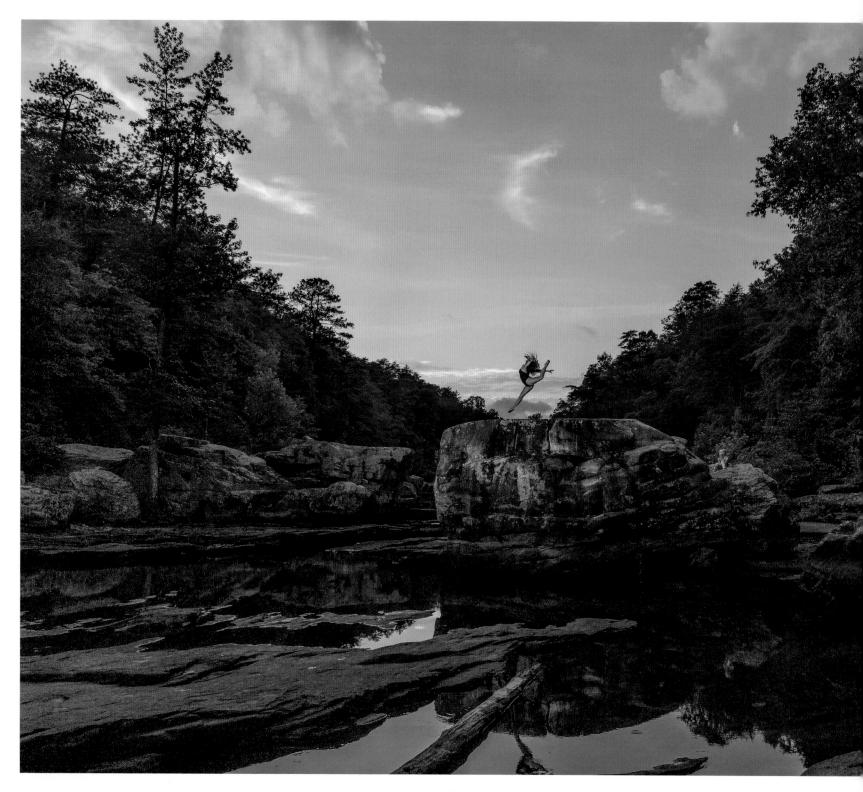

Jenna Tucker - Age 16 **Little River Falls National Preserve, AL**

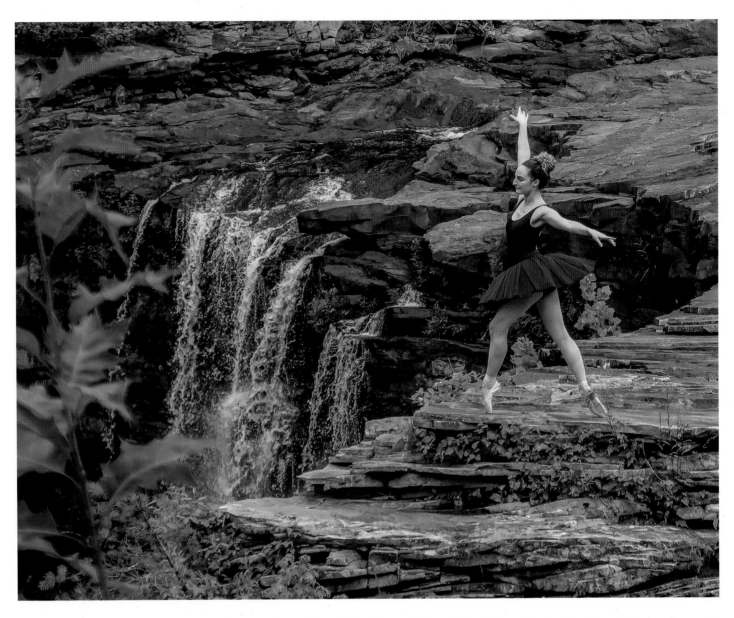

Amanda Martina - Age 24 **Little River Falls, Little River Falls National Preserve, AL**

Have you ever been swimming in an ol' fashioned swimmin' hole? The kind you might read about in a Mark Twain novel. There is such a sense of community and adventure - nothing like going to a city pool. Being out and enjoying nature, splashing around in the clear water and hearing the sounds of nature... it's incredible! City-folk don't generally have these opportunities nearby. But trust me, it's totally worth the drive to find one! So get some friends, a bucket of fried chicken, and get yourself a little closer to nature.

LOUISIANA

The French Quarter

DAY 10

LOCATION 4

JULY 7, 2016

MILES ON BUFORD: 1781

Laissez les bons temps rouler!!! Driving into New Orleans with the Mighty Buford drew a lot of attention. I mean, you would think they had never seen such a fancy van emblazoned with dancers on it before! Driving through the French Quarter, people were whistling and shouting at us. THE MIGHTY BUFORD IS IN THE HOUSE!!! EVERYBODY MAKE SOME NOISE!!!

I met up with the dancers right across the street from Cafe du Monde, at the southern gates of Jackson Square. I love this town, soooooooooo much! We spent our afternoon wandering around the quarter, and what a day we had! The music, the people, the smells of wonderful cajun cooking wafting through the air, it's a little slice of heaven down here.

Founded in 1718 by Jean Baptiste Bienville, the French Quarter was originally a grid of 70 square blocks, that over time evolved into a center of culture and art. The Quarter drew in musical legends like Jelly Roll Morton, Louis Armstrong, Buddy Bolden, and King Oliver, while at the same time attracting writers and artists as well - William Faulkner, Edgar Degas, Sherwood Anderson, and Tennessee Williams, to name a few.

Today when you visit, do not think that New Orleans is only the storied Bourbon Street. There is a wealth of history, art, music, and culture that flourishes here, all of which are the product of generations of people from around the world coming together to make New Orleans their home. If you come, make sure to take a ride on the streetcar through the Garden Disctict, get a beignet from Cafe du Monde, and visit the New Orleans Jazz National Historical Park.

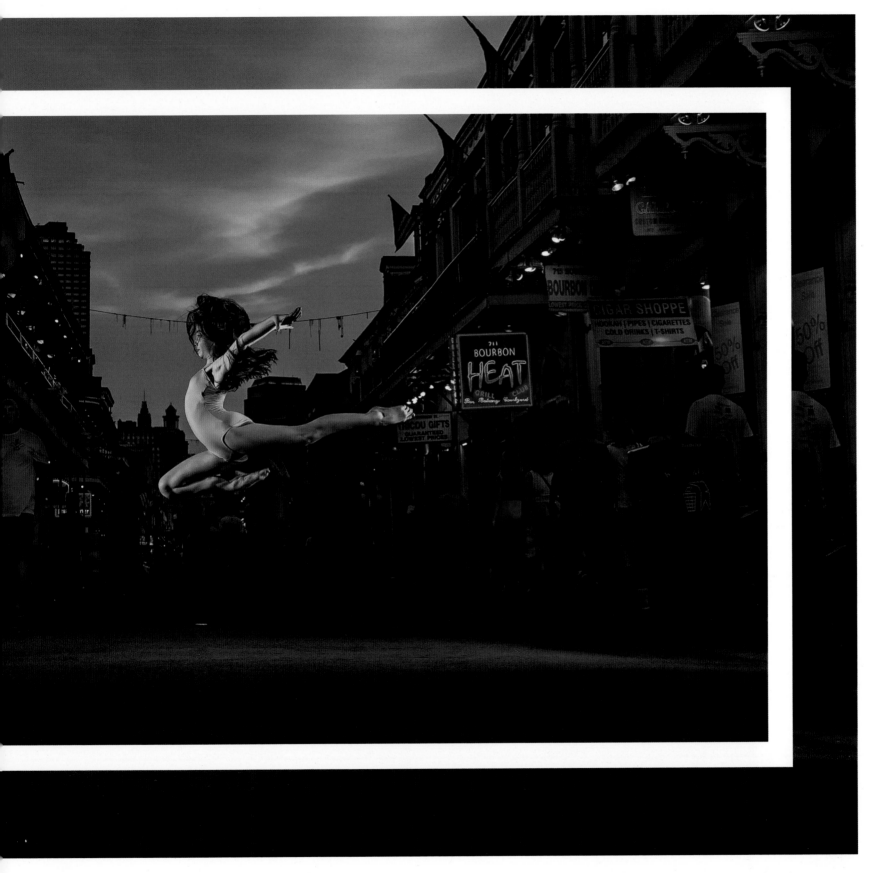

Kaylie Wood - Age 12 **The French Quarter, New Orleans, LA** *31*

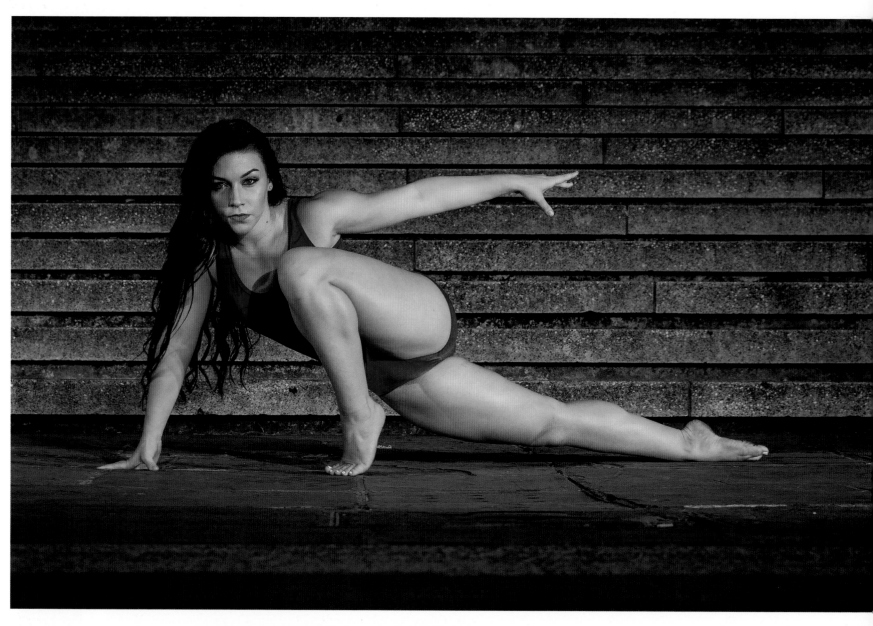

Darian Callais - Age 17 **The French Quarter, New Orleans, LA**

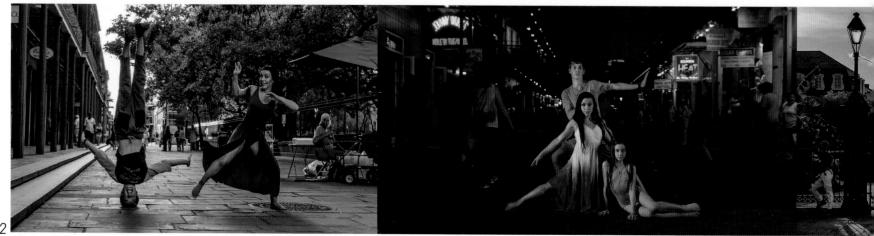

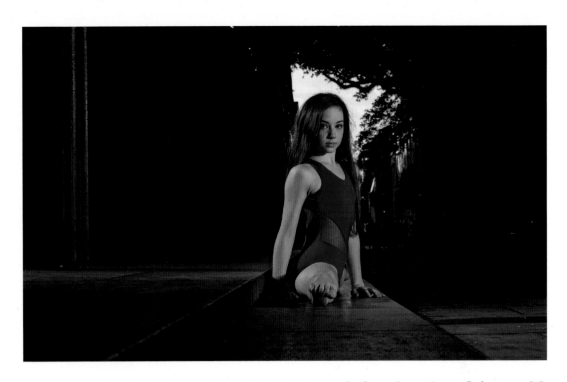

Kaylie Wood - Age 12 **The French Quarter, New Orleans, LA**

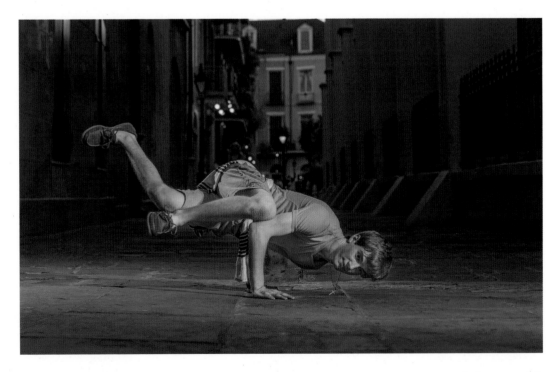

Zachary Wright - Age 20 **The French Quarter, New Orleans, LA**

MISSISSIPPI

Natchez Trace Parkway

DAY 12

LOCATION 5

JULY 9, 2016

MILES ON BUFORD: 2177

The next drive was to Mississippi, not a terribly long way away, but the change was almost immediate! From the busy streets of New Orleans to the relative solitude of the Natchez Trace, I felt like I could relax a little bit. I spent the night in a campground, again enjoying the comfort of the Mighty Buford.

The Natchez Trace Parkway is a park that covers multiple states, and has tremendous ecological diversity and historical significance. Native Americans used this trail for hundreds of years, and later so did Meriwether Lewis (of Lewis and Clark fame). The Trace was even part of the underground railroad!

If you were driving up the Natchez Trace Parkway, it would be very easy to pass by our Mississippi location. There is only a simple arrowhead shaped sign in a small turnout. If you do happen to find it, the moment you walk down the stairs to the trailhead the swamp opens up like a picture book! Particularly at sunrise, the scene is like an old movie.

The swamps of Mississippi are an important part of the wetland ecosystem. Swamps are natural filters, collecting pollutants and excess nutrients, controlling erosion, and replenishing aquifers. They are also places teeming with life, so tread lightly. As in any natural place you visit, the motto "Take only photographs, leave only footprints" holds true. Just like you wouldn't want someone coming into your home and messing it up, the great outdoors is home to everything else on the planet. Enjoy it, experience it, and try not to break it.

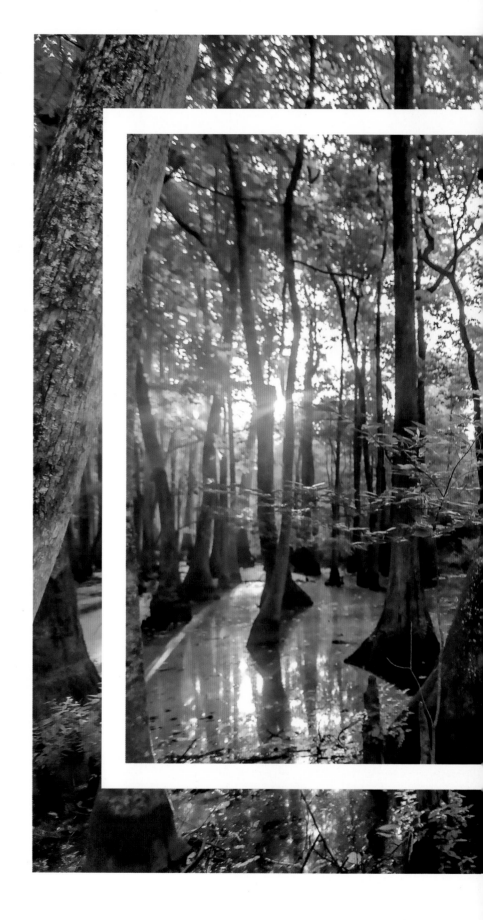

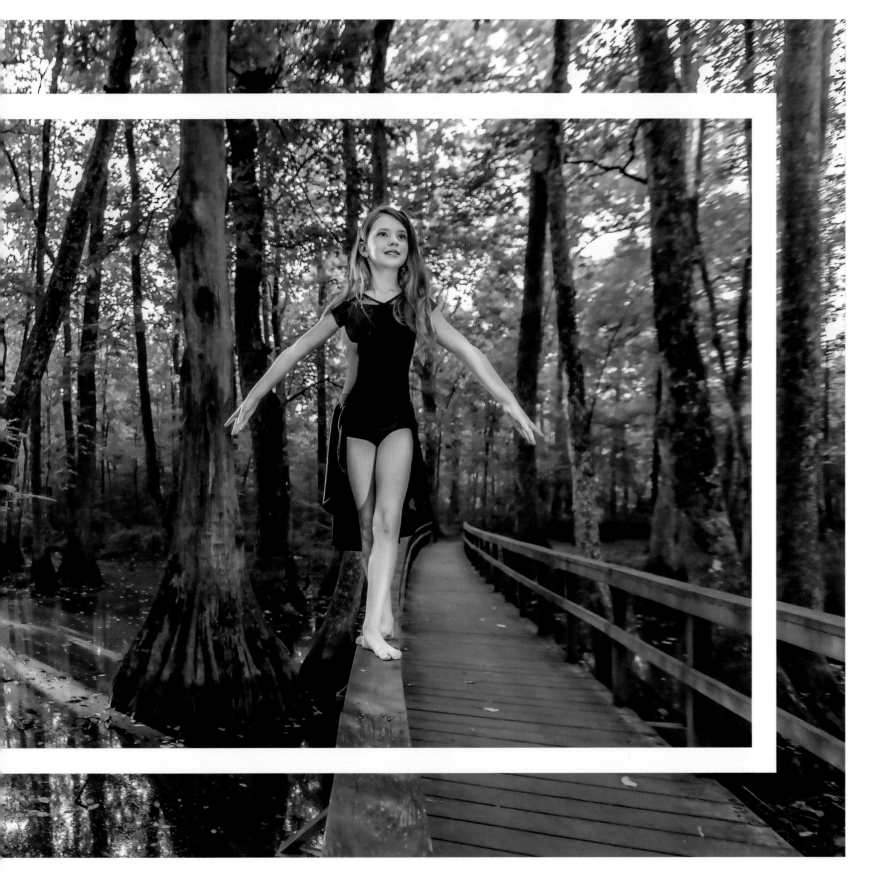

Violet Wiley - Age 9 **Cypress Swamp, Natchez Trace Parkway, MS** *35*

36 Alyssa Smith - Age 9 **Cypress Swamp, Natchez Trace Parkway, MS**

Violet Wiley - Age 9 **Natchez Trace Parkway, MS**

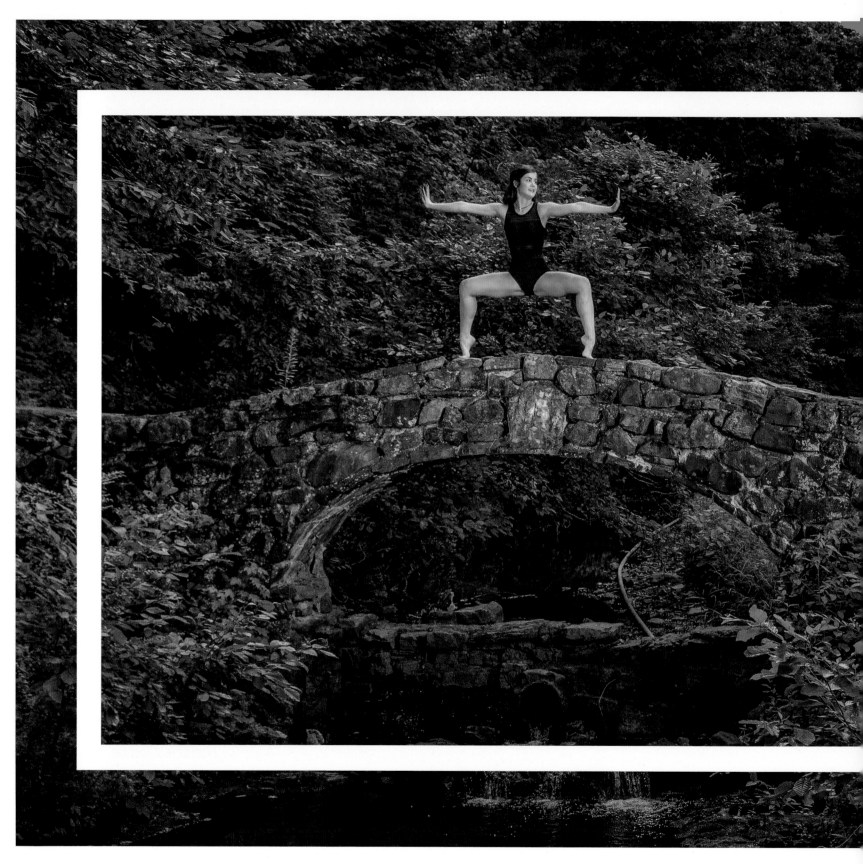

38 Morgan Laney Smith - Age 16 **Fordyce Mill Pond, Hot Springs National Park, AR**

ARKANSAS

Hot Springs National Park
DAY 13
LOCATION 6
JULY 10, 2016
MILES ON BUFORD: 2529

Hot Springs National Park is a gem about an hour west of Little Rock. For centuries people have come to the springs, using its waters for relaxation and therapy. People would come here to swim in the springs, drink the water, and receive various treatments. Bathhouses were built in the late 1800's and early 1900's, which added a level of luxury to the springs as well. Today, some of those bathhouses still stand, called Bathhouse Row. The National Park Services operates their Visitors Center for the national park out of one of these historic houses, the Fordyce Bathhouse. This bathhouse was, without question, the most elaborate of them all.

But Hot Springs National Park is so much more than just Bathhouse Row. There are miles of hiking trails, camping, fishing, swimming, historic buildings, and so many stories! Chat with the locals about ties to the Chicago Mob scene, or go way back to the American Indians who lived around the springs for over 5000 years!

There are many interesting facts about this area. Hot Springs was once the off-season capitol of Major League Baseball, with many teams holding spring training here.

I spent the night in a campsite in the park, which we used as the meeting place for our session here. Our day was quite busy, covering multiple locations and contending with some bad weather as well. But oh, the photos we got! Hot Springs National Park is the smallest of the 59 American National Parks, but it is absolutely worth the visit.

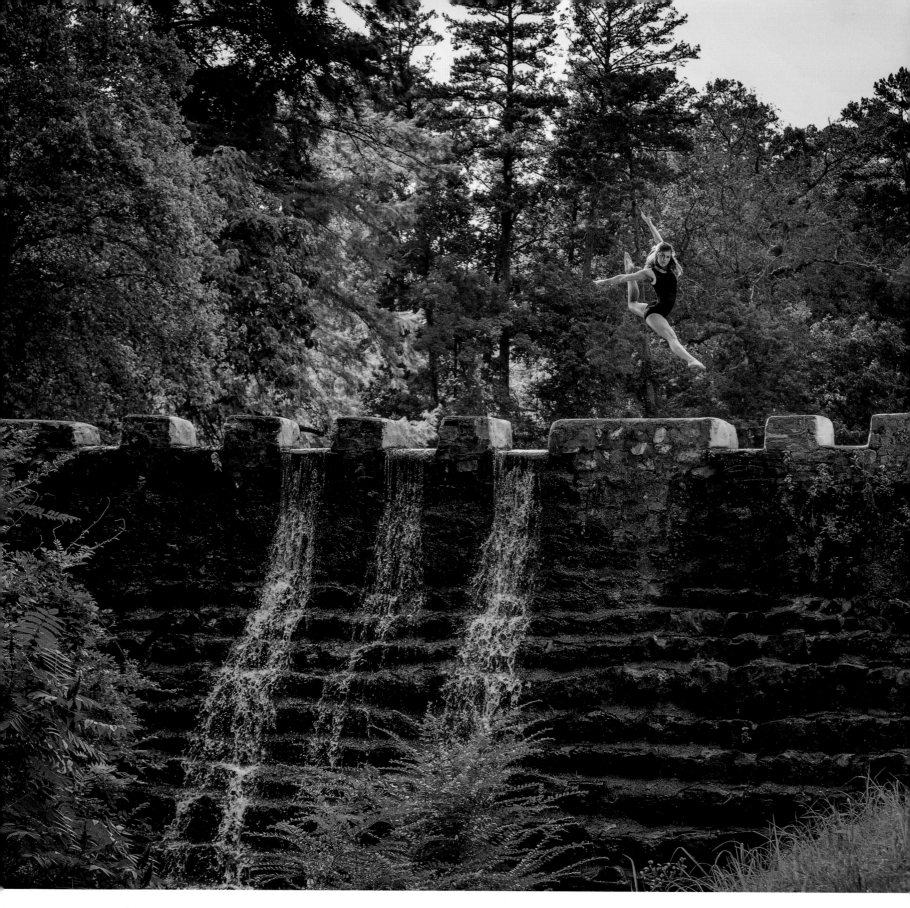

Morgan Laney Smith - Age 16 **Fordyce Mill Pond, Hot Springs National Park, AR**

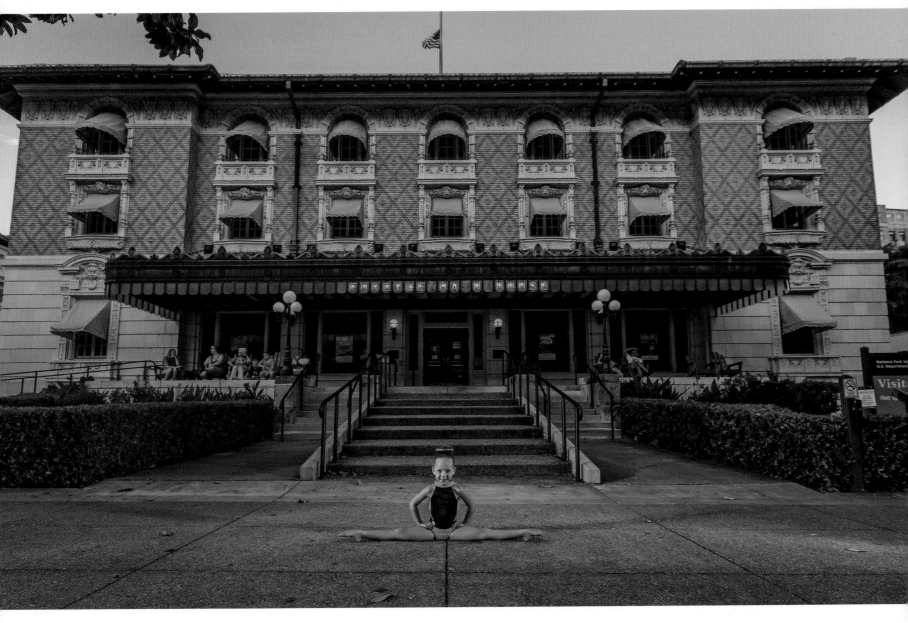

Baylee Badeaux - Age 6 **Fordyce Bathhouse, Hot Springs National Park, AR**

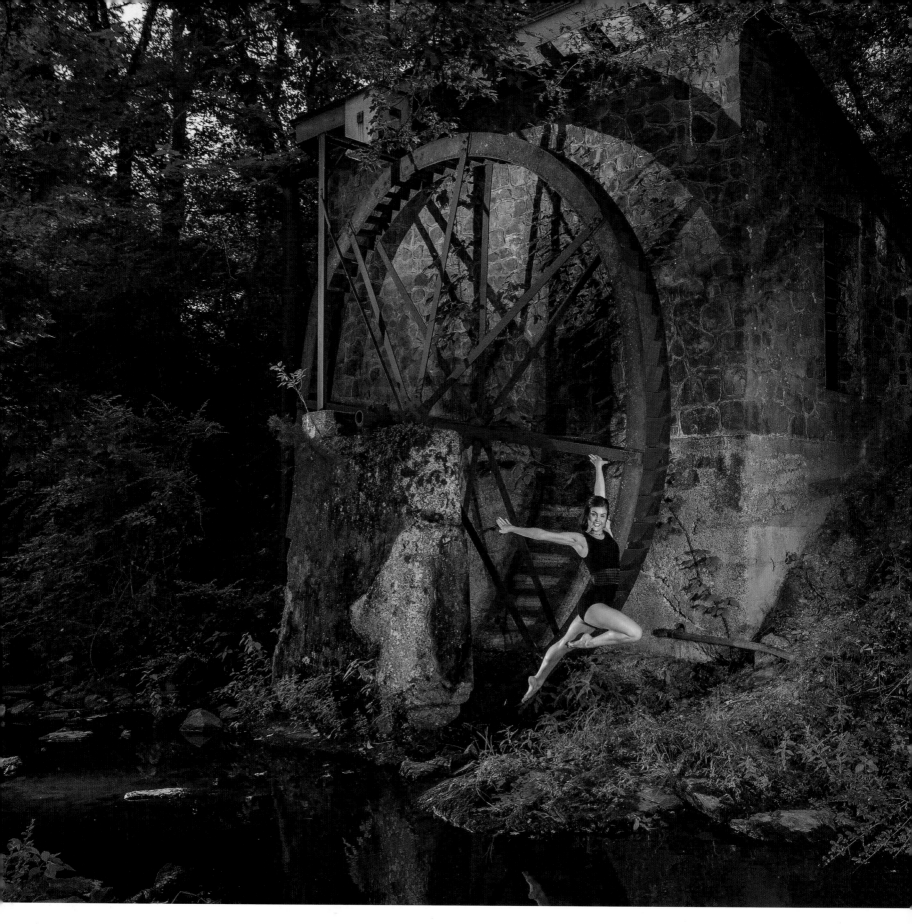

Morgan Laney Smith - Age 16 **Fordyce Mill Pond, Hot Springs National Park, AR**

Gabi Lynn Dulaney - Age 6 **Hot Springs National Park, AR**

Timothy Dale Jefferson - Age 33 **Chickasaw National Recreation Area, OK**

OKLAHOMA

Chickasaw National Recreation Area
DAY 15

LOCATION 7

JULY 12, 2016

MILES ON BUFORD: 2845

Leaving Arkansas and heading west, this was the drive where the scenery really started to change. Up until this point, there had been lots of green forests, but entering Oklahoma brought wide open prairies. There is a palpable difference to the country here, reminding me of my childhood. I lived in Norman, OK as a young lad, and though I was young, I still have a feeling of familiarity when I come here.

Pulling into Chickasaw, I went to explore a bit in preparation for the session that afternoon. There were tons of people enjoying the cool waters of Travertine Creek, which create several waterfalls that are open for swimming. The trails are well maintained, and it was a very peaceful afternoon. During our session here, as in every other location where we had water, I ended up neck deep in the river, just barely keeping my camera dry. It's all about getting the right angle. Which means getting wet, and not breaking anything in the process.

As part of this session, I reached out to the Chickasaw Nation to see if I would be able to have some of their members be a part of DATUSA. They had two volunteers who came and showed us their traditional stomp dance, and told about the history of their relocation to the area. Originally from the Mississippi, Tennessee, and Alabama areas, the Chickasaw were forcefully relocated when the government wanted their land. They are a proud people, with a wealth of history and knowledge.

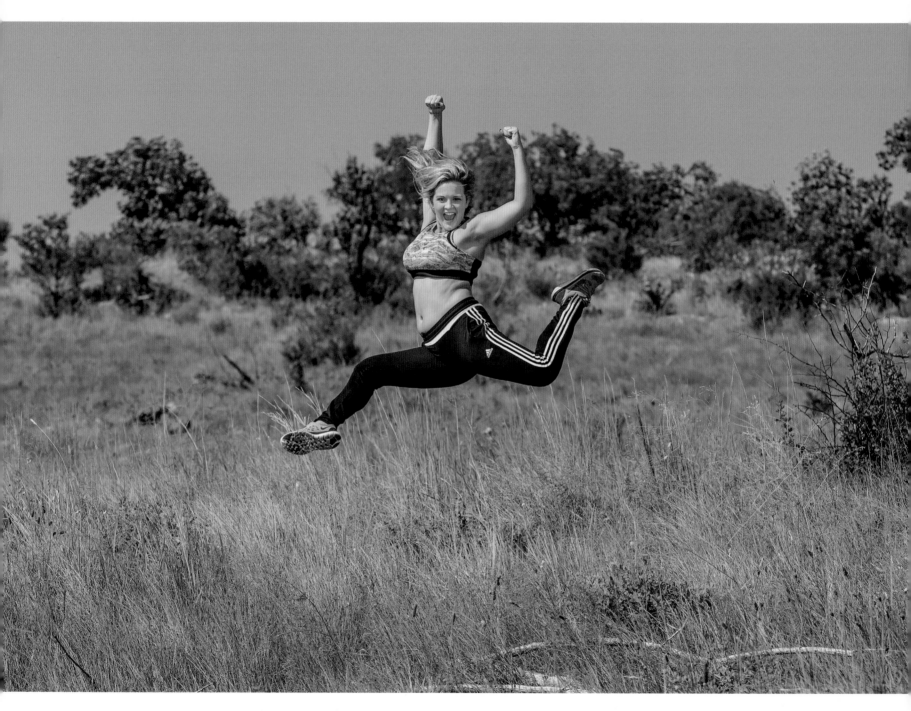

Jaci Erin Armstrong - Age 18 **Chickasaw National Recreation Area, OK**

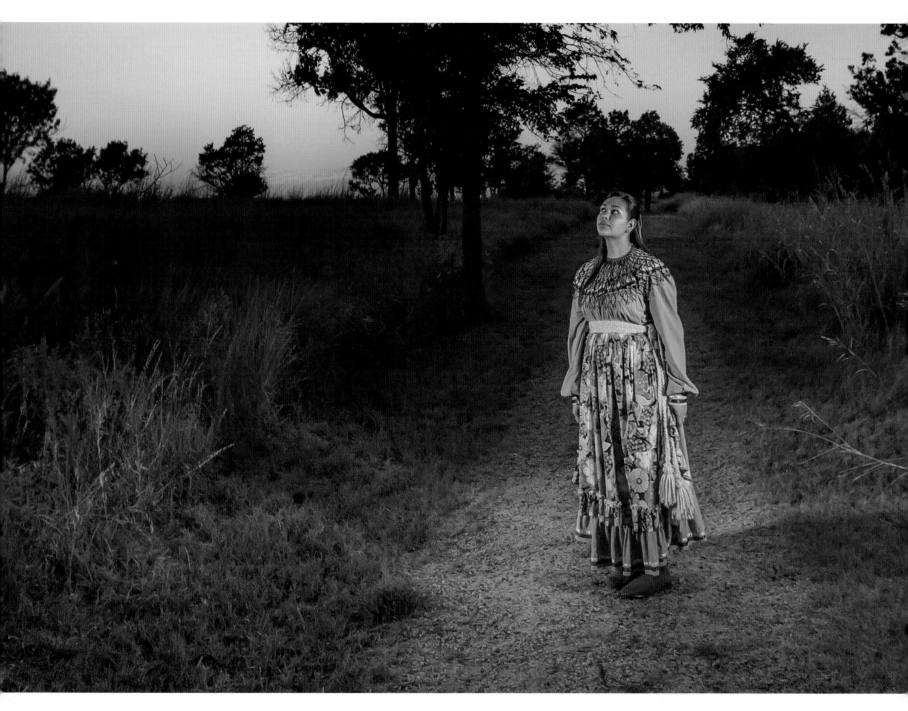

Lori Mala Elizabeth Whitebuffalo - Age 20 **Chickasaw National Recreation Area, OK**

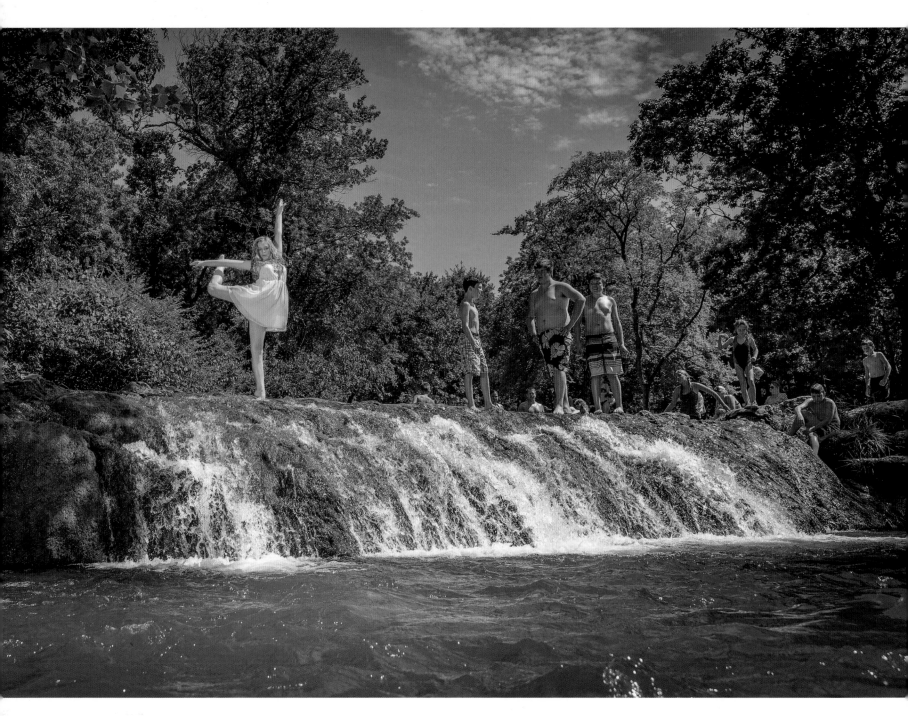

Savannah Truesdale - Age 13 **Chickasaw National Recreation Area, OK**

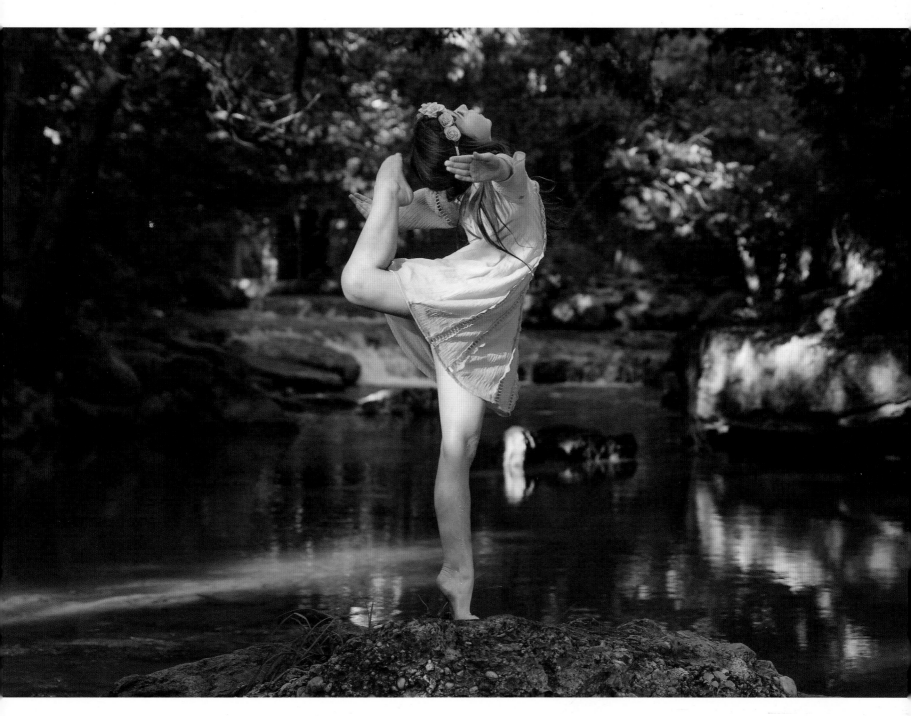

Jordan Biggs - Age 7 **Chickasaw National Recreation Area, OK**

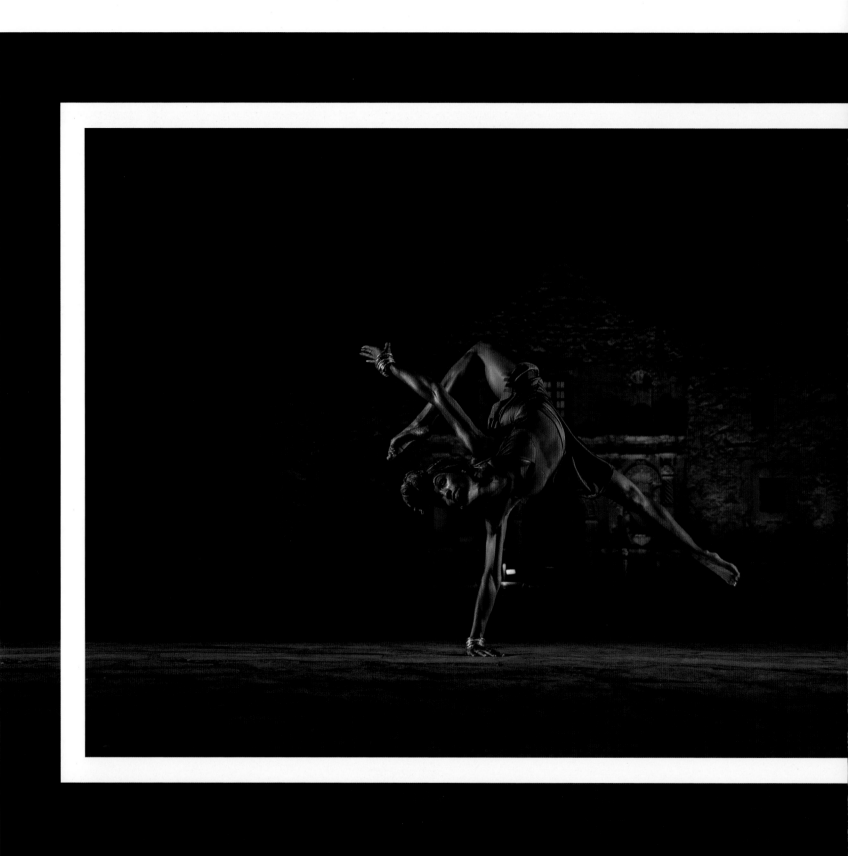

Maryann Payne - Age 24 **The Alamo - San Antonio, TX**

TEXAS

The Alamo
DAY 16
LOCATION 8
JULY 13, 2016
MILES ON BUFORD: 3304

Ok, this one was brutal, I'm not even gonna try to tell you different. I finished the session in Oklahoma at 9pm, and drove all night long to get to the Alamo in time for sunrise. I pulled in right at the exact moment we were meant to start our session, so the timing worked out well! But man, was I tired!

The Alamo is one of those places that most everyone knows about, but not too many know the real history of it. It was a Franciscan (Roman Catholic) mission built around 1718 by the Spanish, and was originally called the *Misión San Antonio de Valero*. Control of the mission changed from Spanish to Mexican hands after the Mexican war for independence from Spain in 1820.

Sixteen years later the US and Mexico were at war, and the Alamo was the site of a 13-day battle where 200 Texans defended their position against a Mexican force of somewhere between 1800 and 6000 men. The Texans were finally overpowered, but that battle became a rallying cry for the remainder of the war for Texan independence. (*Remember the Alamo!*)

We did our session in front of what is called the Church, but the Alamo complex is a series of buildings and land. When visiting the Alamo, make sure you take the time to see the whole of the Alamo, and learn more about its history. It is by learning about history that we grow and improve ourselves, and there is much to learn from this place.

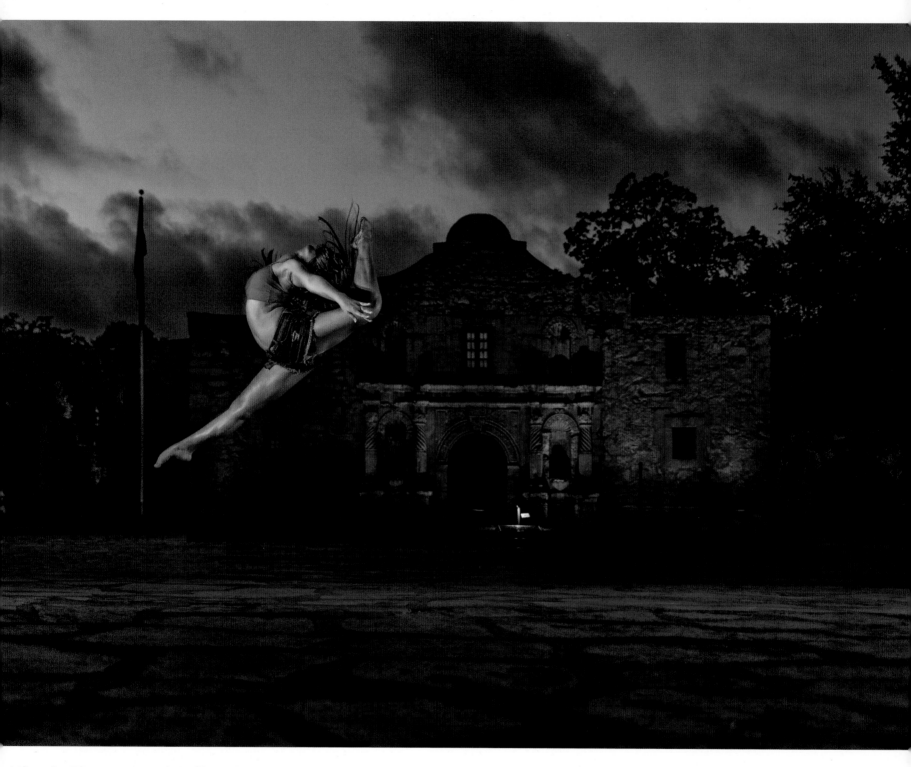

Mikayla Pham - Age 15 **The Alamo - San Antonio, TX**

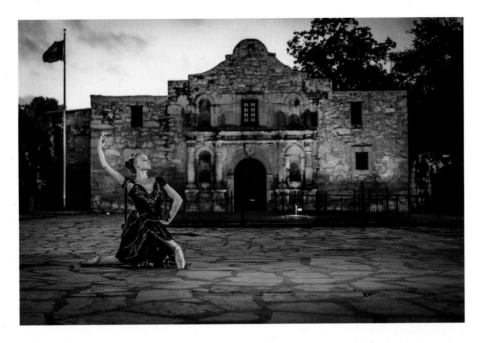

Victoria Stocker - Age 18 **The Alamo - San Antonio, TX**

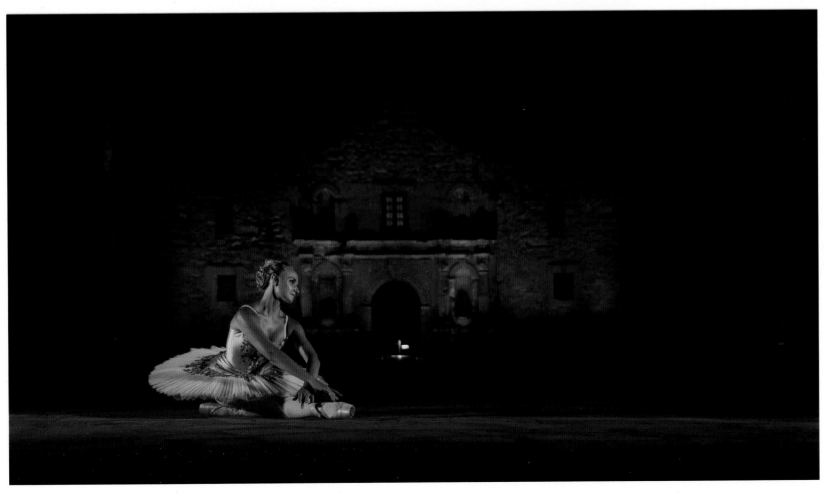

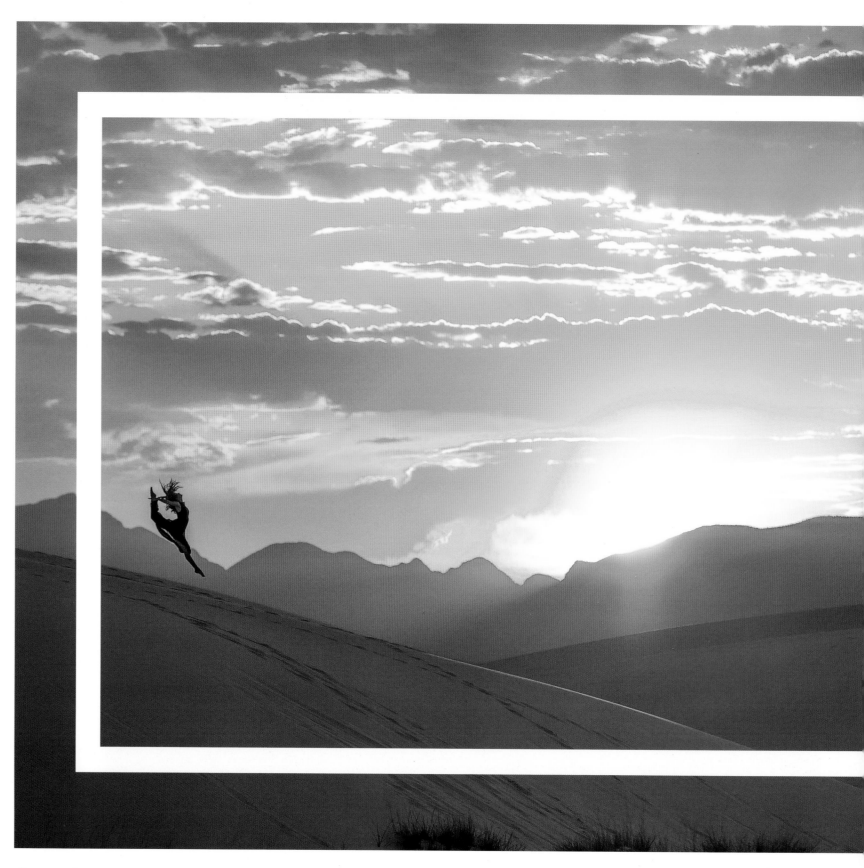

54 Grace Godman - Age 14 **White Sands National Monument, NM**

NEW MEXICO

White Sands National Monument
Day 17
Location 9
July 14, 2016
Miles on Buford: 4046

One of the few places I had not been for this project was White Sands National Monument. I've always wanted to go, and now I finally was! The dunes here are not sand, but gypsum. Because of this, the dunes never get hot, even in the blazing sun. Have you ever gone to the beach and the sand was too hot to walk on? That won't happen here.

When you look at the dunes, at first glance they seem like barren mounds of nothing, but there is a great deal of life here! Of course snakes and bugs like you would expect, but in the dunes you can find mammals like rabbits, coyotes, foxes, over 200 kinds of birds, and even fish! The White Sands Pupfish is found nowhere else in the world, and is a threatened species. The dunes as an ecosystem are quite delicate, and do require visitors to take extra care so as to not damage anything. This is not a place to go off-roading.

The image you see here on the left, that really happened! Sunsets like this are real, and you are changed by seeing things like this in real life. It's almost unbelievable when it happens, like how can this be? But wow, so incredible!

This location was a challenge for us as well in the dancer department. The day before this session all of the dancers backed out. So we had a mad scramble over about 12 hours to arrange replacements. We ended up with the amazing dancers that you see here due to the tireless efforts of my team supporting me back at home. This project was so much more than just me, it absolutely took a village!

55

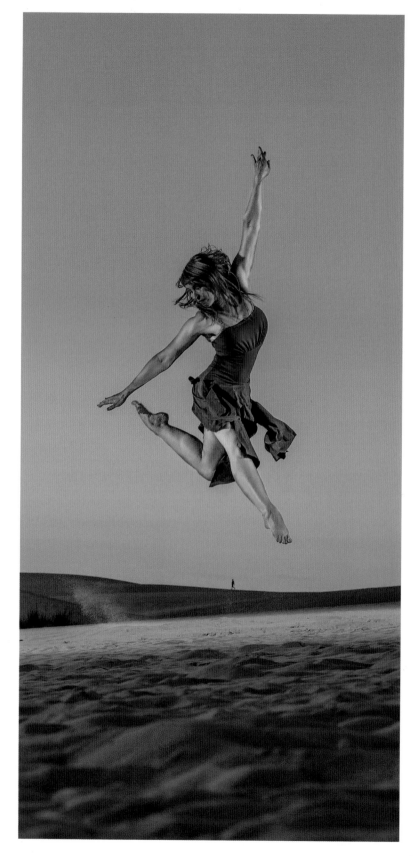

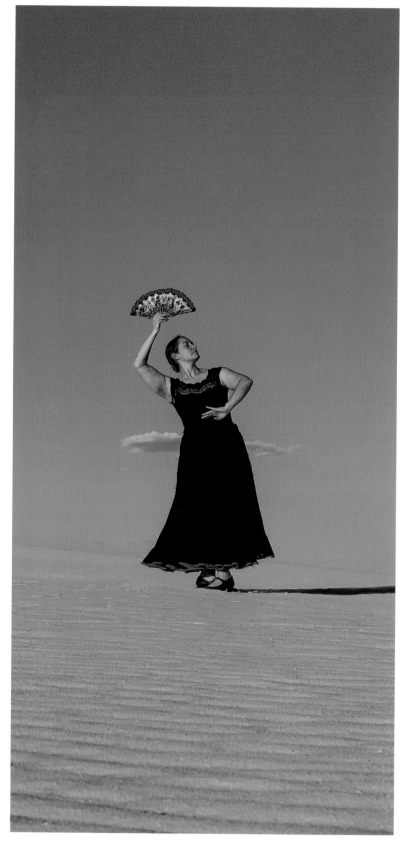

Andrea Severson - Age 31 **White Sands National Monument, NM** Rachel Goodman - Age 35

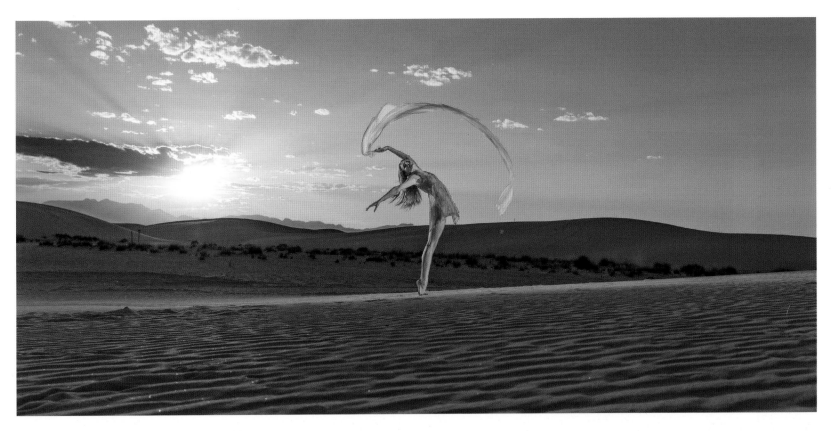

Brianna Spence - Age 19 **White Sands National Monument, NM**

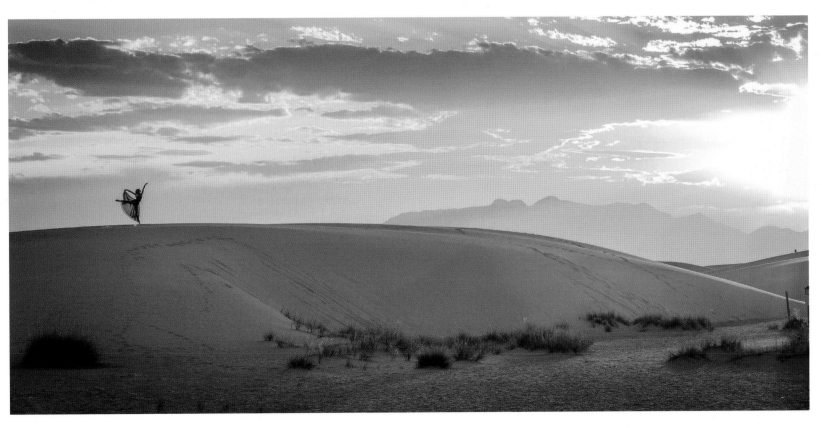

Ariana Mcleod - Age 18 **White Sands National Monument, NM** 57

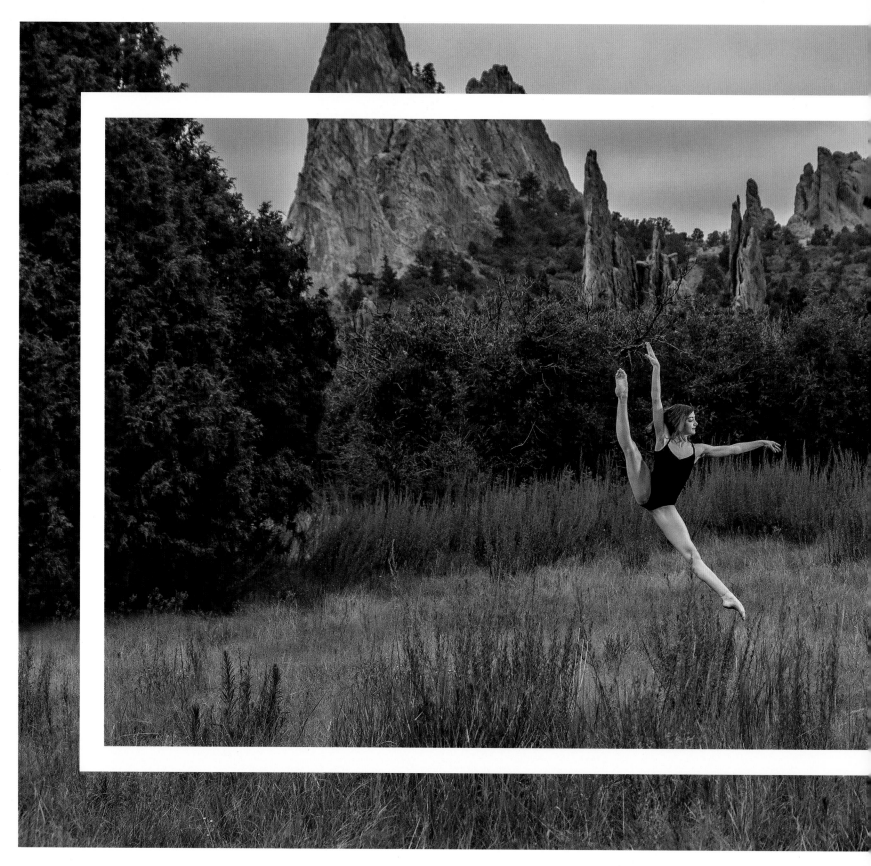

Gabriella Rae - Age 13 **Garden of the Gods, CO**

COLORADO

Garden of the Gods

Day 19

Location 10

July 16, 2016

Miles on Buford: 4576

GO SPARTANS!!! =) I went to high school in Colorado Springs, attending Thomas B. Doherty High. High school was awesome - Louie Bread, Skate City, the 39 cent hamburger stand, such good times! Coming to Colorado meant I had to choose something around the Springs, and Garden of the Gods was the obvious choice. As a kid, I used to hike here, compete in races, it was an escape that was sorely needed back then.

My teenage years came rushing back, but I was getting to see this place I loved with new eyes, and now with a purpose. There were places I knew I had to cover - Kissing Camels, Sleeping Giant, Cathedral Spires, and of course Balanced Rock, but I wanted to explore as well.

The beautiful red rocks of the area are sandstone, limestone, and conglomerates that started off horizontal, and were pushed up from geologic activity. Throughout history there have been numerous tribes attracted to the area, including the Apache, Cheyenne, Kiowa and Ute people.

When you visit today, start by driving around Juniper Way Loop, then park somewhere and go for a hike. You simply can't go wrong, finding stunning views at every turn.

Coming back to my hometown like this was amazing. As adults, we can think back to our younger days and remember the apprehension we had about the future. Big, HUGE shoutouts to Trent "Homer" Ellis, Hayes Alexander, Linda Case, and Karen Reynolds, for being the adults that helped me find my way back then.

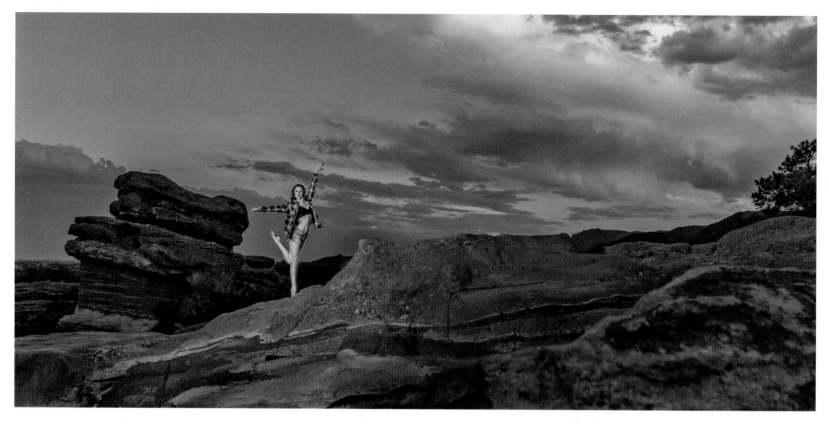

Brianna Micheletti - Age 20 **Garden of the Gods, CO**

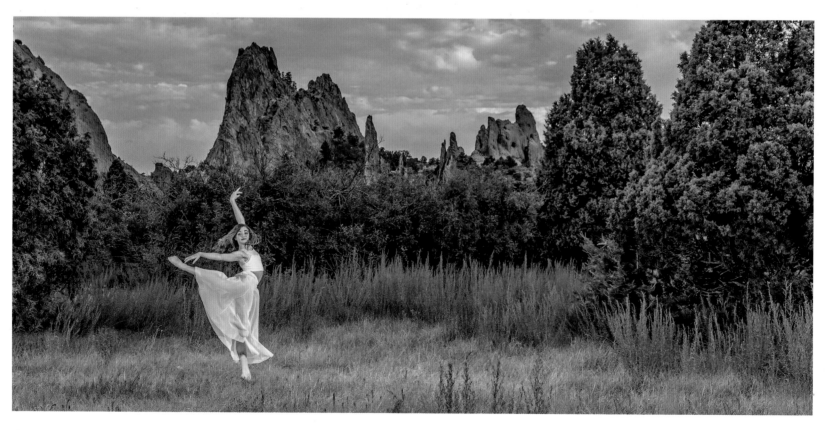

Gabriella Rae - Age 13 **Garden of the Gods, CO**

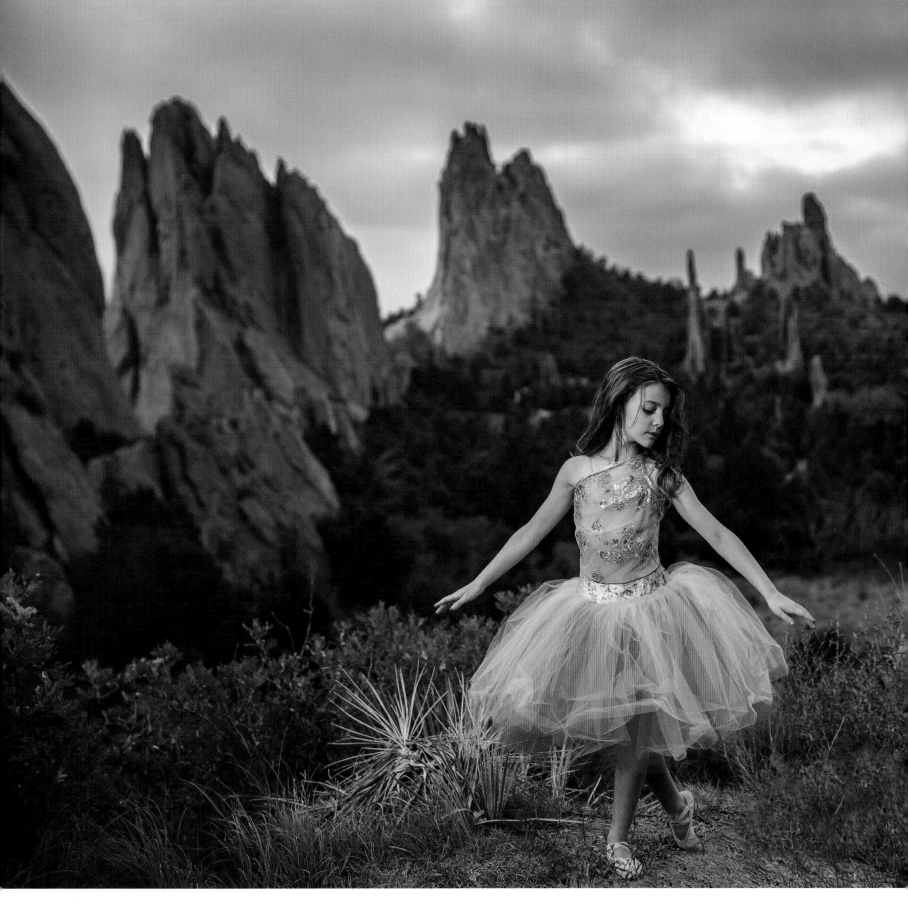

Virginia Buller - Age 9 **Garden of the Gods, CO**

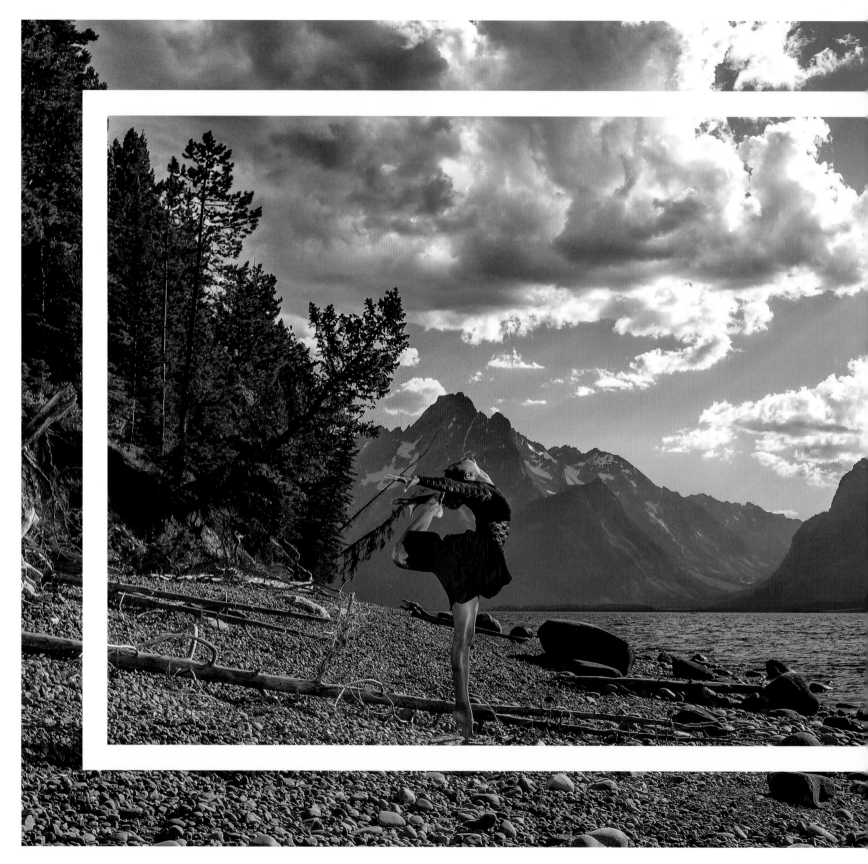

Aliya Edwards - Age 12 **Jackson Lake, Grand Teton National Park, WY**

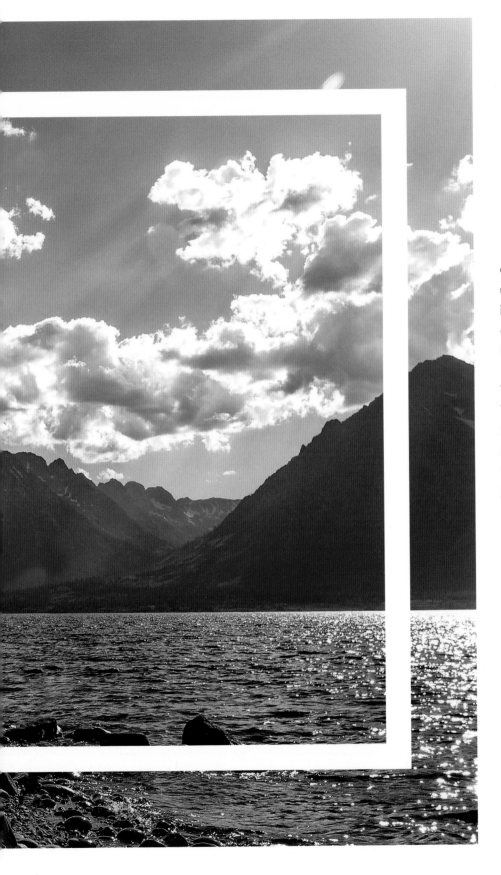

WYOMING

Grand Teton National Park
Day 22
Location 11
July 19, 2016
Miles on Buford: 5188

Grand Teton National Park has always been my favorite. I used to daydream about working here during the summer in the horse stables so I could go for rides every day in such a beautiful location. It really is without compare. No other mountains in the US are as impressive as the Tetons.

There is much more than just the mountains in the park! The history, the flora and fauna, and the biscuits and gravy from the Jenny Lake Lodge. Heaven! But seriously, these mountains are incredible. Towering over the Snake River valley, there are no foothills leading up to the mountains - it's just flat, flat, flat, MOUNTAINS!!!!! Grand Teton, the highest peak, sits at an impressive 13,770 feet about sea level. With over 200 miles of trails, let alone all the backcountry possibilities, you could spend a lifetime in just this park.

On my way into the park, I had to drive through a forest fire, quite literally. There were firefighters on the road battling the blaze to keep vehicles moving through the area. Fires are a natural occurrence, and necessary for the environment, but scary all the same.

We did sessions at two different locations - sunset at Colter Bar, and sunrise the following morning at Mormon Row, which is a series of buildings built by Mormon settlers beginning in the 1890's. Rangers here say the barns at Mormon Row are the most photographed in the world, and it's easy to see why. I decided to stay an extra day here, just so I could soak up a little more of the majesty before I continued my trip. Next stop, Idaho!

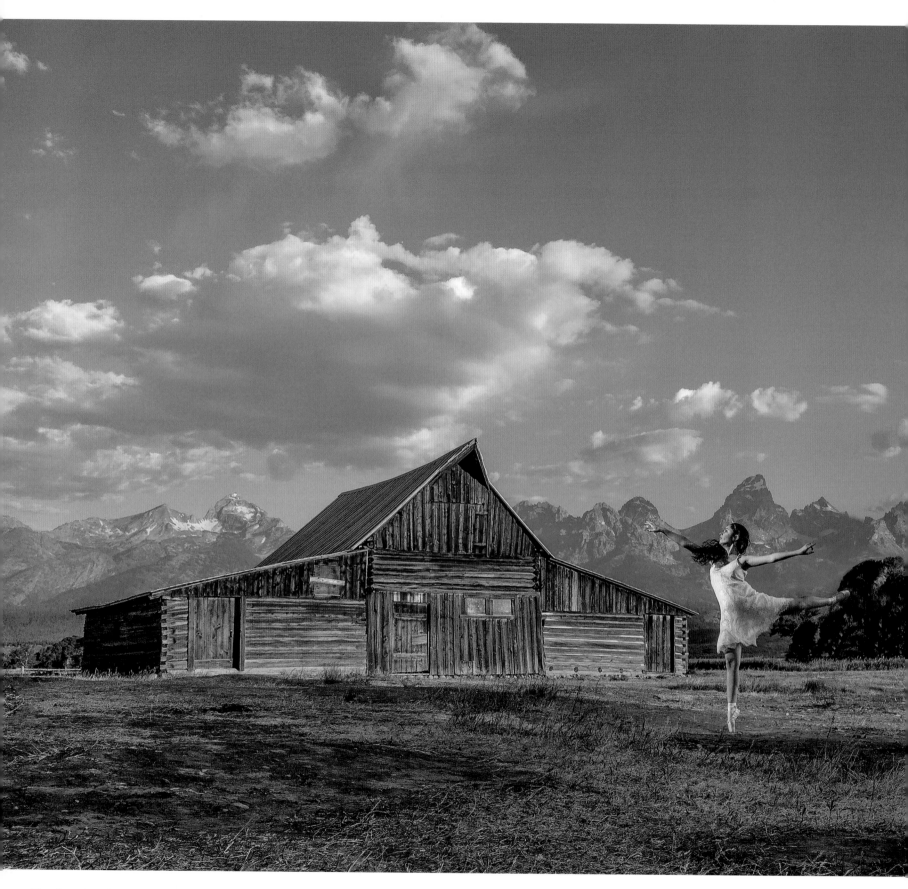

Taylor Gutierrez - Age 15 **Mormon Row, Grand Teton National Park, WY**

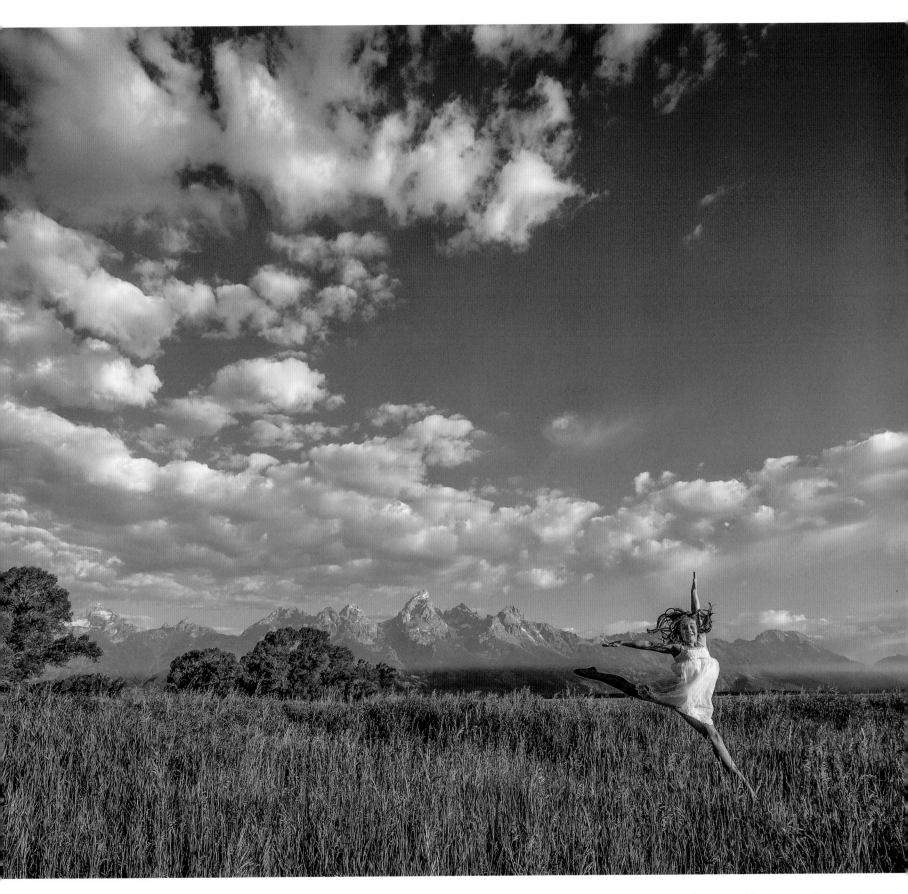

Shailee Parks - Age 9 **Mormon Row, Grand Teton National Park, WY**

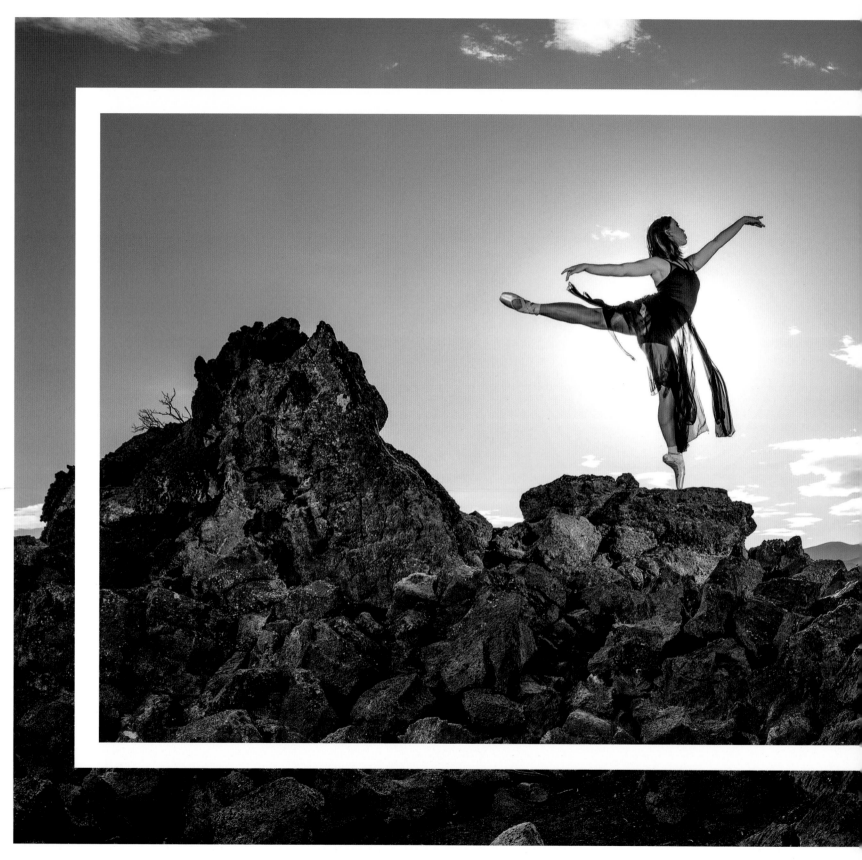

Ayriss Torres - Age 16 **Craters of the Moon National Monument, ID**

IDAHO

Craters of the Moon National Monument
Day 24
Location 12
July 21, 2016
Miles on Buford: 5468

Craters of the Moon National Monument and Preserve is a very large park, at about 1100 square miles (around the size of Rhode Island). It is an area covered by old lava flows, the most recent of which occurred around 2000 years ago. There are several types of lava flows and other volcanic features, some of which are incredibly fragile. Sticking to the trail is advised, and in some places going off trail is specifically prohibited. We made extra care to follow the rules, and not damage this wonderful landscape. There are daily postings in parks about current conditions, and visitors should check those out before their arrival.

The history of this park goes back a long way, but part of that history of this area includes NASA. Apollo 14 astronauts used the park for some of their training, so they could become familiar with the terrain they would encounter on the moon. The first modern exploration of the area began in the 1850's, but Native Americans activity can been seen here over several thousand years. The Shoshone tribe even have stories of witnessing eruptions in the area!

Again, this park is fragile and can be dangerous if you do not follow the rules. Please make sure that when you visit, you understand the areas that you can and cannot walk in. While the view is amazing, it's not worth you injuring yourself or damaging the area for. Please don't take home rocks or souvenirs without permission. It's simple math: If every visitor took home a rock, eventually all the rocks would be gone. So leave them alone for the next visitor to enjoy. Travel well!

Avery Rooney - Age 15 **Craters of the Moon National Monument, ID**

"Dancing is something I can't not do. It's like breathing... it's how I live."~
Avery Rooney

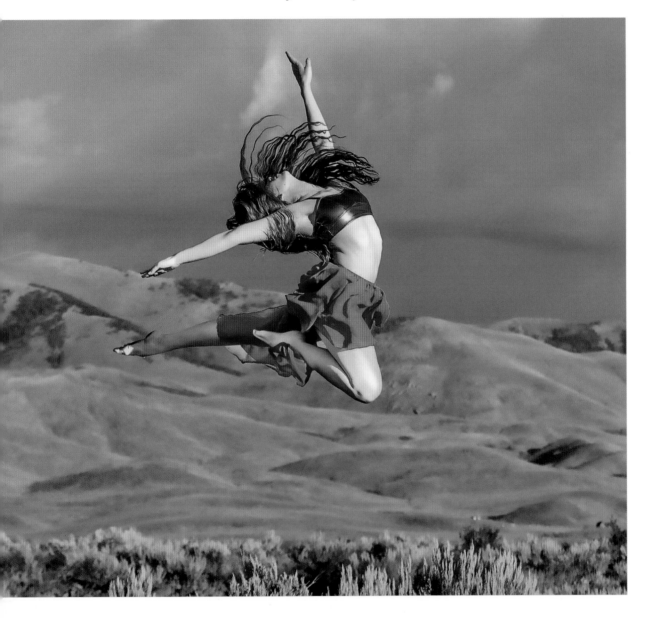

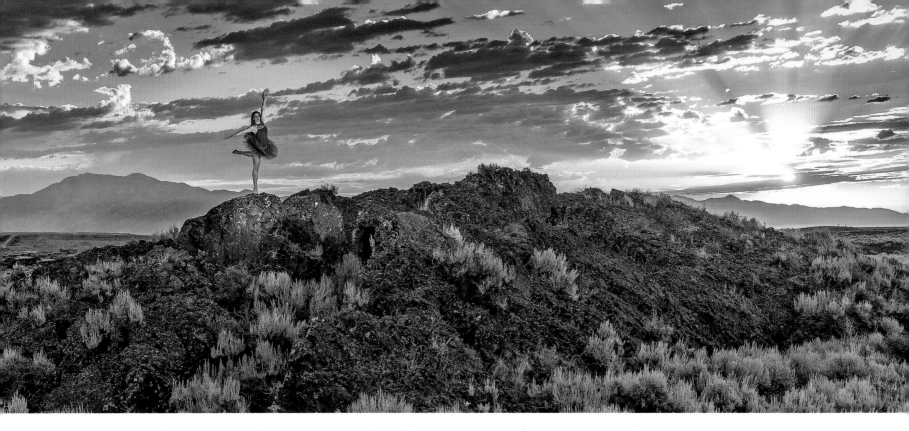

Avery Rooney - Age 15 **Craters of the Moon National Monument, ID**

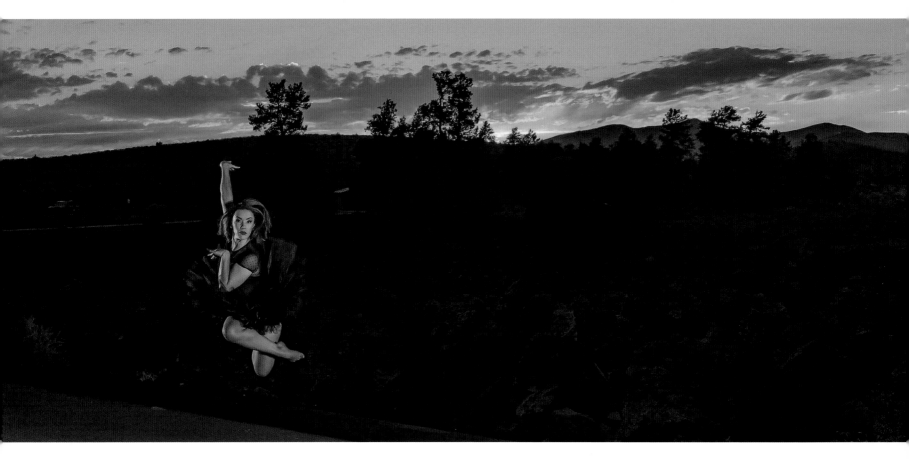

Ayriss Torres - Age 16 **Craters of the Moon National Monument, ID**

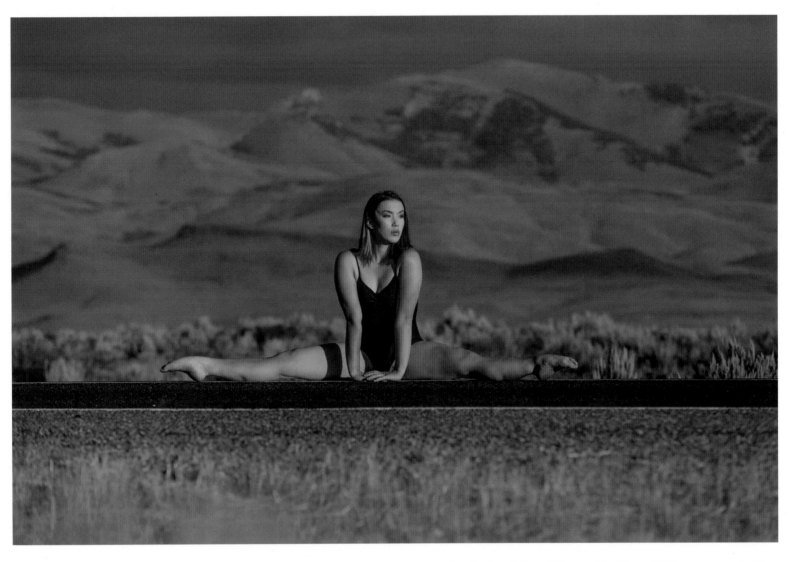

Ayriss Torres - Age 16 **Craters of the Moon National Monument, ID**

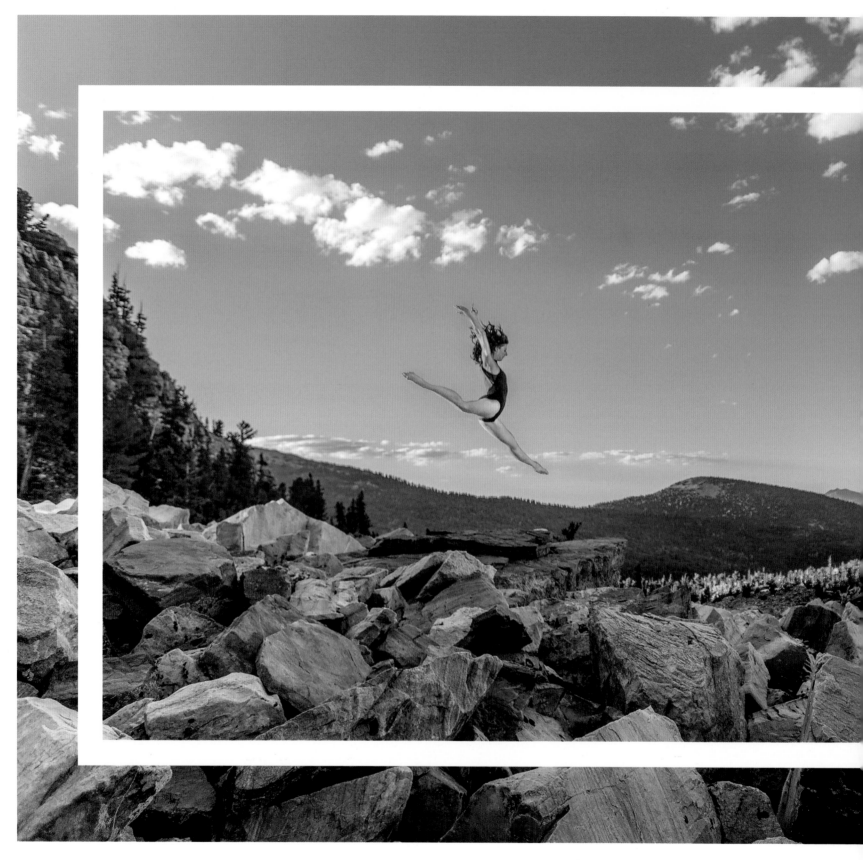

72 Chelsea Dee Robinson - Age 28 **Great Basin National Park, NV**

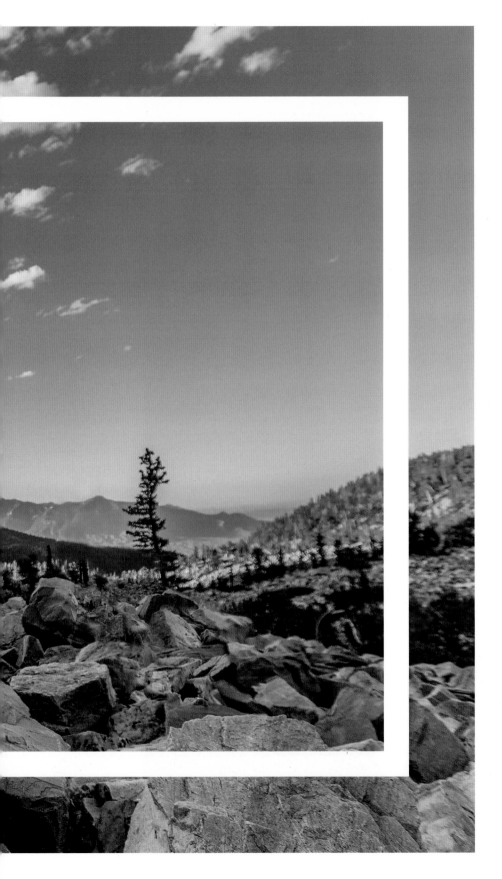

NEVADA

Great Basin National Park

Day 26

Location 13

July 23, 2016

Miles on Buford: 5943

This was our first location with some serious hiking. I wanted to get us up to the Bristlecone Pine forest, which sits around 11,000 feet above sea level. The trail, called Bristlecone Trail, starts at the Wheeler Peak Campground. We had a ranger as our guide, who led us up the trail to the base of the glacier on Wheeler Peak, where we were treated to a stunning view of the land below, as well as the oldest trees on earth. The oldest of these trees are over 5000 years old, and still growing!

Our hike was almost four miles round trip, but with an elevation gain of 800 feet and 80 pounds of camera gear, water, and supplies on my back, this was rough. But we were dedicated - going up the mountain where no dance photo has ever been made before!

I would be remiss if I didn't also give mention of our hotel here - the Silver Jack Inn. Every now and again I would get a hotel, so I could have extended access to wifi and not need to spend the night in a parking lot somewhere. The Silver Jack Inn was legendary around here, with great food and tons of character. It has since been sold and rebranded, but anyone who stayed here will never forget it!

Lastly, that night sky! We unfortunately had a moon that night, or it would have been even more amazing. It is both humbling and empowering looking at an endless starry sky. You can always get more sleep, but you MUST get the chance to see a clear night like this!

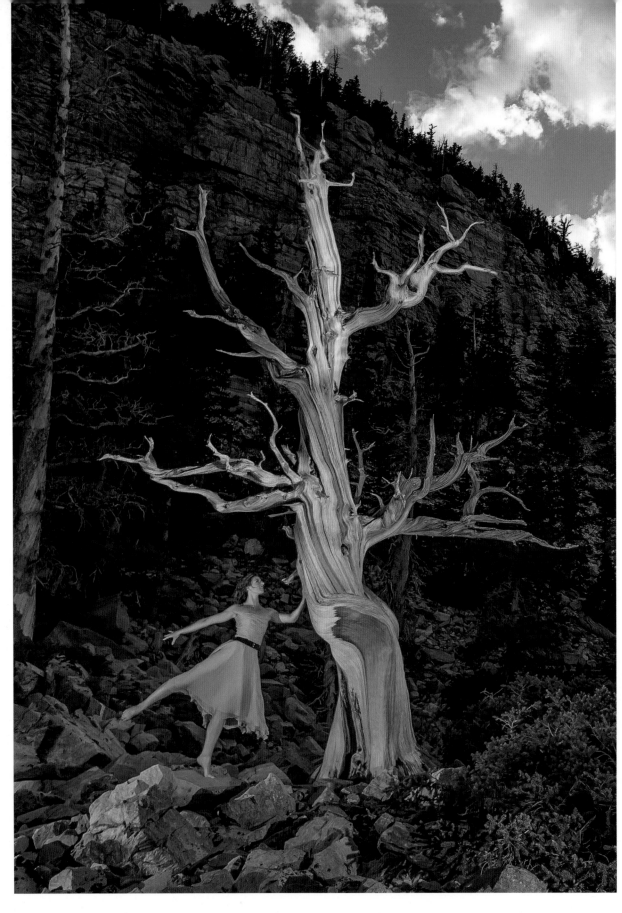

74 Chelsea Dee Robinson - Age 28 **Great Basin National Park, NV**

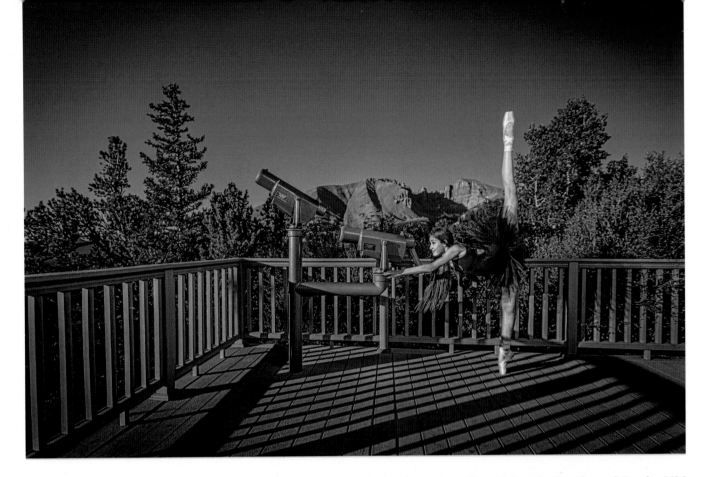

Ellie Grace Kay - Age 14 **Great Basin National Park, NV**

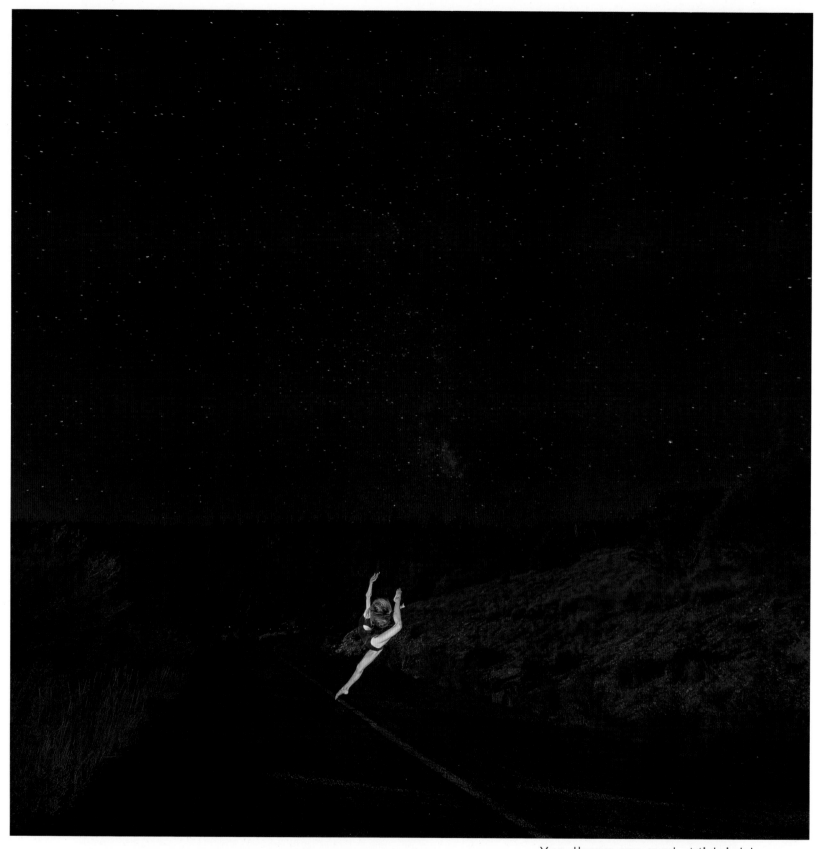

76 Ellie Grace Kay - Age 14 **Great Basin National Park, NV**

Yes, these are real. Midnight, on the road up to Wheeler Peak.

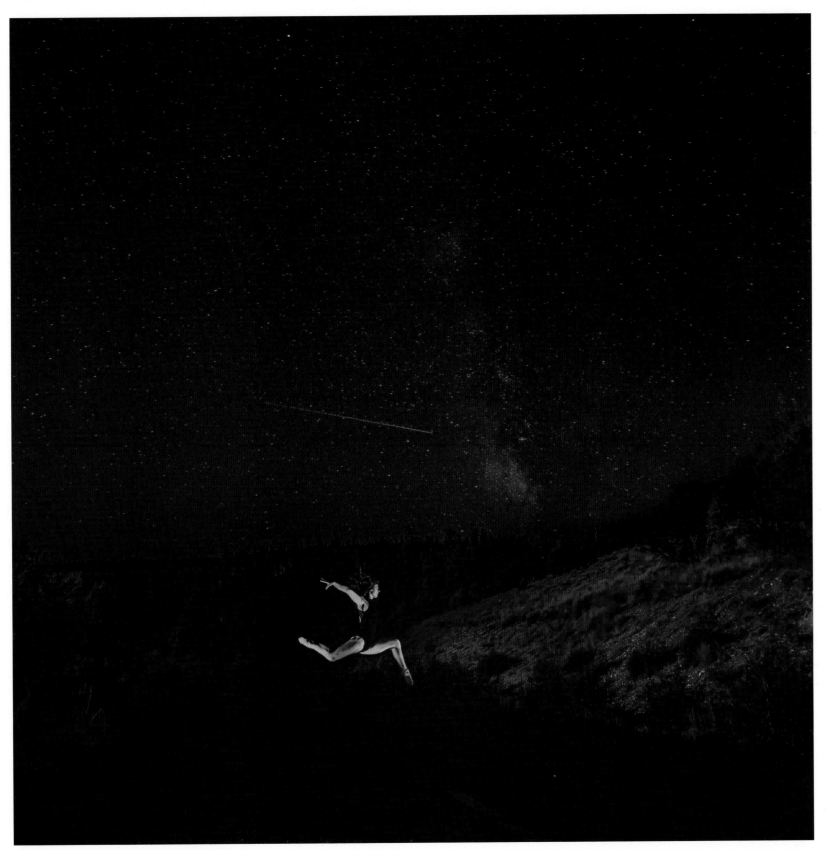

Real jumping dancer, real sky.
Nevada - BOOM!

Chelsea Dee Robinson - Age 28 **Great Basin National Park, NV** 77

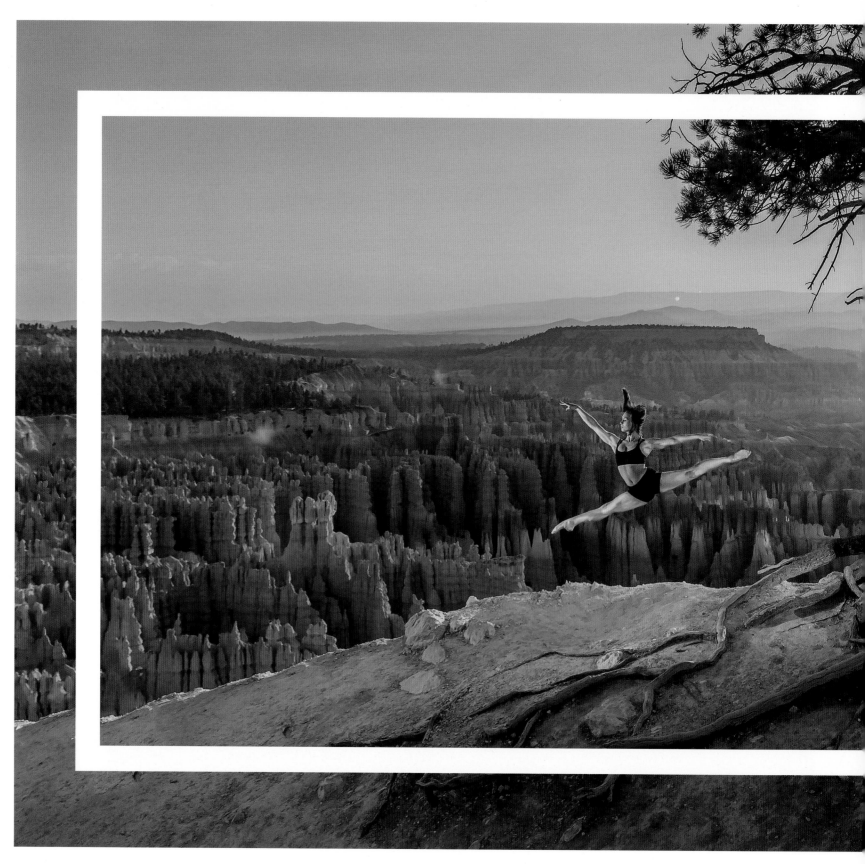

78 Lydia Forsgren - Age 20 **Inspiration Point, Bryce Canyon National Park, UT**

UTAH

Bryce Canyon National Park
DAY 28
LOCATION 14
JULY 25, 2016
MILES ON BUFORD: 6231

HOODOO!!! Who do Hoodoos? I do! =) A hoodoo is simply a rock pillar made by erosion, and Bryce Canyon is full of them! Walking up to the canyon is life-changing. When you arrive in the parking lot for Inspiration Point, all that you can see there is just a ridge, with a simple fence along the edge. As you approach, the canyon appears out of nowhere, suddenly taking up your complete field of vision. It's amazing, and how incredible that we had the opportunity to do a photo session here!

Our ranger used to be a gymnast, so she had some idea of what we might be doing, which was very helpful. Under her watchful eye, we approached the edge of the canyon to create our shots, and she checked each location making sure we would be safe. Her experience as a gymnast helped her understand what the dancers would be doing to execute the moves, which gave us a great way of getting the best location while keeping everyone safe.

This particular image(to the left), would have been impossible were it not for one of the toys I brought along with me. I am a very organized and well prepared fella, and I packed a ladder. Not just any ladder, but a collapsible one that reaches 16 feet tall! From this angle if you stood on the ground, you would have been looking up at the roots of the tree, and would not see the canyon at all. Sometimes, just changing your perspective makes all the difference. This is true not only in photography, but also in life. There you go, we're now a motivational book as well as a photography book. You're welcome.

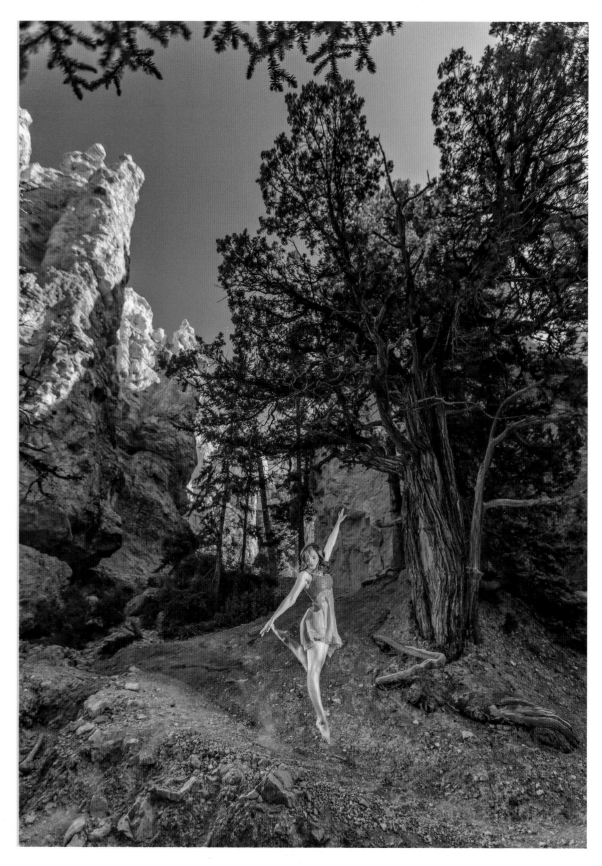

80 Jessica Stewart- Age 38 **Queens Garden Trail, Bryce Canyon National Park, UT**

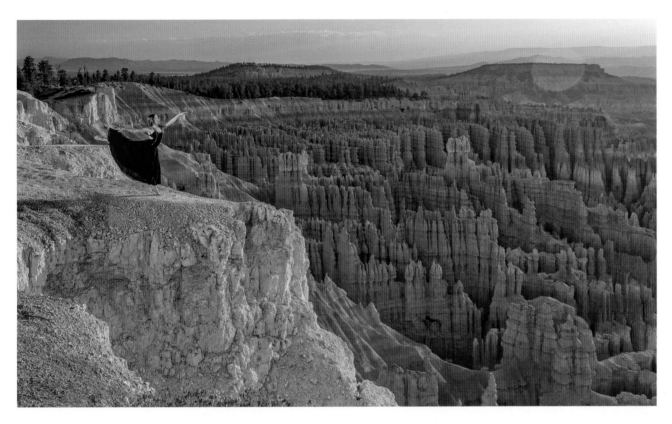

Paige Welsh - Age 16 **Inspiration Point, Bryce Canyon National Park, UT**

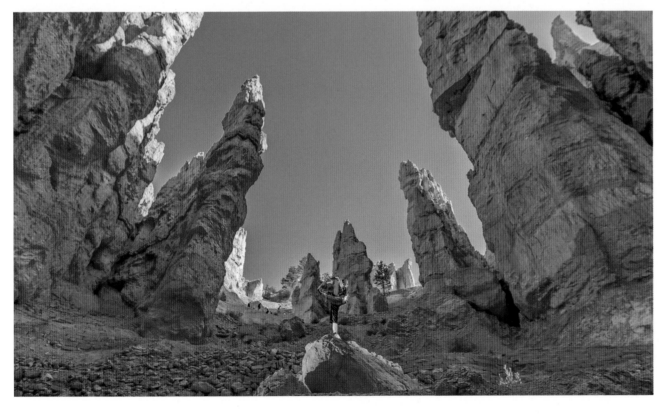

Kandace Rosalee Holm - Age 12 **Navajo Loop Trail, Bryce Canyon National Park, UT**

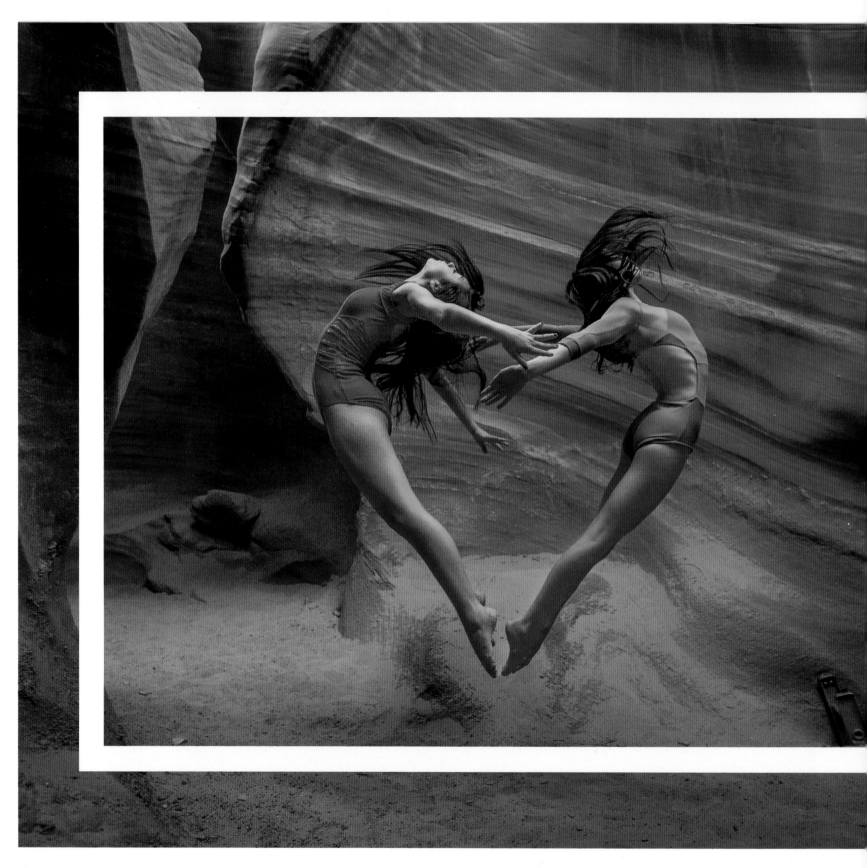

Gabby Pulido - Age 14 and Chevelle Heller - Age 13 **Antelope Canyon, Navajo Nation, AZ**

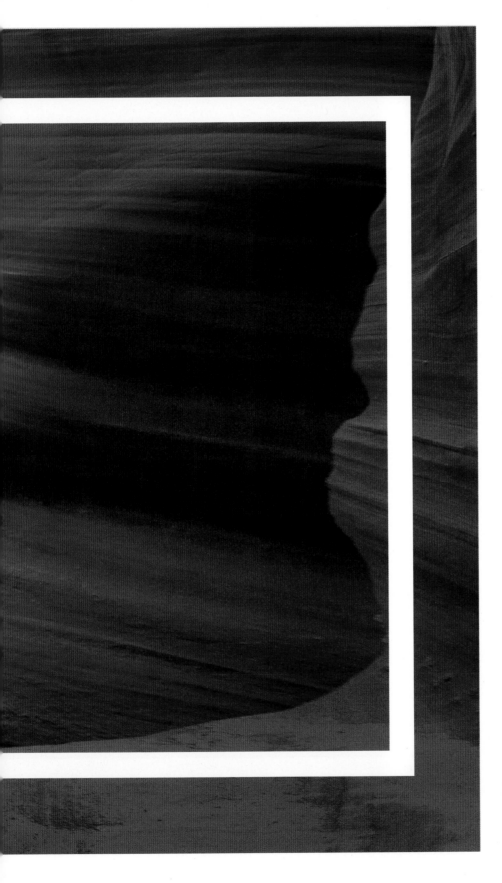

ARIZONA

Antelope Canyon
DAY 30
LOCATION 15
JULY 27, 2016
MILES ON BUFORD: 6571

The Navajo Nation is the largest land area still belonging to a Native American tribe. Covering parts of Arizona, Utah and New Mexico, some of the most beautiful country you will ever visit is here. One of the jewels of the landscape is called Antelope Canyon. Requiring special permission to access the canyon, this is a mystical place.

There are several specific areas that make up what is known as Antelope Canyon. The location we used is a much more private place called Rattlesnake Canyon, and we were the only ones there. I had arranged for a private two-hour window just for us, so we would not be bothered nor would we bother anyone. The place defies description, it is so beautiful. The two dancers were both beside themselves, as was I. This was a bucket list location, to be sure.

We bounced across the Arizona desert in an old 4x4 suburban, watching the landscape and the animals around us. When we arrived to the canyon, all we saw was a ladder leaning against the rocks. When we climbed it, we were suddenly enveloped by the rugged beauty of the canyon.

To visit this wonderful place yourself, it is just outside of Page, Arizona, or about two hours north of Flagstaff. Your best bet is to make a reservation well in advance, if you don't want to miss out. This is not a place you can just show up and see, as it does take a little bit of planning. Like anywhere else, be respectful of this place. Don't carve your name into the rocks, or leave trash everywhere. Make sure the place is just as pristine when you leave as it was when you arrived.

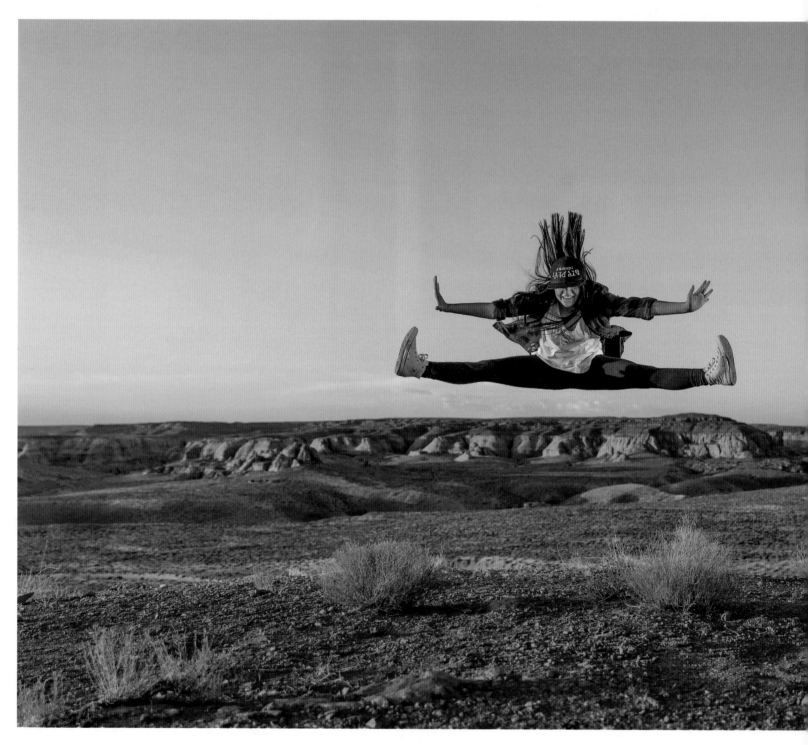

Gabby Pulido - Age 14 **Antelope Canyon, Navajo Nation, AZ**

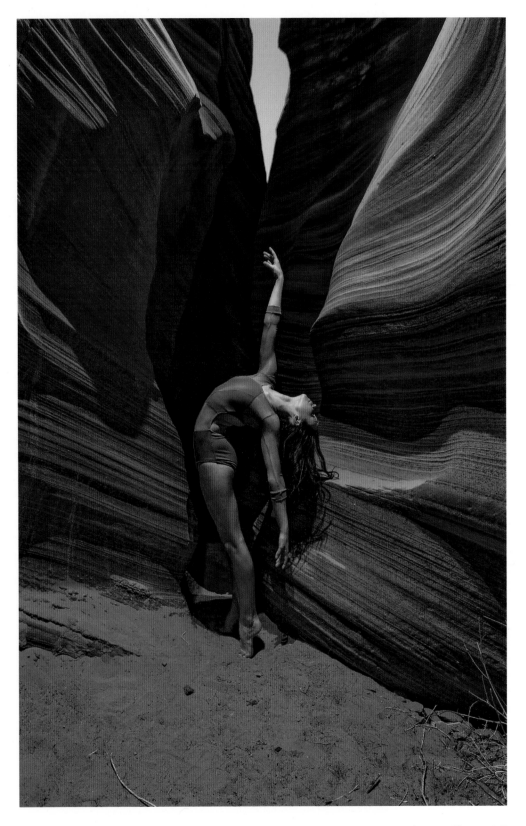

Chevelle Heller - Age 13 **Antelope Canyon, Navajo Nation, AZ**

Chevelle Heller - Age 13 **Antelope Canyon, Navajo Nation, AZ**

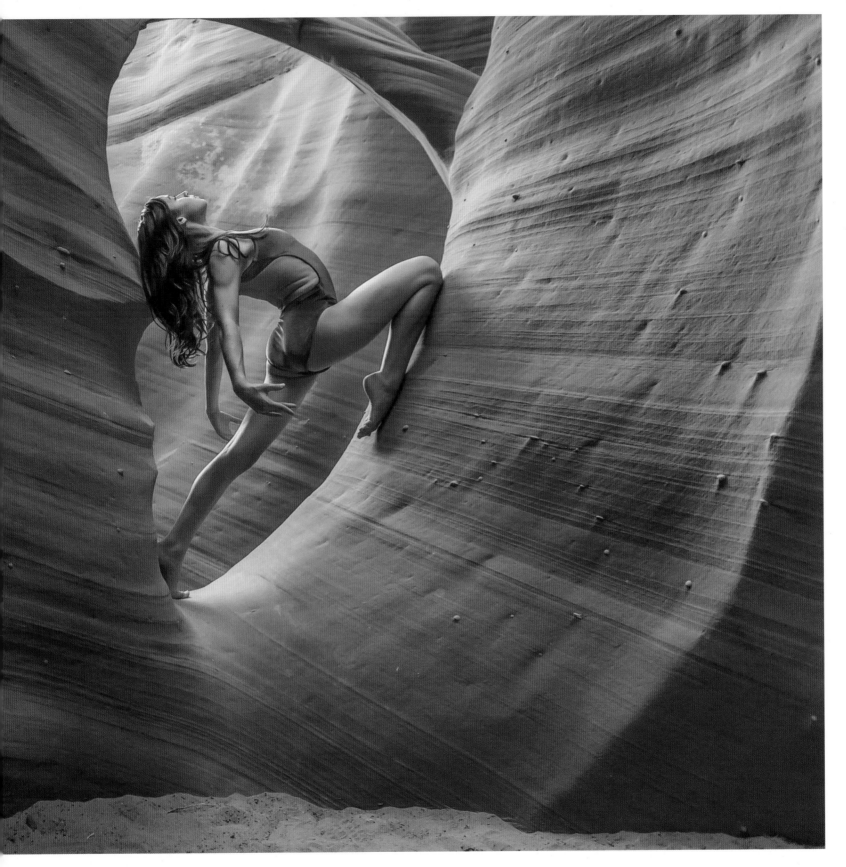

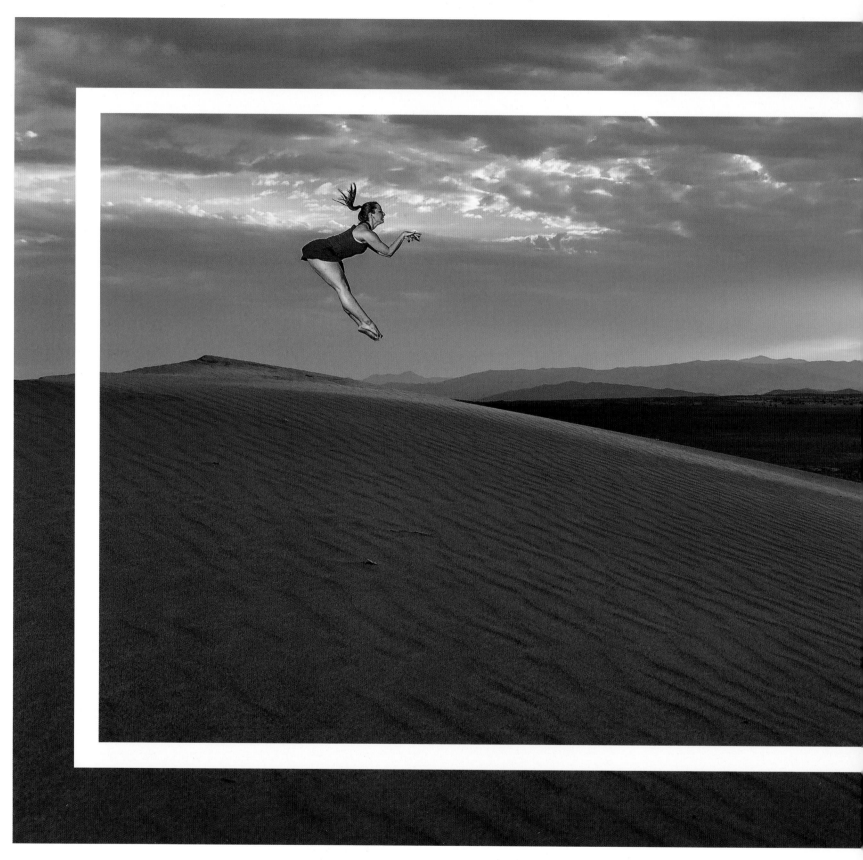

88 Masha Balovlenkov - Age 28 **Dumont Dunes, Death Valley, CA**

CALIFORNIA

Death Valley
DAY 31
LOCATION 16
JULY 28, 2016
MILES ON BUFORD: 7221

If you are a sci-fi movie fan, then you should recognize the sand dunes from this part of Death Valley as Tatooine from *Star Wars*, where the droids first land. Yup, I'm a geek. What you might not know is that Death Valley really lives up to its name... IT'S SO HOT YOU WANT TO DIE!!! 125° F during the day (according to my thermometer in Buford), sand so hot you cook yourself if you walk in it. And it was my bright idea to come here in July. In 2016, July was the hottest month ever recorded here - with an average temperature of 107.4° F. Remember, that includes nighttime temps, too. The average low for July was 95°.

We began our session here at sunset, capturing the colors in the sky until it got dark, then we set up camp. The three dancers and I all camped in the sand, cooked hamburgers, and tried to stay cool. It was kind of hard to do. It was so incredibly windy that my ez-up tent for shade broke, never to be replaced.

When the sun came up, it was like a different world. Light began to creep across the valley, and in the moments before sunrise everything was bathed in a beautiful lavender glow. Then, with a flash, the sun crested the mountains in the distance, and the world was on fire! A harsh environment, but beautiful to behold. We finished, and ran away from the heat. Just outside of the valley we found a diner where we could have pancakes for breakfast, with just enough time for me to make it to the airport for my flight to Hawaii. Talk about a switch!

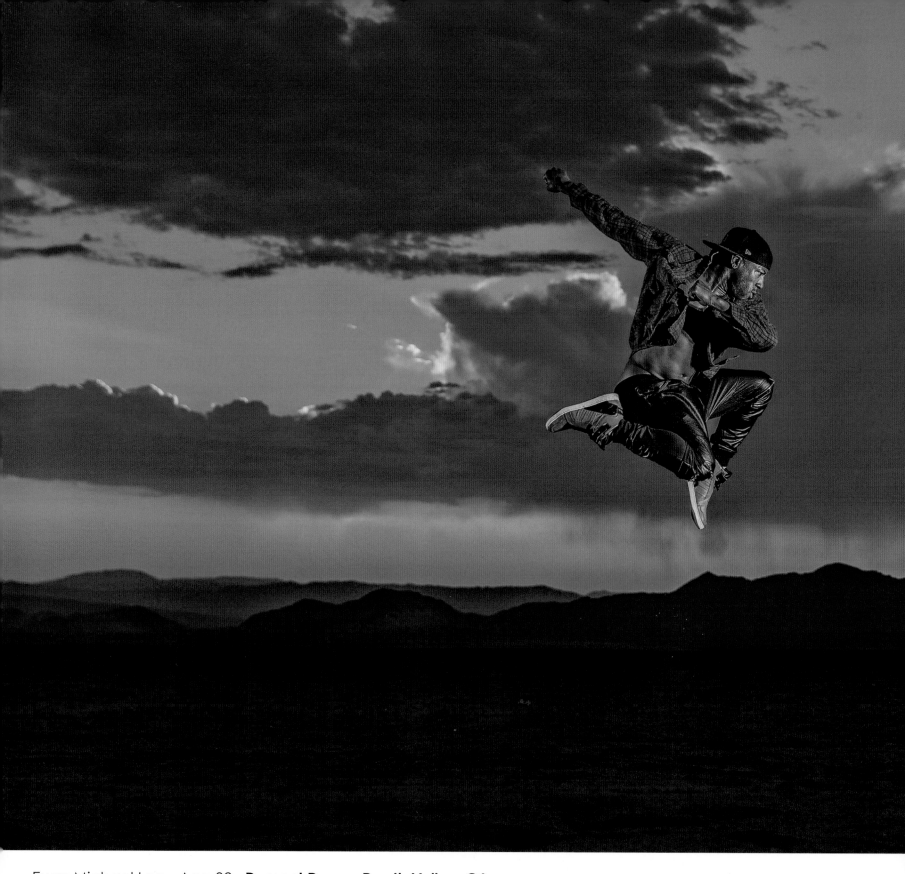

Evan Michael Lee - Age 32 **Dumont Dunes, Death Valley, CA**

*"Just dance it out.
You'll feel better."*

- Evan Michael Lee

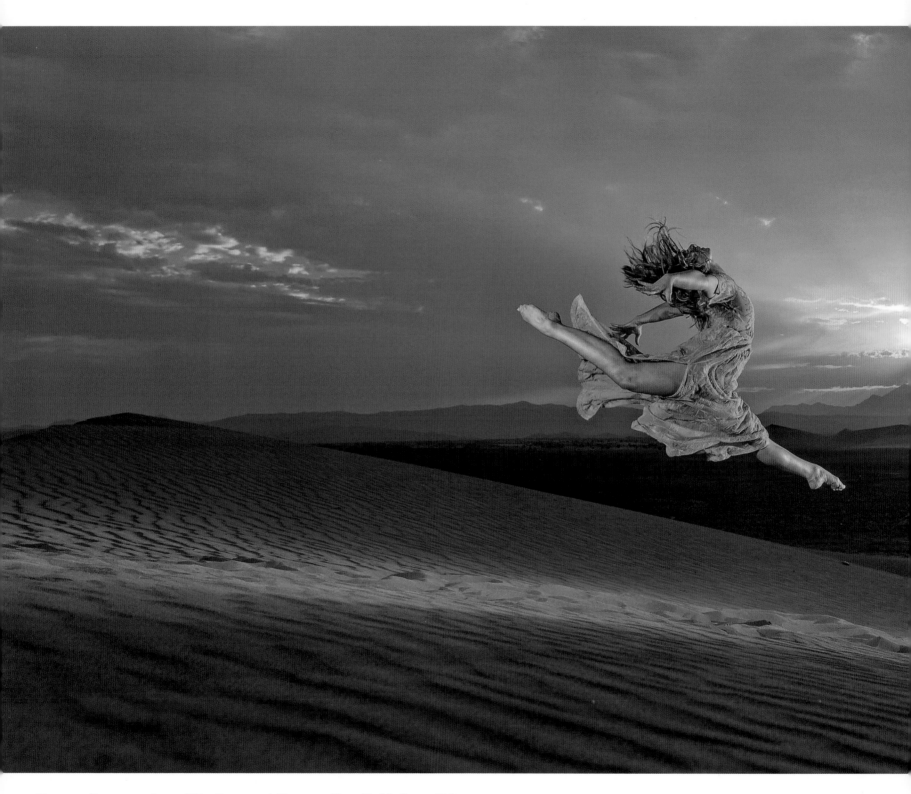

Emma Krauss - Age 27 **Dumont Dunes, Death Valley, CA**

"Raise your vibrations and create a life that is yours." - Emma Krauss

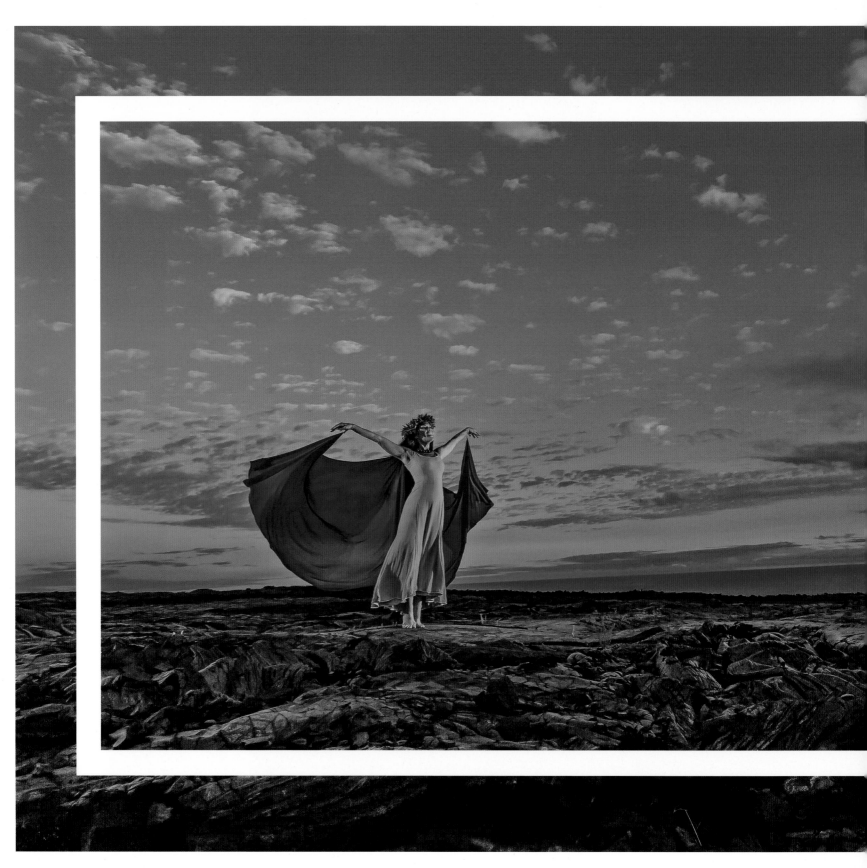

Heidi Lee Hart - Age 56 **Hawai'i Volcanoes National Park, HI**

HAWAII

Hawai'i Volcanoes National Park
Day 33
Location 17
July 30, 2016
Miles on Buford: 7716

Aloha käkou! After leaving the brutal heat of Death Valley, I flew to the lush tropics of Hawaii. Volcanoes National Park on the Big Island (named Hawai'i) is stunning, with incredible diversity not found in any other park. The park covers everything from seashore to mountaintop (13, 678 feet above sea level to the top of Mauna Loa), lush tropical forests, and barren lava fields.

This park is open 24 hours a day, which makes the viewing of the active volcano exceptionally cool! This is very sacred land to Hawaiians, and I wanted to be sure to have that culture represented as well. To many Hawaiians, molten lava is the body form (or kino lau) of the goddess Pele. Heidi, representing Hawaiian culture, performed a ceremony honoring Pele before we began, and it was beautiful to behold.

Due to the active volcano, this is the only state which is actually growing! New land is formed every time lava reaches the ocean, with almost 600 new acres of land formed in the past 30 years.

This location marks off another extreme for us. The most southern part of the USA, period, is called Ka Lae, or South Point. Only 30 minutes from the park, there is no land between here and Antarctica - only water for 7000 miles or so! Next week, the westernmost part of the lower 48. By the way, although Buford could not actually drive here, he came in spirit - I brought a lug nut with me!

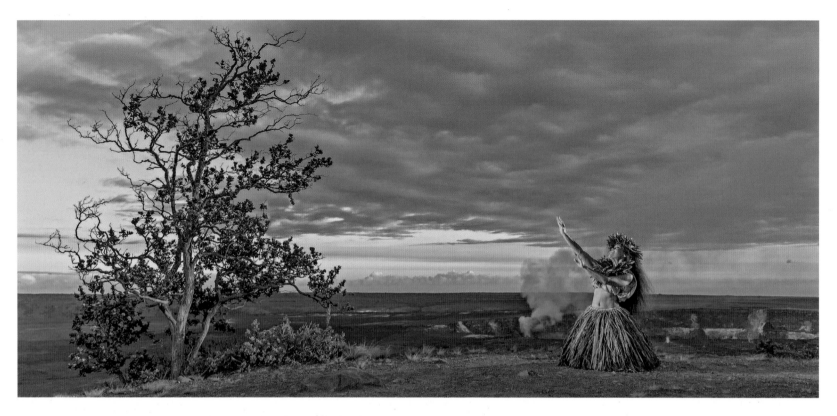

Heidi Lee Hart - Age 56 **Hawai'i Volcanoes National Park, HI**

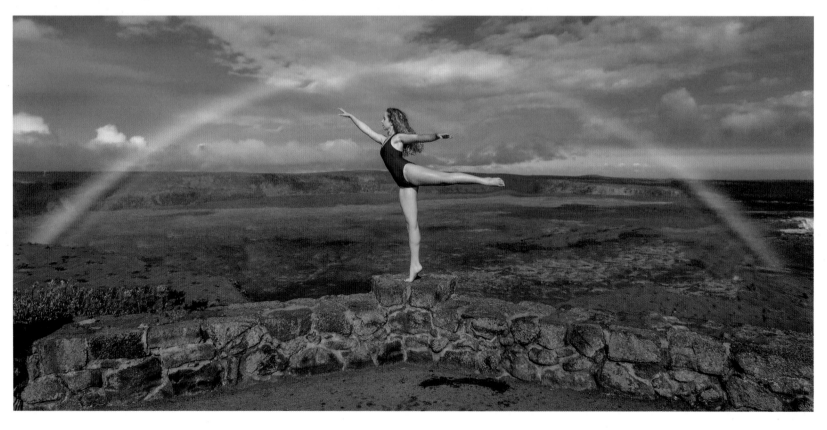

Sonja Giardina - Age 13 **Hawai'i Volcanoes National Park, HI**

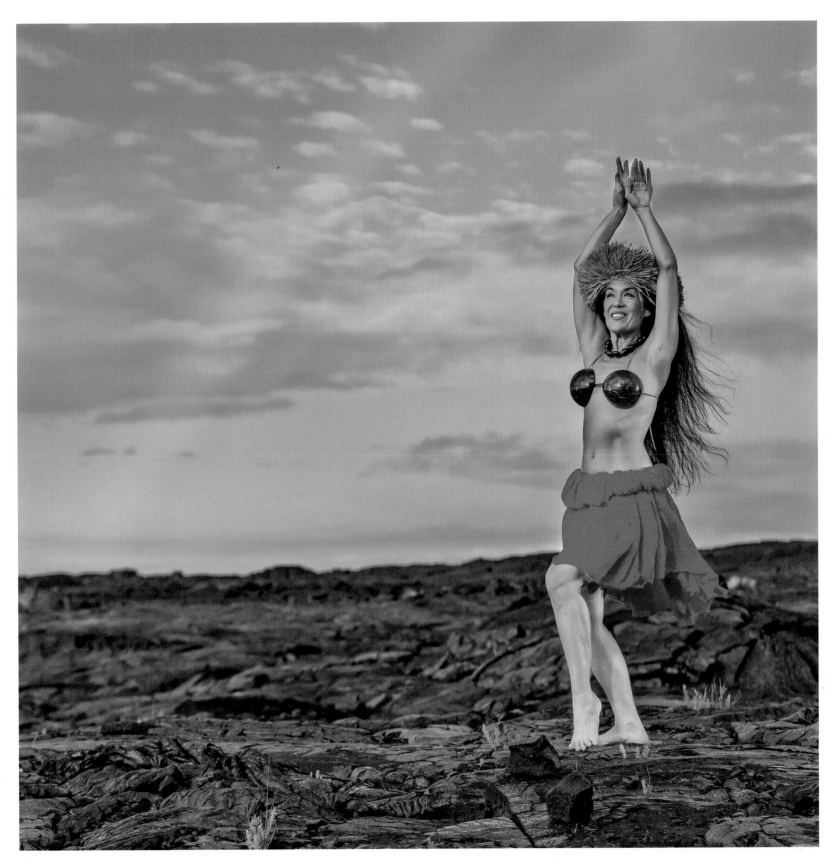

Heidi Lee Hart - Age 56 **Hawai'i Volcanoes National Park, HI** 97

Sonja Giardina - Age 13 **Hawai'i Volcanoes National Park, HI**

"Before written language, before spoken word, there existed the language of the body. A raw form of personal expression unhindered by the boundaries of conscious thought. Dance is pure movement and emotion channeled into a manifestation of one's true self."
~ Sonja Giardina

CALIFORNIA

King's Canyon National Park
DAY 36

LOCATION 18

AUGUST 2, 2016

MILES ON BUFORD: 7924

King's Canyon National Park is a wonderful place, not far from Fresno, and nestled in the middle of Sequoia National Forest. It is connected to (and operated with) Sequoia National Park, and is just a quick hop away from Yosemite National Park as well. But, just on the other side of the mountains is Death Valley, not even 100 miles away! California is a study in extremes.

Here we had an amazing ranger who led us around the park, and it was here that we saw our first bear! The park is home to a large variety of wildlife, and some very impressive flora as well. A little side note on the bear. Like any other park or natural space, there are animals that live there. They are fuzzy, they can be cute, but they are wild! This is not a petting zoo, so do not approach them or try to get a killer selfie! Because it may literally be just that. Enjoy the wildlife, but leave them alone.

King's Canyon is home to the world's largest tree, measured by volume. It is 275 feet tall, and over 36 feet wide at the base. His name: General Sherman. This park is also home to the largest remaining natural grove of giant sequoias in the world, with over 16,000 of these incredible trees.

There is also an extensive cave system here. More than 200 caves have been identified between King's Canyon and Sequoia Parks. One you can visit is Crystal Cave, which boasts over three miles of passage underground! There is so much to see here, and it is definitely worth a trip.

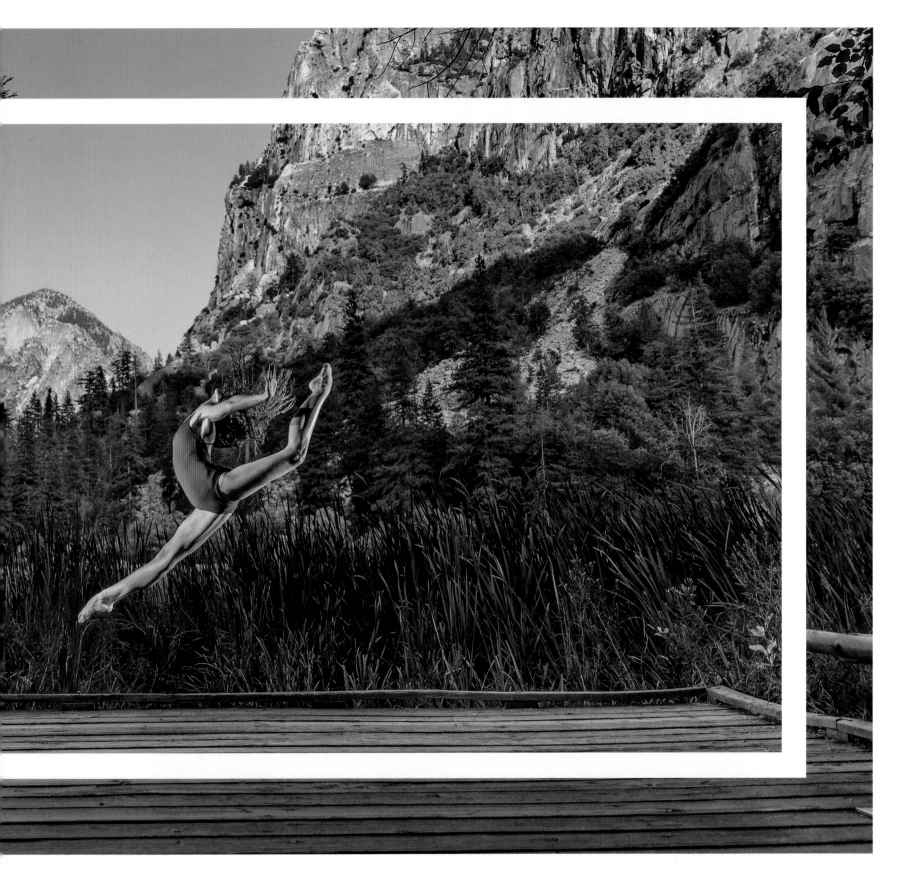

Brooke Jordan - Age 12 **King's Canyon National Park, CA**

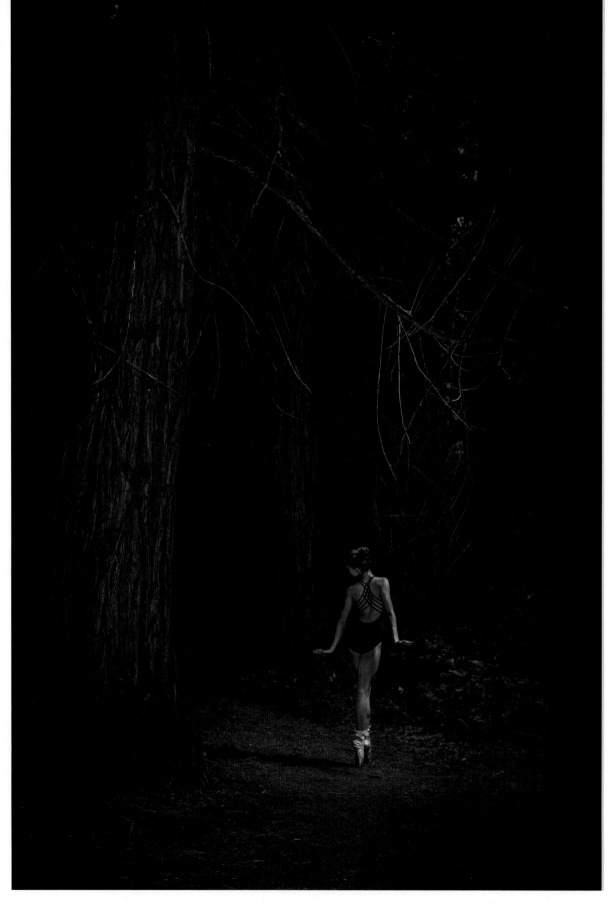

Brooke Jordan - Age 12 **King's Canyon National Park, CA**

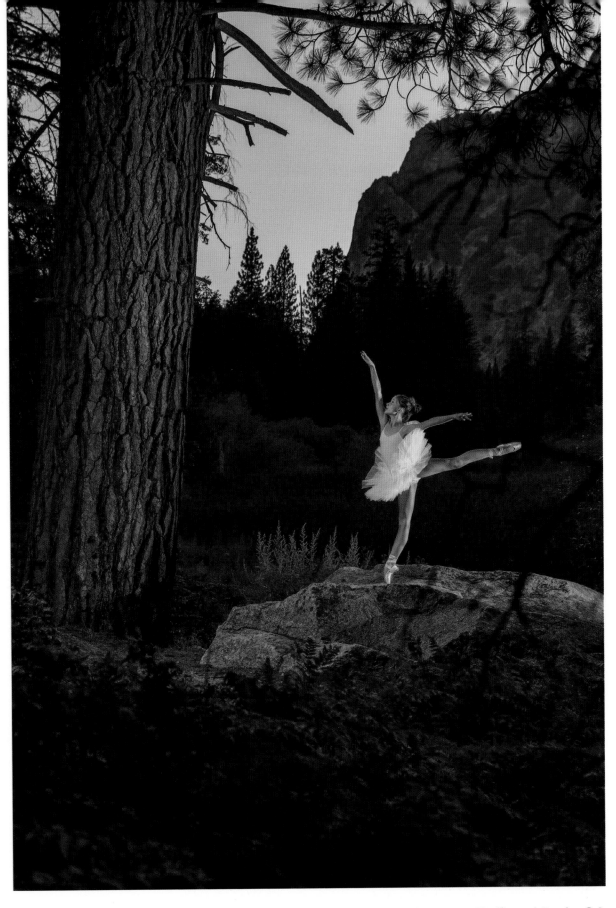

Brooke Jordan - Age 12 **King's Canyon National Park, CA**

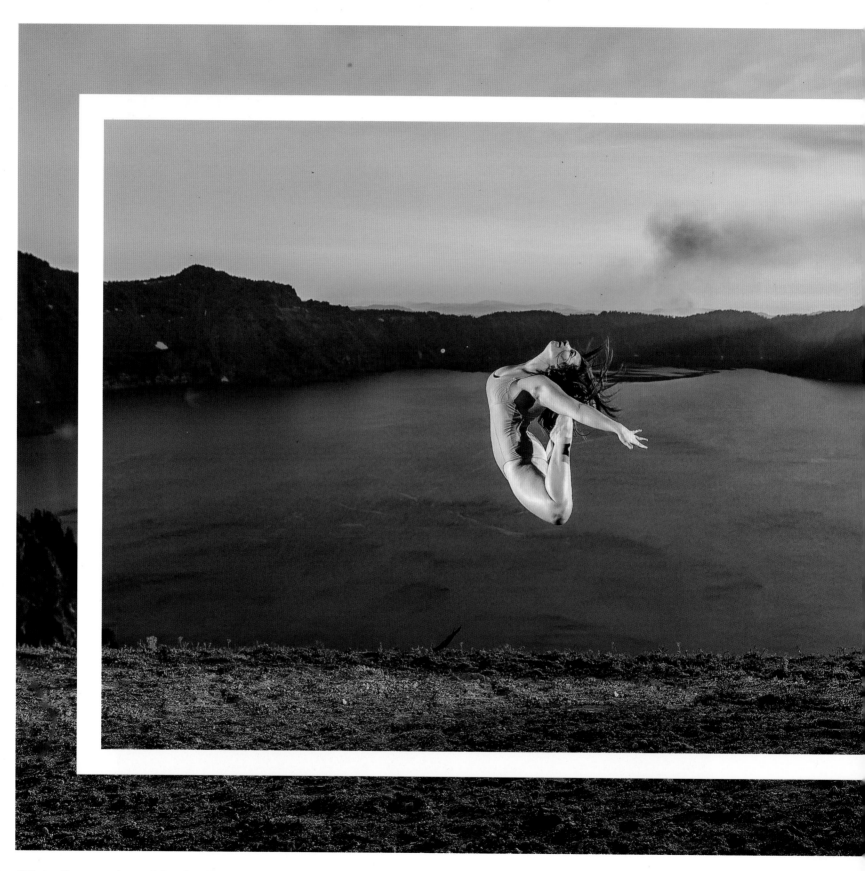

Olivia Bean - Age 15 **Crater Lake National Park, OR**

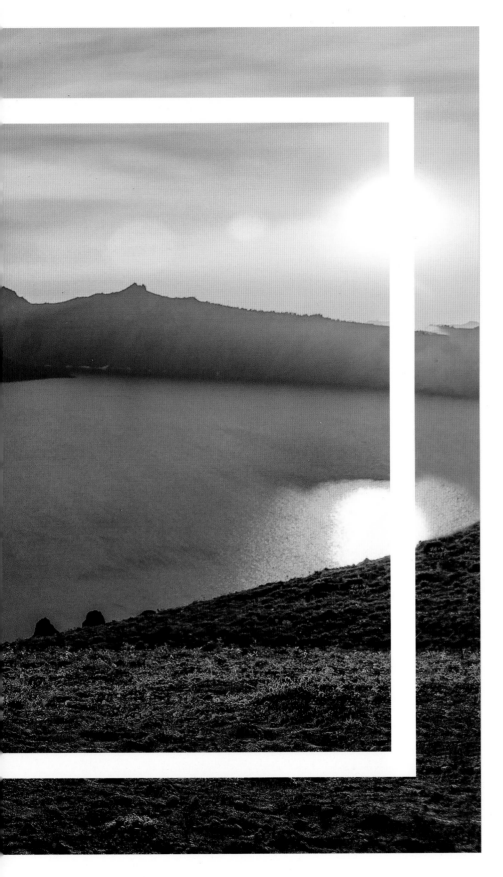

OREGON

Crater Lake National Park

DAY 37

LOCATION 19

AUGUST 3, 2016

MILES ON BUFORD: 8620

Fire is something that occurs naturally, and when it happens in a national park, it is looked at part of the circle of life. In late July 2016, a fire started called the Bybee Creek fire. Although never officially determined, it is suspected that it was human caused. With the fire burning over 1000 acres of land (none of which was actually in the park), the park still closed areas due to smoke and other hazards. (These areas have now been reopened at the time of this writing, so hurray for that!)

The original location I had in mind for Crater Lake was exactly the area that was closed, so we were forced to make other plans. As you can see, smoke was still an issue here, even on the opposite side away from the fire. (The fire is at the top right of the photo.) Having a schedule like we did, there was no time to delay, we had to push forward no matter what. Permits for our sessions were specific to the day, even the hour, and they were planned weeks in advance. So, press on we did!

Crater Lake National Park was formed when the volcano that was here, called Mount Mazama, erupted, quite literally blowing its top. This eruption happened around 7700 years ago. The explosion and resultant ash cloud were so massive, that ash can be found in Alberta, Canada, which is over 1000 miles away. After years of rain and snow filling the crater, this is now America's deepest lake. The depth varies due to evaporation and precipitation levels, but the deepest measurement was 1949 feet.

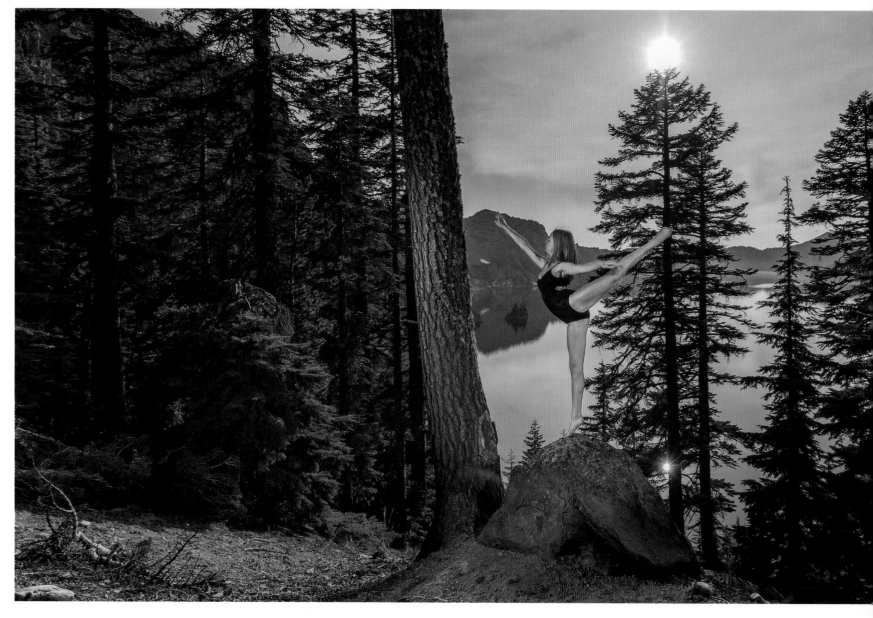

Clover Meyer - Age 14 **Crater Lake National Park, OR**

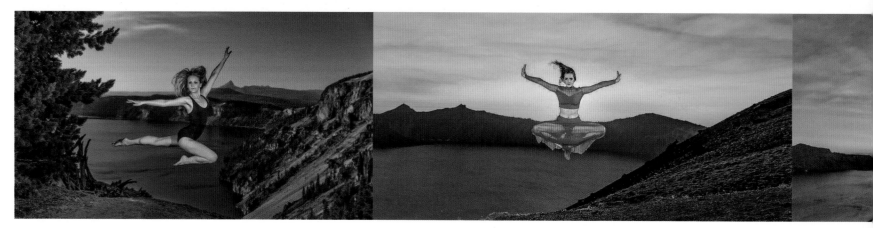

106 Makayla Rice - Age 15

Mika Doman - Age 16

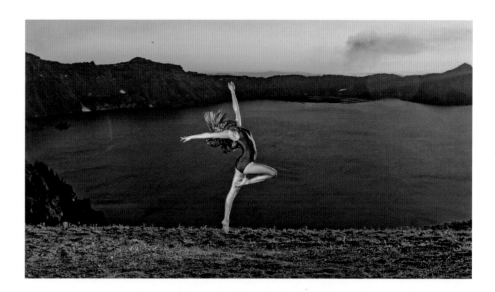

Clover Meyer - Age 14 **Crater Lake National Park, OR**

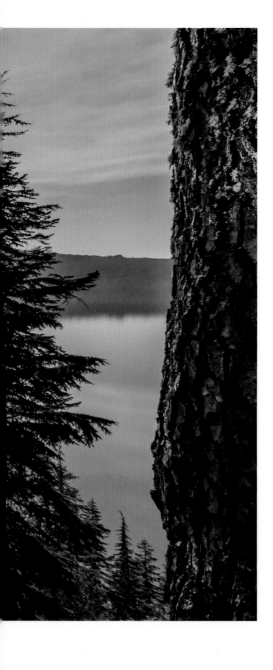

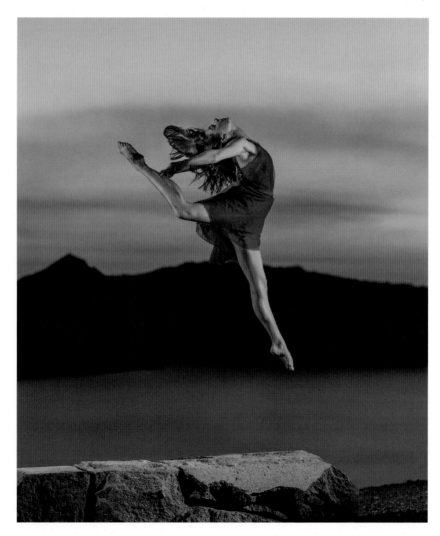

Caitley Criswell - Age 16 **Crater Lake National Park, OR**

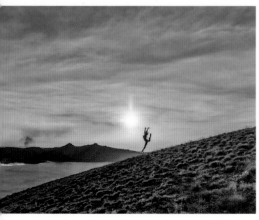

Jayley Ward - Age 14

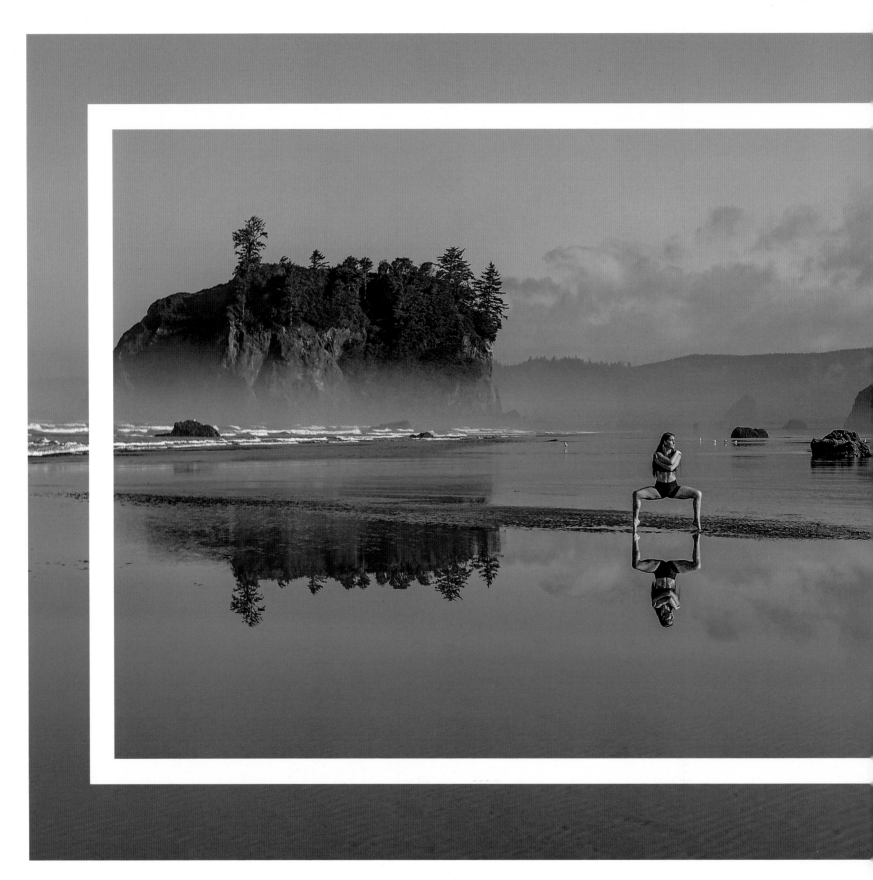

Sarah Wilensky - Age 15 **Ruby Beach, Olympic National Park, WA**

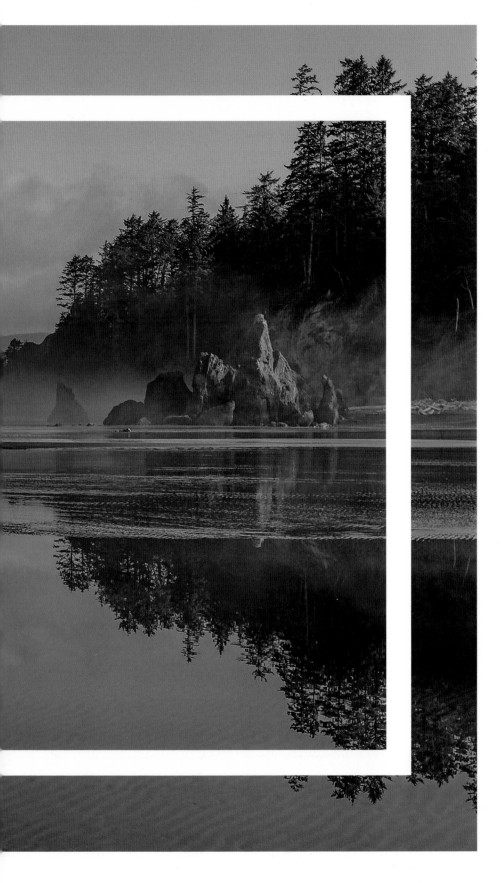

WASHINGTON

Olympic National Park
DAY 38
LOCATION 20
AUGUST 4, 2016
MILES ON BUFORD: 9207

Olympic National Park is located in the northwest corner of the state, and is renowned for the diversity of its ecosystems. Not only is it a National Park, but it is also a Unesco World Heritage Site. Ranging from alpine mountains, to temperate forest, to the rugged Pacific shore, this park has it all. Wherever you go, you will discover something different and beautiful. I decided on the coast, a place called Ruby Beach, and it was magical!

Arriving at low tide, the waterline receded revealing what looked like a giant mirror. It was pretty chilly, so we started a fire on the beach. This is one of the few areas where you are actually encouraged to burn the driftwood, as there is just so much of it. Even with the fire it was still pretty chilly, and I think it took me about a week to warm up after this one. Thank goodness for the ability to make coffee in Buford, otherwise I don't think I would have survived this one!

This park marks the opposite side of the country from where we began. Key West, Florida, is the farthest southeast you can drive, and this would be the farthest northwest (of the lower 48). The actual point is Cape Alava, in the top left corner of the park. Going strong so far!

Another fun fact about this place is that four of our dancers here are related. Three sisters and their mother, and they call themselves the Campbellettes. Between them and our other two dancers, Madison and Sarah, we had one heck of a day!

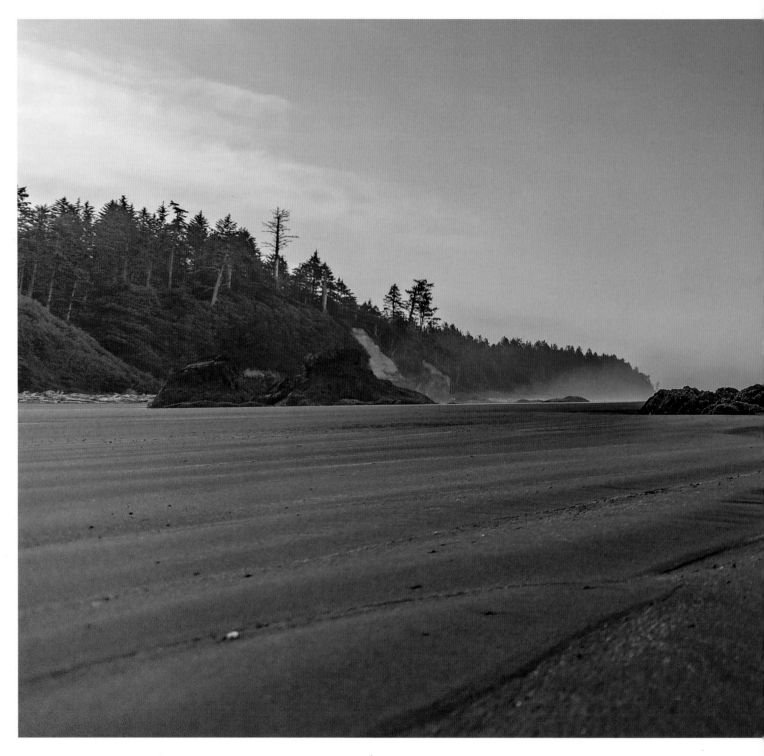

Phoebe Campbell - Age 11 **Ruby Beach, Olympic National Park, WA**

"Dance is my whole heart--it's just me, the music and the movement" ~ Phoebe Campbell

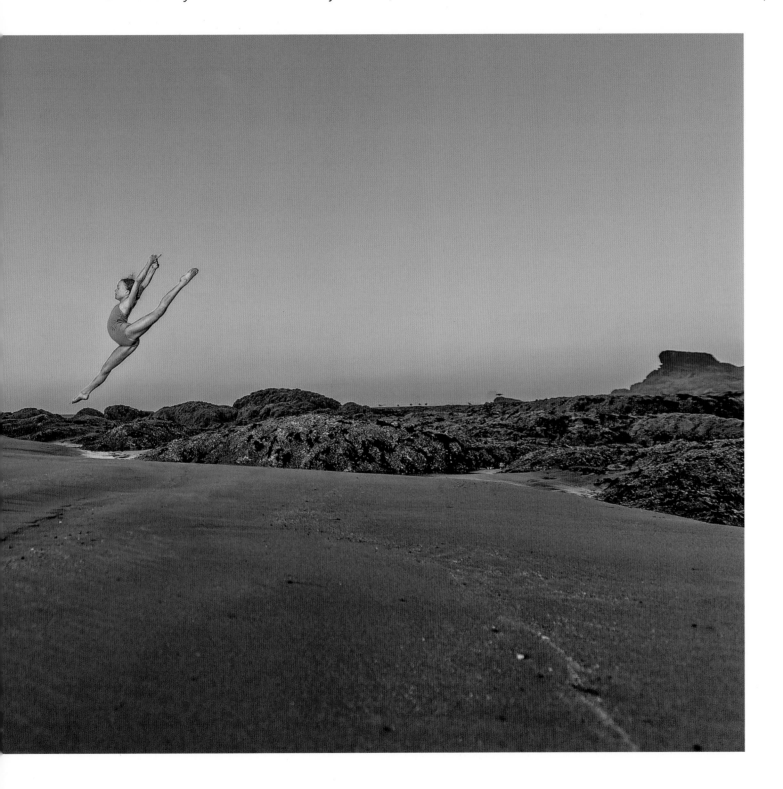

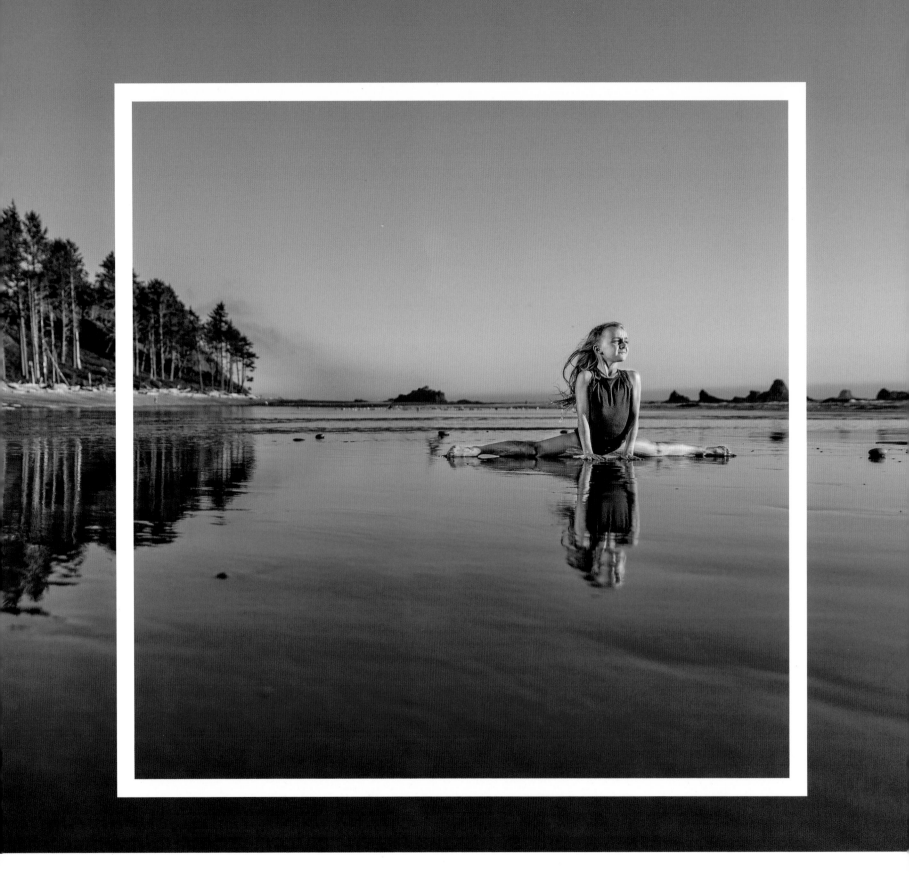

AvaRose Campbell - Age 9 **Ruby Beach, Olympic National Park, WA**

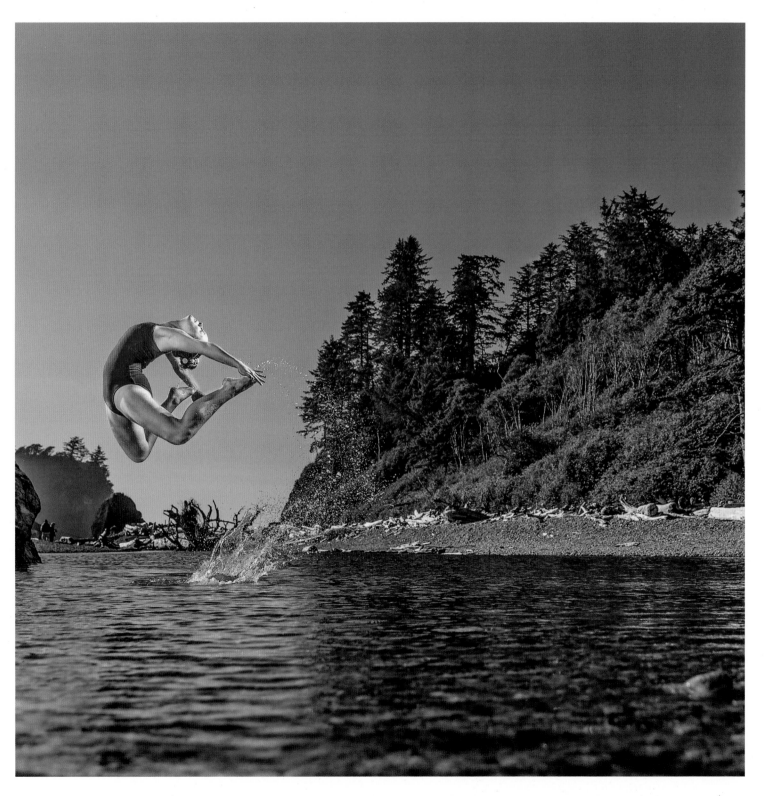

Chloe Campbell - Age 15 **Ruby Beach, Olympic National Park, WA**

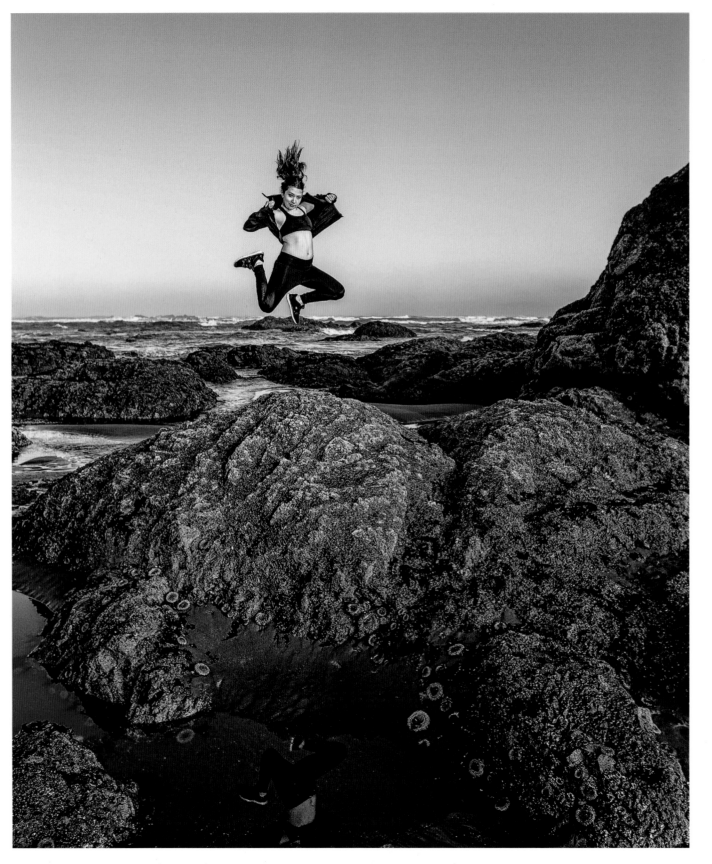

114 Madison Young - Age 14 **Ruby Beach, Olympic National Park, WA**

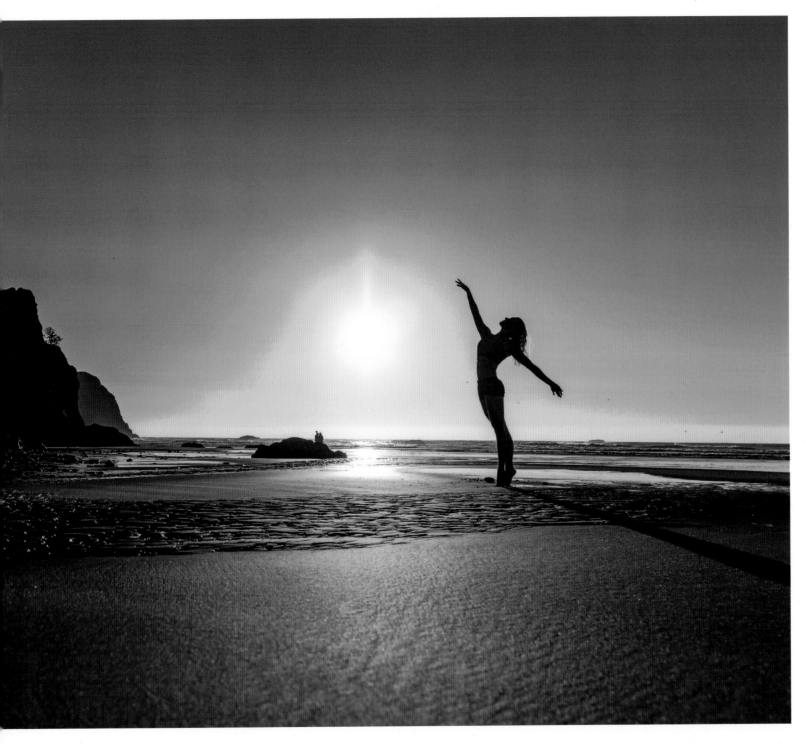

Debbie Knowlen-Campbell - Age 46 **Ruby Beach, Olympic National Park, WA**

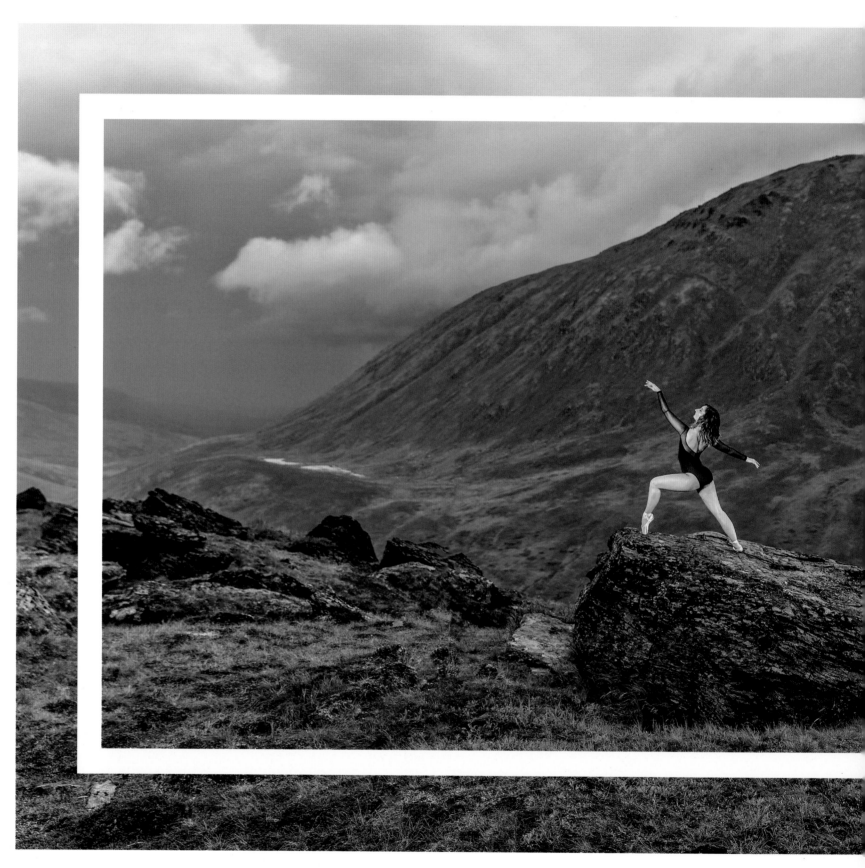

Cheyenne Bydlom - Age 22 **Hatcher Pass, AK**

ALASKA

Hatcher Pass
Day 41
Location 21
August 7, 2016
Miles on Buford: 9625

Up to The Last Frontier! Alaska's official nickname speaks to its many opportunities and lightly settled regions. With a population density of only 1.3 people per square mile, if you want space, then this is the place for you. Alaska is rugged territory, but amazingly beautiful as well.

We had made arrangements to have this be another extreme location for us - the largest park in the system, which is Wrangell–St. Elias National Park. We had a plane booked to fly us out to a glacier (landing on the actual glacier!!!) to do our photo shoot. But the day before our trip, the flight company called, saying their plane had broken down, and we could not fly like we had planned. After a bit of last minute research, we found a place nearby that we could drive to, called Hatcher Pass.

A little over an hour outside of Anchorage, Hatcher Pass is named after a prospector who launched the gold boom in the area. The mines around Hatcher Pass were extremely profitable, and even today there are still active gold mines. In fact, this area is open for recreational mining, which means you can go try you hand at mining as well.

With snow still on the ground in places, we explored the area in our rental SUV (still with Buford's lug nut), and found several beautiful locations until the clouds rolled in. It is a good lesson for life - make your plans, but be prepared to adjust anything and everything at any given moment. Like any good dancer - BE FLEXIBLE!!!

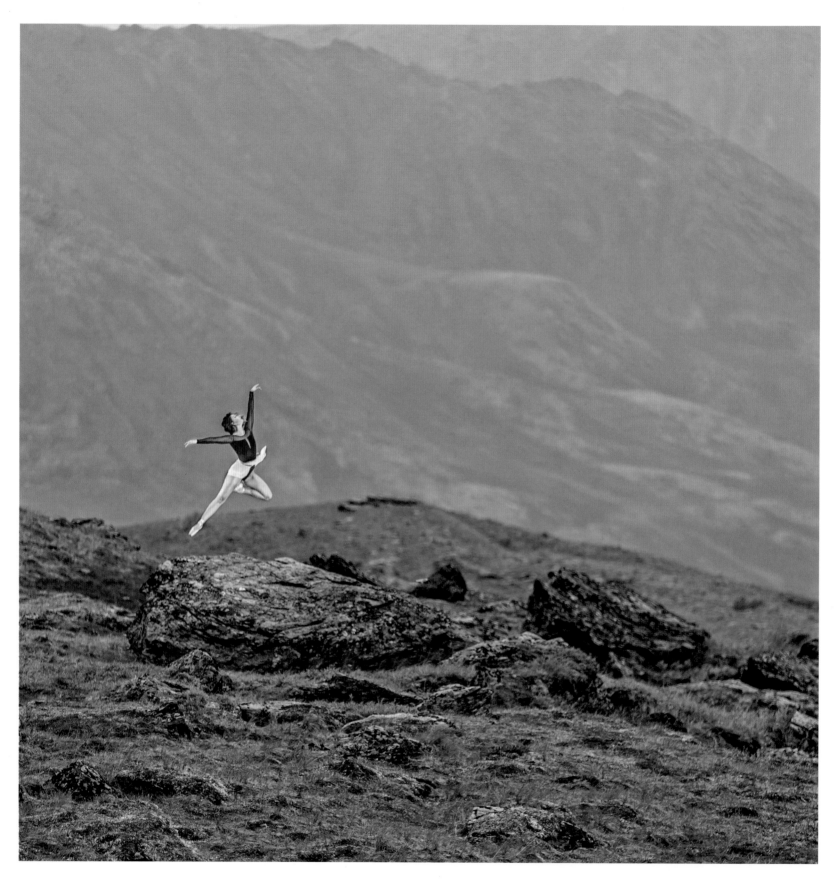

Cheyenne Bydlom - Age 22 **Hatcher Pass, AK**

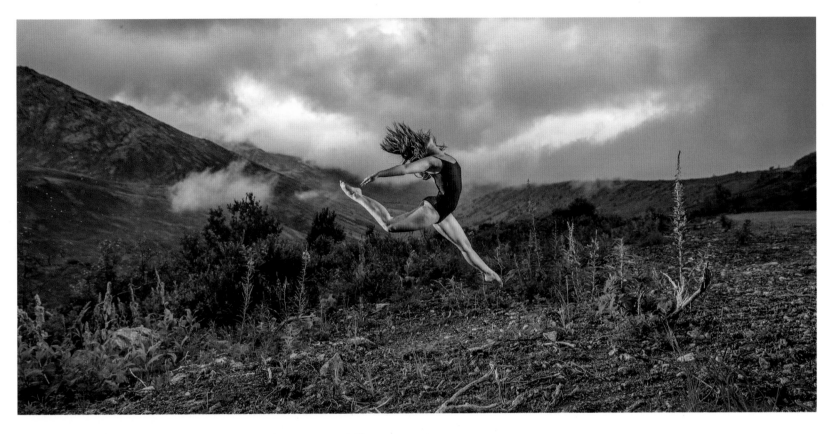

Cheyenne Bydlom - Age 22 **Hatcher Pass, AK**

Leigh-Ann Givens - Age (it's a secret) **Hatcher Pass, AK**

I cannot say it enough, but were it not for the tireless efforts of my wife Leigh-Ann, this project could not have happened. It was dumb luck that aligned her schedule with mine, so that she was getting off of a ship in Seattle the same day I got there with DATUSA. She was then able to come to Alaska with me, and this is she, standing as a test model for me while Cheyenne prepared for our session. So this is my little shout-out to the love of my life (who by the way, never lets me take her photo, either). Thank you for everything, not the least of which was marrying me!

120 Becky Erickson - Age 33 **Lake McDonald, Glacier National Park, MT** *(She's 4 months pregnant here!!!)*

MONTANA

Glacier National Park
DAY 44
LOCATION 22
AUGUST 10, 2016
MILES ON BUFORD: 10348

Remember what I said about being flexible? Well, again, that was the case here as well. Driving to Glacier National Park was hard... so hard. It was super long, and I was dead tired. This is where I learned the lesson about what I call Jonathan Principle - the more tired the Jonathan is, the less well the 5 Hour Energy drink works. In my current state, it was more like 45 minute energy. Ack!

The drive from the valley floor up to Logan Pass (our location) was so beautiful! As I was driving up the narrow winding road on the edge of the mountain I could see for miles; gorgeous valleys, waterfalls, clouds, suddenly there were more clouds, even more clouds, so many more clouds... then it was nothing BUT clouds. In fact, I couldn't even see the front of Buford anymore! I was driving about 2 miles an hour up the mountain, with a rock wall on one side, and a 100 foot drop on the other, with the visibility of about 7 inches. When I reached the top, even finding the visitors center (our meeting place) was difficult! When we finally gathered everyone and met the ranger, she graciously offered to lead us to other parts of the park, which she was able to as she was the one who did our permit in the first place!

We saw parts of Glacier that most people do not get access to, and I have to thank our wonderful ranger Paige who saved the day. So what is the lesson here, kids? If you follow the rules and work WITH the people in charge, they are more inclined to help you out if something goes wrong.

122 Eliza Krogh - Age 14 **Lake Mconald, Glacier National Park, MT**

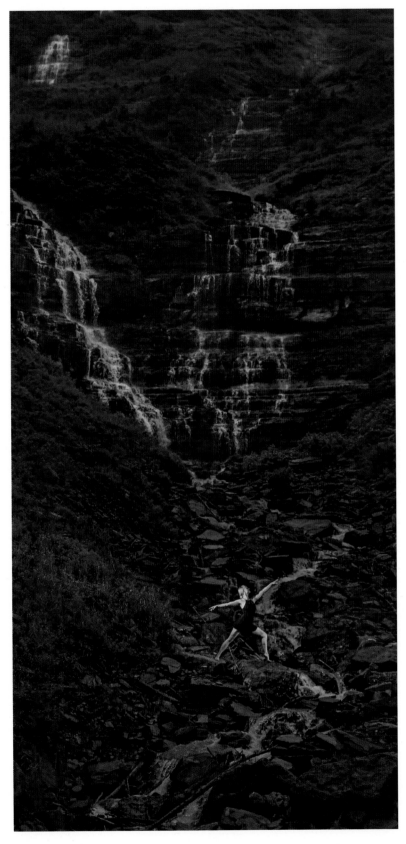

In the image below, that gray square, this is what it looked like at the top of the mountain at Logan Pass. I wanted to be sure to catch that moment, to demonstrate just how thick the fog actually was. In this photo, Eliza and Buford posed together.

On the left, this was a waterfall just a little ways down the road out of the fog bank. As we drove down the road away from the pass, Ranger Paige allowed us to climb up these falls, while she kept us safe.

Becky wins the prize for the farthest distance traveled to shoot with us - she drove 10 hours to meet us here! While most everyone we photographed lived in the state where the session was, we had a couple that traveled. Becky was not available when we were in Utah, but was very eager to work with us, and her schedule worked with this date here. She and her husband made the drive together, and I am so glad that they did!

Becky Erickson - Age 33 **Glacier National Park, MT** *(She's 4 months pregnant here!!!)*

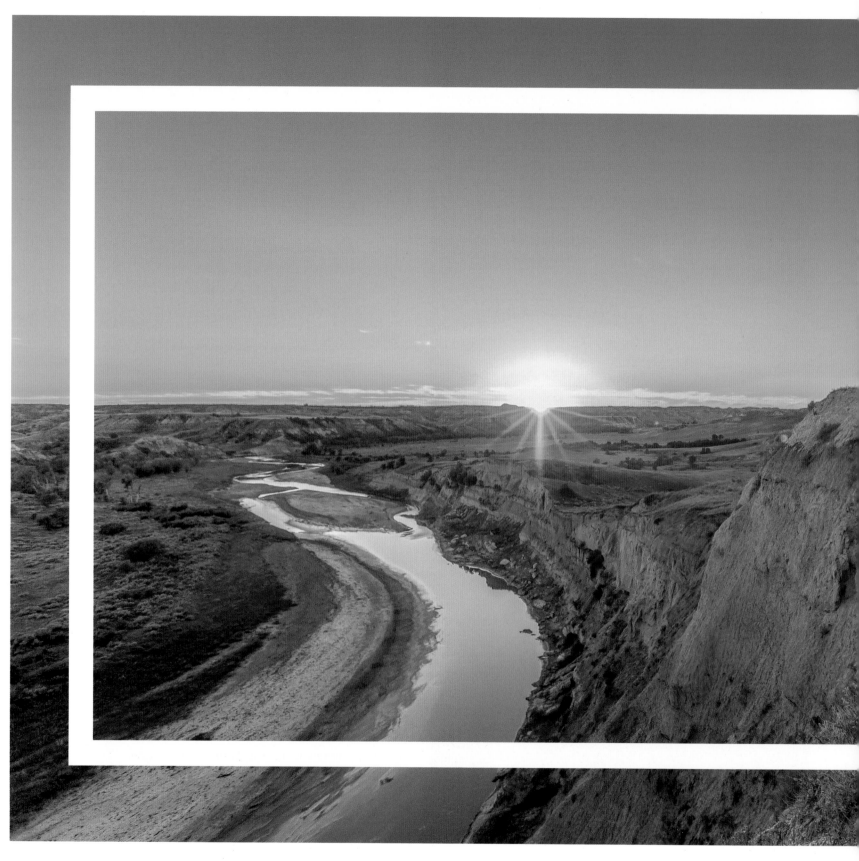

Ieree Lundin - Age 13 **Theodore Roosevelt National Park, ND**

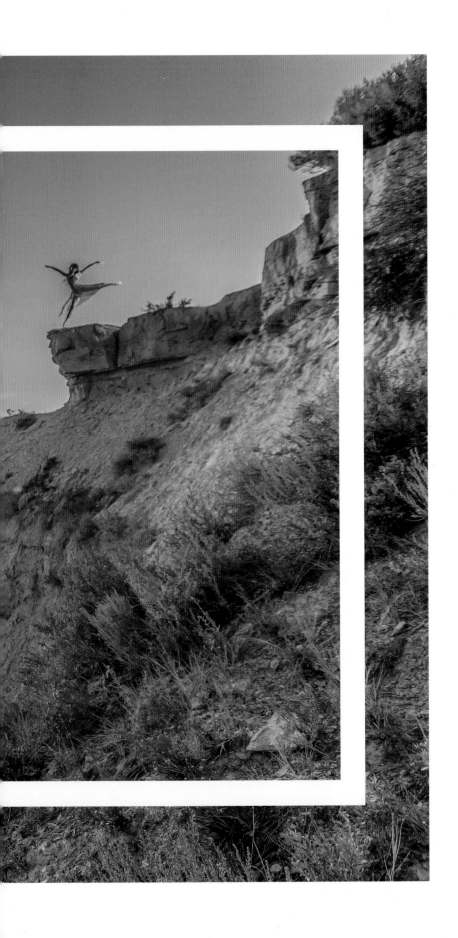

NORTH DAKOTA

Theodore Roosevelt National Park

DAY 47

LOCATION 23

AUGUST 13, 2016

MILES ON BUFORD: 11091 (HALFWAY THERE!)

North Dakota is not a place you visit accidentally. Making your way up here is something that you would have planned to do, and something that you SHOULD plan to do. What a cool place to visit! Theodore Roosevelt National Park has quite a collection of rock formations, wide open expanses, and bison! This is one of the few places where you can see a herd of wild bison.

Bison (or buffalo) used to number over 60 million, but they were brought to the brink of extinction by human greed. Beginning in the 1800s massive hunts for bison would occur, with the peak being in the 1870s. During this time, as many as 250,000 buffalo hides were sold in one or two days. By the start of the 20th century, there were less than 300 wild bison left in the world. The bison were completely killed off in North Dakota, but were reintroduced to Theodore Roosevelt National Park in 1956. Today, there are 500 or so bison living in the park. They are fiercely protected, and are an important part of the park.

The night before our session, we enjoyed the Medora Musical, then met at sunrise to begin. Today I got to get a nap in (naps are awesome!) and then we did a follow up session for sunset, which included a television crew coming to interview us for the news. It was a great day all around!

This park marked our halfway point, at least as far as distance was concerned. Buford was going strong, with no issues and comfortable as ever. Go Buford!!!

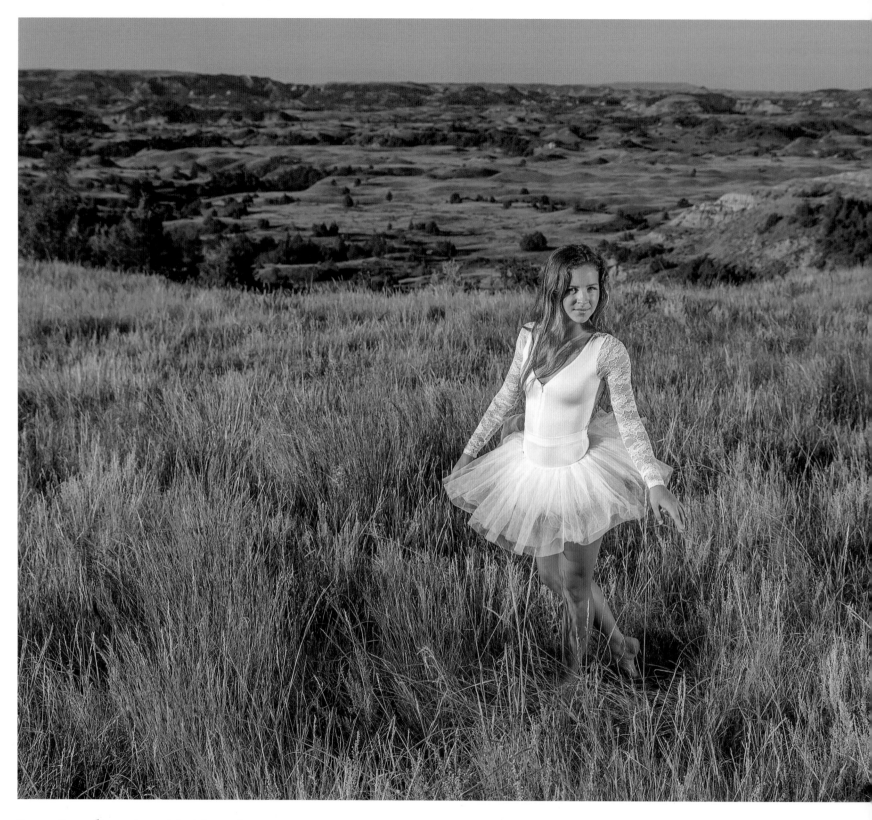

Ieree Lundin - Age 13 **Theodore Roosevelt National Park, ND**

"Dance tells the stories I can't get out of my mouth... I dance with joy. I dance with fear. I dance to overcome."
~ Ieree Lundin

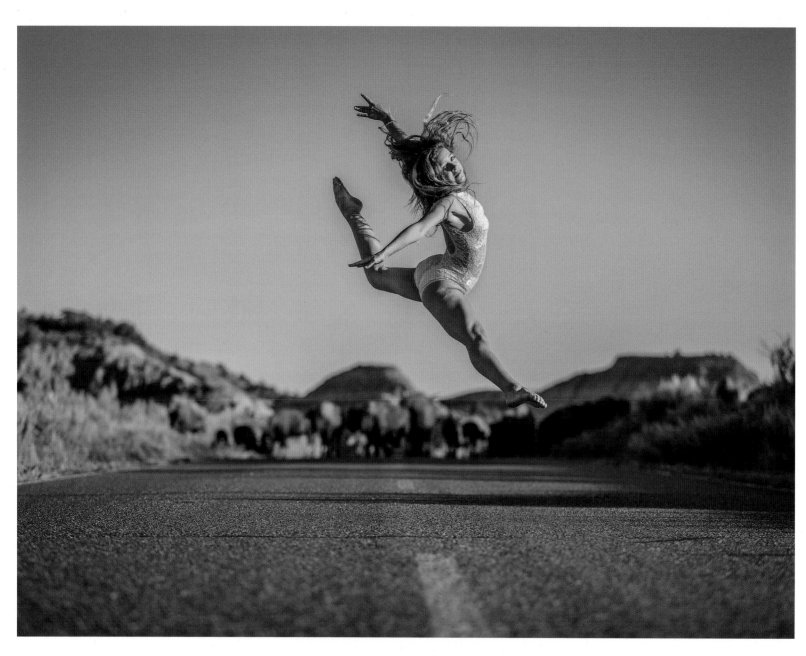

Ieree Lundin - Age 13 **Theodore Roosevelt National Park, ND**

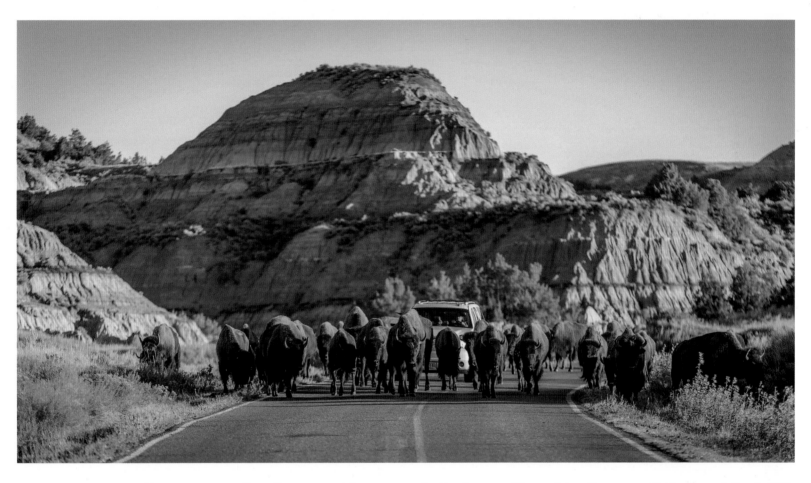

Buffalo surrounding Ieree and her mom in their car - **Theodore Roosevelt National Park, ND**

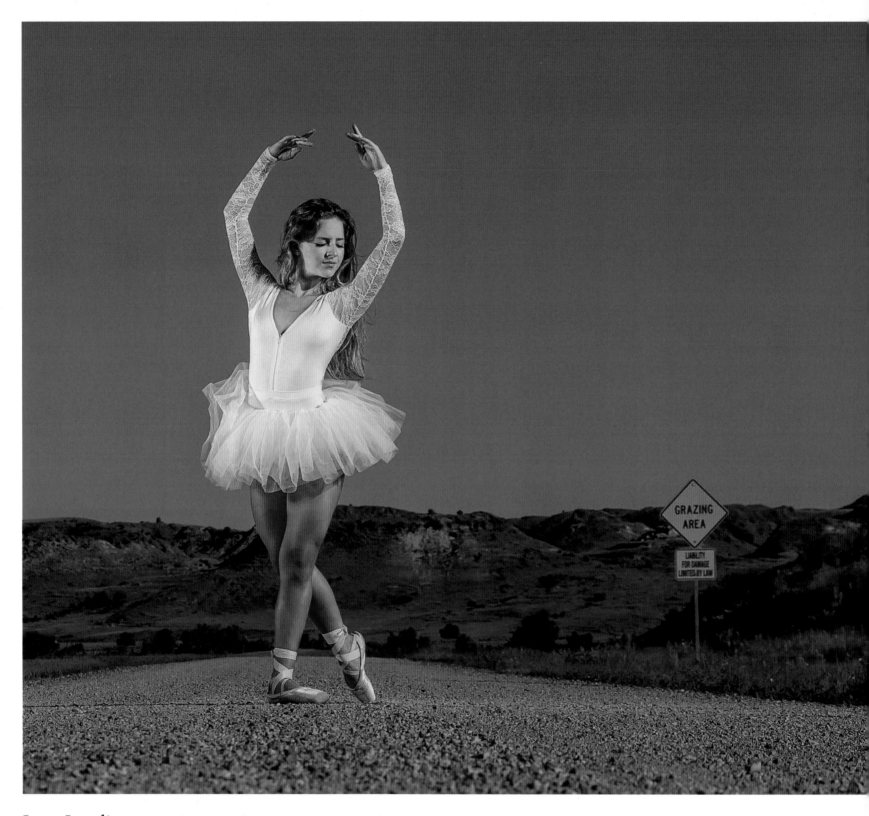

Ieree Lundin - Age 13 **Theodore Roosevelt National Park, ND**

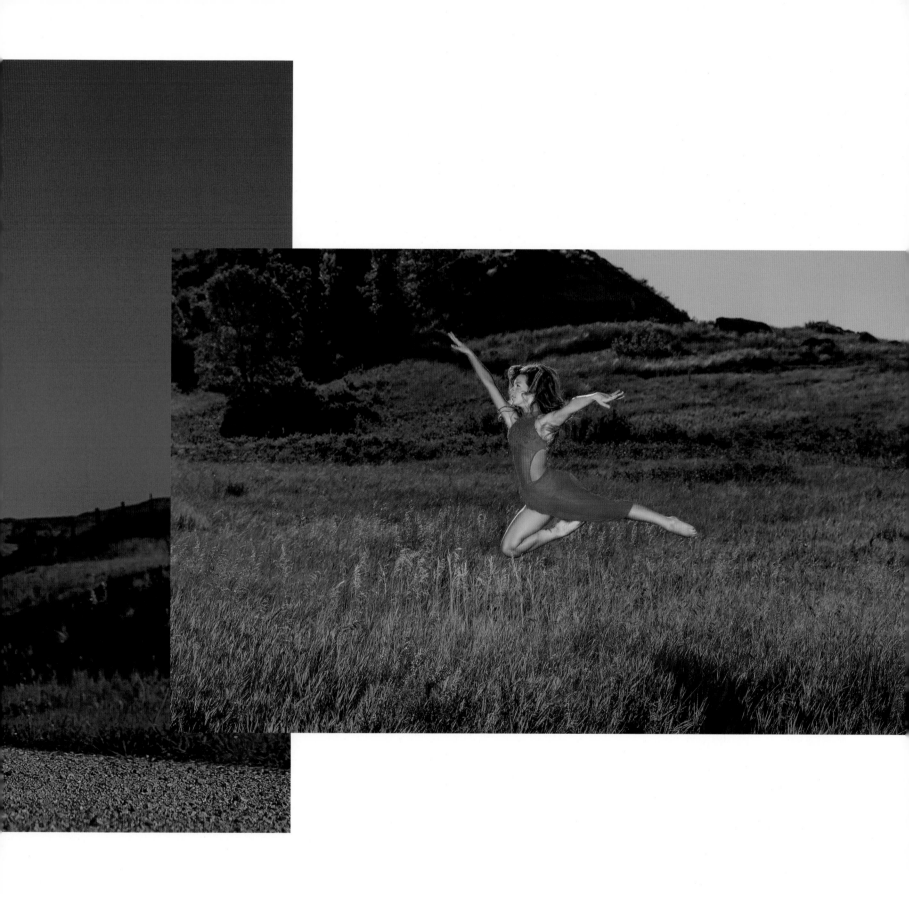

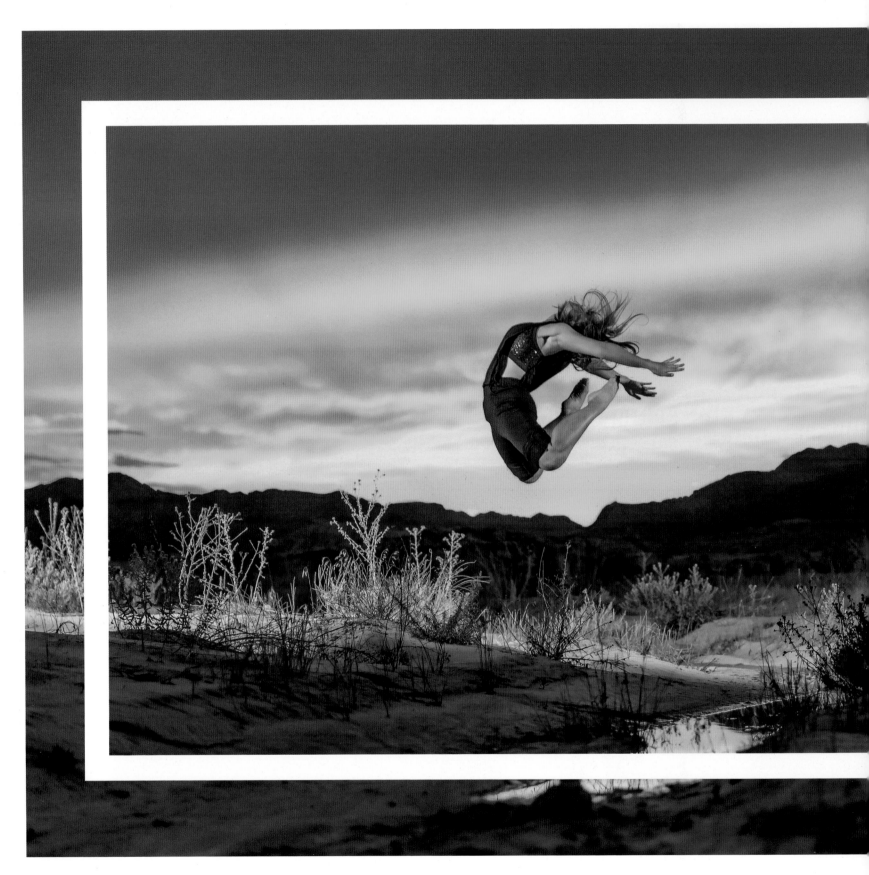

132 Karah Haug - Age 17 **Badlands National Park, SD**

SOUTH DAKOTA

Badlands National Park
DAY 49
LOCATION 24
AUGUST 15, 2016
MILES ON BUFORD: 11621

Crazy what a difference a few miles makes! About 300 miles to the south of Theodore Roosevelt National Park you will find Badlands National Park. It is absolutely another world here! We had two wonderful dancers come out to play, and some of the best stories happened here as well.

You may look at this photo here to the left and wonder if that sky was really that color. Oh yes, it truly was! I have never seen such sunsets as I did here in South Dakota. There is a bunch of science behind what makes for a great sunset, but it comes down to a few factors - clean air, high clouds, low humidity, and calm winds.

The incredible rock formations here at Badlands National Park are the product of erosion and deposition. There are layers to the rocks, and each layer came from a different source, and there are basically two types - sedimentary rock from water deposits, and ash from volcanic eruptions. In the sedimentary sections, you can find evidence of both salt water and fresh water, due to the types of fossils found in each. The erosion came from rivers running over these layers, which gives us the crazy shapes and towering spires.

It's called the Badlands for a reason. The Lakota people called this place "mako sica" or "land bad." Extreme temperatures, lack of water, and the exposed rugged terrain led to this name. When we were there, while we camped the night before the session, the weather was intense with wind gusts of 80 miles per hour! Camping in a hurricane... YEEHAW!!!

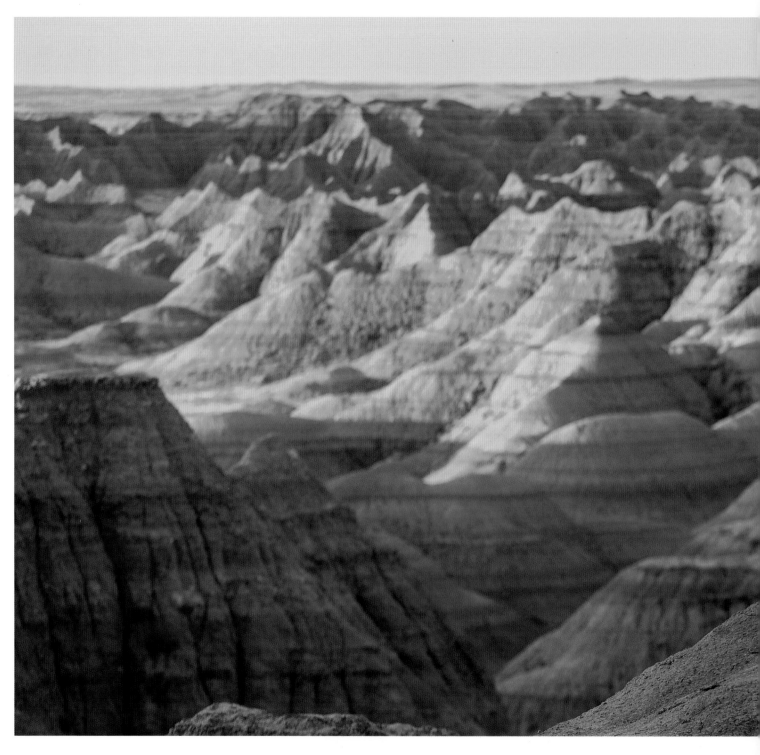

Lily Simmons - Age 11 **Badlands National Park, SD**

"Dancing is my getaway, it's not about tricks and flexibility, it's about passion and soul throughout the art. I love dancing because it helps me through life's situations. It never gets easy, you just get better."
~ Lily Simmons

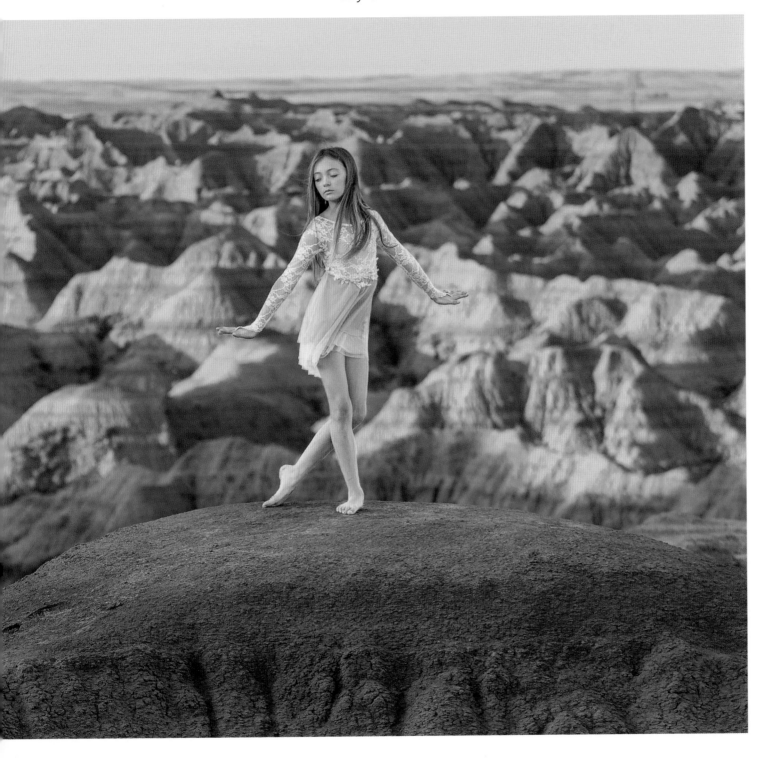

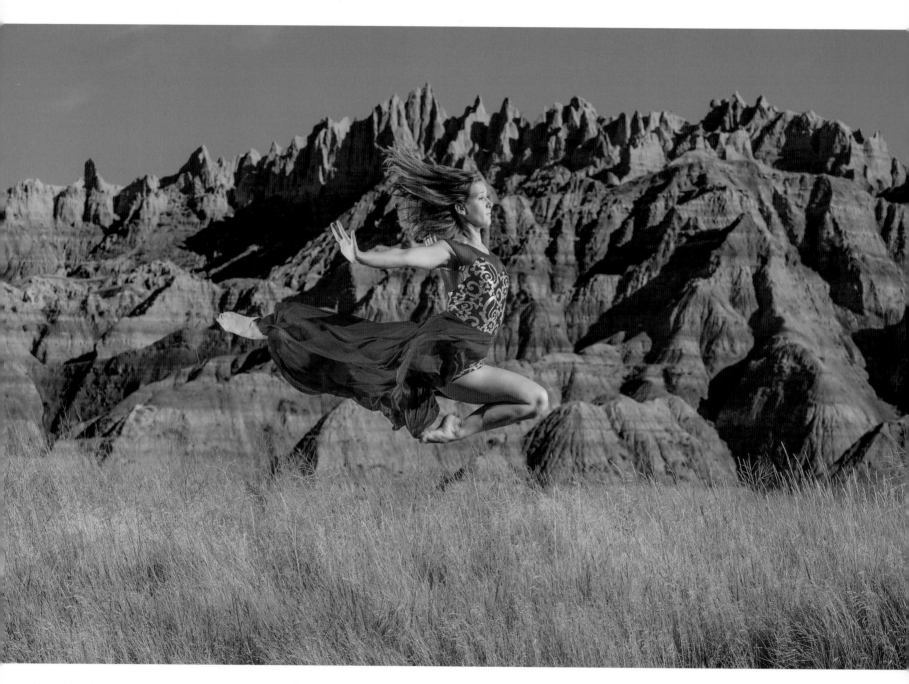

Karah Haug - Age 17 **Badlands National Park, SD**

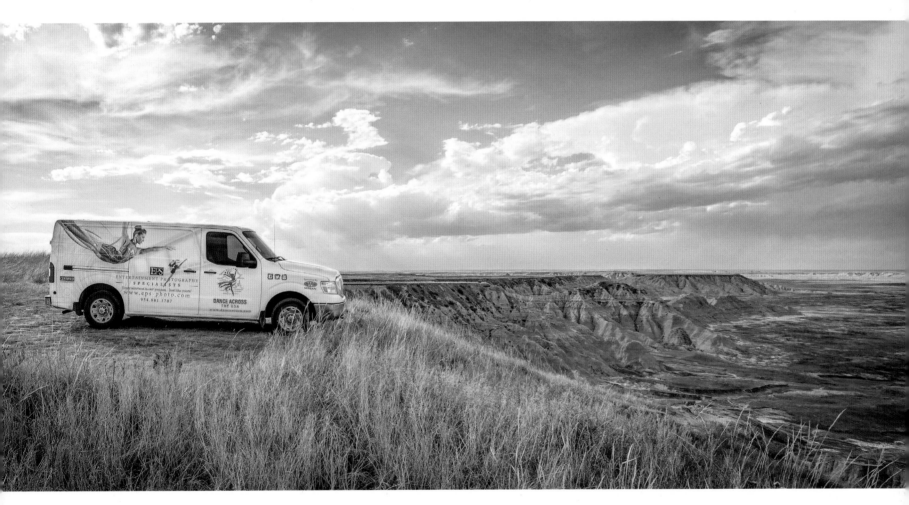

The Mighty Buford - Age 3 **Badlands National Park, SD**

Kynlee McBride - Age 11 **Missouri National Recreational River, NE**

NEBRASKA

Missouri National Recreational River

DAY 51

LOCATION 25

AUGUST 17, 2016

MILES ON BUFORD: 12170

I love Nebraska. I do! I simply love it. There are so many great things that come from here - Kool-Aid, Runza, Fred Astaire, and gosh darn it, the people are nice! Oh, the Henry Doorly Zoo in Omaha... AMAZING! Their Center for Conservation and Research does great work as well.

This is where I need to give a very special shout out to IATSE Local 42 and the crew at the Orpheum Theater. I came through here on several occasions (most recently with the touring musical version of *How the Grinch Stole Christmas*; I was the head carpenter), and every time I visited, these folks were fantastic.

The location for Nebraska is called the Missouri National Recreational River. The river runs much of the border between Nebraska and South Dakota. When we arrived, one of the mothers commented, "You've been to all these amazing places... and we get a bridge." LOL, but she soon saw that there were amazing images to be found here as well!

Louis and Clark made their way through here on their expedition to find the headwaters of the Missouri. They were the first modern people to travel the entire length of the river. The Missouri is the longest river in the US, at 2341 miles long, and is the 15th longest in the world. Where our session was, in South Yankton, NE, we also used the Meridian Bridge, which is listed on the National Registry of Historic Places.

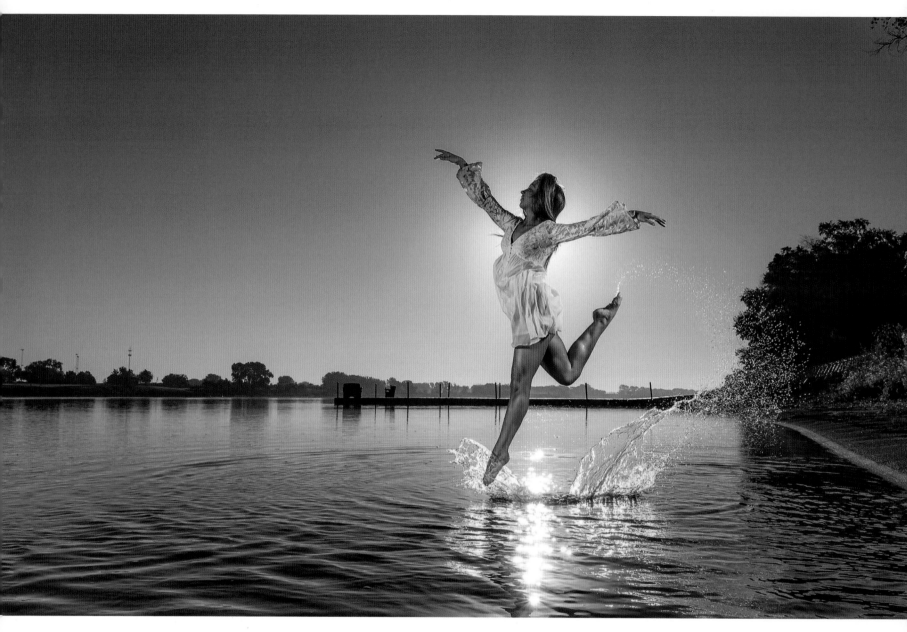

Madison Chizek - Age 14 **Missouri National Recreational River, NE**

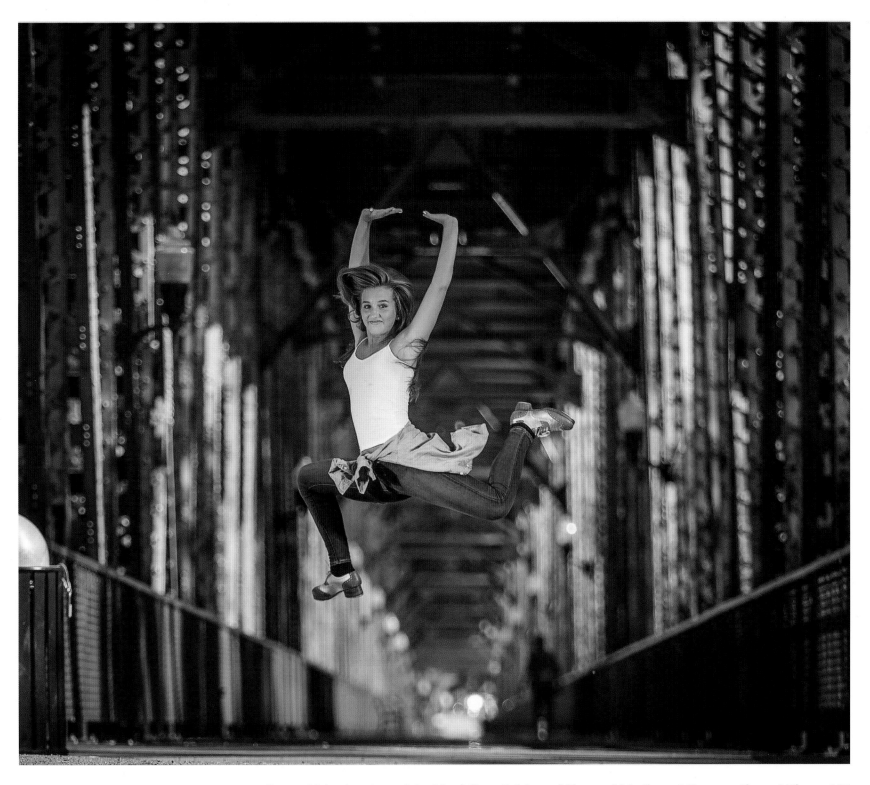

Madison Chizek - Age 14 **Meridian Bridge, Missouri National Recreational River, NE**

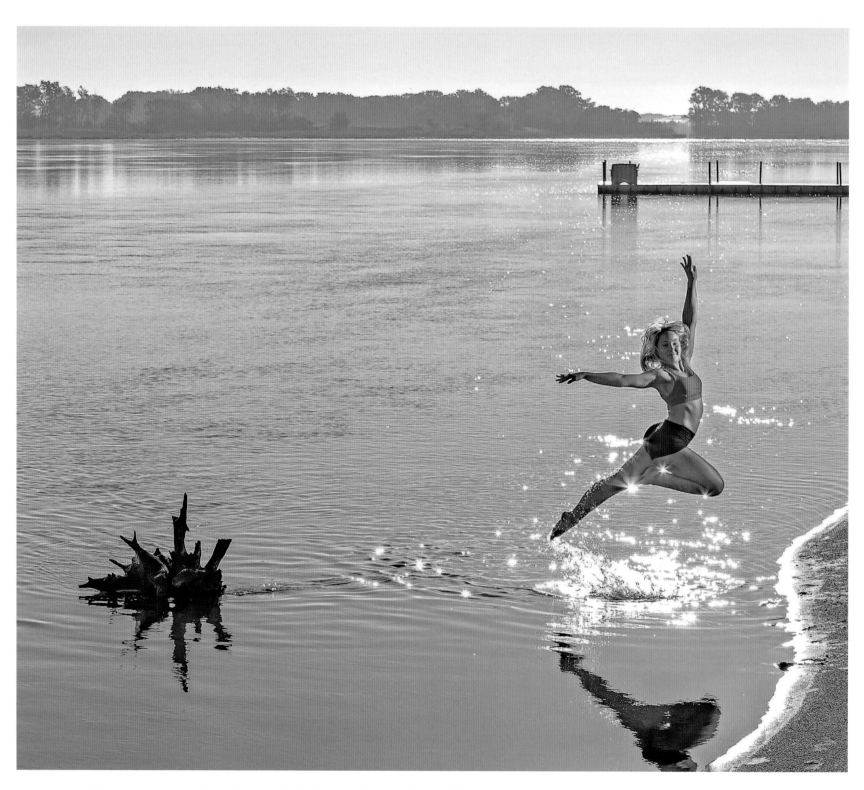

Macy O'Connell - Age 14 **Missouri National Recreational River, NE**

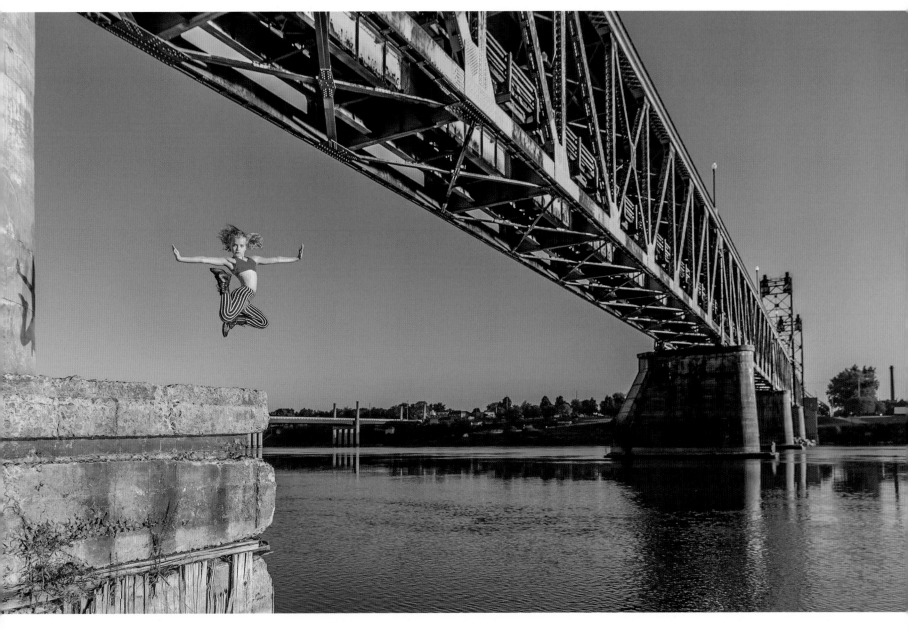

Kynlee McBride - Age 11 **Meridian Bridge, Missouri National Recreational River, NE**

144 Ashley Gonzalez - Age 16 **Voyageurs National Park, MN**

MINNESOTA

Voyageurs National Park
DAY 53

LOCATION 26

AUGUST 19, 2016

MILES ON BUFORD: 12926

At the top of Minnesota, the land of 10,000 lakes, there is Voyageurs National Park. Located just outside of International Falls, this park is practically all water. In fact, to get to all of the campsites, you must go by boat. This is truly a watersports paradise!

This again was one of the many locations where I was up to my neck in water to get the angles I wanted. And that water was cold!!! Did I mention the bugs? They tried to fly away with us, but we prevailed. One of the local jokes is that the state bird of Minnesota is the mosquito. It is actually the common loon, but from personal experience I can see why it could be the mosquito.

I found a wonderful boat captain to take us around the park, from a company called Voyageurs Outfitters. Captain Eric was a fantastic guy, very knowledgeable and super friendly. We went to a little island, aptly named Little American Island. We scurried around for a while, enjoying our private island experience, and of course the gorgeous sunset.

A little known fact about this island, it was the location of the Rainy Lake Gold Rush! In 1893 gold was found on this island, which brought in a swarm of prospectors and people eager to make their fortune. This was short-lived, however, with the mine going bust only six years later. Today you can find a few remnants of the mine, but nature has mostly reclaimed the island.

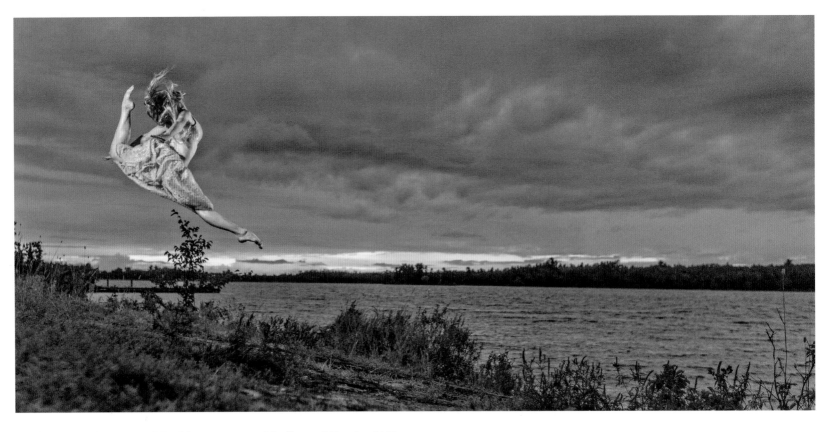

Emily Ferrell - Age 25 **Voyageurs National Park, MN**

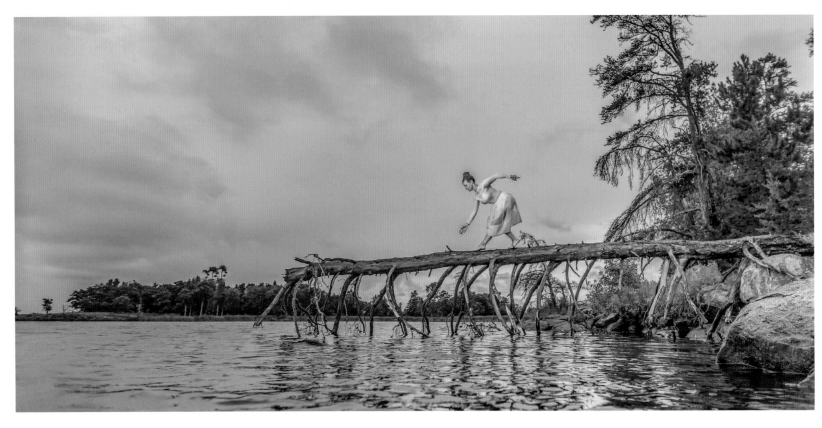

Patience Stellmach - Age 36 **Voyageurs National Park, MN**

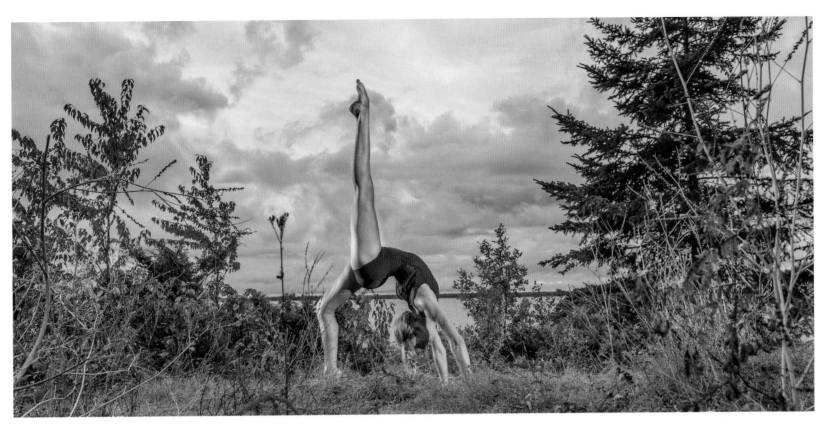

Abby Roberts - Age 13 **Voyageurs National Park, MN**

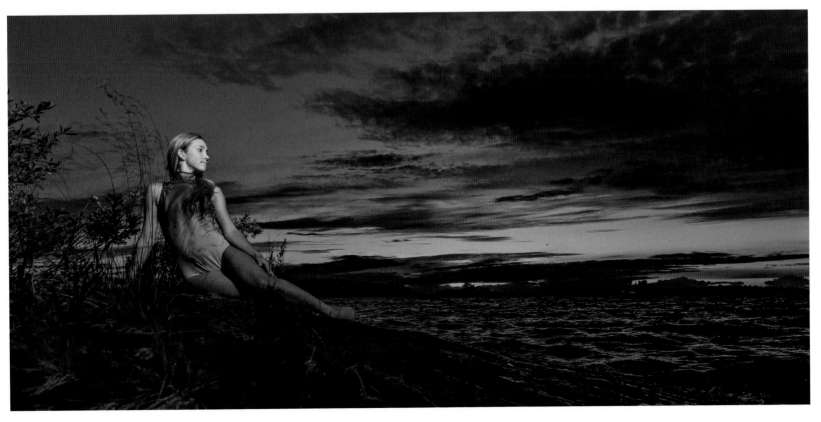

Abby Roberts - Age 13 **Voyageurs National Park, MN**

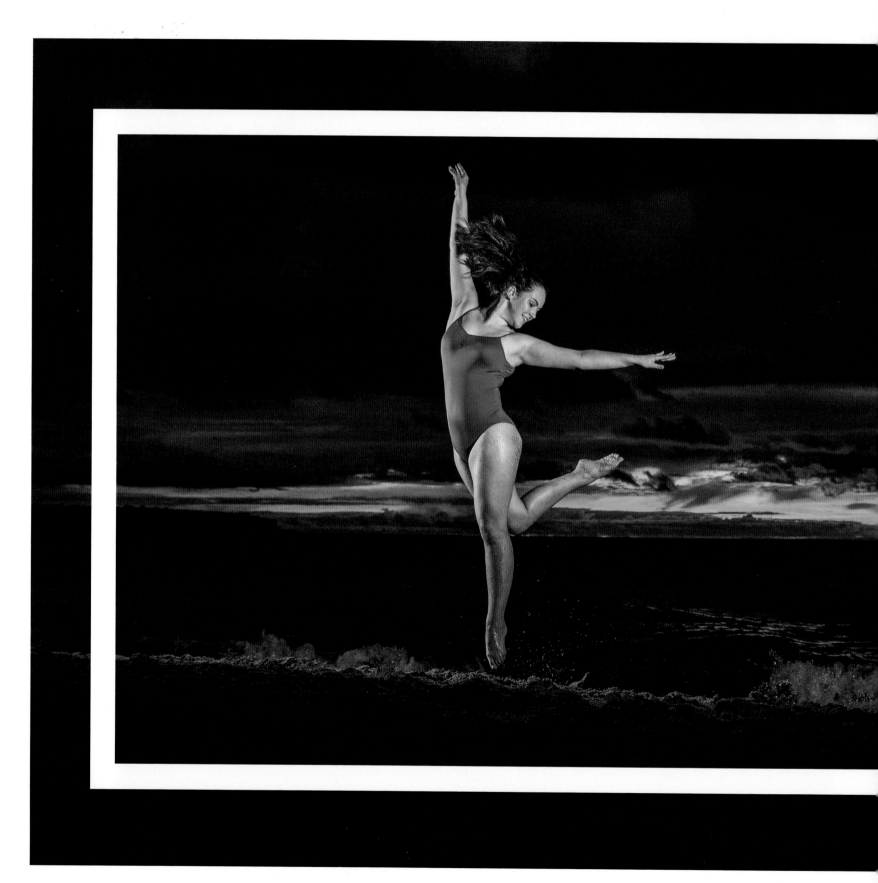

148 Devon Winn - Age 16 **Apostle Islands National Lakeshore, WI**

WISCONSIN

Apostle Islands National Lakeshore

DAY 54

LOCATION 27

AUGUST 20, 2016

MILES ON BUFORD: 13244

Located on the shores of Lake Superior, the largest of the Great Lakes, you will find the Apostle Islands National Lakeshore. Windswept beaches, stunning cliffs, and trails for days, this is another great example of an outdoor wonderland! Lighthouses, sea caves, and even ice caves are the hallmarks of this place.

The weather was not our friend today. We met at the trailhead at Meyer's Beach, and began a hike into the woods to see the sea caves. About two miles in, right when we began being able to view the caves, it began to rain. And not just rain, but like the heavens opened, and all the water came down. Every. Last. Drop. I was ready for rain, with gear to protect myself and my photo equipment, but not for something like this.

We decided to call it, and cancel the session. Since we were two miles out, all we could do was turn around and go back. In the pouring rain. Which had the added benefit of making the trail into a giant mud covered slip-and-slide. Normally this sort of this is fun for me, (I don't mind getting dirty), but not when you have 80 pounds of photo gear and supplies on your back.

As we were approaching the trail head again, the rain started to ease up, and I could see signs of a pretty sunset in the works. We picked up our pace, and got to the beach just in time! We did a follow up the next morning for a couple more shots, and then I was off to the next state. Bring it, Michigan!

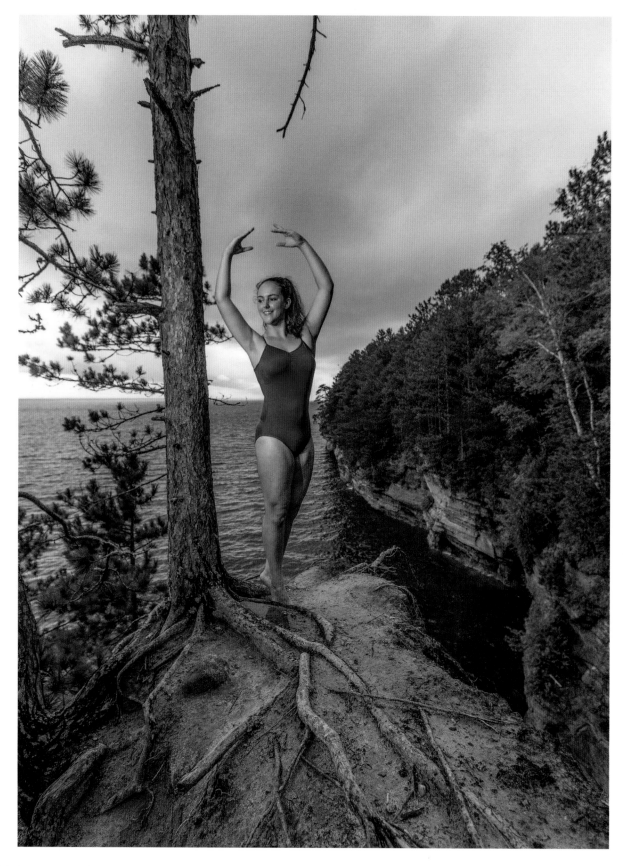

150 Devon Winn - Age 16 **Apostle Islands National Lakeshore, WI**

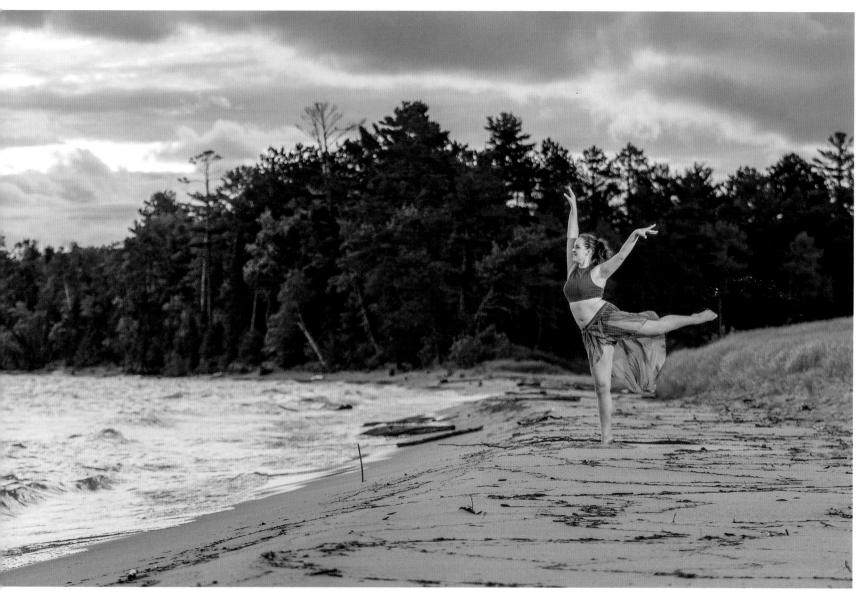

Devon Winn - Age 16 **Apostle Islands National Lakeshore, WI**

MICHIGAN

Pictured Rocks National Lakeshore
Day 55
Location 28 (28 more to go!)
August 21, 2016
Miles on Buford: 13570

On the other side of Lake Superior, there is another national lakeshore even more beautiful than Apostle Islands, and that's saying something! Pictured Rocks has many of the same features as the other, but here they are all turned up to eleven. The sea caves are incredible, and there is a gigantic sand dune here - the Grand Sable Dunes.

Grand Sable is an example of a perched dune, which means it is a dune formed on an existing coastal bluff. The dune is over 300 feet high, and covers five square miles! Talk about your big piles sand.

Have you ever tried to climb a sand dune? At Grand Sable, you start at the top of the dune, which is what can get people into trouble. From the parking lot, it is an easy quarter mile hike to the top of the dune. Going down is easy. Really easy. Like, "OMG, I can't believe this is so easy," kind of easy. Then you try to go up...and...you wish you were dead. Going uphill any hill is hard enough (especially when the hill is at a 50° angle). Add into that beautiful, soft, squishy sand, and what took you about 20 seconds to go down will take you what seems to be 20 hours to go up. Fortunately, we did not go all the way down the dune. We might still be there if we had.

The dunes are not the only place we used, we also were at 12 Mile Beach. It's like the ocean, but without the salt. A gorgeous beach that goes on for miles. Actually 12. Which would explain the name, 12 Mile beach. Funny how that works, isn't it? =)

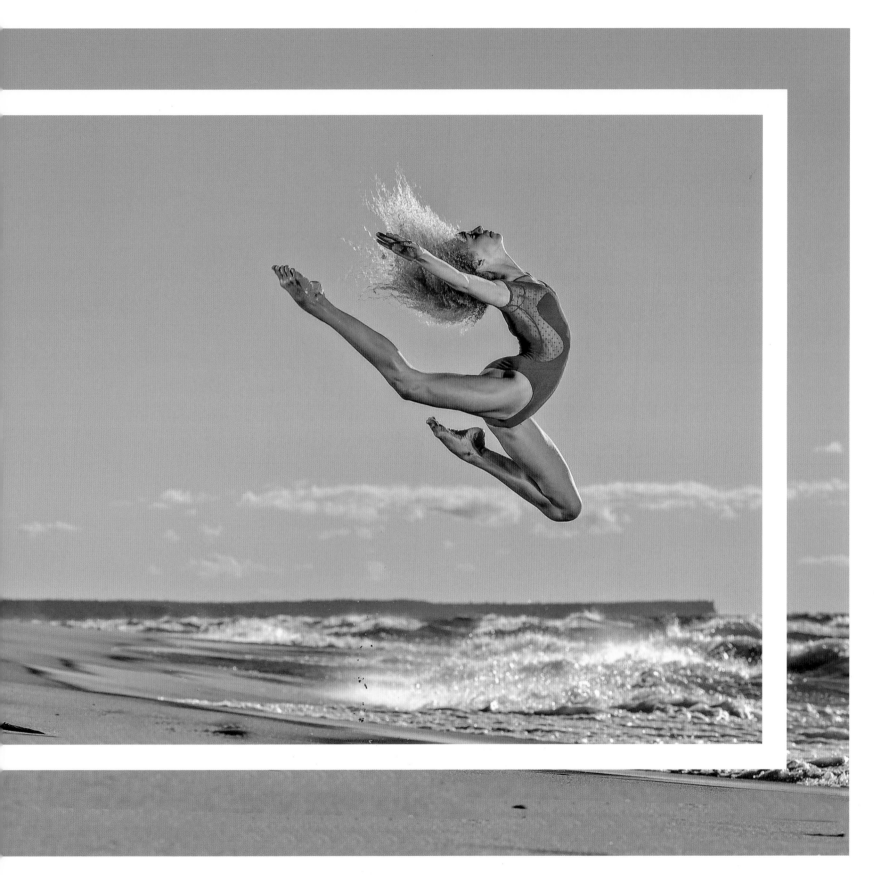

Zoey Cappatocio - Age 13 **Pictured Rocks National Lakeshore, MI** *153*

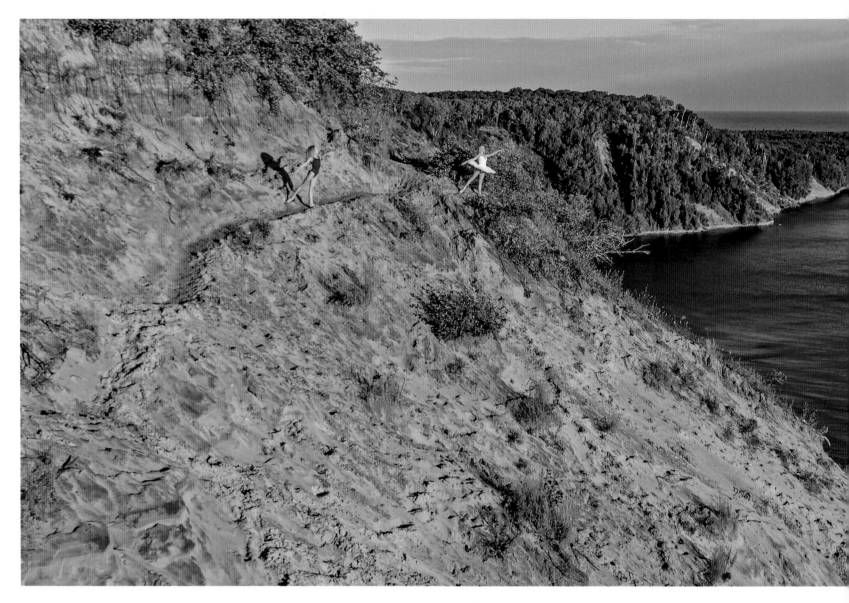

Zoey Cappatocio - Age 13 and Hope Bennethum - Age 14 **Pictured Rocks National Lakeshore, MI**

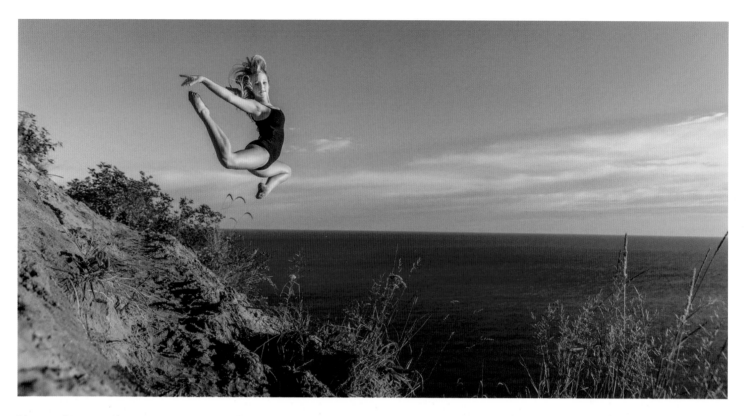

Hope Bennethum - Age 14 **Pictured Rocks National Lakeshore, MI**

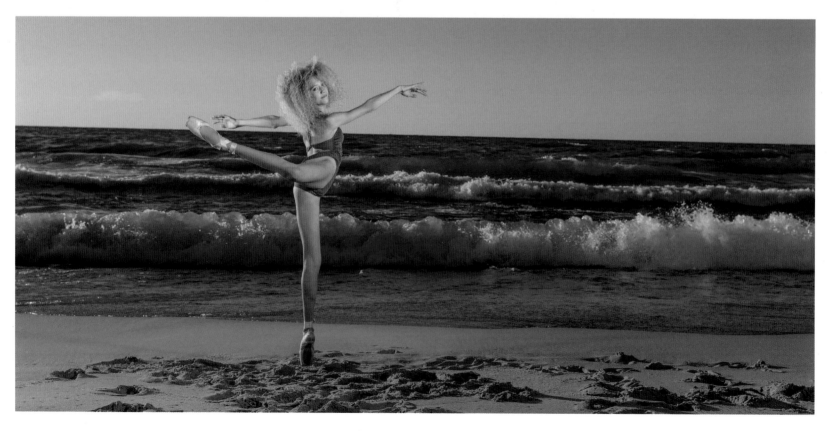

156 Zoey Cappatocio - Age 13 **Pictured Rocks National Lakeshore, MI**

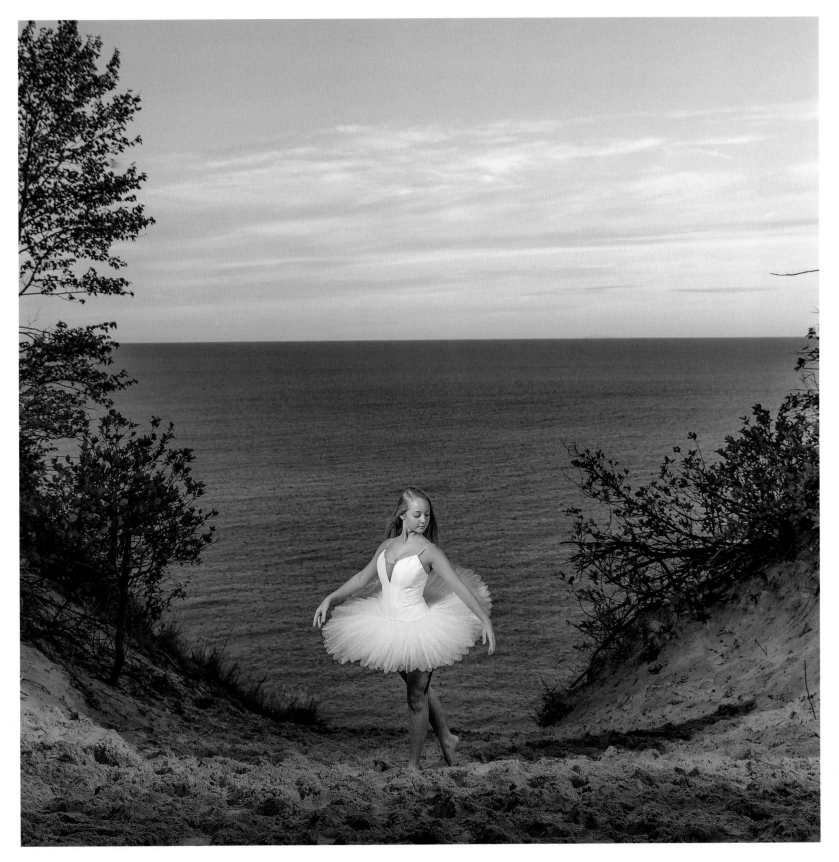

Hope Bennethum - Age 14 **Pictured Rocks National Lakeshore, MI** *157*

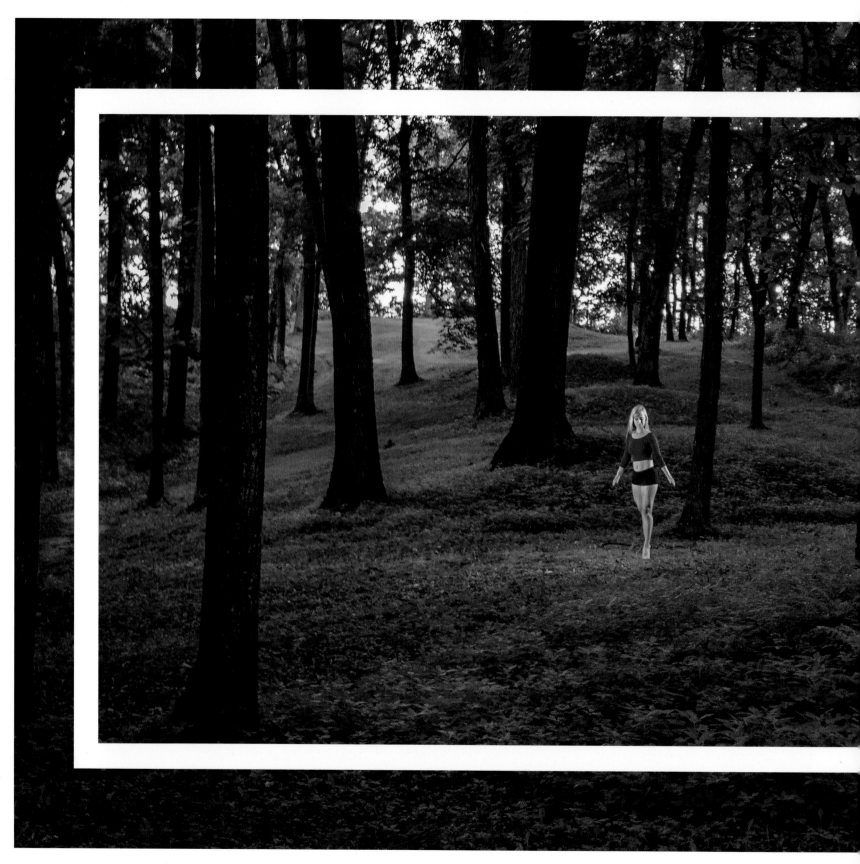

Josa Comstock - Age 18 **Effigy Mounds National Monument, IA**

IOWA

Effigy Mounds National Monument
Day 57
Location 29
August 23, 2016
Miles on Buford: 14065

At the top of a beautiful hill overlooking the lush valley below, Native Americans created a sacred space. Effigy Mounds is part of Native American culture - going back thousands of years. This area ties together 20 present-day tribes, all of whom have a connection here. Several of the mounds are built in the shape of animals. At this site, there are over 200 mounds, 31 of which are bird- or bear-shaped effigies.

We arrived here early, well before sunrise, so we would have time to make the hike up to the ridge before the sun actually made an appearance. The moment you leave the visitor's center, the trail instantly goes up. I was out of breath after about 100 yards of walking! It is a fairly steep climb, but once you reach the top it is incredible. The trail winds its way through the mounds (we did the Little Bear and Great Bear trails), where we took a moment of silence.

Have you ever been someplace where you felt the weight of history on you? This is one of those places. It is obvious how important this area was and is, and visiting here allows you to be a part of it. The mounds are both a burial site, and a site to honor the history and culture of Native Americans. There are many sites around the country where mounds like this exist, and all of them are just as important and historically valuable. When you do come to visit, make sure you do not climb the mounds. Staying in between them is fine, but recognize the sanctity of the area, and show some respect.

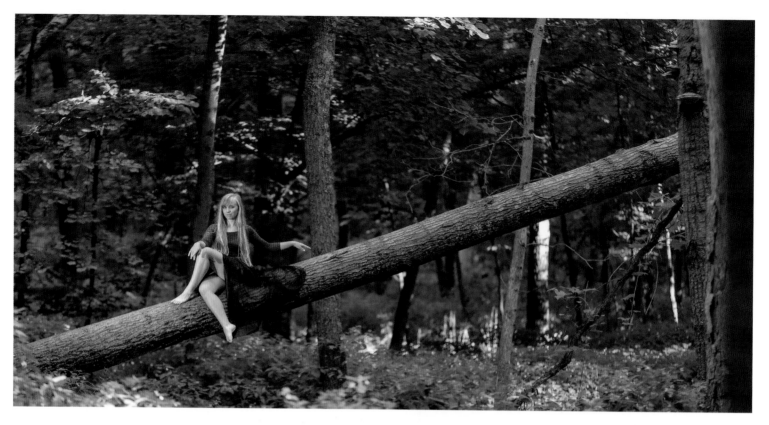

Josa Comstock - Age 18 **Effigy Mounds National Monument, IA**

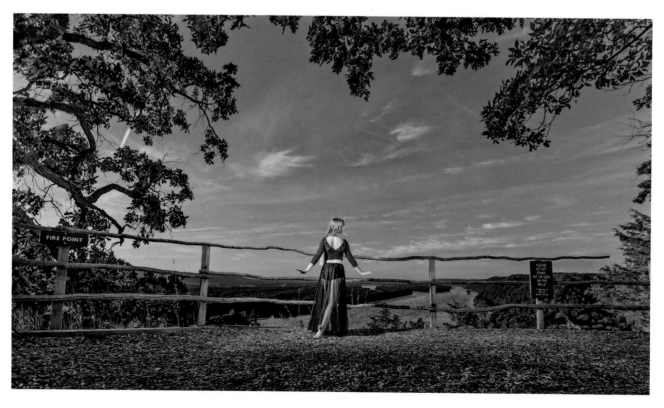

Josa Comstock - Age 18 **Effigy Mounds National Monument, IA**

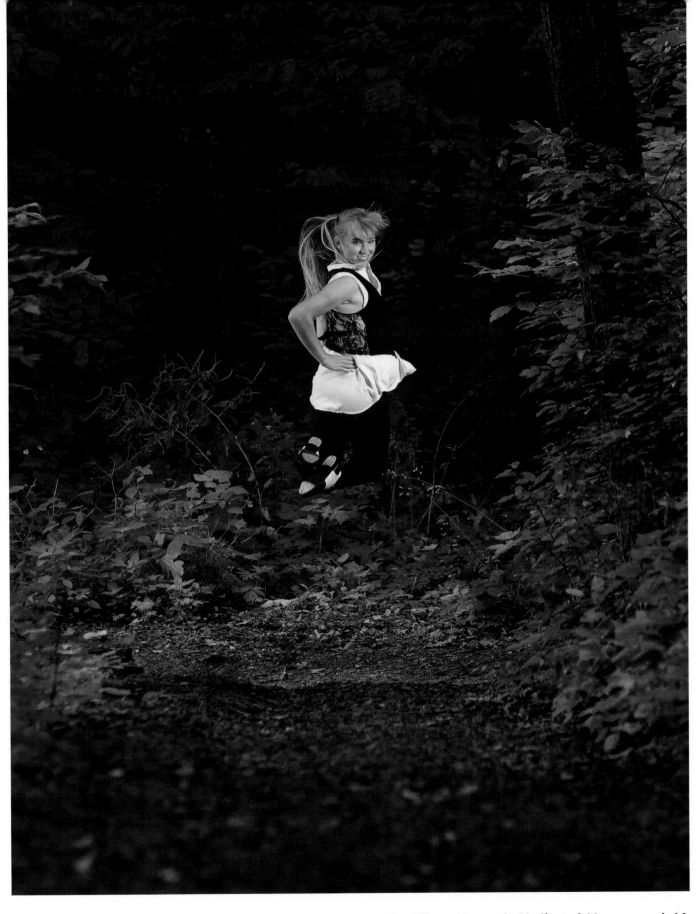

Josa Comstock - Age 18 **Effigy Mounds National Monument, IA**

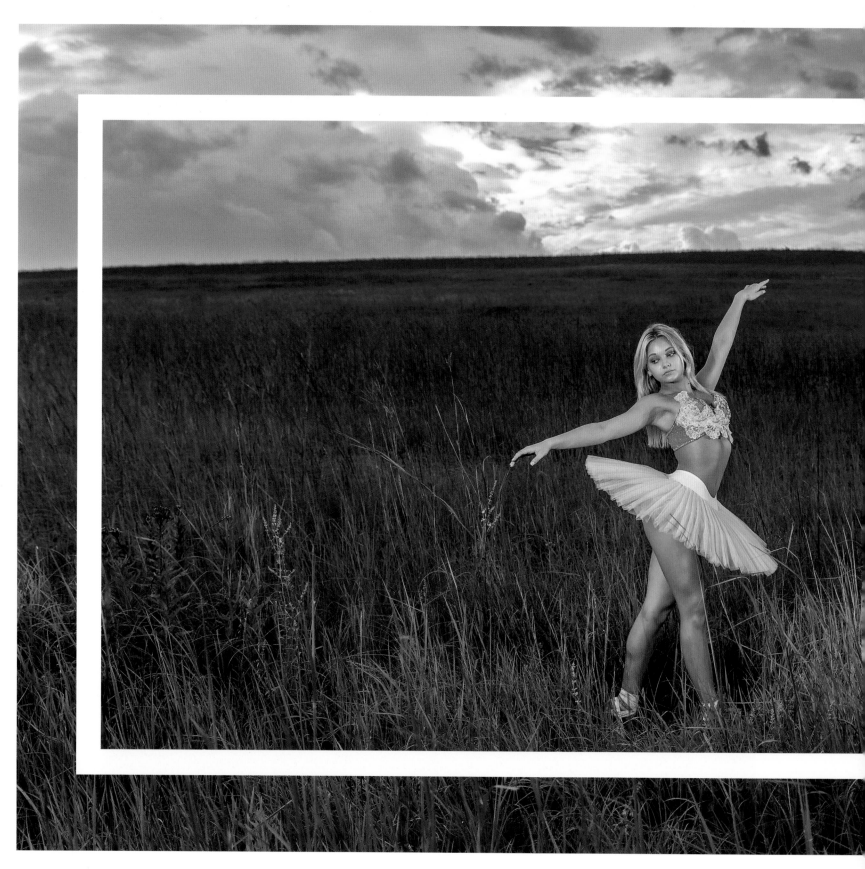

Paige Pickett - Age 14 **Tallgrass Prairie National Preserve, KS**

KANSAS

Tallgrass Prairie National Preserve
DAY 58
LOCATION 30
AUGUST 24, 2016
MILES ON BUFORD: 14674

In the middle of Kansas, in practically the middle of the country, there sits Tallgrass Prairie. Estimates say this prairie used to cover over 170 million acres of land. To put it another way, if the area that used to be prairie was its own country, that country would be the 18th largest in the world, at over 625,000 square miles. Today, there is less than 4 percent of this type of open prairie left, most of which can be found at this park.

This was one of the parks where they did absolutely everything they could do to be helpful to our project! The ranger waited for hours after her shift was done for me to arrive here, just to show me around and make sure all was going according to plan. She showed me the trails I could drive around, and gave me access to areas not typically traveled as well. It was fantastic! Now if only the weather had cooperated.

This was another location where rain messed around with us. The storms come up fast in this part of the world! Within about an hour, the sky went from sunny and beautiful to completely black and crazy lightning! But not before we got what we came here to do. This place also included us doing some heavy off-road driving as well. In fact, this is where I crossed a river in the Mighty Buford! If you visit our website at www.danceatusa.com, you can see the page for Buford, and find the video about this crossing. It's things like this that make my wife say I am four years old.

163

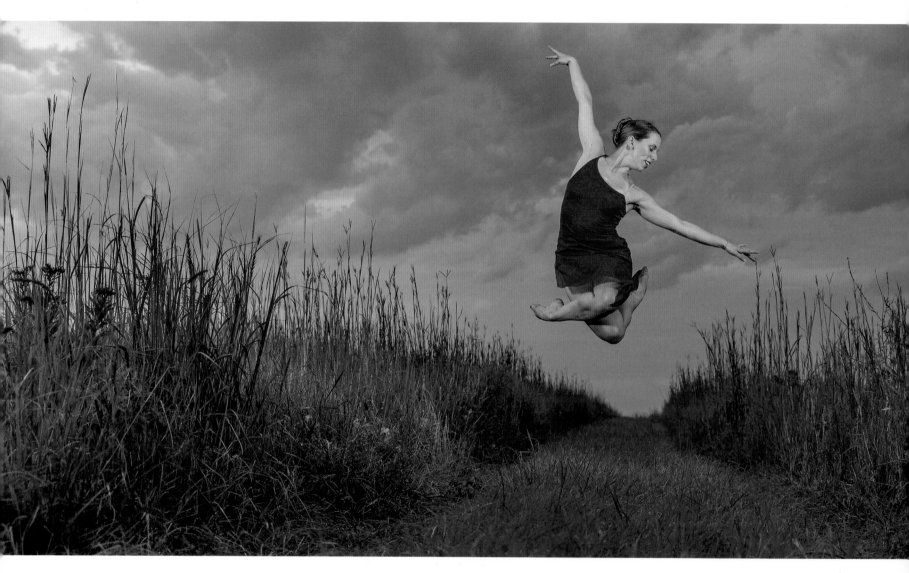

Lindsey Smith - Age 27 **Tallgrass Prairie National Preserve, KS**

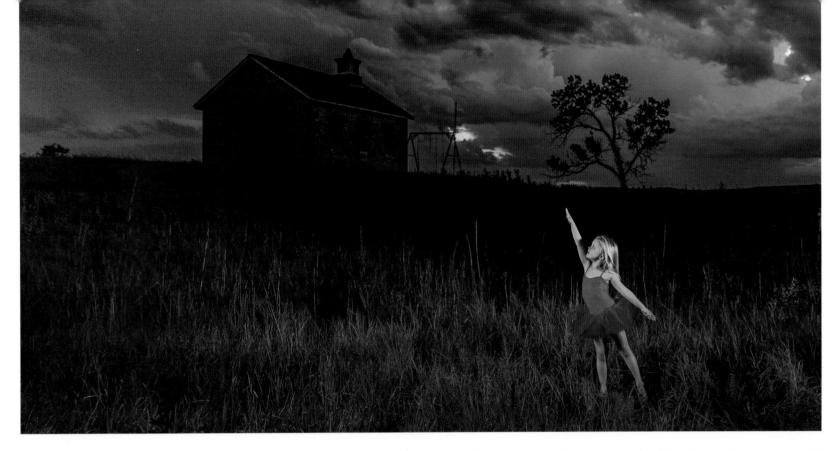

Luca Branit - Age 5 **Tallgrass Prairie National Preserve, KS**

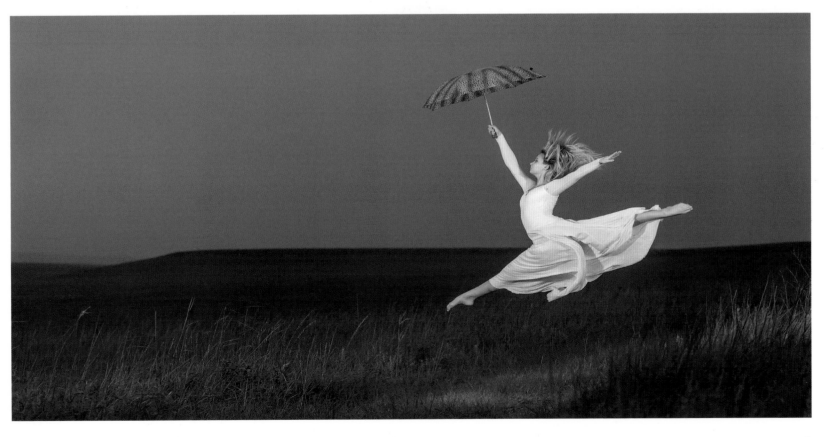

Paige Pickett - Age 14 **Tallgrass Prairie National Preserve, KS**

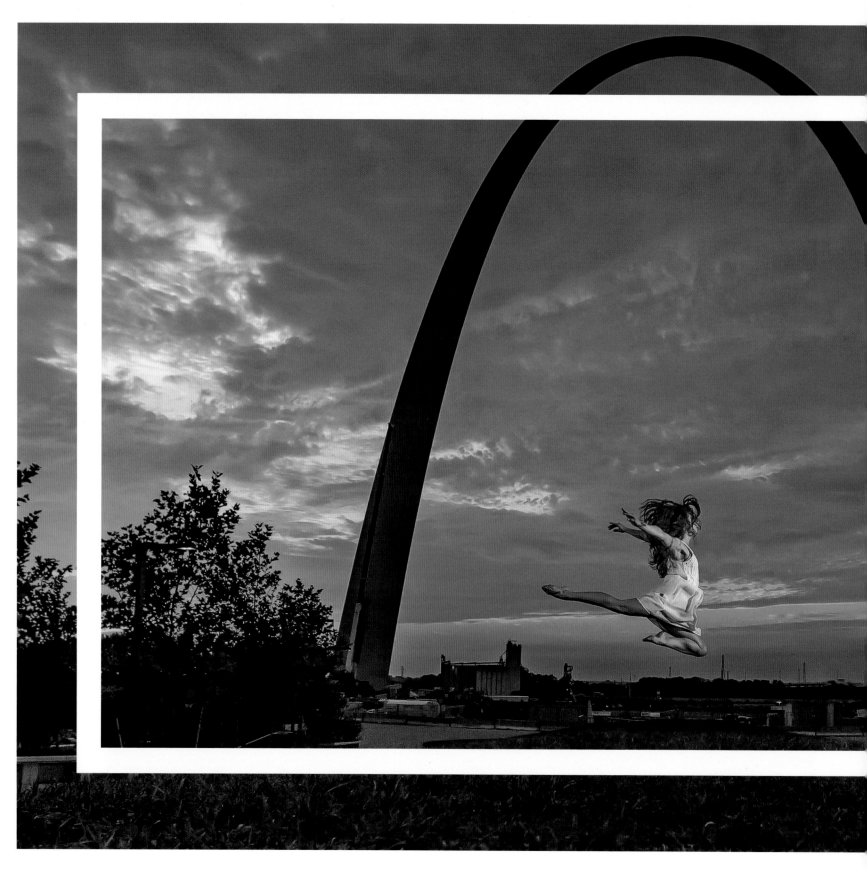

166 Sarah Svoboda - Age 32 **The Gateway Arch, Jefferson National Expansion Memorial, MO**

MISSOURI

The Gateway Arch
Jefferson National Expansion Memorial
Day 59
Location 31
August 25, 2016
Miles on Buford: 15125

This date was the birthday of the National Park Service - 100 years old! Signed into existence by President Woodrow Wilson, the Organic Act created the NPS to "... promote and regulate the use of the Federal areas known as national parks, monuments and reservations...by such means and measures as conform to the fundamental purpose of the said parks, monuments and reservations, which purpose is to conserve the scenery and the natural and historic objects and the wildlife therein and to provide for the enjoyment of the same in such manner and by such means as will leave them unimpaired for the enjoyment of future generations."

The Gateway Arch was designed as part of a nationwide competition in 1947. Eero Saarinen, an immigrant from Finland, designed it to honor the spirit of western pioneers. Construction began in 1963, and was completed on October 28, 1965. When we arrived, the complex around the Arch was midway through a three-year renovation, due to be completed Spring of 2018.

This location was a marker for me. The "Gateway to the West" swings both ways, and it meant the end of the western portion of my trip. The drives would all be shorter now, generally speaking, and with only a month remaining, this was the back end of the trip. "It's all smooth sailing from here on in," I thought to myself. Little did I know what was coming in Tennessee...

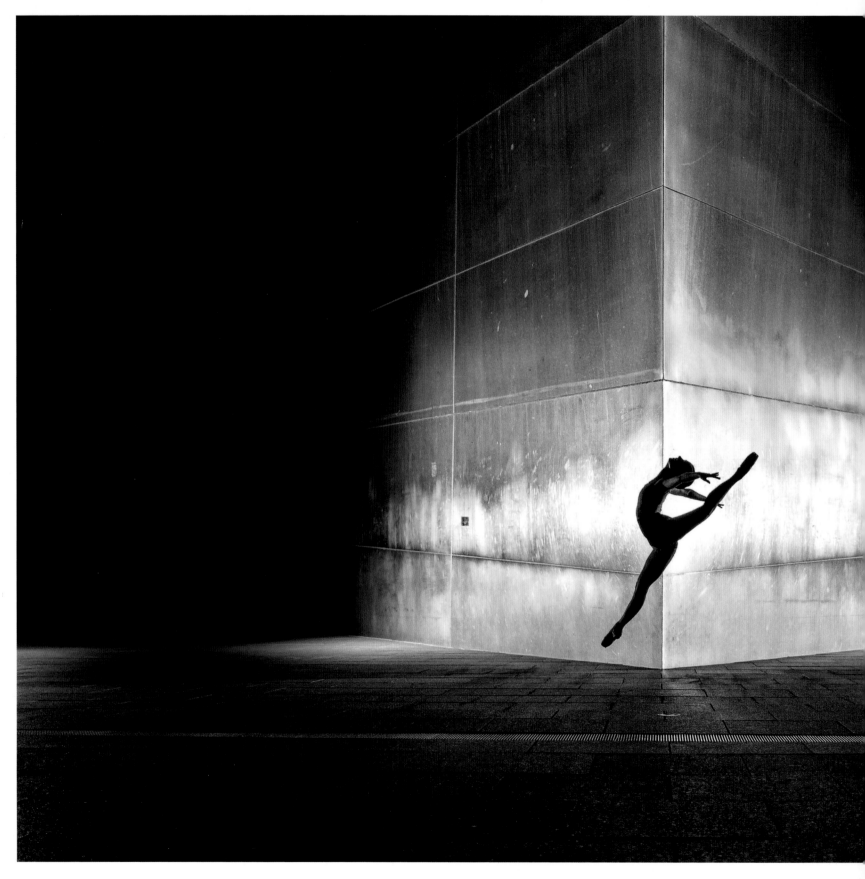

168 Jocelyn Green - Age 25 **The Gateway Arch, Jefferson National Expansion Memorial (JNEM), MO**

Jocelyn Green - Age 25 **The Old Courthouse, JNEM, MO**

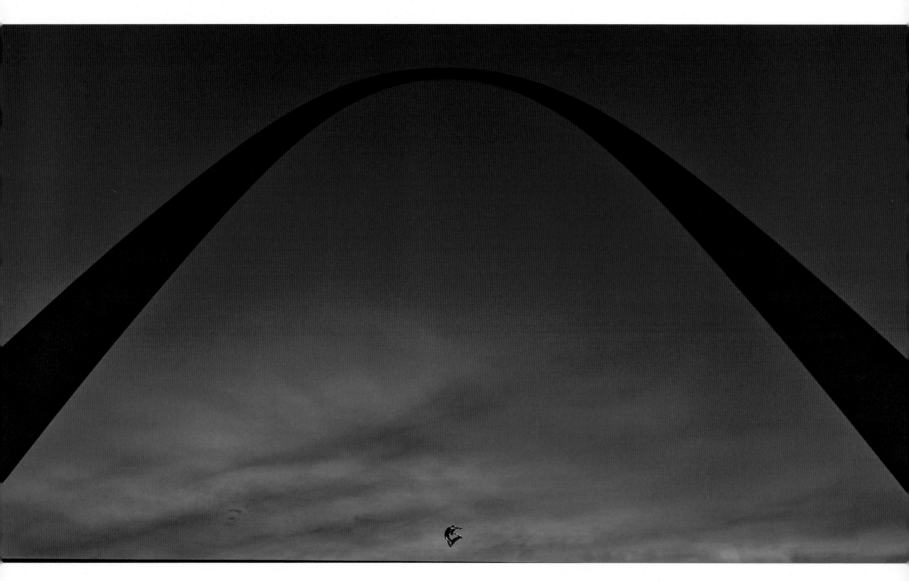

Cora Tyler - Age 12 **The Gateway Arch, Jefferson National Expansion Memorial, MO**

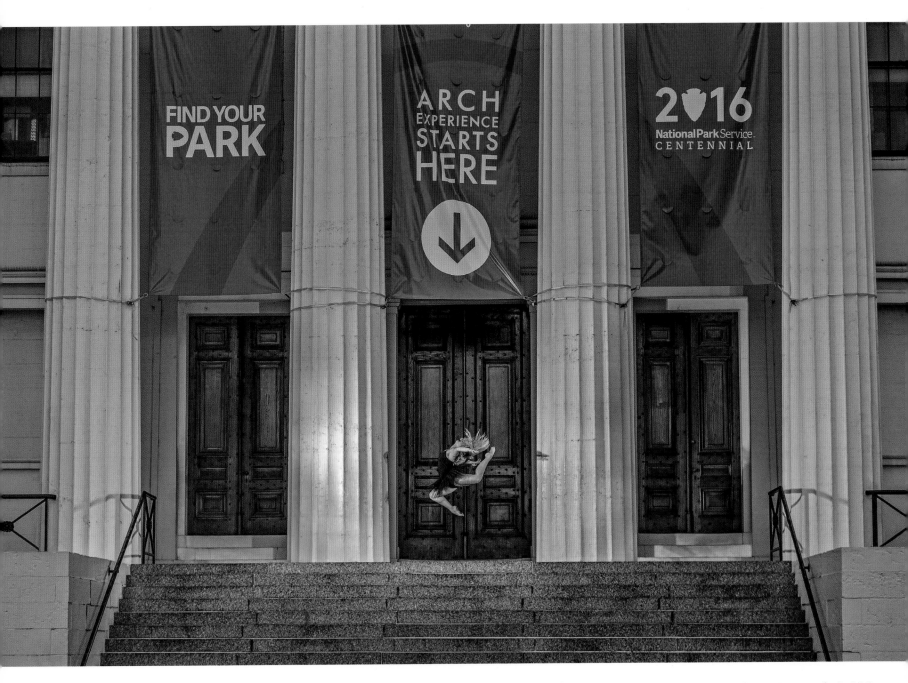

Lexi Lewis - Age 21 **The Old Courthouse, Jefferson National Expansion Memorial, MO**

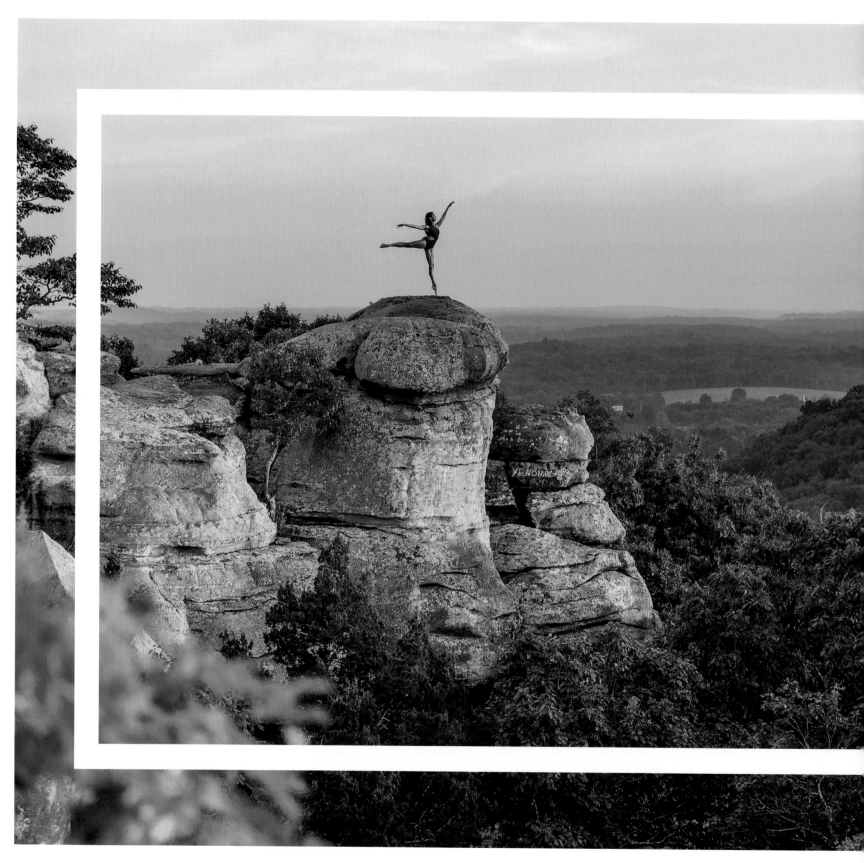

172 Alexandria Franklin - Age 29 **Garden of the Gods, Shawnee National Forest, IL**

ILLINOIS

Shawnee National Forest
DAY 61

LOCATION 32

AUGUST 27, 2016

MILES ON BUFORD: 15357

The second location of our trip called Garden of the Gods, this one is located in Shawnee National Forest in southern Illinois. The rock formations here are quite unusual considering their Midwestern surroundings. They consist of many bluffs, some of which are over 100 feet tall. There are miles of trails for hiking and horses, camping, and much more to do here.

Most of the surrounding land here is what would be considered "second growth forest." Up until the 1930's this was almost entirely agricultural land. During the New Deal years, several acts were passed whose purpose was to eliminate the overproduction of crops, which was leading to the compete collapse of farms by driving down the costs of farmer's products. These acts paid farmers to not use their land, sometimes up to 40% of it. These unused land parcels slowly became woodlands again, and the federal government began to assemble these areas into national forests.

Today, national forests are incredibly important! They cover over 193 million acres of land, and provide recreational areas, habitats for countless plant and animal species, and give us clean air to breathe. Preserving these forests is a global responsibility. This is, after all, the only planet we have, and we need to take care of it. Going to visit these wonderful places will help you appreciate all that they do for us. Get out there and explore!

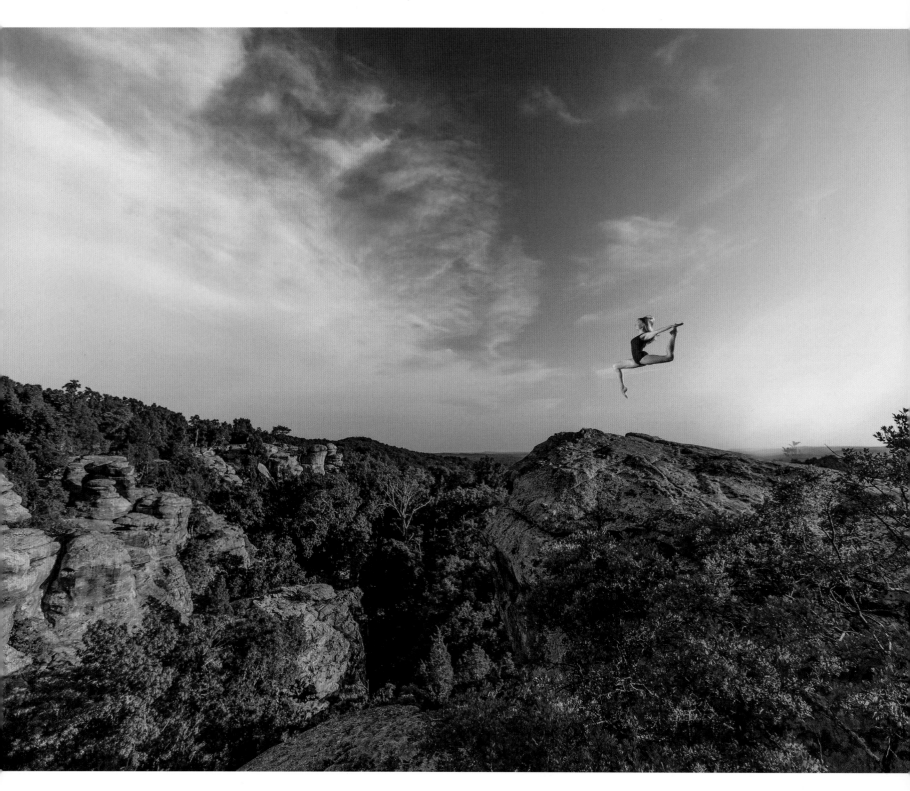

Emily Spiller - Age 13 **Garden of the Gods, Shawnee National Forest, IL**

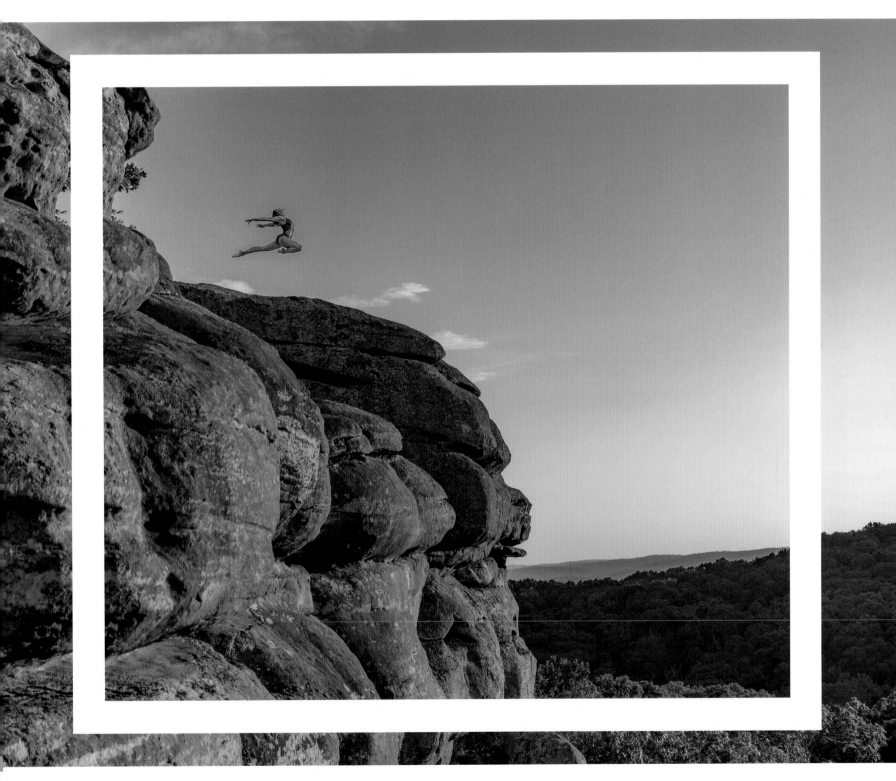

Alexandria Franklin - Age 29 **Garden of the Gods, Shawnee National Forest, IL**

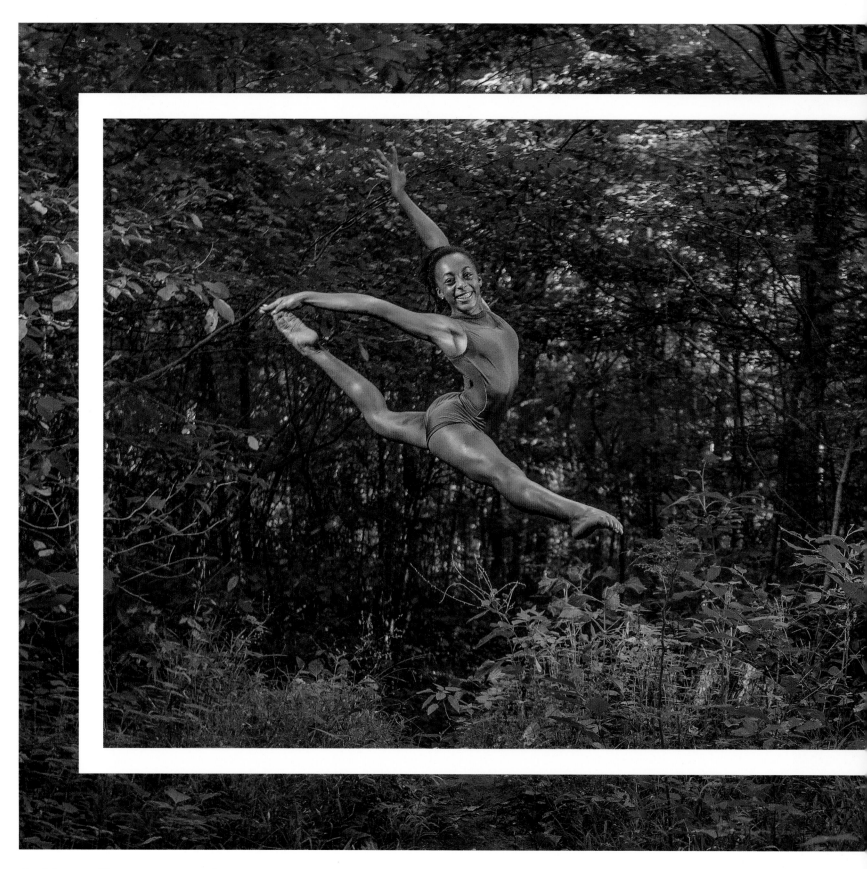

176 Gabby Mullins - Age 13 **Pioneer Mothers Memorial Forest, Hoosier National Forest, IN**

INDIANA

Hoosier National Forest

Day 62

Location 33

August 28, 2016

Miles on Buford: 15602

Old growth forests are rare in the US, with some sources estimating that only 10% of old growth forests remain. In Indiana, that figure is even less. Pioneer Mother's Memorial Forest is one of the last remaining large tracts left - consisting of only 88 acres. Owned by the Cox family since 1816, the forest was protected from destruction until it was sold to a lumber company immediately following the death of Joseph Cox, grandson of the original purchaser. A local uproar soon followed, and the land was successfully purchased back from the lumber company and given to the Forest Service to care for.

Today, this small tract of land is a monument to the massive forests that used to cover much of Indiana. The trail that runs through the forest is quiet and calm, a great place to reconnect with nature and enjoy the peace that can only be found in a great big ol' forest.

This was the first session where I consistently had the pleasure of face fulls of spiderwebs. Not the last, though. It seemed as though it had been a while since anyone had hiked this trail, and the bugs were only too happy to make use of the space. Better me than the dancers, of course, but no fun, for sure.

People often ask "What can I do, I'm just one person?" It was the foresight of just one person that allowed this forest to remain intact for us all to enjoy. Everyone of us can make a difference, so find a way to make yours!

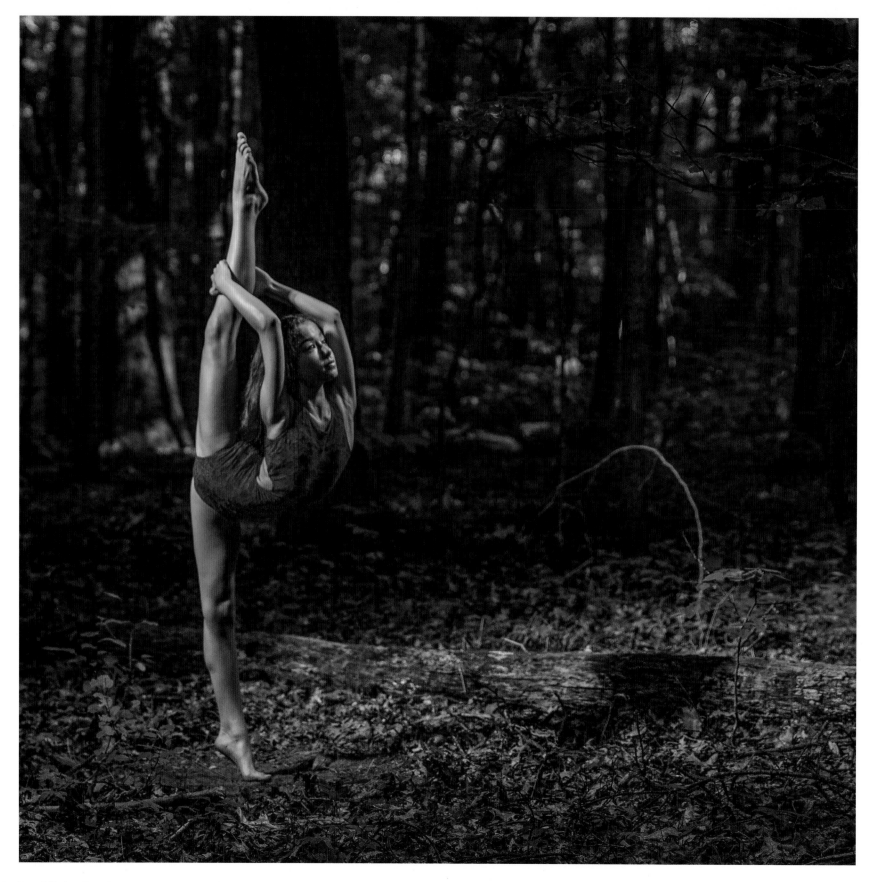

178 Olivia Taylor - Age 11 **Pioneer Mothers Memorial Forest, Hoosier National Forest, IN**

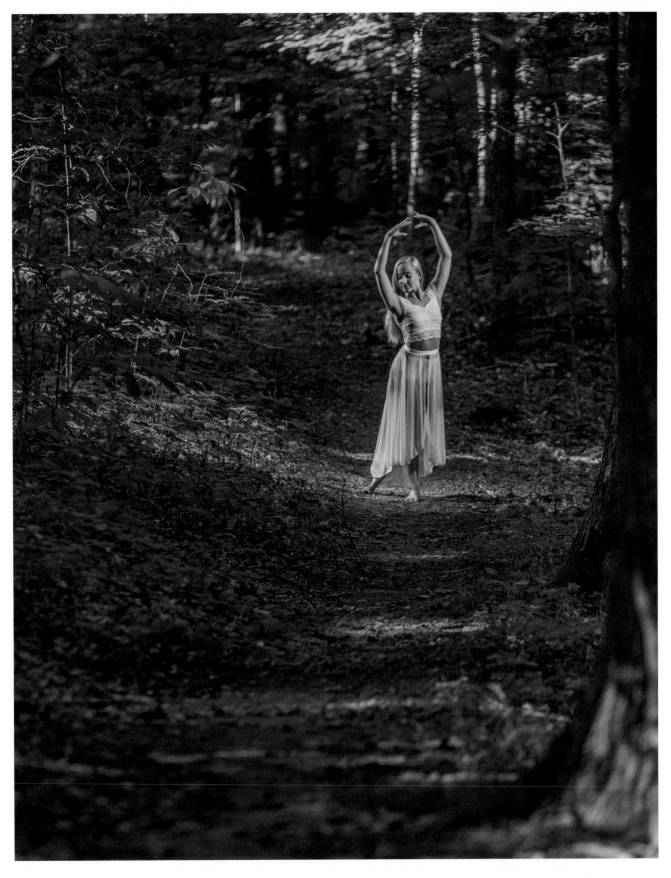

Kerrington Nolte - Age 16 **Pioneer Mothers Memorial Forest, Hoosier National Forest, IN**

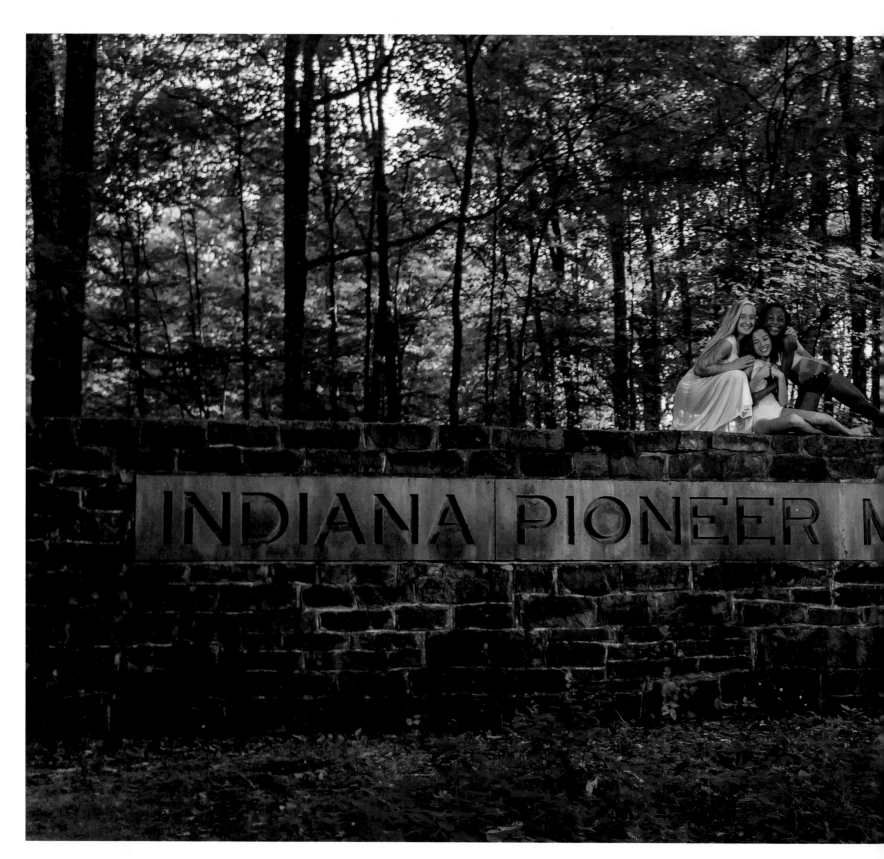

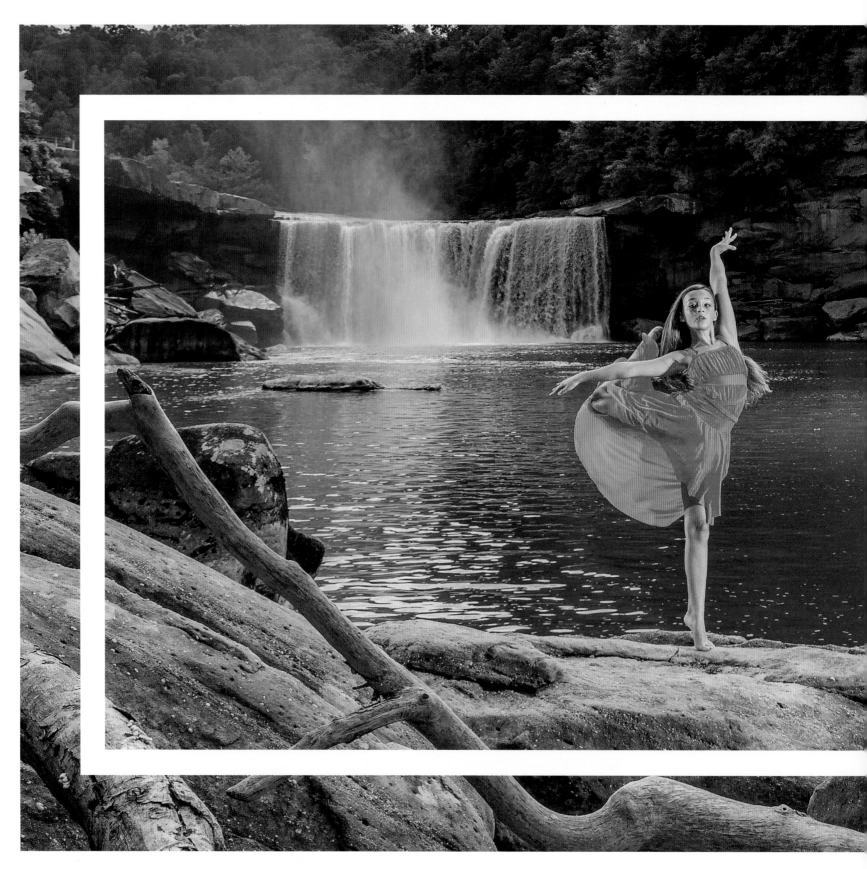

Jennifer Ferguson - Age 11 **Cumberland Falls, Daniel Boone National Forest, KY**

KENTUCKY

Daniel Boone National Forest
Day 63
Location 34
August 29, 2016
Miles on Buford: 15903

Inside of Daniel Boone National Forest is the Niagara of the South, Cumberland Falls. The falls are 125' wide, and stand 68' high. Right smack in the middle of Cumberland Falls State Resort Park, this entire area has been built around providing people access to nature and its activities.

One of the more unusual features of these falls is the phenomenon know as a moonbow. A moonbow is a rainbow that only occurs under the light of a full moon. While that may sound made up, I promise it's real! There are only few places where they regularly occur in the world, and this is one of them.

When we arrived here, the water level was pretty low due to some less than normal rainfall, which gave us fantastic access to the shoreline, and angles of view that would not otherwise be possible! In fact, just a few months later, the area we had been shooting in was under many feet of water. We may or may not have had a dancer or two fall into the water, but fortunately we had prepared for such things. A quick trip to the gift shop after the session for a snack, and we were all right as rain!

Cumberland Falls was another example of a park that really helped us in our project. In addition to thanking them as an organization, I have to specifically thank Roy Johnson, the Resort Park Manager, for taking such great care of us while we were here. Everyone here was so kind and accommodating, which I am sure you will see for yourself should you plan a visit.

Jennifer Ferguson - Age 11 **Cumberland Falls, Daniel Boone National Forest, KY**

Sydney Hall - Age 14 **Cumberland Falls, Daniel Boone National Forest, KY**

Aleyah Lyon - Age 14 **Fall Hollow Waterfall, Natchez Trace Parkway, TN**

TENNESSEE

Natchez Trace Parkway
DAY 64

LOCATION 35

AUGUST 30, 2016

MILES ON BUFORD: 16212

"Once upon a Natchez Trace..." The Broadway musical *The Robber Bridegroom* by Alfred Uhry and Robert Waldman opens with a song about the Natchez Trace, and every time I hear the phrase "Natchez Trace" I have it run through my head.

This is our second visit to the same park, but this time it's in Tennessee! I thought it would be fun to visit both ends of the same park, although I took the long way around. Instead of the 444 miles going from Natchez, MS to Nashville, TN, I drove 14,035 miles to get to end up in the same place.

The Natchez Trace (An All-American Road), originally a trail used by Native Americans for centuries, began to become the Parkway it is today in the 1930's. Construction began in 1939, and was overseen by the National Park Service. This road has a ton of history, but today it is a gorgeous drive as well! Like cruising Route 66, driving the Trace is an event all on its own, and one you should slow down and savor.

Along the route are multiple historic markers and points of interest, including sections of the original trail. For our location, I chose an area with three different waterfalls, just a bit south of Franklin, TN. The trail here at Fall Hollow is largely an "unimproved trail," which basically means choose-your-own-adventure when you try to get to the place you are going. It's slippery, very muddy, but oh so worth the effort!

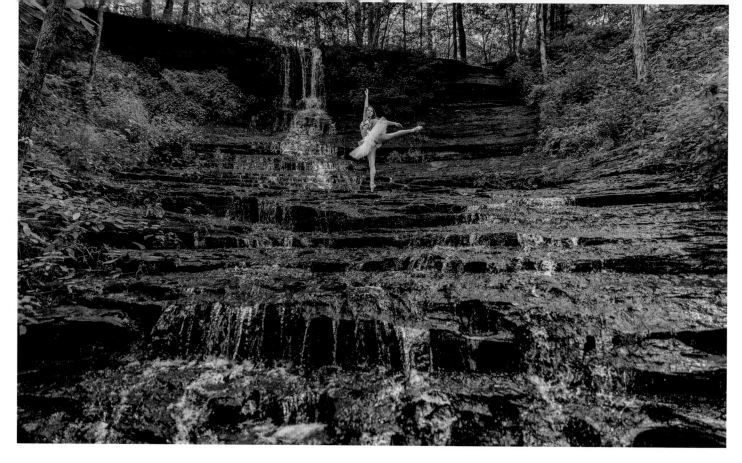

Molly Ann Puckett- Age 16 **Fall Hollow Waterfall, Natchez Trace Parkway, TN**

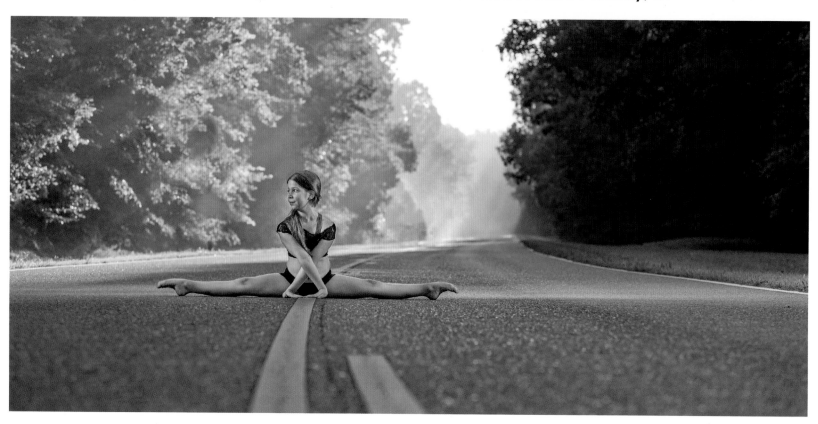

Annalaura Lyon - Age 10 **Natchez Trace Parkway, TN**

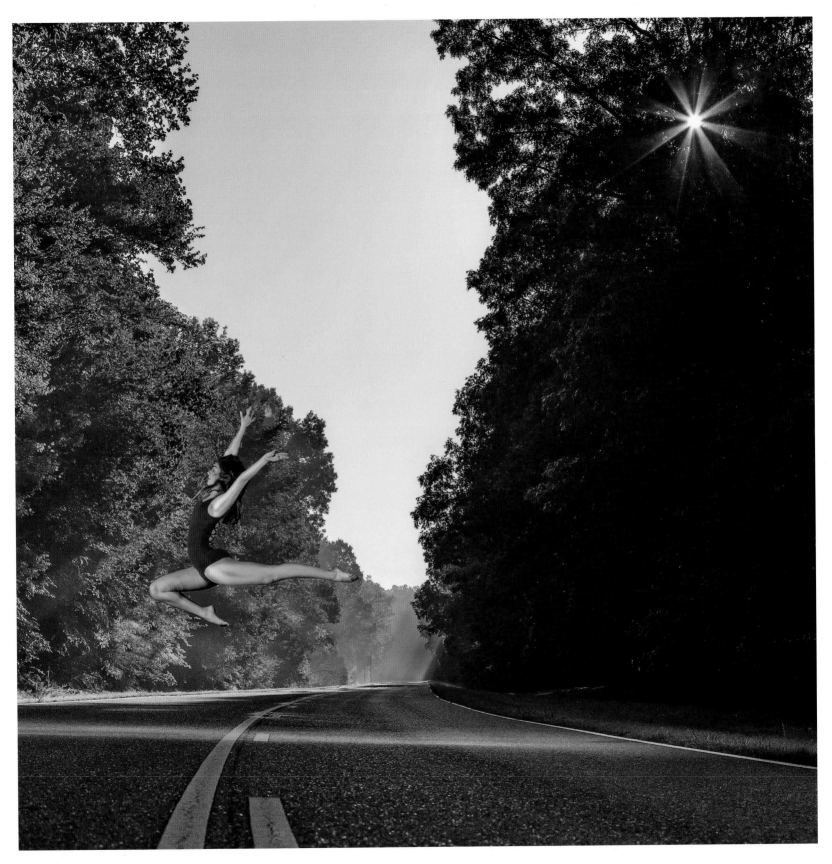

Lily Painter - Age 14 **Natchez Trace Parkway, TN** *189*

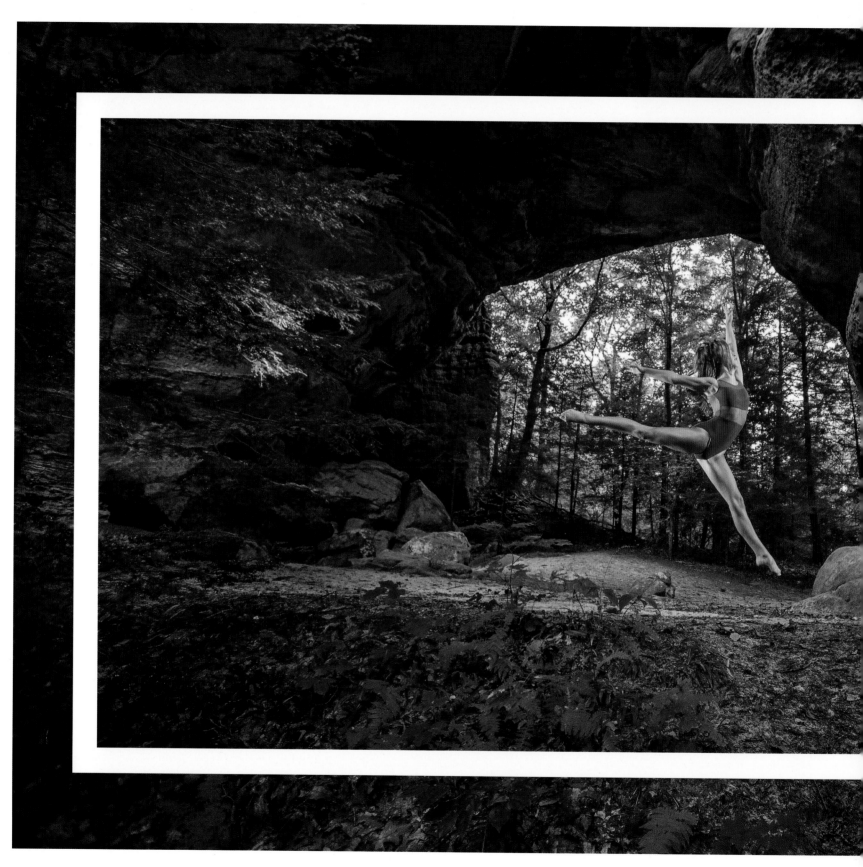

190 Chloe King - Age 13 **Big South Fork National River, TN**

TENNESSEE

Big South Fork National River
Day 65
Location 36
August 31, 2016
Miles on Buford: 16463

Well, this one was a doozy! It started off so well... but we were bound to have something happen somewhere, and this was it.

At this location, like most, I wanted a couple places to work in. We started the day at the Twin Arches - gorgeous, super cool, I really enjoyed it. Once we finished, I decided to go to another trail, Honey Creek. It was not too far away, and it sounded like a nice easy hike that we could knock out in an hour or so. Honey Creek: The words send shivers up my spine even now!

We arrived at Honey Creek at about 6:30 pm, and with sunset due to happen by 8:10pm, I figured we had about two hours for our total trip, including the photos I wanted to create. We found the map, got some photos of it for reference, (generally a very good habit to get into) and headed down the trail. The map said it was about a mile down to the falls, and less on the way back. Little did we know, the sign lied. The sign itself was in the wrong place, by over a quarter of a mile! So following the trail right next to the sign, we ended up being on the new John Muir trail, not the Honey Creek one.

First, the sign lied when it said "You are Here." The sign saying this was nowhere near the actual head of this trail. So while we thought we were headed out onto the trail to Honey Creek and its waterfall / overlook, what we actually got onto was the John Muir Trail. Here is the description I found online of the trail we ACTUALLY went on:

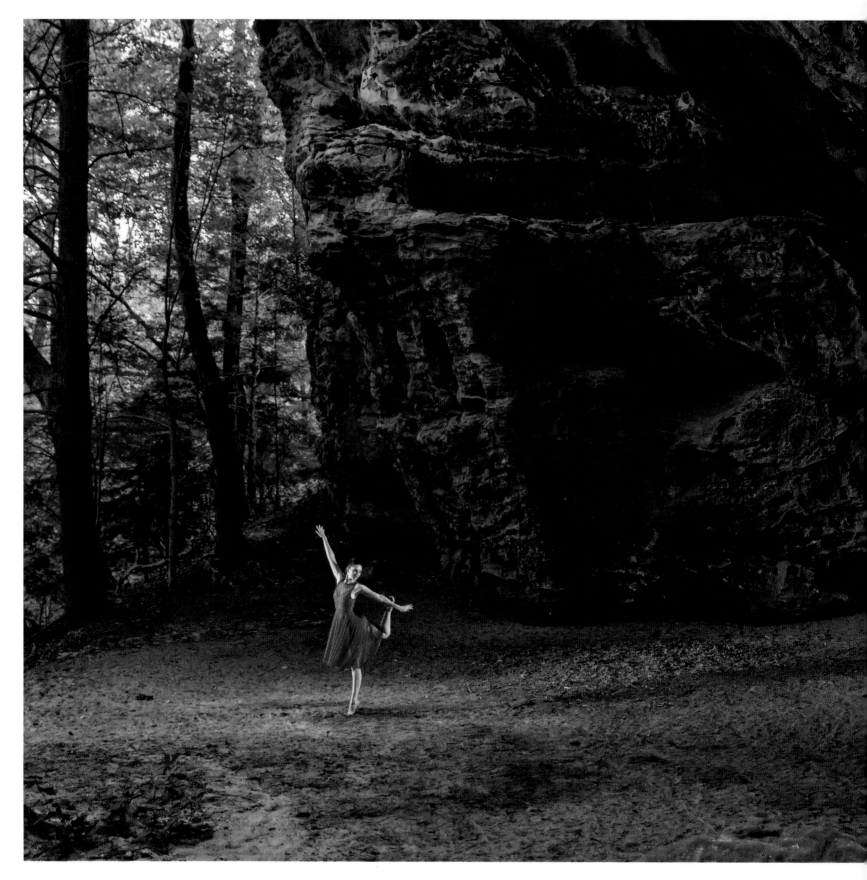

Darbey Rutledge - Age 20 **Big South Fork National River, TN**

For those wishing to escape from mankind and lose (or find) themselves in the wild forests of the Cumberland Plateau, the John Muir Trail—named after one of this country's most famed outdoorsmen—is a great place to "keep close to Nature's heart and break clear away," as he would say.

Hikers should be warned, though, this is not a well-maintained trail like you might find in the Smokies. While some developments have been made to the park in recent years, hikers should still be prepared to ford rivers, camp in imperfect sites, and generally improvise along their way north. We'd also suggest buying a good, topographical map of the area and a guidebook like Hiking the Big South Fork by Deaver, Smith, and Duncan. Permits are required.

Marked by the blue, bearded silhouette of its namesake, the John Muir Trail meanders for 44 miles through Big South Fork and requires about 5 days for most hikers to complete. Sign in at the Brandy Creek Visitors Center before setting out on this long expedition. Starting at the south end, hikers are advised to to park in the relatively well-lit Leatherwood Ford parking lot to avoid theft while on the trail. From Leatherwood Ford, you'll head north to the Angel Falls overlook and continue along the west side of the Cumberland River before following the trail away from the river, across Chestnut Ridge to the John Muir Overlook. Cross the Big South Fork boundary into Pickett State Park and finish at the trailhead for Hidden Passage Trail, where your second car should be parked.

We had no clue what we were in for. As we hiked down to the falls (or so we thought), the "trail" went from a trail to some serious bouldering and rather obscure paths. However, we did follow the trail markers, so we knew (HA!) that we were still on the trail. In about 40 minutes, we got down to a waterfall, which we thought was the falls at Honey Creek. While the area was rugged and gorgeous, it was not much in the way of a waterfall. But we got our images in about 20 minutes, and then headed back out. Instead of retracing our steps, we did what I thought was the straight line return trail in the middle of the maps. This is where the adventure really began.

I did not mention that three dancers all brought someone with them. Hailey brought her mom Rana, Chloe brought her mom Amber, and Darbey brought her boyfriend Chaz, as well as their dog Capone. When I say dog, I mean Mack Truck. This was a nine-month-old American Pitbull Terrier weighing 120 lbs, AND IS STILL GROWING! Such a sweetheart, though, and very well behaved.

We began our hike back, and after the first couple of minutes, we got to what I thought was the "steep ladder" part on the map. It was just a rope with knots tied into it, that you needed to pull yourself up a rock face. So up we went, feeling like we were summiting Mount Everest. We all made it up (the puppy was a rockstar!) and we were off and running.

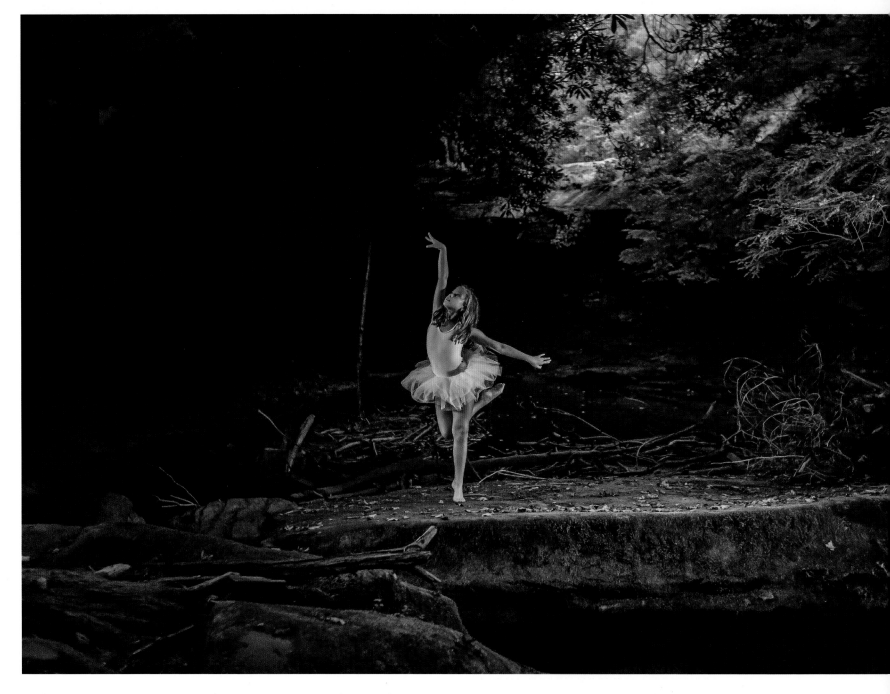

Hailey Hornby - Age 10 **Big South Fork National River, TN**

But the trail kept going, and going, and going. It got rougher. We were sliding through caves, crossing streams, oh, and the bugs! Particularly the spiders. I was leading, and the trail had not been hiked in quite a while, so it was both overgrown and COVERED WITH SPIDER WEBS!!! Which I removed for everyone by using my face. =(

It was now dark, and we should have made it back to the cars, but we pressed on. We were still following the trail markers, so we THOUGHT we were still in the right place, and looking at Google on our phones (no service, but the GPS was tracking still) we were almost at the road. However, the "road" Google showed us was no longer a road, it was now a horse trail. We found a sign, calling out mileages, but nothing was anywhere close to us.

As I stood there, trying to decide our best course of action, I noticed that we suddenly had a flicker of service on the cell phone. Since I was at a loss, I decided it was time to call in the cavalry.

"911 - what is your emergency?"

"Hi, we're hiking, and seem to be lost, although we are still following the trail markers, we have gone much further than we should have needed to. Can you help?"

We chatted with the dispatcher, for about 30 minutes, with her putting us on hold in between radio calls. Most of the local rangers had gone out west, to assist with all the fires, I was told. We finally got a park ranger connected to us, and he told us that to get out, we would still have to hike 1.7 miles out to the O&W Bridge. It's a new trail, not on any map. And, considering the terrain and darkness, it would take us about 90 minutes to complete. And this is nowhere near our cars, so they would meet us there and drive us back around to where we parked.

Now, we did have flashlights. I brought three with me - two epic bright ones, and my headlamp. Thank goodness for that! Darby and Chaz had a couple as well, and everyone had cell phones. So, at 10:15pm, we began our hike out.

Did I mention we were soaked from sweat, tired, and pretty much everything hurt at this point? So with packs full of tutus, dance clothes, and camera gear, we headed out.

Along the way, we ran into snakes, MANY more spiders, but this trail was much nicer. Downhill, and actually a trail, as opposed

to what we had been on. At least, until the last half mile or so. It was then that we lost the trail.

As we hiked, the markers vanished, and the terrain got really rough. Very steep downhills, slippery rocks, streams, there was nothing to indicate we were on a real trail. I was left to guess as to what the trail was supposed to be. But, as it turns out, I guessed right. We had some great teamwork, with Chaz and Darbey taking the lead down with one of my big lights, and I took up the rear, making sure to keep everyone together with no mishaps. We finally saw headlights.

When we got up to the road, there were 10 vehicles from the Scott County Rescue Squad, the park ranger, and the Sheriff as well. We had now hiked a total of 11.52 miles that day. One and a half miles of that was from our first location. But from 6:30pm to 12:15am, we hiked 10 miles of some of the most difficult, brutal, and obscure trails I have even been on in my life. And now had to ride back to Buford. That ride took 26 miles, and almost an hour.

So, in the end, we finally made it back to the vehicles at around 1:15am. Some blisters, sore knees and ankles, but safe, and in good spirits. This was, without a doubt, the hardest photoshoot I have ever attempted.

With the benefit of hindsight, there is one thing I should have done differently, aside from not getting lost in the first place, of course! I have begun to rely too much on technology, and sometimes it doesn't work so well. When hiking in unfamiliar territory, having a paper map backup would be better. Then, if things went pear-shaped, I would have the ability to do some good old fashioned orienteering. Your compass is always going to work, and a paper map can't run out of batteries.

Thank you to the Scott County Rescue Squad, Scott County 911 dispatch, Ranger Gary (never got his last name) and the Scott County Sheriff's Department for helping us out. Thank you T-Mobile for actually working when I needed you most. And thank you to my intrepid team, the DATUSA dancers for Big South Fork. You are THE most extreme people, and you made it through a very difficult situation with grace and composure.

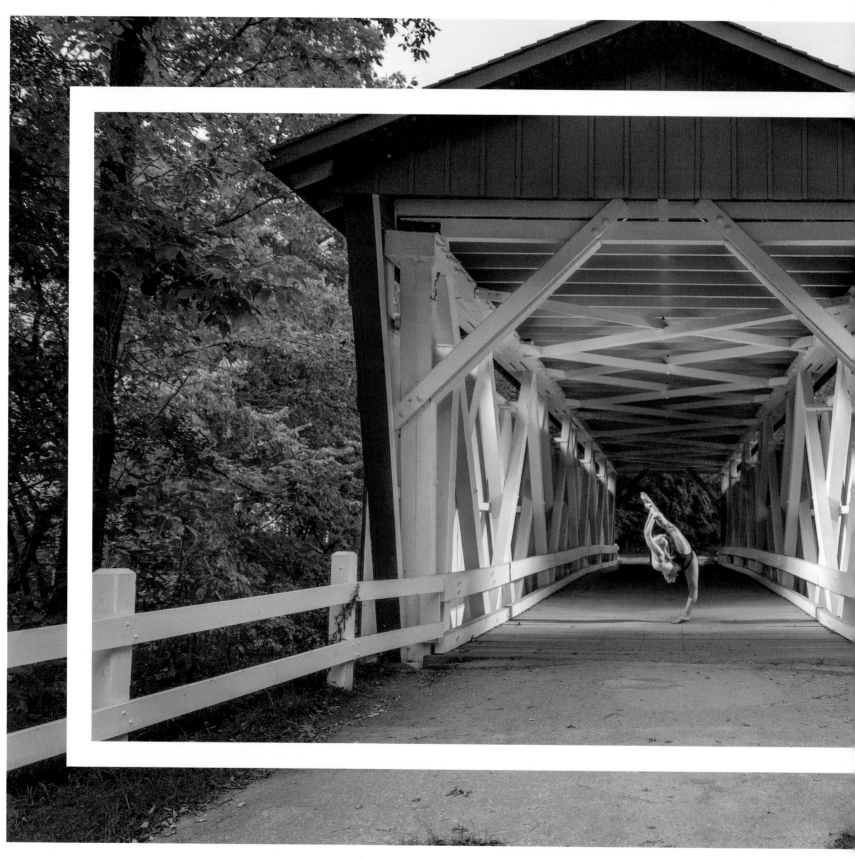

196 Tara Johnson - Age 15 **Cuyahoga Valley National Park, OH**

OHIO

Cuyahoga Valley National Park
Day 67
Location 37
September 2, 2016
Miles on Buford: 16967

Cuyahoga Valley National Park is a bit different than other parks, in that it is an eclectic mix of features, including towns, quiet byways, forests, a railroad, golf courses, performance spaces, and much more! Beginning as a National Recreational Area, it has morphed over time to include more and more.

Two of the features I wanted to focus on were the beautiful waterfalls, and the famous Everett Covered Bridge. To be as efficient as possible, I had to be selective about where I was going to shoot. Bear in mind, I had no chance to scout out these locations before hand. I was literally showing up at a predetermined time, someplace I had decided to go to weeks before, where I needed to instantly create photos. It's all about snap judgments, and just trusting that things are going to work out. And if / when it doesn't, you quickly change tactics, and do something else.

Cuyahoga Valley National Park is a lot like the Cheesecake Factory. You've been there before, right? You open the menu, and there are twenty million things to choose from, and you can't decide where to start. Yeah, it's like that. Do you hike the Buckeye Trail? Follow the Ohio and Erie Canal Towpath? Bike around Hampton Hills Metro Park? Maybe go swimming in Water Works Park, or watch a production of Romeo and Juliet at the Porthouse Theater. There are tremendous options here, and quite literally something for everyone. Kind of like Ohio itself. Ohio is cool. Lots of cool people come from Ohio - Thomas Edison, Steven Spielberg, Paul Newman, Annie Oakley, and Julie Cross.

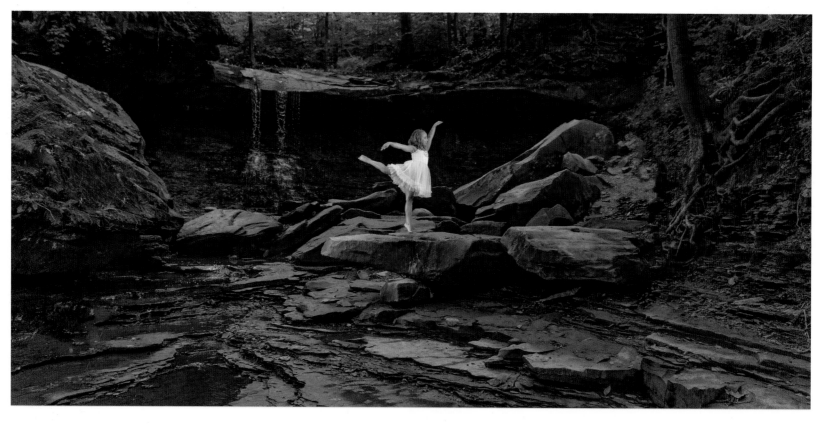

Allison Payton - Age 8 **Cuyahoga Valley National Park, OH**

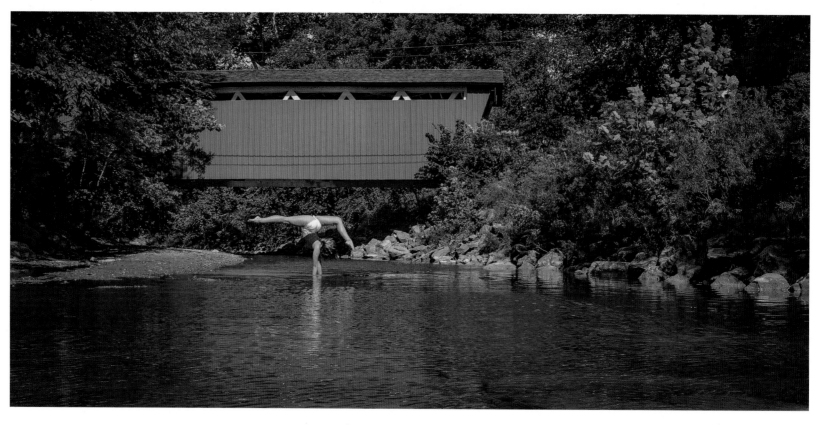

Mary Dent - Age 14 **Cuyahoga Valley National Park, OH**

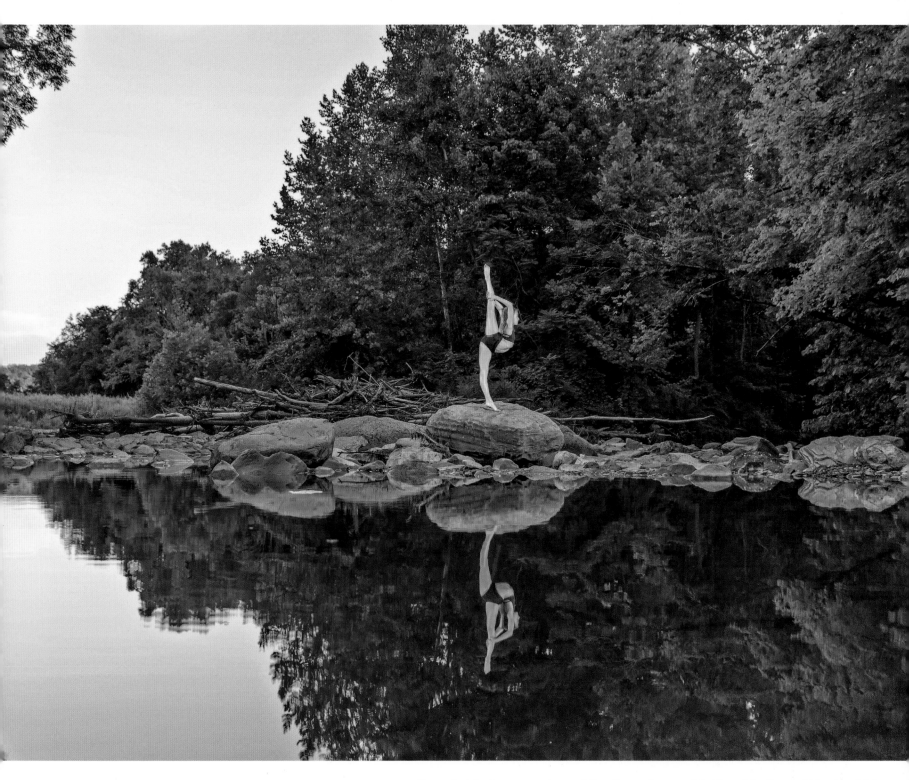

Sarah Maloney - Age 13 **Cuyahoga Valley National Park, OH**

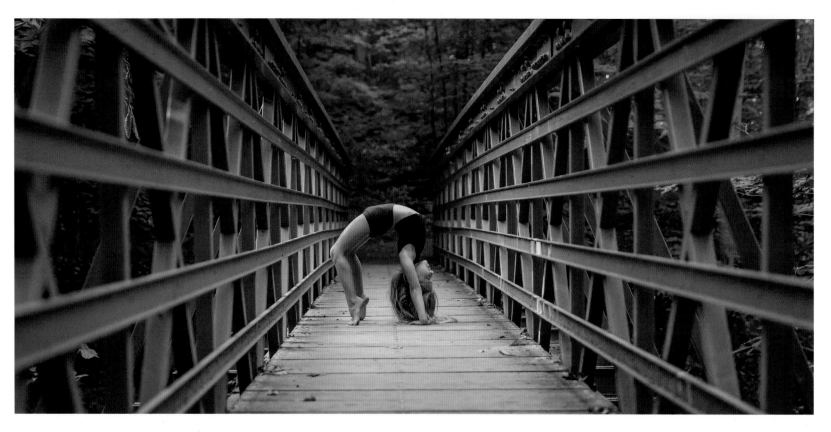

Audrina Reese - Age 8 **Cuyahoga Valley National Park, OH**

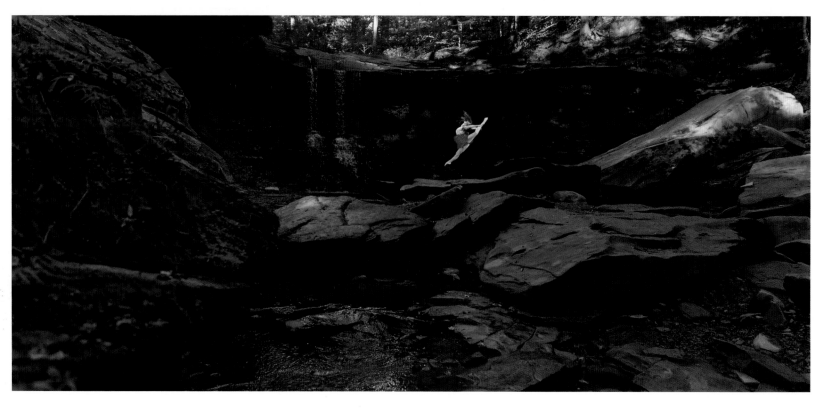

Chloe Stevens - Age 15 **Cuyahoga Valley National Park, OH**

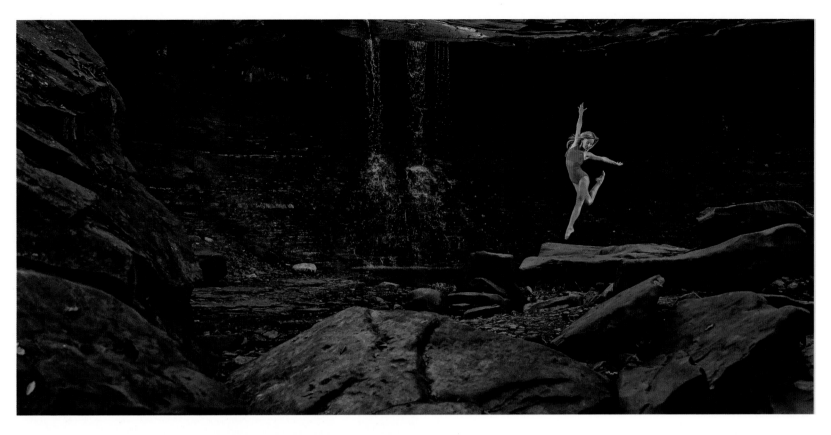

Kiera Reese - Age 12 **Cuyahoga Valley National Park, OH**

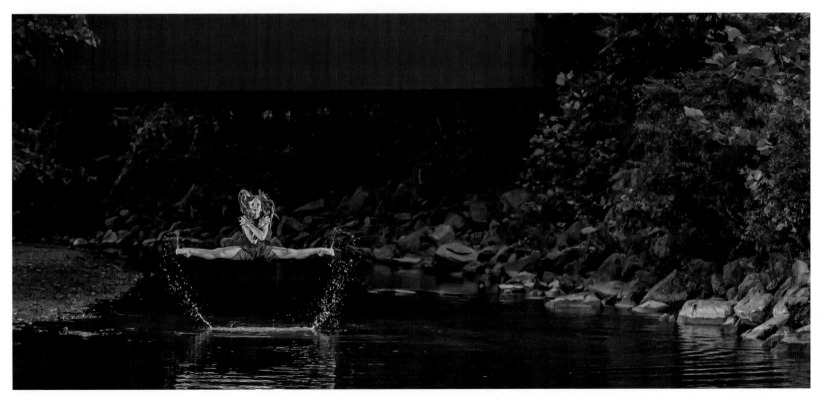

Saylor Kaufman - Age 12 **Cuyahoga Valley National Park, OH (This was her birthday, so HAPPY BIRTHDAY!!!)**

VERMONT

Marsh-Billings-Rockefeller National Historical Park

Day 69

Location 38

September 4, 2016

Miles on Buford: 17662

Way up in the northeast, and it feels like fall up here already! Our location is called Marsh-Billings-Rockefeller National Historical Park. Charles Marsh built the house in 1805, which was then purchased by Frederick Billings, who modified the house into what you see today. He also created an ideally arranged farm, which is still there today. Lastly the property was bought by the Rockefellers, specifically Laurance and Mary French Rockefeller (Mary was the granddaughter of Frederick Billings). They gifted the house and property to the people of the US in 1992, and then the park was created.

The land around the home is full of beautiful trees, as is the whole of Vermont. Did you know that by the late 1800s, 80 percent of the woods in Vermont had been cleared by settlers? The forest has come back, reclaiming abandoned farms and pastures, to where today 80 percent of Vermont is forest again. Our ranger told us how, although the trees in the park are not technically part of an old growth forest, it has recovered to the level where the effects of human disturbance is no longer evident. People in this part of the world have really found a way to co-exist in close proximity to nature.

Another wonderful gift our ranger gave us here was that he cherry picked our locations for us, bringing us to one of his favorite places, which was where I got to enjoy my absolute favorite sunrise of the entire project. I actually wept, it was so beautiful here! Like real, full-on crying. It was gorgeous, simply gorgeous.

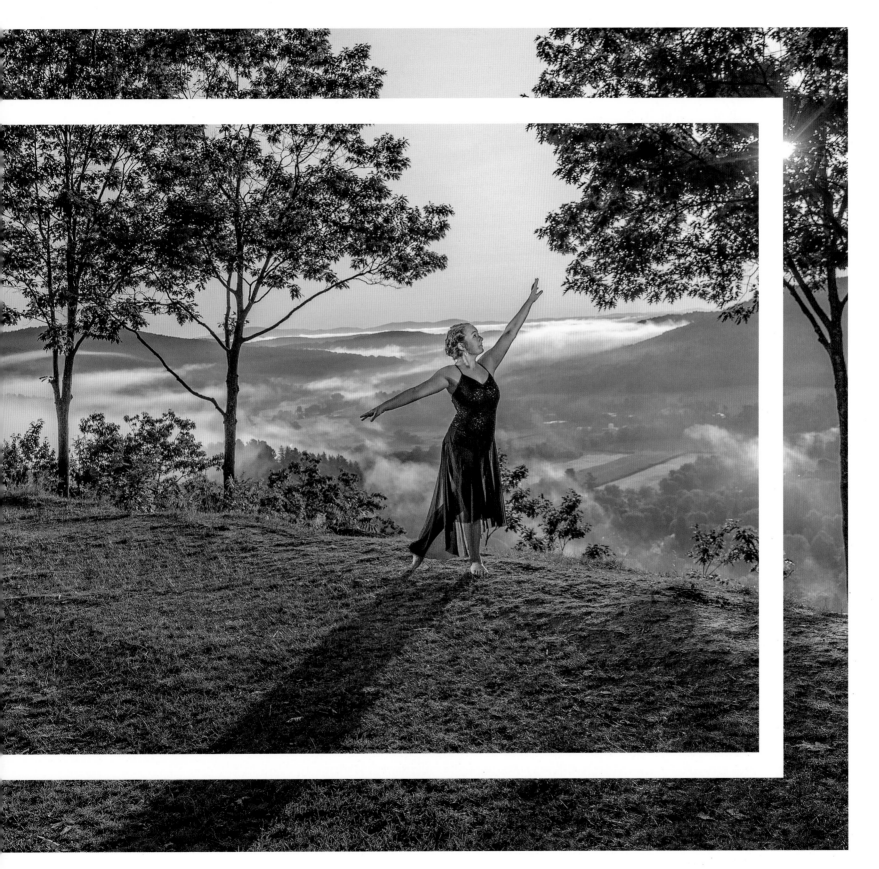

Breanna Friedrich - Age 15 **Marsh-Billings-Rockefeller National Historical Park, VT** 203

Breanna Friedrich - Age 15 **Marsh-Billings-Rockefeller National Historical Park, VT**

Breanna Friedrich - Age 15 **Marsh-Billings-Rockefeller National Historical Park, VT**

NEW HAMPSHIRE

White Mountain National Forest

DAY 70

LOCATION 39

SEPTEMBER 5, 2016

MILES ON BUFORD: 17822

Remember how I said in Tennessee that had been the hardest photoshoot of my life? Enter Franconia Ridge. Yeah, this was harder. So much, much harder.

I was a Boy Scout. I was a long distance runner. I was a dancer. The key word here is WAS. In my head, I can still do everything I used to be able to do. As I get older, I find people think that. So, reading about how this was a strenuous hike, I thought, "I got this."

We met at 3:30am. I wanted to reach the top by sunrise. With headlamps and a pack full of gear, we headed out. Having just gone through the "Great Big South Fork Debacle of 2016", I thought nothing could be any harder, and it was smooth sailing to the end. The first quarter mile of this hike was simple, easy, and exciting. Then we got to the real trail. When I say it went up, we were no longer walking. It was climbing. Bouldering would be a good description. Up waterfalls, like, actually climbing up through a waterfall. The dancers were blasting ahead, having a great time. Me? Not so much.

We made it to the top just after sunrise, got our shots, and then crossed the ridgeline taking more images to where the trail went down again. This portion of the trail is part of the famed Appalachian Trail, a 2000 mile trail stretching from Maine down to Georgia. We were literally on top of the world, with planes flying UNDER us! By now, my legs were done, knees trashed, body wiped, but we had to continue. On the way down, under the weight of my 80 pound pack, my knees started to give out. I finally told the dancers to go on ahead, so as not to make them wait for the old man dying in the back. My body wanted to die. Everything, literally everything, hurt. It was sheer force of will that allowed me to finish.

When they say this hike is hard, do me a favor: BELIEVE IT!!!

Kyle Tanguay - Age 18 **Franconia Ridge, White Mountain National Forest, NH** 207

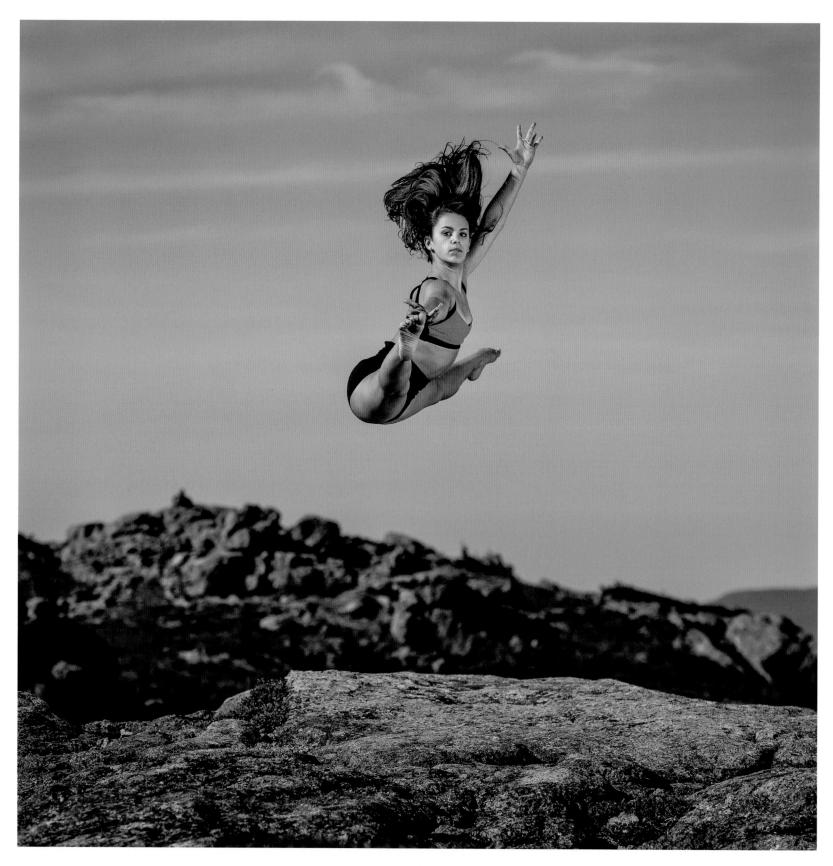

Jenna Connors - Age 14 **Franconia Ridge, White Mountain National Forest, NH**

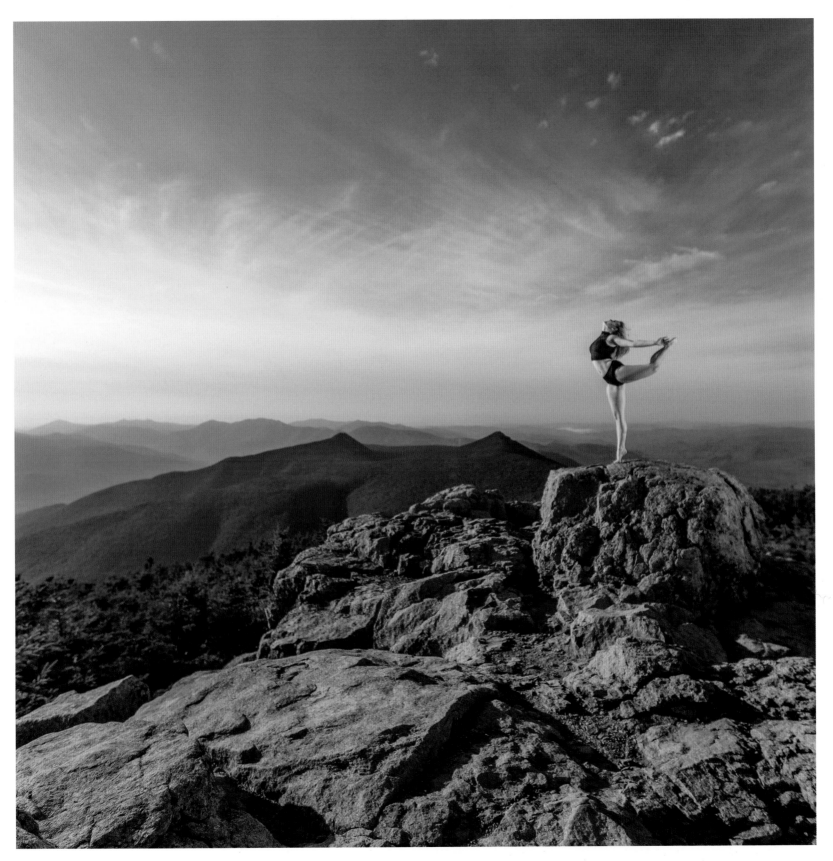

Rachel White - Age 21 **Franconia Ridge, White Mountain National Forest, NH** 209

He found himself over a long and treacherous road, and the more treacherous the road became, the more of himself he found. - Kyle Tanguay

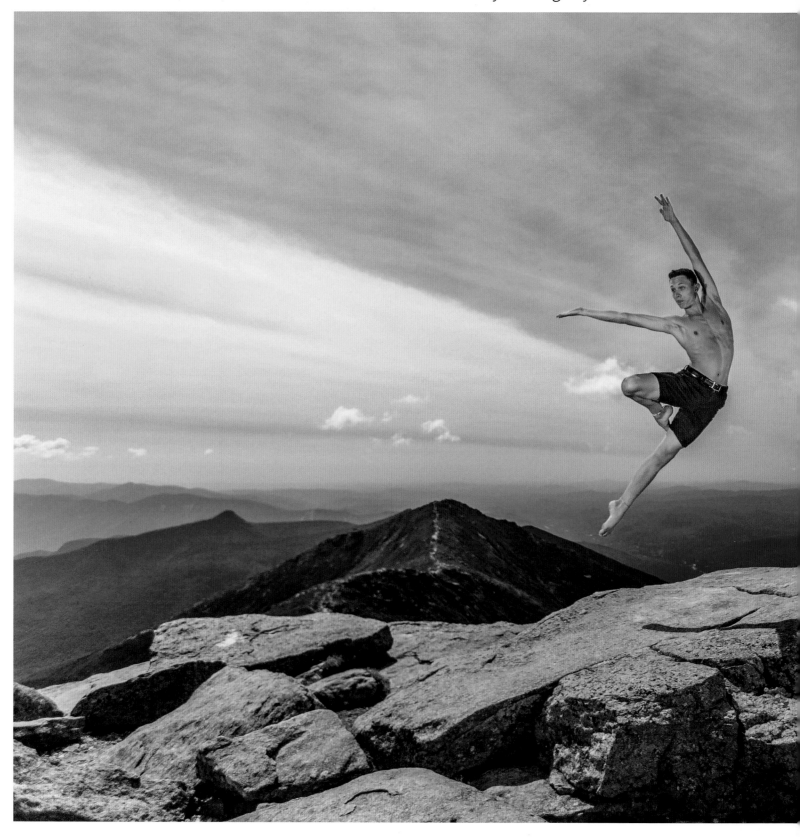

Kyle Tanguay - Age 18 **Franconia Ridge, White Mountain National Forest, NH**

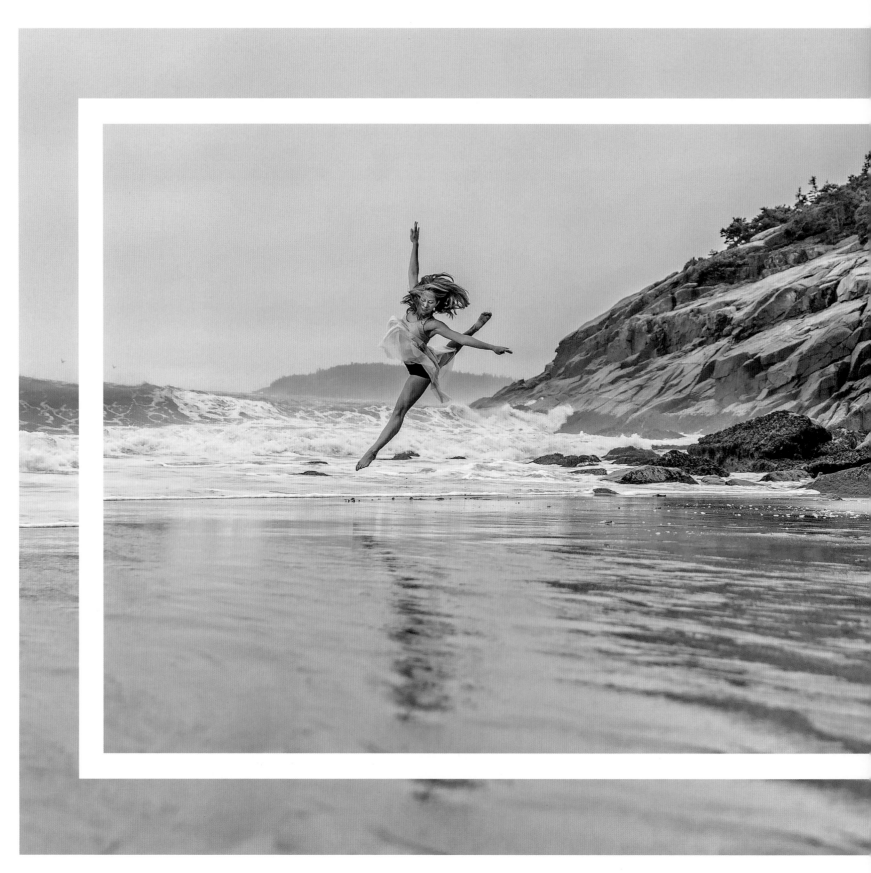

Hope LeClair - Age 15 **Acadia National Park, ME**

MAINE

Acadia National Park

DAY 71

LOCATION 40

SEPTEMBER 6, 2016

MILES ON BUFORD: 18144

This location found us in the top right-hand corner of the country! Our starting location here was Cadillac Mountain, where it is said (and debated) the sun first touches the 50 states. We got here early, meeting our ranger for before sunrise. There was just one problem - you couldn't see 10 feet in front of you! The mountaintop was completely encased in clouds, so there was no sunrise, no gorgeous sweeping horizon, just gray. Gray, gray, with a side of gray, and gray dipping sauce. Crap.

Our ranger to the rescue! As the man who authorized the permit in the first place, he could then authorize changes on the fly. So on his recommendation, we headed down the mountain to the coast. His idea was spot-on, and we came to Sand Beach, ready for attempt number two!

Here again is yet another reason why you get permits and work with the location when you do a photoshoot; because if something goes wrong, they can help you overcome the obstacle! It's GOOD to follow the rules.

When we got out on the sand, was a lovely morning, just a little cool, with great waves. It all combined into a perfect day, and the start of our homeward run. From here on out, I was heading back south, back towards my wife and puppies. 19 days to go, but still 16 locations left to shoot. As you might imagine, I was pretty tired at this point! With over 18,000 miles behind me, Buford and I had been through a lot. So, Acadia complete, we headed south to park the car in Harvard yard.

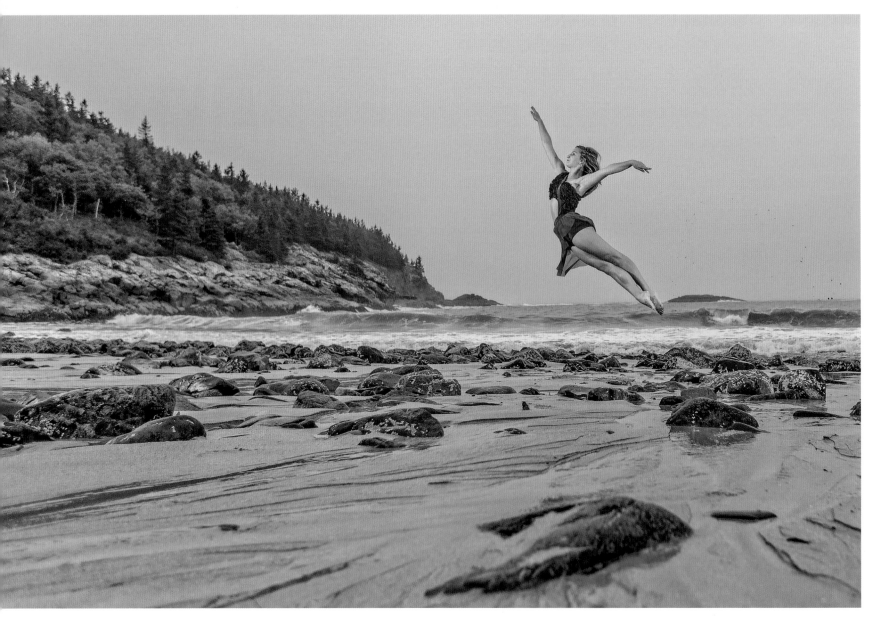

Emily Thompson - Age 15 **Acadia National Park, ME**

Sunrise on Cadillac Mountain with Emily Thompson.
Too much fog, not so much to see, here!

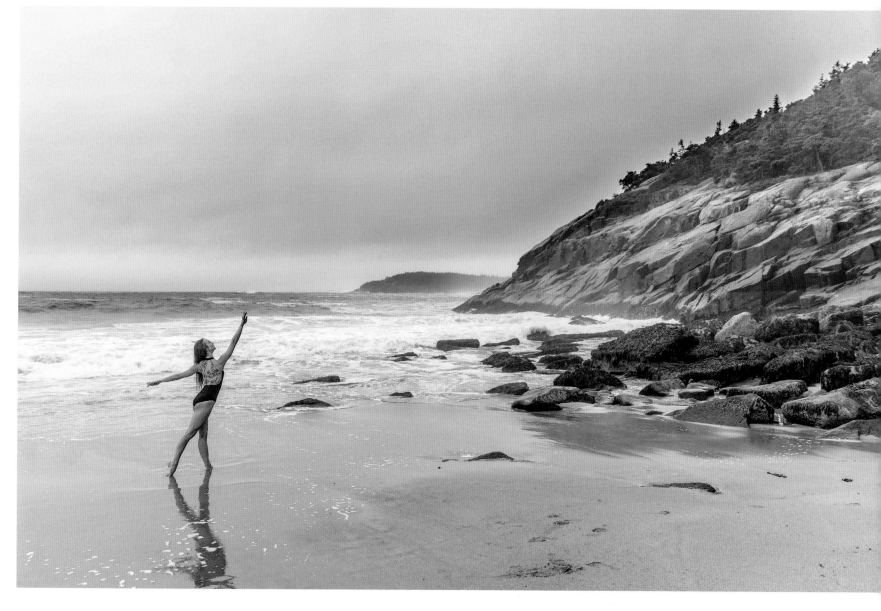

Ciara Harriman - Age 15 **Acadia National Park, ME**

Ciara's kitten that she brought to the session.

MASSACHUSETTS

Boston Harbor Islands National and State Park

DAY 72

LOCATION 41

SEPTEMBER 7, 2016

MILES ON BUFORD: 18527

"I'm shipping off to Boston... to find my wooden leg." Props to Woodie Guthrie and the Dropkick Murphys for that song! Even without trying, I altered my music to be relatively location-centric. I have a very eclectic music collection, and coupled with Apple Music, I have access to a ton of stuff. As you can imagine, I listened to a lot of music on this trip! Well, music and NPR. Since I was headed down to Boston, I popped on some Click and Clack and some Boston Pops. Then some Harry Carney, Aerosmith and the Mighty Mighty Bosstones to round it out. Have you heard Harry Carney's version of *It Had to be You?* Love it!

Our location was meant to be Fort Warren, in the middle of Boston Harbor, but Mother Nature had other ideas, and the bay was too choppy to make the trip. Yet again, we had to switch to our backup location. Still part of the same park of course, but this one didn't require use of a boat! We had made the arrangements in advance with the park administration to allow this change just in case. The whole "plan for the worst, and hope for the best" thing. That is always a good way of looking at things. While you can make plans, something is always bound to come up, and you have to be prepared for that, at least you should if you want to be successful.

Named after former Weymouth police captain William K. Webb, this park had previously been the site of underground NIKE missile silos, and is now a place of quiet solitude. With access to the harbor, and views of Grape Island and Slate Island, it served us well! Today was a double location day, so the instant we finished I was back in Buford headed down to little Rhodie.

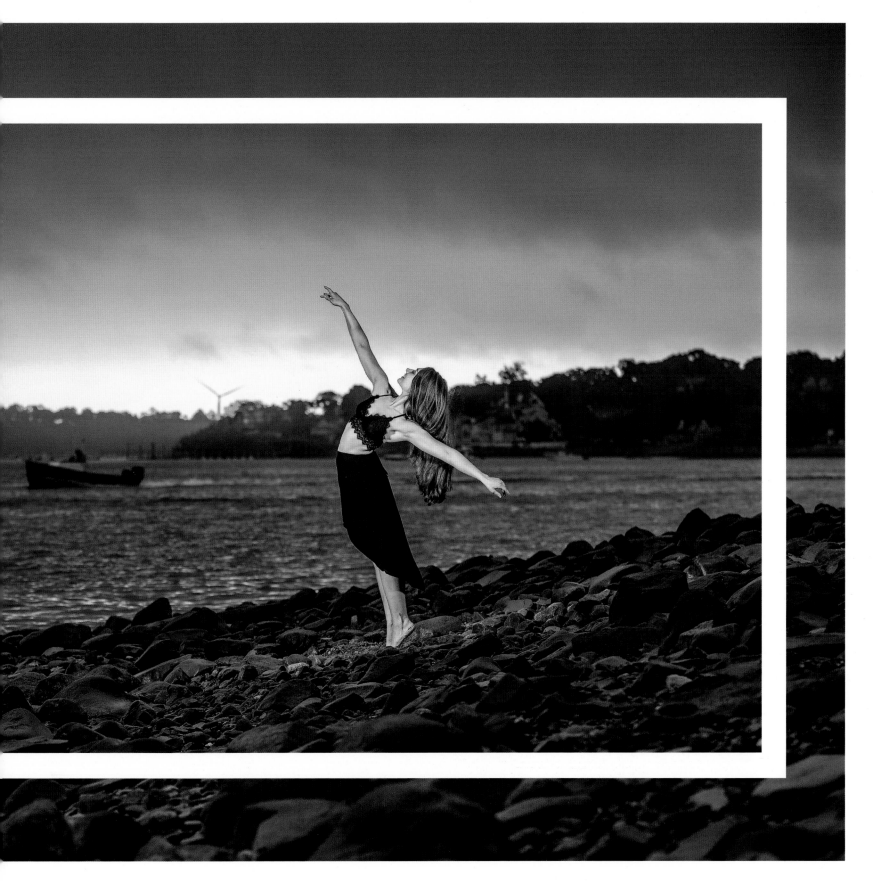

Kaitlyn Webber - Age 24 **Webb Memorial, Boston Harbor Islands National and State Park, MA** *217*

Kira Marderosian - Age 13 **Boston Harbor Islands National and State Park, MA**

Mary Scott - Age 14 **Boston Harbor Islands National and State Park, MA**

Grace Luiso - Age 12 **Boston Harbor Islands National and State Park, MA**

RHODE ISLAND

Brenton Point State Park
DAY 72
LOCATION 42
SEPTEMBER 7, 2016
MILES ON BUFORD: 18847

"And you, you come from Rhode Island, and little old Rhode Island is famous for you!"

I will forever equate Rhode Island with my buddy Jerome. His family owned a restaurant in Narragansett (Galilee) on Point Judith called The Sunflower, home of the greatest lobster bisque on the planet! The Sunflower has closed, but the memory of that lobster bisque remains. So hungry... must... have... lobster bisque...

Remember that storm that kept us from going out in the harbor in Boston? This location was still the same day, but now that storm was my best friend for what it was doing to the water here! We began in the afternoon while the rain and the ocean spray kept us completely soaked, but after about an hour, it vanished! The sun came out, the wind died down, and we were treated to an exceptional evening.

Brenton Point State Park was once part of one of the most grand estates along Ocean Drive. Ocean Drive is listed by the National Park Service on the National Register of Historic Places. This district is renowned for its architecture and distinctive landscape, and the park here offers a wide variety of activities. Which, apparently, include dance photography opportunities! =)

One bit of advice, if you are going to attempt a session on the rocks like I did: Make sure your shoes don't float away. Just saying.

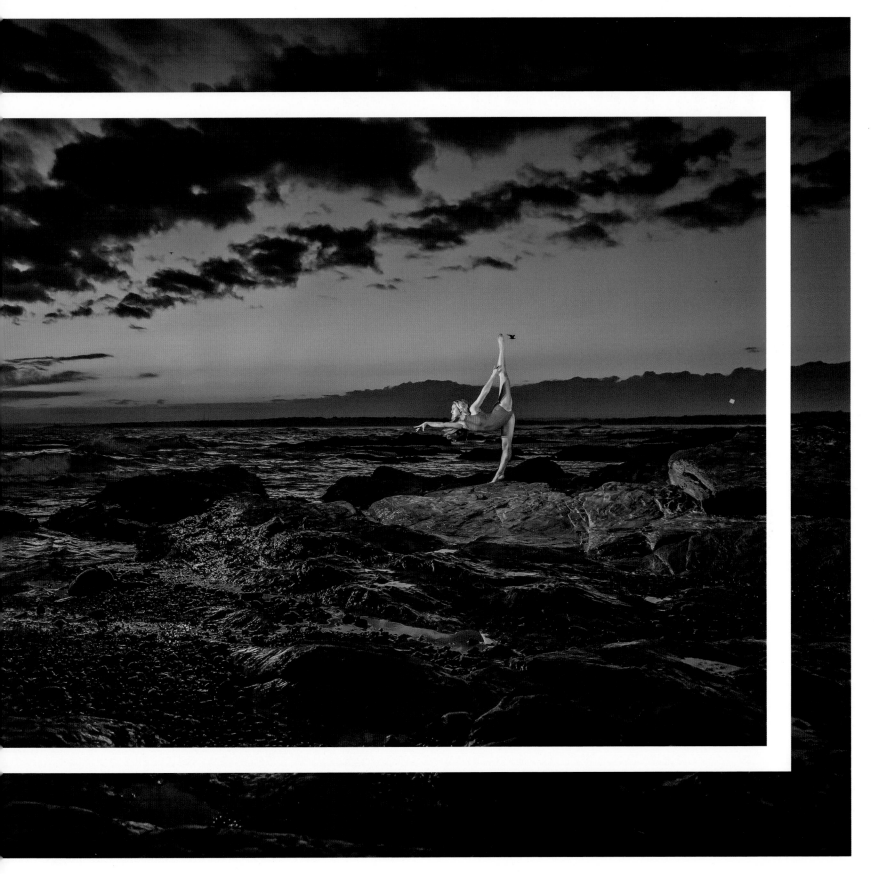

Sari Thaler - Age 16 **Brenton Point State Park, RI** 221

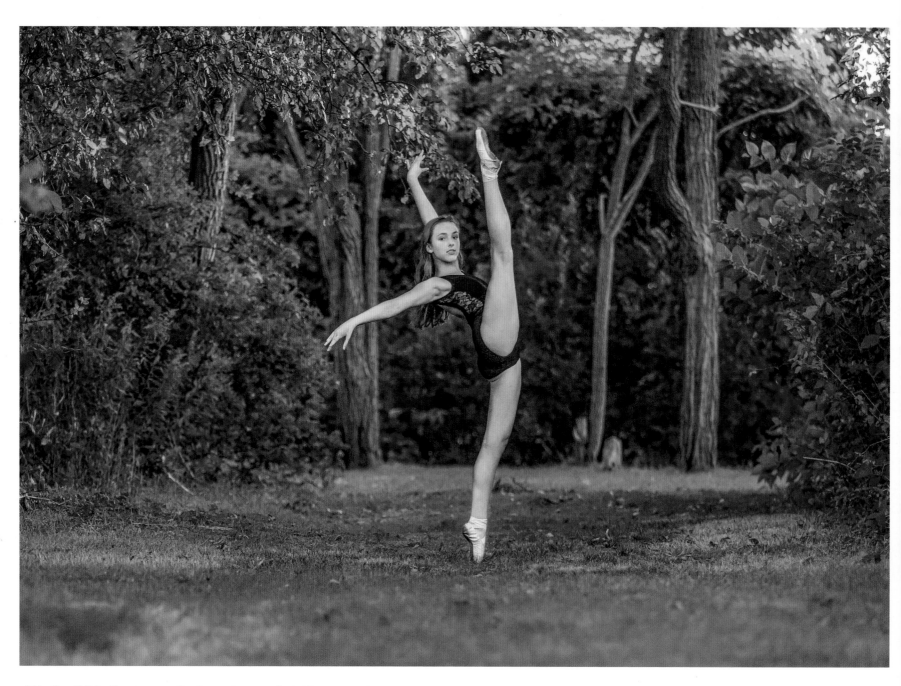

Trinity O'Neill - Age 13 **Brenton Point State Park, RI**

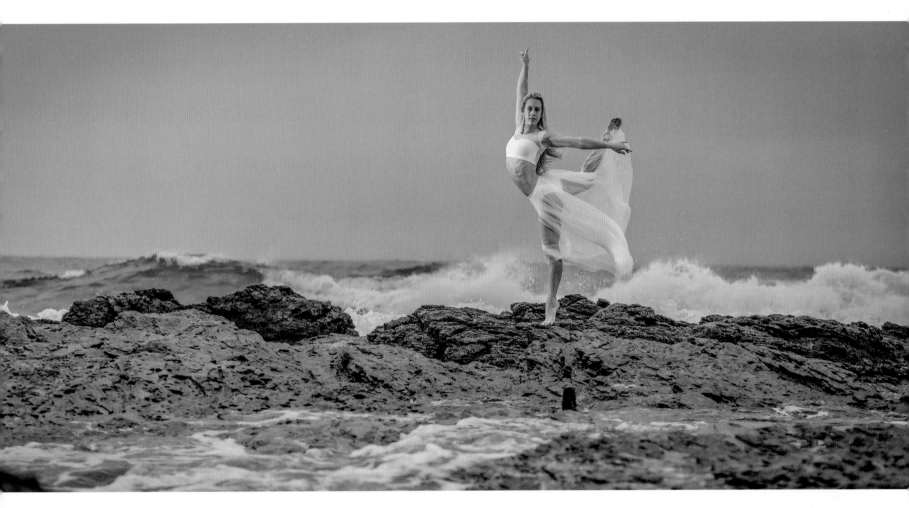

Sari Thaler - Age 16 **Brenton Point State Park, RI**

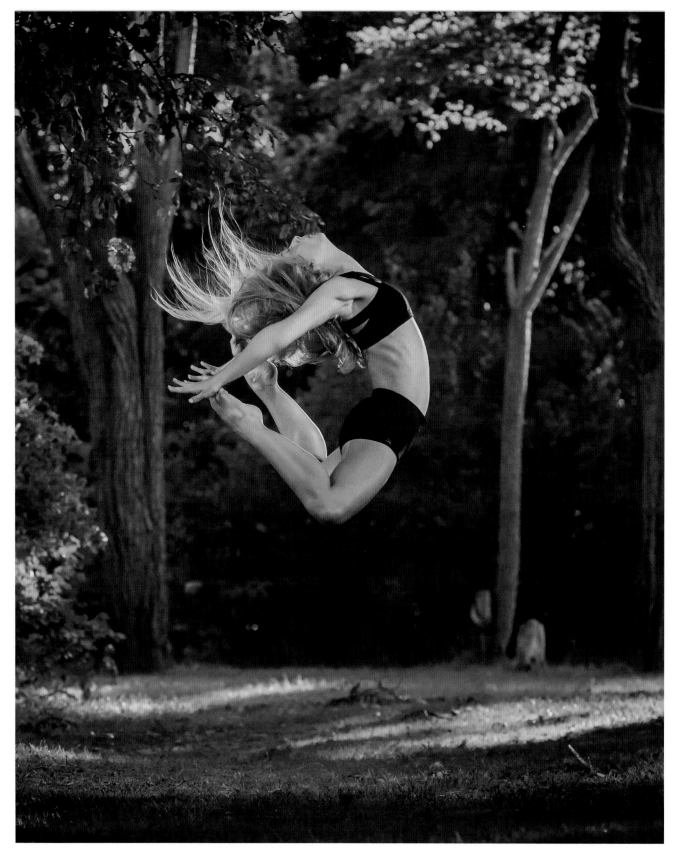

224 Ashley Cromack - Age 15 **Brenton Point State Park, RI**

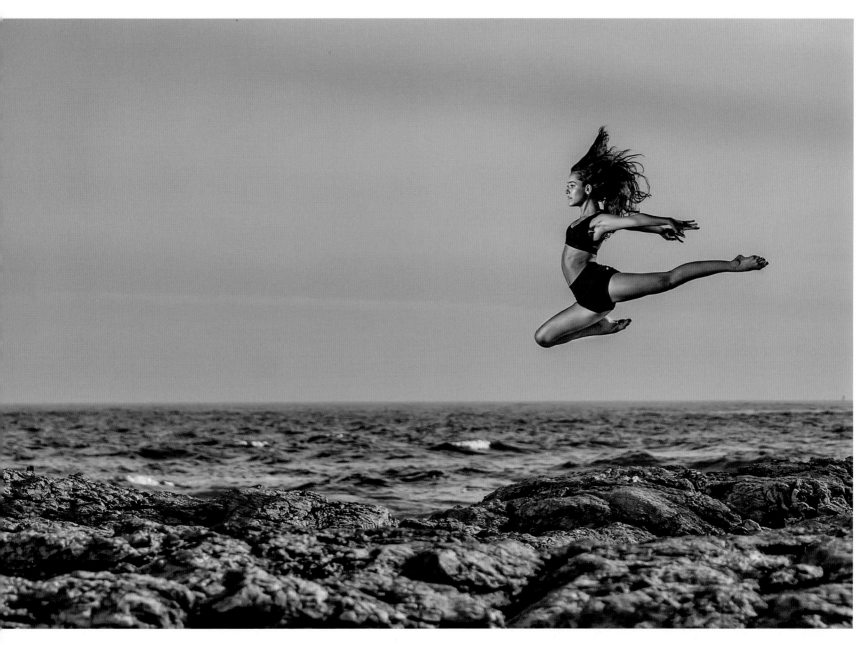

Gabrielle Santos - Age 14 **Brenton Point State Park, RI**

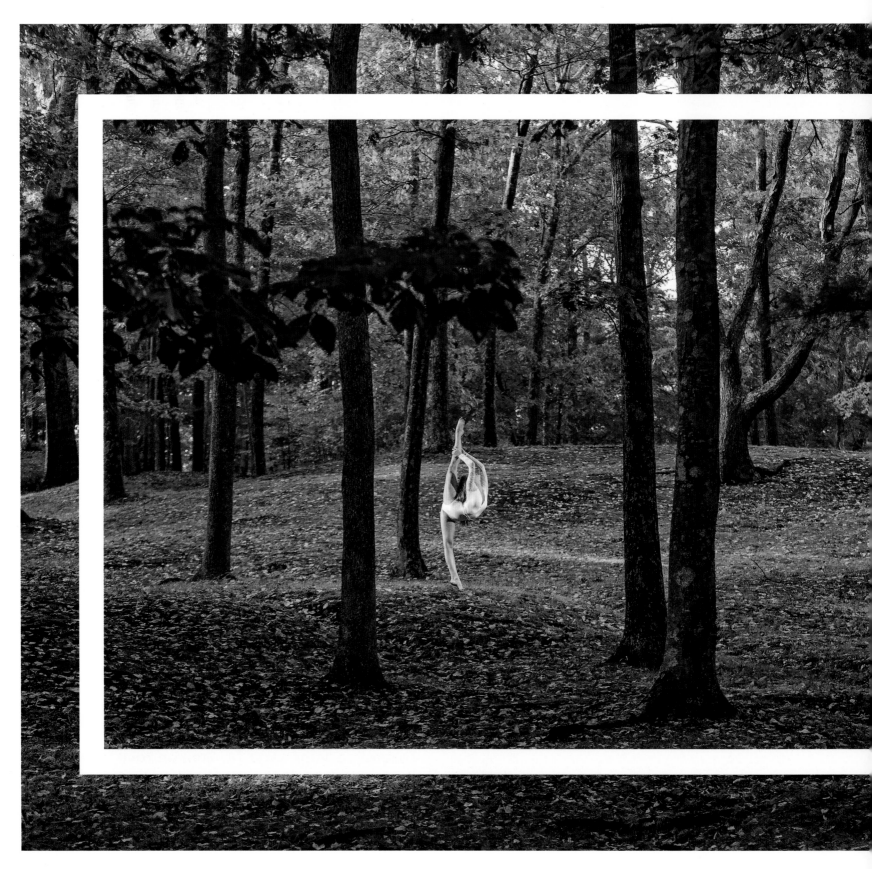

226 Haley Huelsman - Age 14 **Gillette Castle State Park, CT**

CONNECTICUT

Gillette Castle State Park

DAY 74

LOCATION 43

SEPTEMBER 10, 2016

MILES ON BUFORD: 18846

The location in Connecticut was pretty special to me, due to the man who built it and his history. He and I have a lot in common! Gillette Castle, originally called Seventh Sister, was built by William Gillette (no relation to the razor guy). William Gillette was an actor, stage manager, inventor, and director. He is probably most famous for his portrayal of Sherlock Holmes, on stage, on the radio, and even in early movies.

The castle is incredible, overlooking the Connecticut river, and surrounded by a gorgeous landscape. There are several really interesting aspects to the house and surrounding property, including the doors (designed and build by Gillette himself), the train, and the custom furniture. Now managed by the state of Connecticut, it is one of the most visited attractions in the state, in spite of being rather difficult to find! When driving in this area, before sunrise, it can be a bit precarious. Steep, winding roads with hidden turnoffs, a ton of deer and other animals, and an extreme lack of cell phone service make it all a little stressful. But once you are here, it's all suddenly worth it!

Another cool thing about this state is it's where my wife is from. Her hometown of Gaylordsville, CT is a charming little place. I actually got to drive through right after this session was over on my way to New York City, where I was going to have her come and help with the sessions there! On my way through town, I stopped in at the ice cream shop she has told me about from when she was a child. That was great. Can you tell I'm a big fan of my wife? She's pretty cool. I love you, Puddin' Pop!

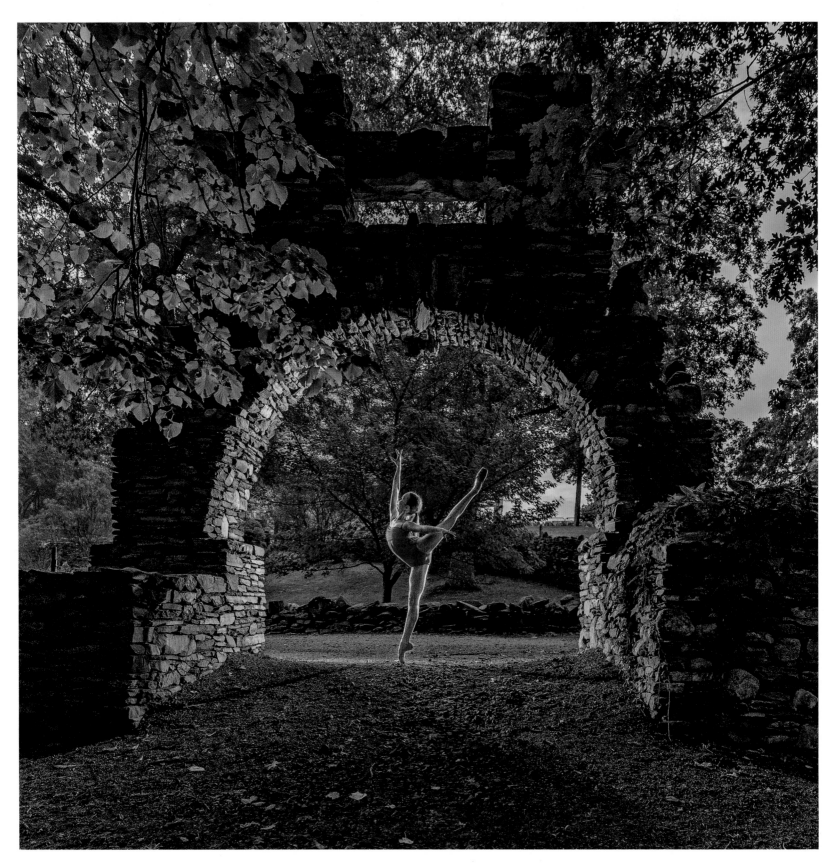

228 Francesca Kraszewski - Age 10 **Gillette Castle State Park, CT**

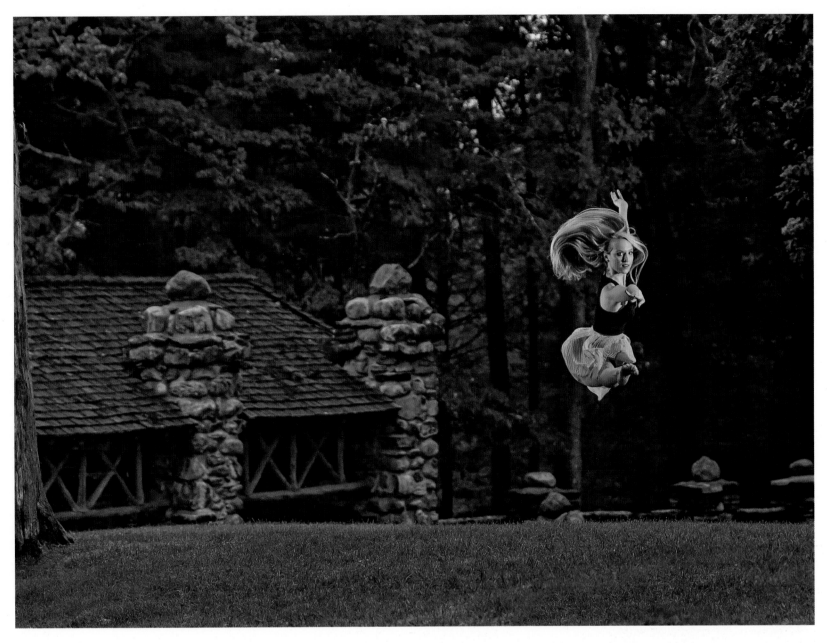

Heather Conn - Age 24 **Gillette Castle State Park, CT**

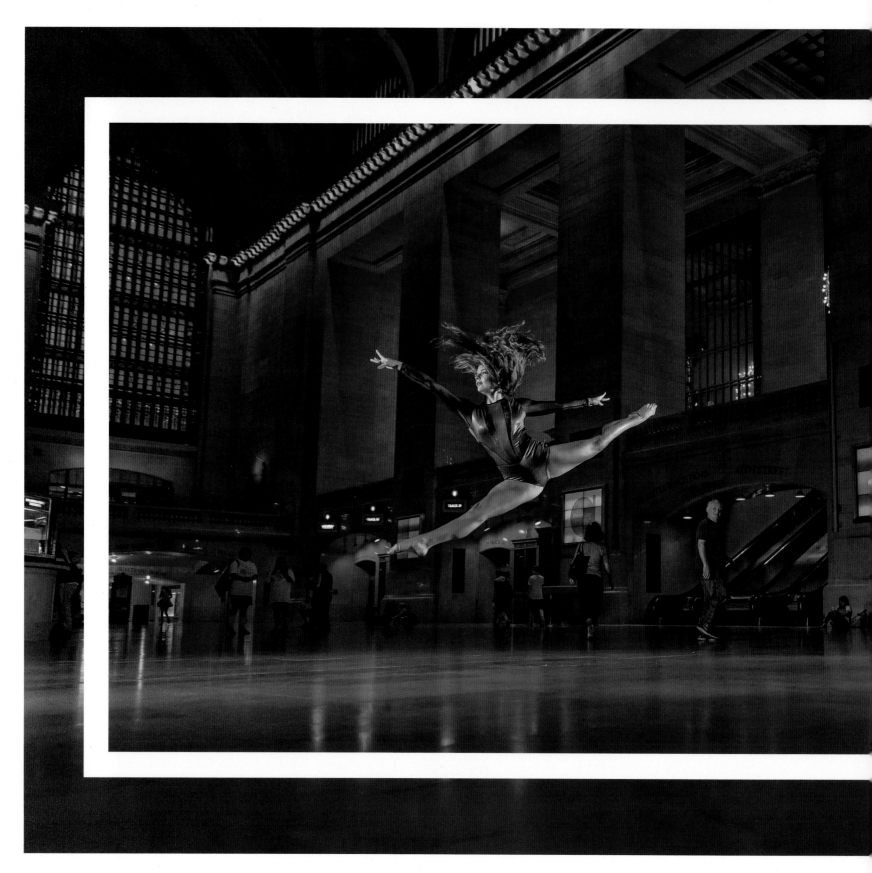

230 Alexis Gergely - Age 15 **Grand Central Terminal, New York City, NY**

NEW YORK

Grand Central Terminal
DAY 75
LOCATION 44 & 46
SEPTEMBER 10 & 11, 2016
MILES ON BUFORD: 19041

I moved to New York City in the winter 1996, sure that I was going to be a famous performer. My first time in Times Square, I walked right up to the statue of George M. Cohan, did a triple jazz pirouette, and shouted, "I'm gonna be a star!" (I was a little over-dramatic, in those days.) While I worked, got my Equity Card, and was doing the whole "New York actor thing," I never achieved stardom. However, living in the City made a huge, indelible mark on my life.

You will never forget the first time you go into Grand Central Station. That moment was quickly followed by me getting yelled at by a conductor that it was not called Grand Central Station, but Grand Central TERMINAL. "Terminals are the end of the line, stations are in the middle. This ain't no freakin' station!" Got it. It wasn't until I went to Europe that I ever saw anything that made such an impression on me. I loved the details, the craftsmanship, the many thousands of people that come through there every day, and I loved knowing how to navigate it. That made me feel like a "real New Yorker." That, and walking in the street to get around all the slow-poke tourists on the sidewalk. Walking in NYC could be an Olympic sport.

Like anywhere else, you are required to get a permit for photography in the Terminal, but here, it's free! So should you want to try your hand at it, go ahead!

Just don't call it a station.

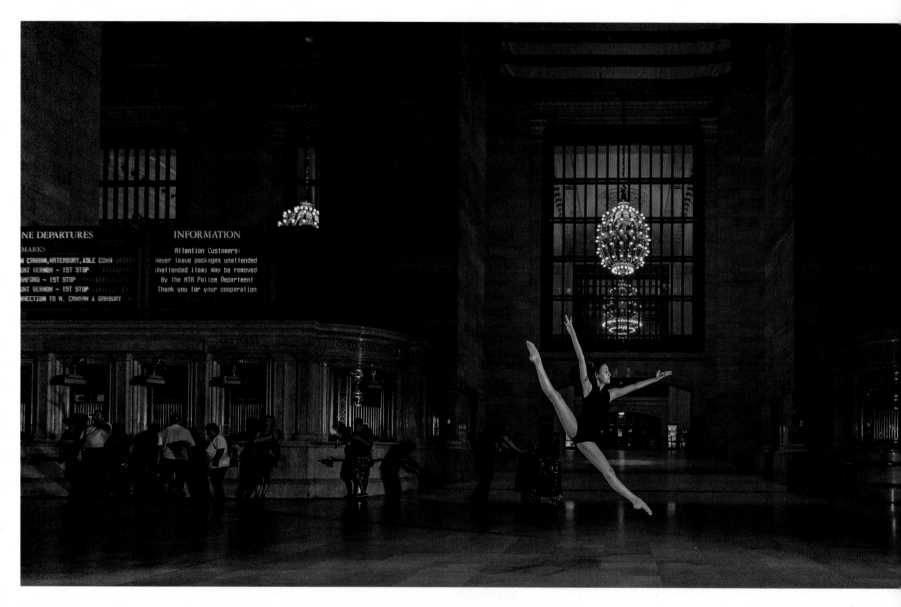

Victoria Loran - Age 13 **Grand Central Terminal, New York City, NY**

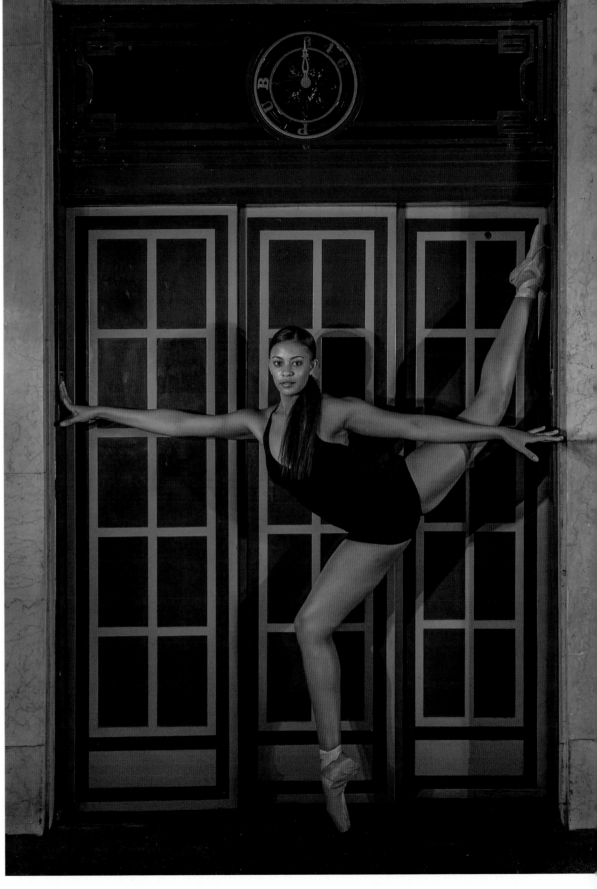

Mikayla Scaife - Age 18 **Grand Central Terminal, New York City, NY**

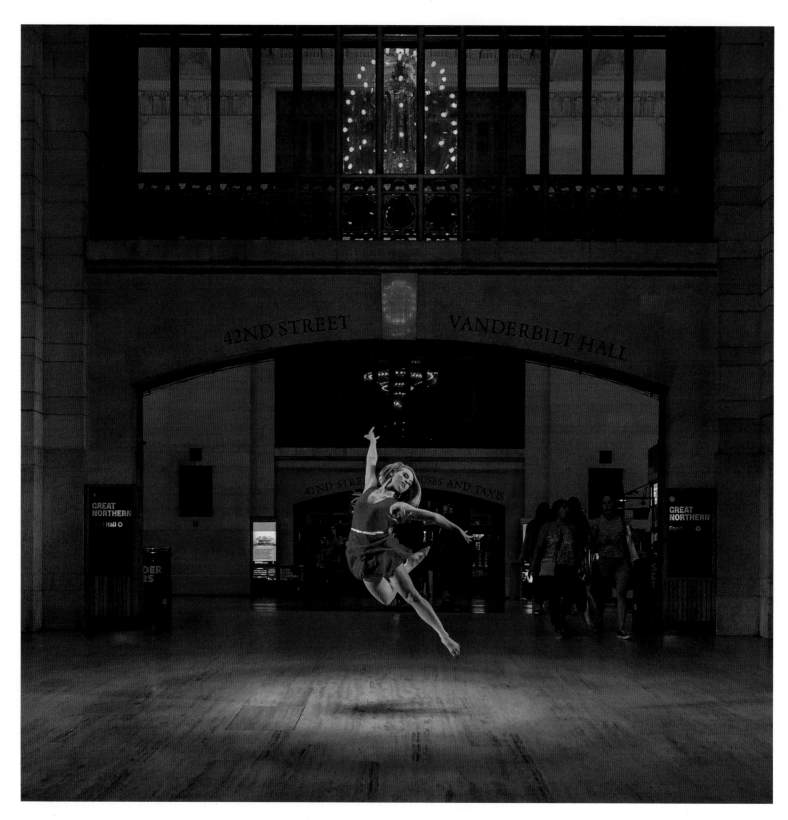

Heather Conn - Age 24 **Grand Central Terminal, New York City, NY**

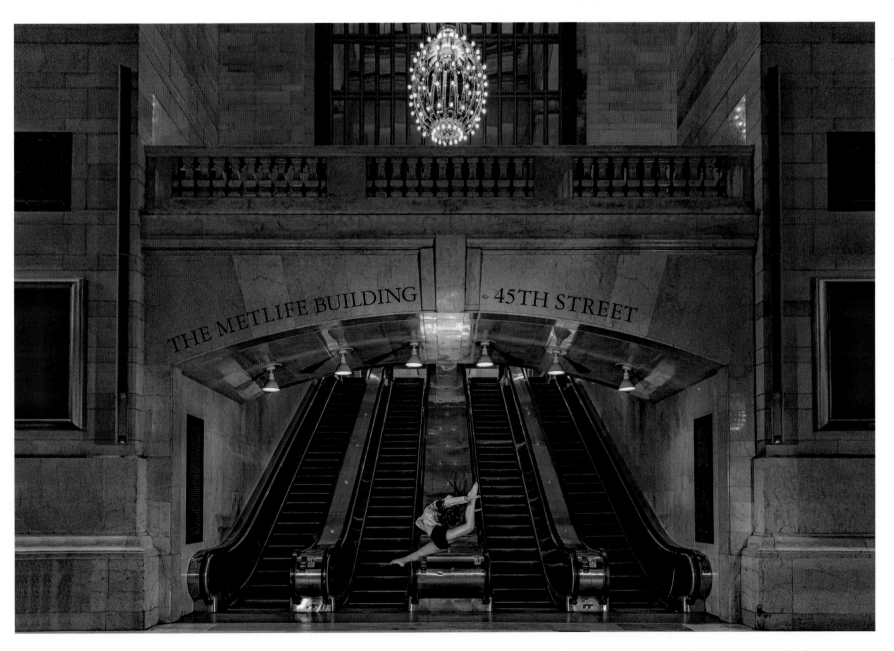

Kaycee Dominguez - Age 13 **Grand Central Terminal, New York City, NY**

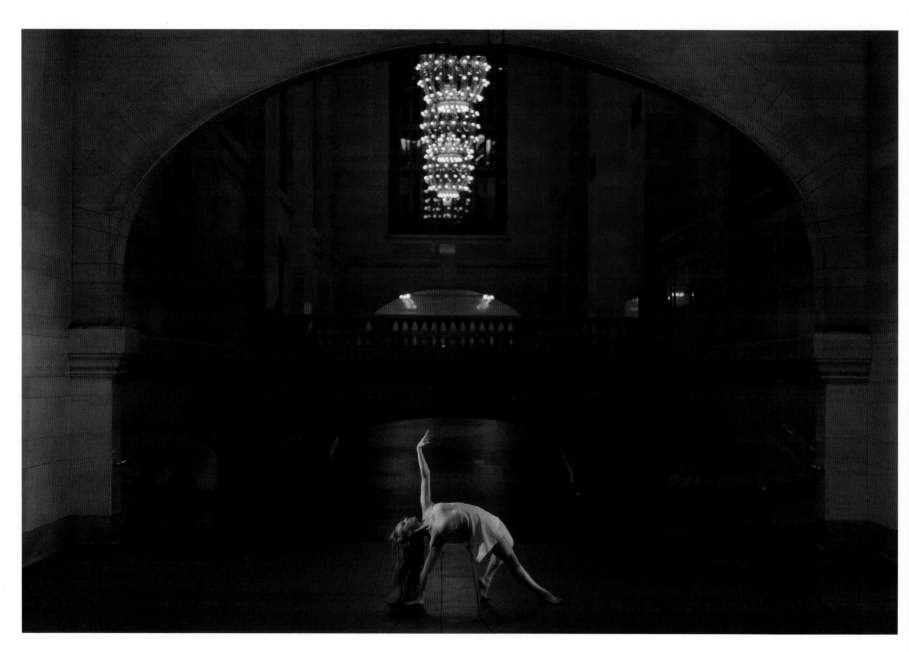

Heather Conn - Age 24 **Grand Central Terminal, New York City, NY**

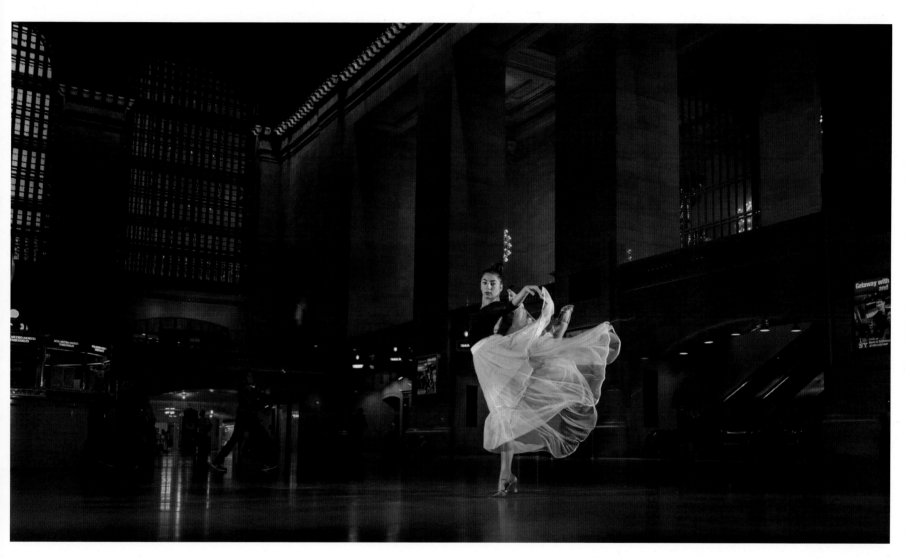

Teresa Bonello - Age 22 **Grand Central Terminal, New York City, NY**

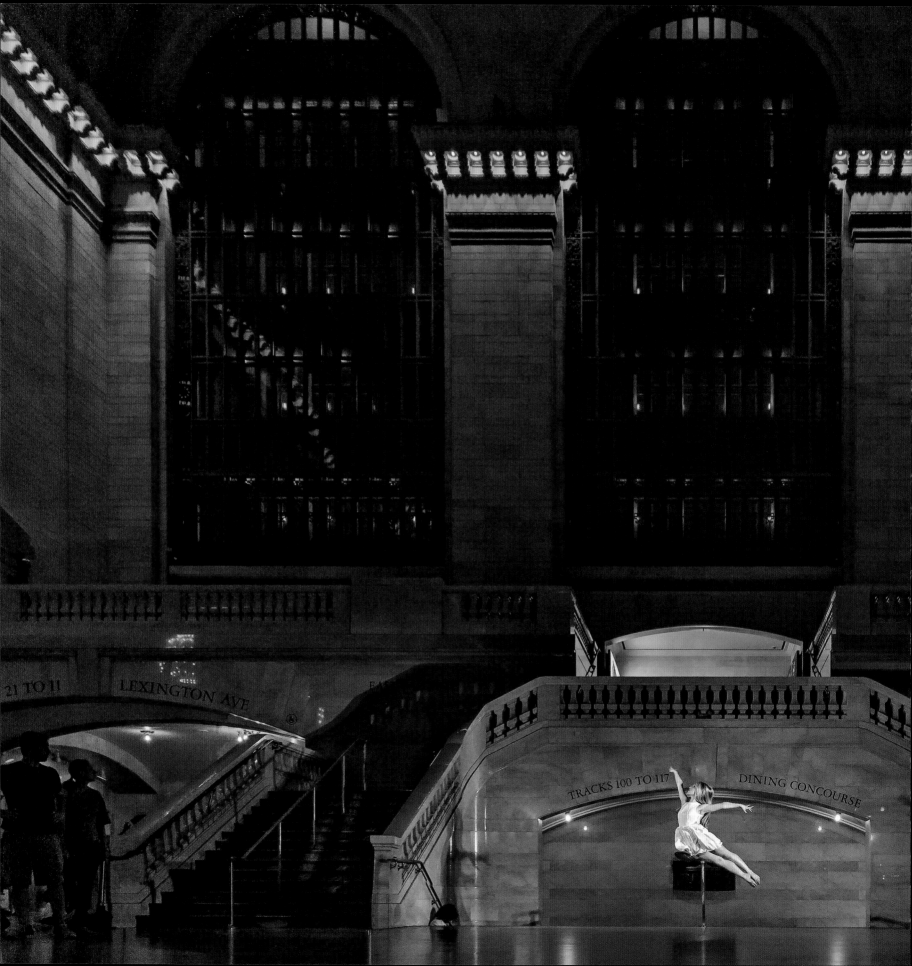

"Never give up on the artist in you. The world needs it. Heart and passion will always take you further than you think. "

~Heather Conn

Heather Conn - Age 24
Grand Central Terminal, New York City, NY

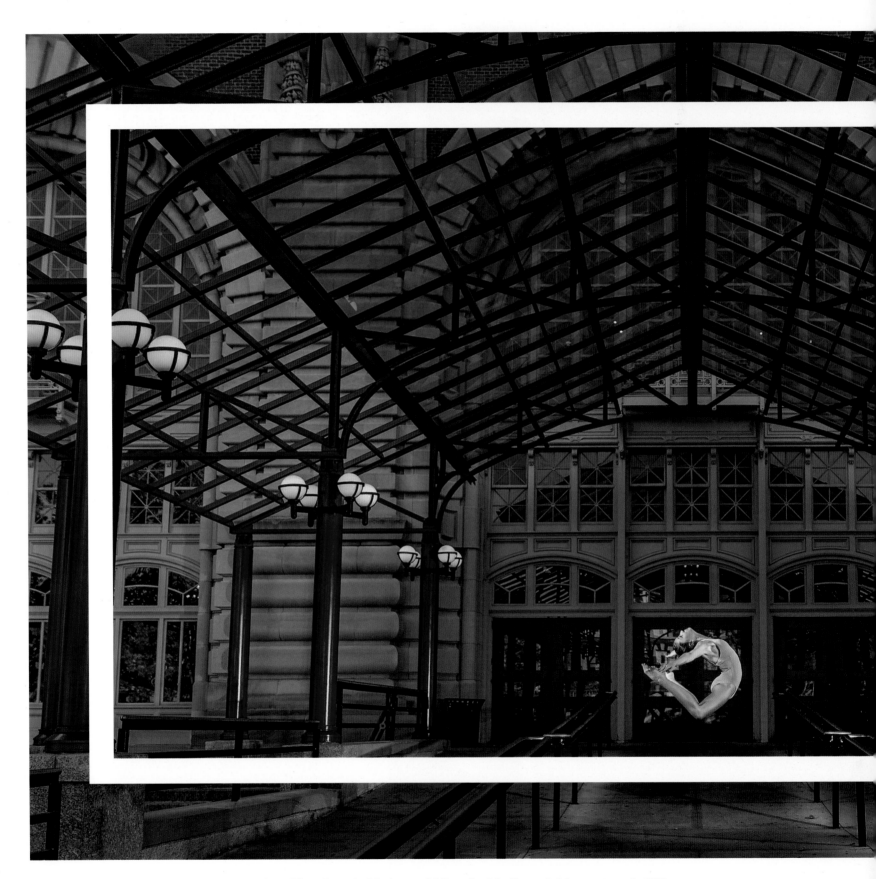

240 Jaclyn Assimacopoulos - Age 13 **Ellis Island, Statue of Liberty National Monument, NY**

NEW YORK

Ellis Island, Statue of Liberty National Monument
DAY 78

LOCATION 45

SEPTEMBER 13, 2016

MILES ON BUFORD: 19054

There used to be a theater company in Philadelphia called American Family Theater. I did a few tours with them. It was non-union,and paid poorly; my first national tour with them I earned $215 a week. No per diem, and not only did we had to share hotel rooms, we also had to drive ourselves all over the country, doing these shows. Three show days, starting sometimes as early as 8am. If you can live through an AFT tour, you can live through anything! "Everybody gather round, I'll tell you what to do..."

One of the shows I did with them was called *Ellis Island*. Because it was about Ellis Island. Creative! The show had lots of facts and figures (some correct, some not so much), you know, as educational shows do. I have to say, it actually sparked my interest in this place. I was fascinated by the stories about people immigrating to the USA. The hope of a new life, leaving everything behind to start over, it spoke to me - I kind of did the same thing myself. While I do not have any relatives that came through here, I still look at this place with wonder. The iconic nature of both Ellis Island and the Statue of Liberty made it a place that I just had to include in DATUSA.

I was able to arrange a private time for our session, before anyone else was allowed on either island. That was amazing on its own! Being at the Statue of Liberty with no one else there - wow! Just our intrepid little band of dancers, and a whole bunch of geese.

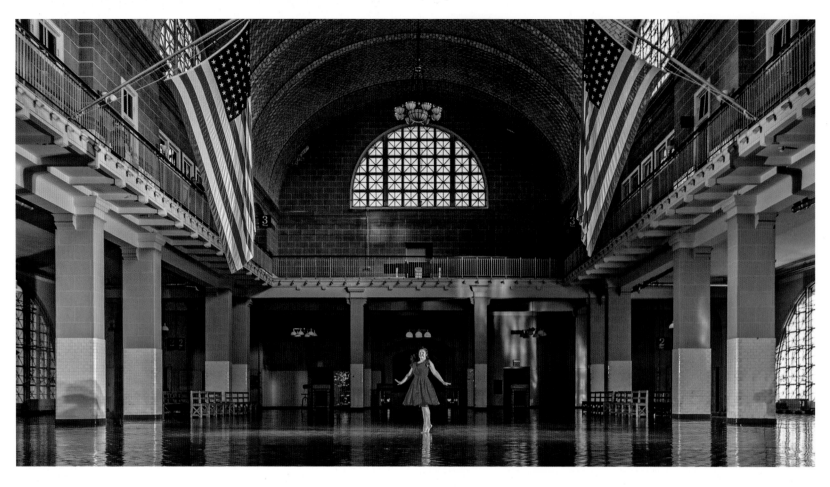

Daniella Colon - Age 17 **Ellis Island, Statue of Liberty National Monument, NY**

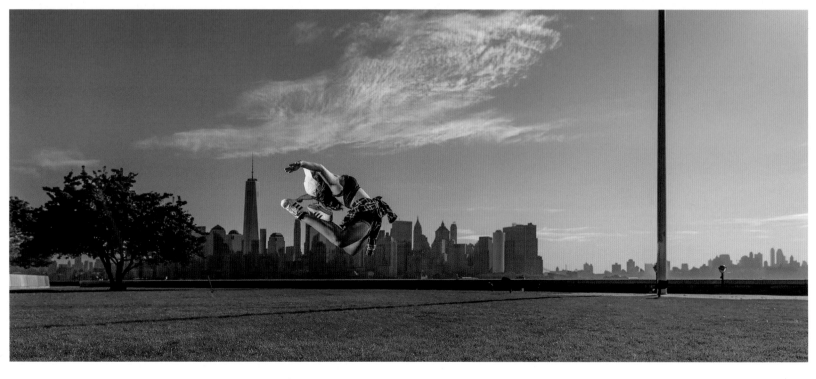

Leah Tsambazis - Age 14 **Ellis Island, Statue of Liberty National Monument, NY**

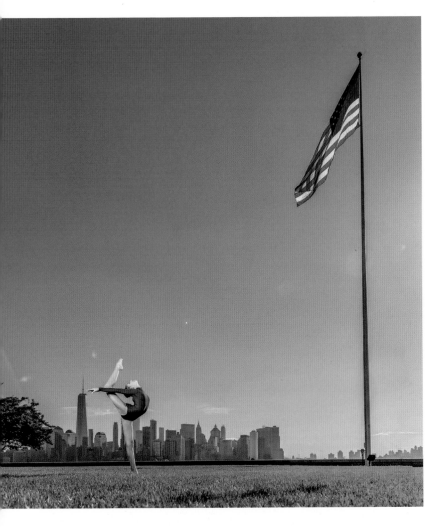

Jaclyn Assimacopoulos - Age 13

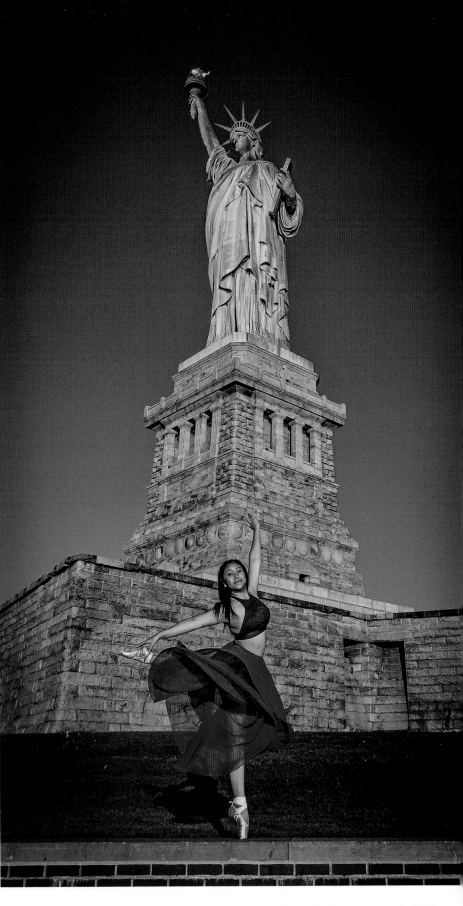

Destiny Lam - Age 15 **Statue of Liberty National Monument, NY**

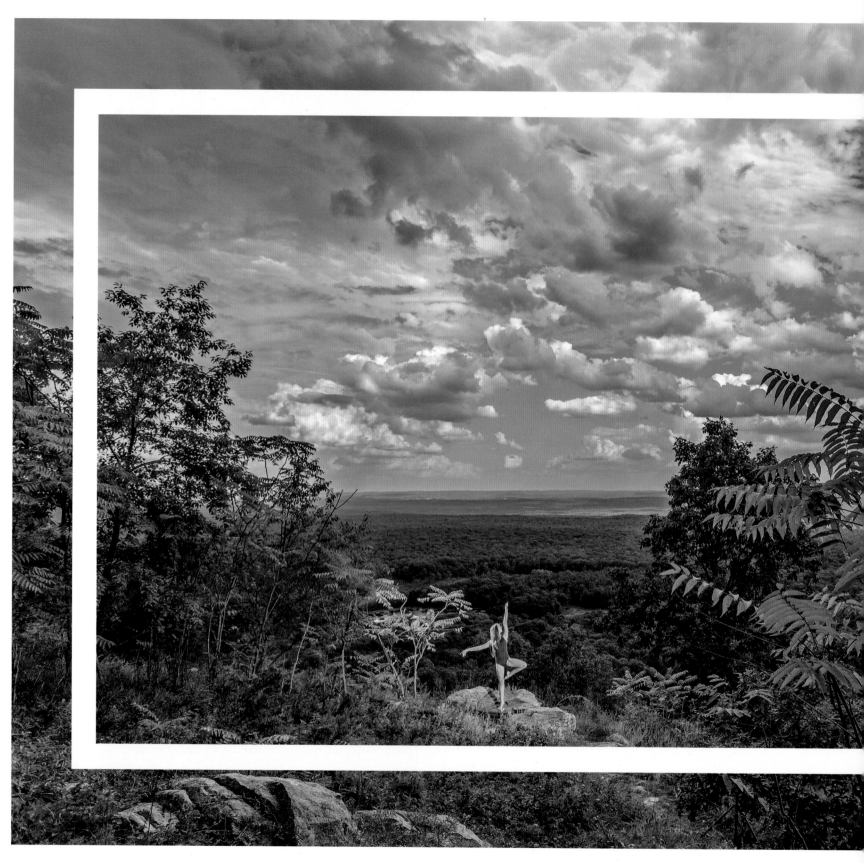

244 Jessica Esposito - Age 13 **Delaware Water Gap National Recreation Area, NJ**

NEW JERSEY

Delaware Water Gap National Recreation Area
DAY 79
LOCATION 47
SEPTEMBER 14, 2016
MILES ON BUFORD: 19201

In the 70's, I used to live in New Jersey. We would go "down the shore" in the summer, and that was mostly what I remembered about it - the boardwalks, the smell of food and sunscreen, and the taffy. It was all about the yummy, delicious, salt water taffy. And for some reason, bologna.

Since then, my impression of New Jersey had been colored by living in New York: it's cool for New Yorkers to dump on New Jersey. (even though New Yorkers regularly go to the Jersey Shore for vacation.) I had always appreciated the joke from the film *Miss Congeniality* - "Why is New Jersey called 'The Garden State?'" "Because it's too hard to fit "Oil and Petrochemical Refinery State" on a license plate?" I stand here today to tell you all that New Jersey is beautiful, and I have proof!

<========= See?!?

It's gorgeous!!! This area is called the Delaware Water Gap, and it is chock full of beautiful forests, hiking trails, historical structures, lakes, streams, and not a man-made thing in sight. This is what New Jersey looked like before it became the manufacturing and shipping hub that it is today. If all you ever experience of New Jersey is the turnpike, you are missing out, my friend. And believe me, this is just a small portion of it. Just another reason why I wanted to do this project - to show everyone that there are beautiful things in every state. So take that, *Miss Congeniality*. Got a problem with that? Come at me, bro!

245

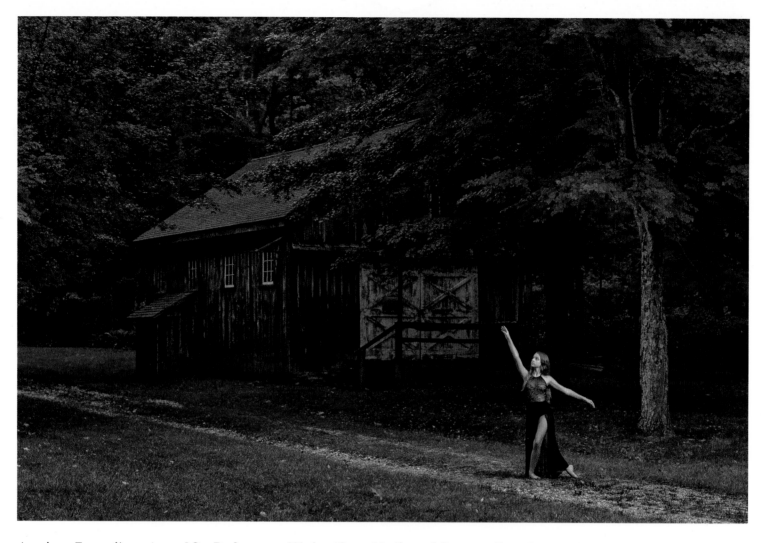

Jessica Esposito - Age 13 **Delaware Water Gap National Recreation Area, NJ**

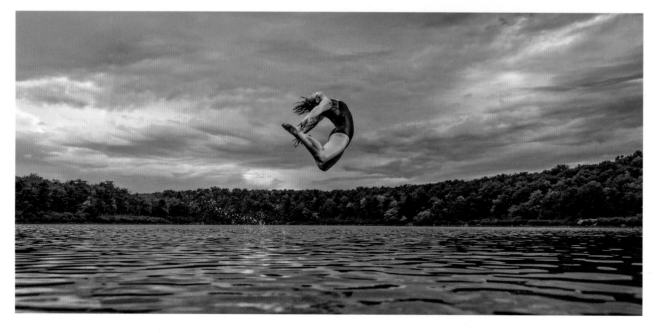

Melissa Hunt - Age 25 **Delaware Water Gap National Recreation Area, NJ**

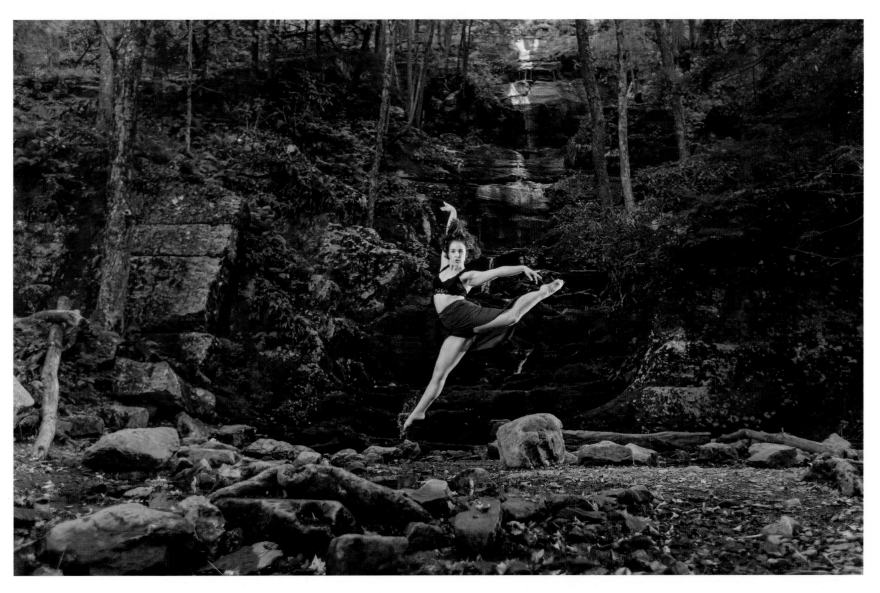

Melissa Hunt - Age 25 **Buttermilk Falls, Delaware Water Gap National Recreation Area, NJ**

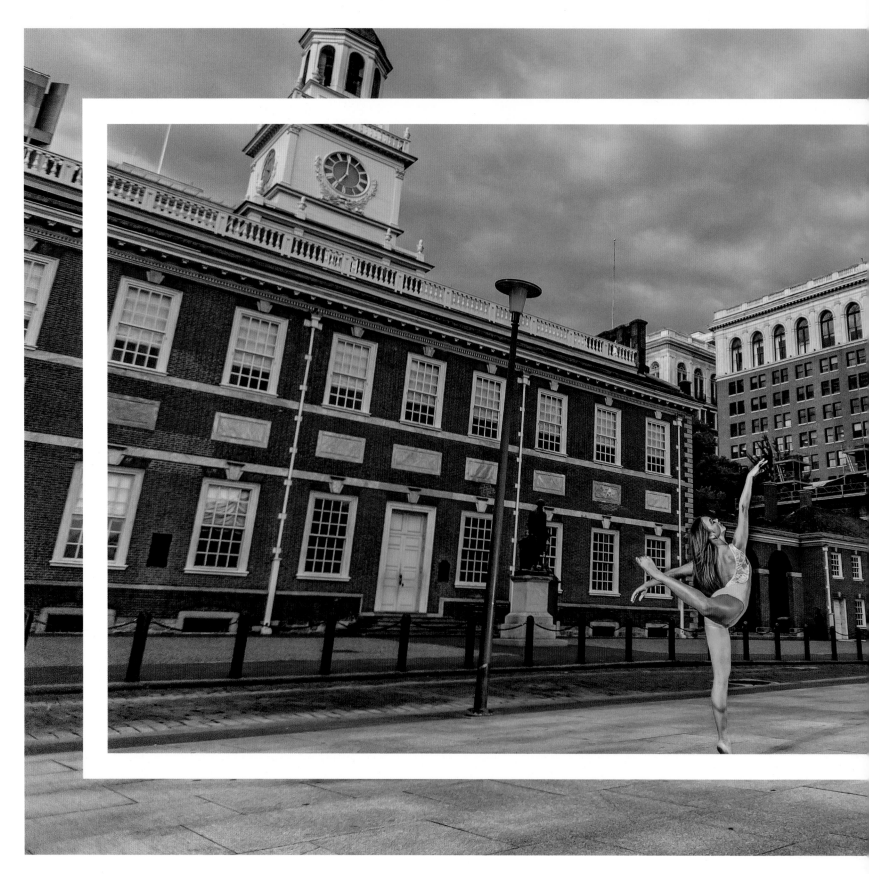

248 Remi Rosenwald - Age 14 **Independence Hall National Historical Park, PA**

PENNSYLVANIA

Independence Hall National Historical Park

DAY 80

LOCATION 48

SEPTEMBER 15, 2016

MILES ON BUFORD: 19382

The city of brotherly love, site of the Continental Congress, signings of both the Declaration of Independence AND the Constitution of the United States, this place is dripping with American history!

The complex here covers multiple sites, and artifacts galore! Some of the other properties here are:

- The Liberty Bell Center
- Independence Hall
- Old City Hall
- Washington Square
- Merchants Exchange Building
- First Bank of the United States

But again, back to the Cheesecake Factory analogy, too many options. I decided to focus on just Independence Hall. Iconic, recognizable, in a great big clear area good for dancing, and a place I could get to before sunrise without an act of Congress! Seriously though, where else should I go for *Dance Across the USA* other than the place where America was created?

Did you know that for about 10 years, Philadelphia was the Capital of the United States? From 1790 to 1800, Philly was the last city that had this distinction before Washington DC became the Capital. Other cities were Baltimore MD, Lancaster PA, York PA, Princeton NJ, Annapolis MD, Trenton NJ, and New York City NY.

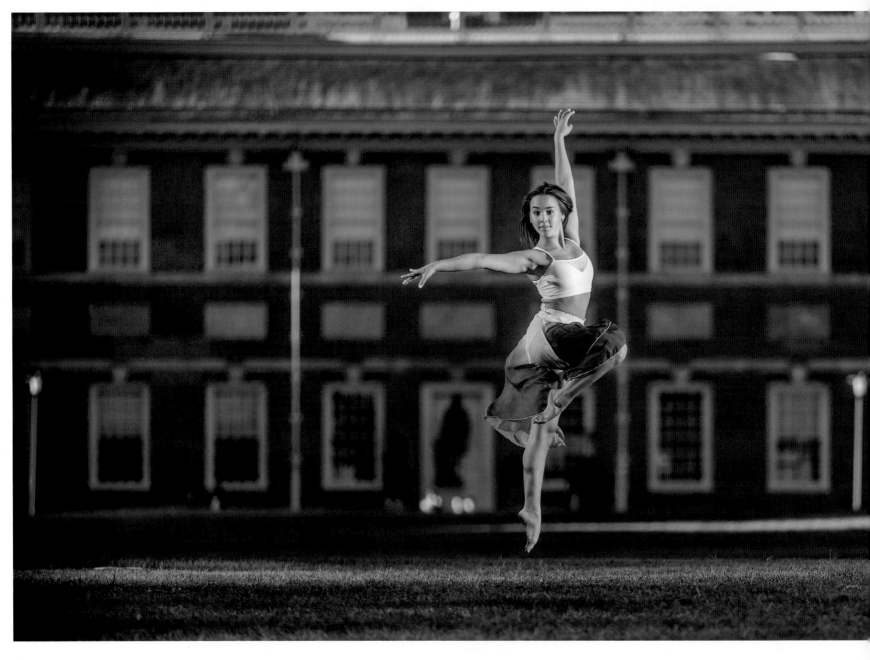

Remi Rosenwald - Age 14 **Independence Hall National Historical Park, PA**

Layla Goodwin - Age 8 **Independence Hall National Historical Park, PA** *251*

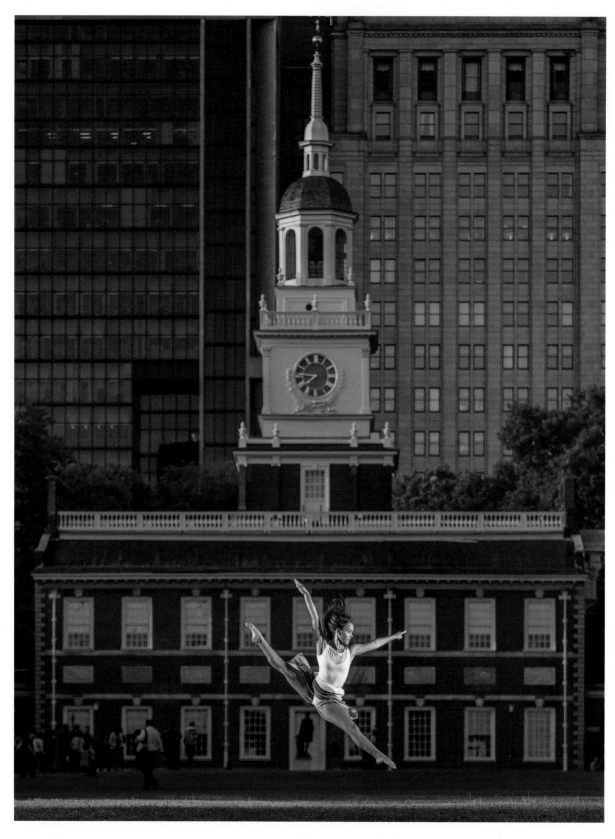

Remi Rosenwald - Age 14 **Independence Hall National Historical Park, PA**

Layla Goodwin - Age 8 **Independence Hall National Historical Park, PA**

Ayla Flowers - Age 9 **First State National Historical Park, DE**

DELAWARE

First State National Historical Park

Day 81

Location 49

September 16, 2016

Miles on Buford: 19497

One of the newest locations managed by the National Park Service, First State National Historical Park covers seven different locations in two different states. It includes the oldest church in America (as it was originally built), homes, a town park, a courthouse, a fort built by the first American Swedish colony, and 1100 acres of rolling hills and woodlands. This open area, known as Beaver Valley, is where we chose to meet.

Beaver Valley was owned by William Penn, but prior to that had Quaker settlements and of course was also inhabited by Native Americans. This was all part of a privately owned park until it was donated to the National Park Service for the establishment of the First State National Monument in 2013. The monument was reformed as First State National Historical Park in 2015 as part of the National Defense Authorization Act. None of this would have been possible without the efforts of Senator Tom Carper.

It was the beautiful rolling hills that I found most beautiful here. Hikers, people on horseback, and dog walkers abound, all enjoying the peaceful serenity of this area. Hiking along the river bank is a favorite activity of many of the locals. I spoke with several of the folks who live nearby who were all super friendly and happy to chat for a moment. Even the horses that came by were friendly! Maybe there is something in the water here.

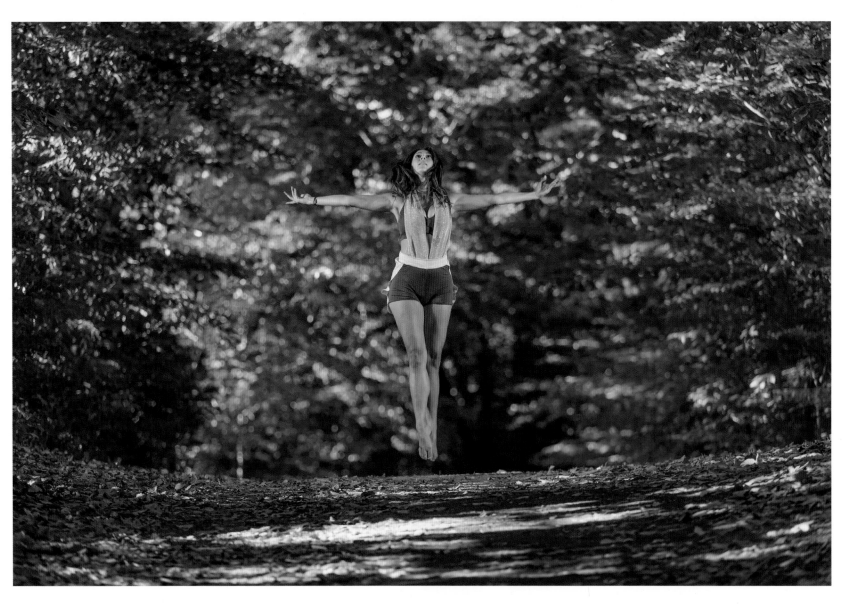

NIkki Di Giorgio - Age 31 **First State National Historical Park, DE**

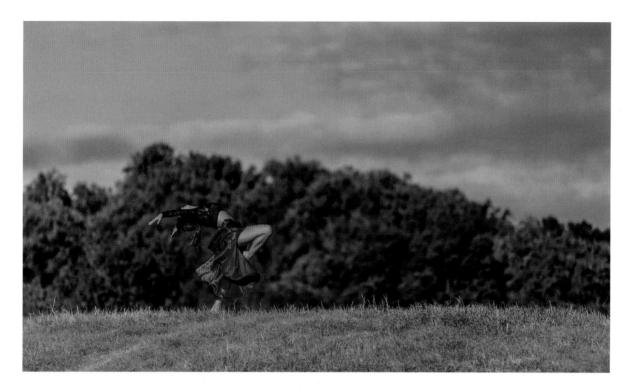

NIkki Di Giorgio - Age 31 **First State National Historical Park, DE**

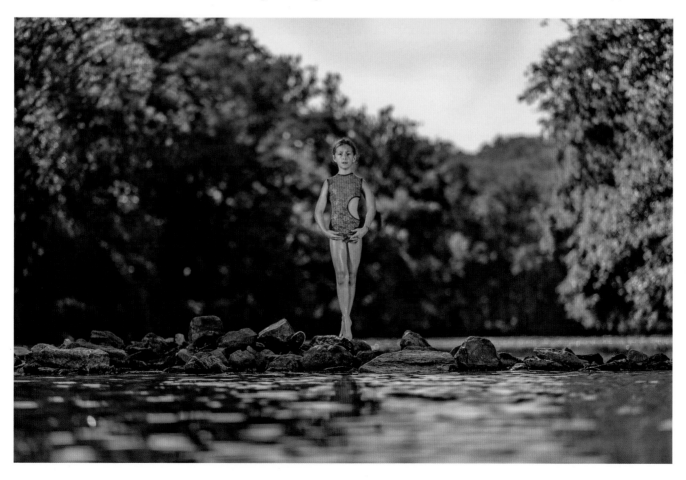

Ayla Flowers - Age 9 **First State National Historical Park, DE**

MARYLAND

Assateague Island National Seashore

DAY 82

LOCATION 50

SEPTEMBER 17, 2016

MILES ON BUFORD: 19700

With wild horses and beautiful beaches, Assateague Island National Seashore almost seems unreal. The land here is simply a ribbon of sand, not quite a mile wide from side to side, but 37 miles long. It is one of the few places where you can see wild horses, brought to worldwide attention by the book *Misty of Chincoteague*, written by Marguerite Henry in 1947. There are around 300 horses here, divided into two herds - one cared for and fed by the Chincoteague Fire Department, and the other left completely alone. Should you see them during your visit, make sure you keep your distance!

There are, of course, all the typical beach / water activities here, which when we were there included dancing! The beaches are all undeveloped, meaning there is no fast food anywhere nearby! This is a place to come to relax, and immerse yourself in the beautiful surroundings.

The beaches here are large and easy to access, and you can spend the day here without be surrounded by people. This is a wonderful place to be able to have a peaceful beach day with your family, something I think every family should be able to enjoy. Even for those of us who are lucky enough to live near a seashore, it never loses its magic. So get your family together, and make your way to the beach. You'll be glad you did!

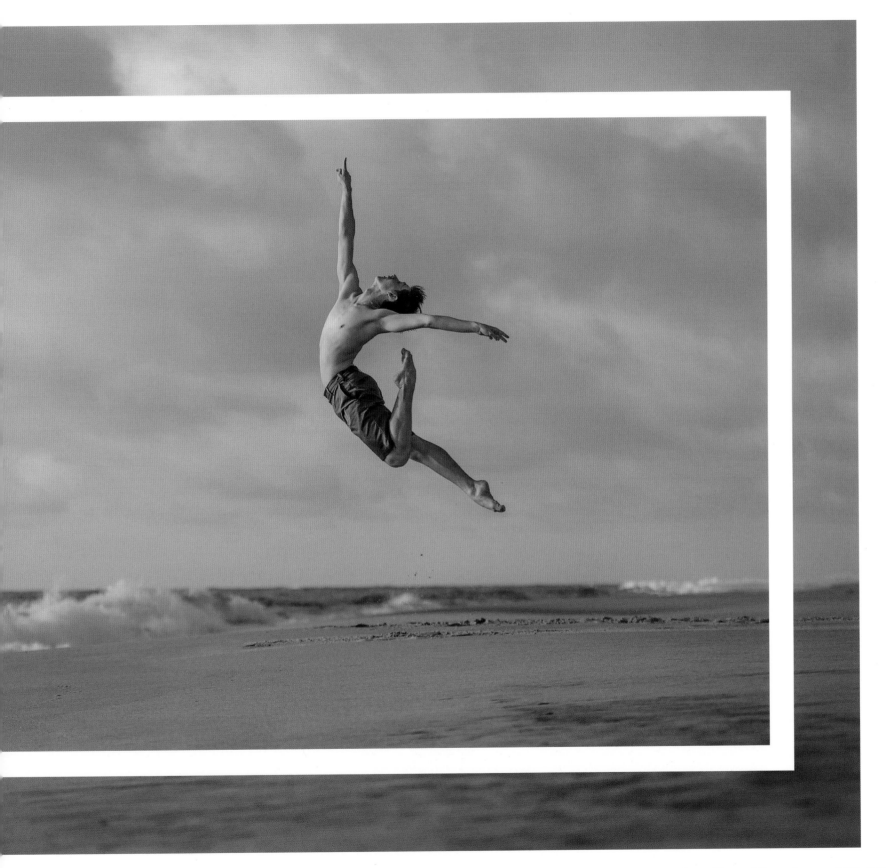

Gabe Needle - Age 17 **Assateague Island National Seashore, MD** 259

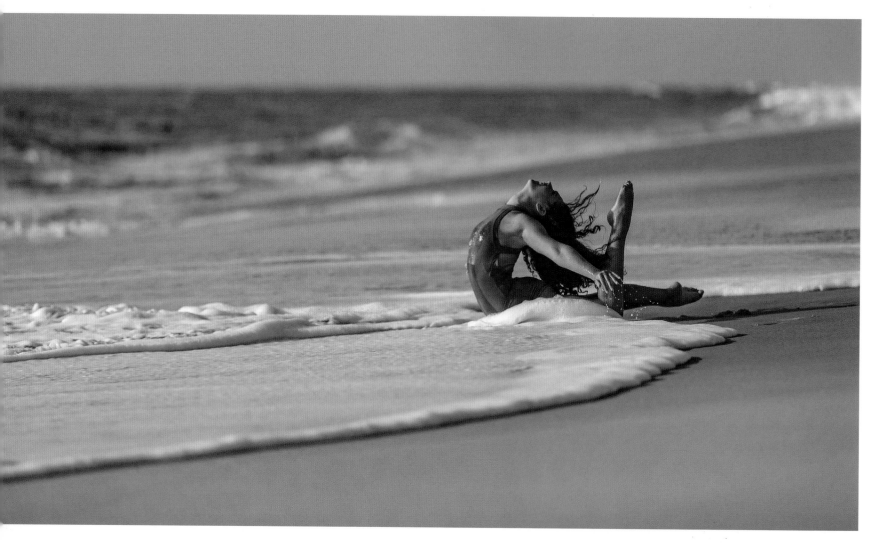

Riley Miknich - Age 12 **Assateague Island National Seashore, MD**

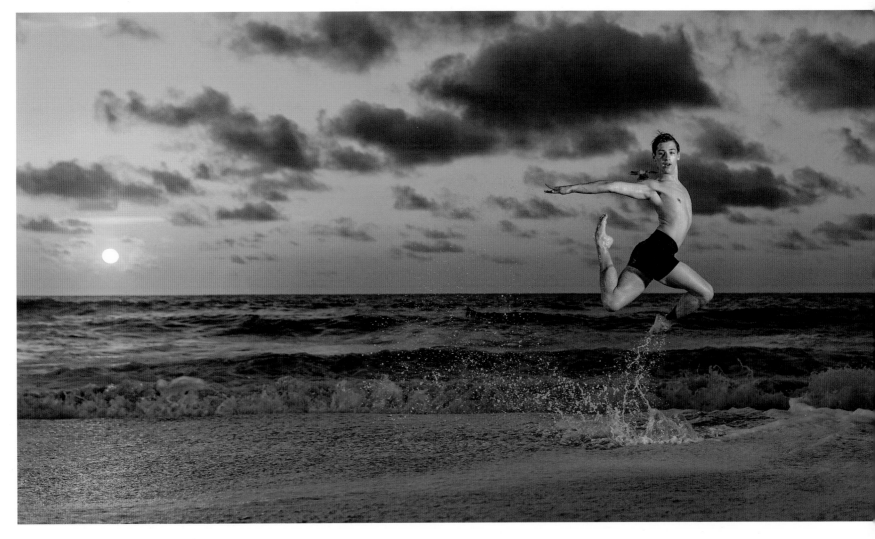

Gabe Needle - Age 17 **Assateague Island National Seashore, MD**

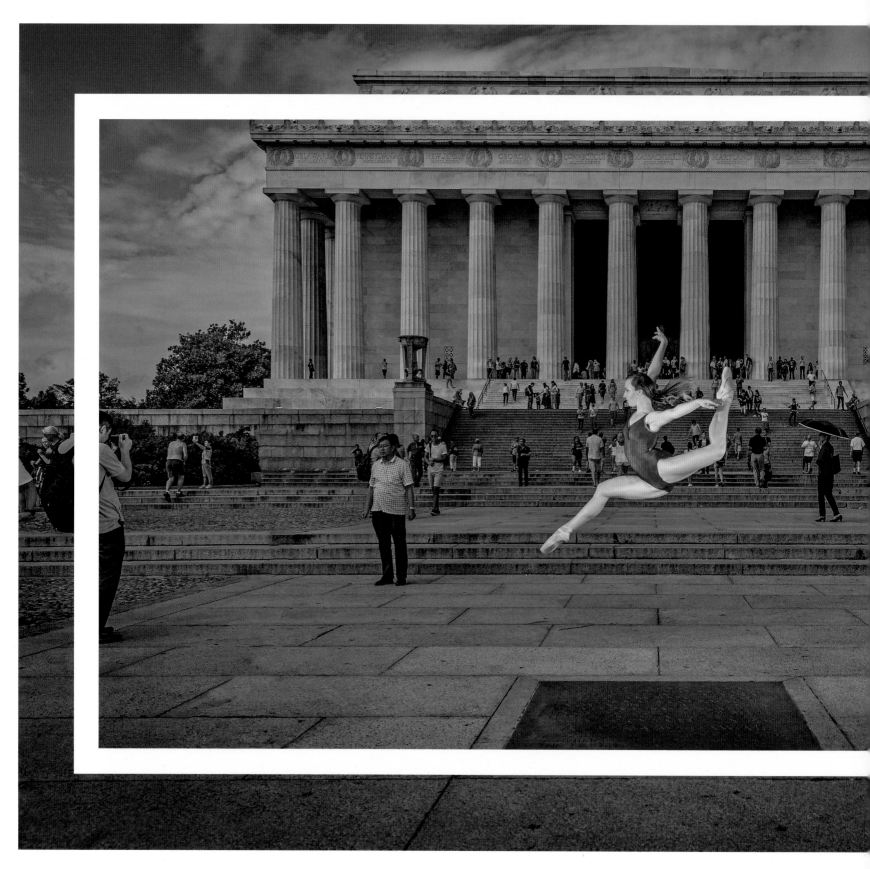

Bryanna Krause - Age 18 **Lincoln Memorial, Washington D.C.**

WASHINGTON D.C.

Lincoln Memorial and Washington Monument

DAY 83

LOCATION 51

SEPTEMBER 18, 2016

MILES ON BUFORD: 19939

Here we are, in the Nation's Capital! When I originally conceived this idea, I had hoped to be able to do a session on the White House lawn. I was politely told, in so many words, "Give it up kid, it ain't ever gonna happen." So I made other plans, and honestly I'm glad I did. The locations we used were perfect, and the inclusion of all the other people in the background makes it that much better, I think.

Construction of the Lincoln Memorial began in 1914, and used materials from across the country - granite from Massachusetts, marble from Colorado and Alabama, limestone from Indiana, pink marble from Tennessee, and the statue itself is carved from 28 pieces of Georgia marble. All these choices were made to represent the reunification of the country under Lincoln. Construction was completed in 1920, and the Lincoln Memorial was dedicated on May 30, 1922.

Construction began in 1848, based on a design by Robert Mills. The design for the monument was complicated and expensive. Six years after it began, work stopped due to a lack of funds. The architect died the following year, further complicating things. For over 20 years, the monument stood unfinished, only 25% complete. In 1876, Congress voted to assume the project, and restart construction. The Army Corps of Engineers took charge, and had many issues to overcome. The quarry for the original stone was gone, so a replacement had to be found. Then a second replacement. In 1884, 36 years after it started, construction was completed by the placement of the 3,300 pound capstone at the top, finished with a 8.9" aluminum tip. The monument stood 555 feet, 5.125 inches tall, and at the time was the tallest building in the world.

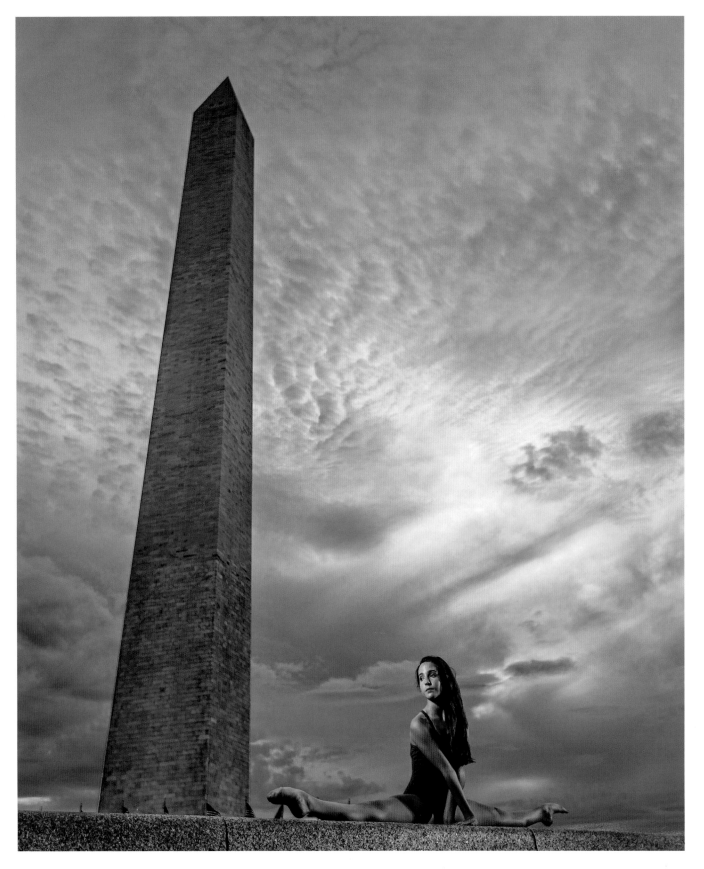

Ella Foster - Age 15 **Washington Monument, Washington D.C.**

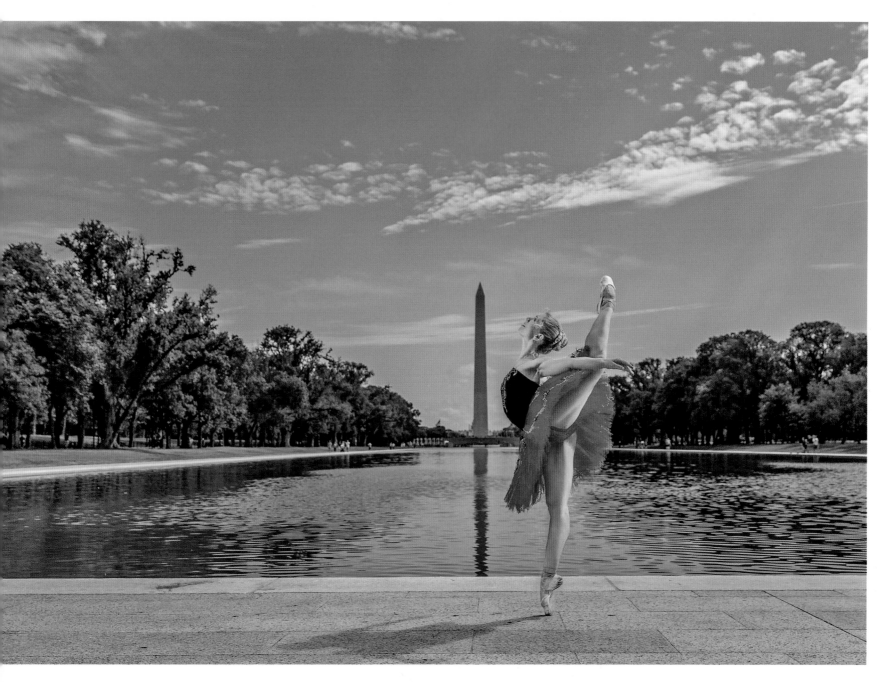

Anna Russell - Age 23 **Washington Monument, Washington D.C.**

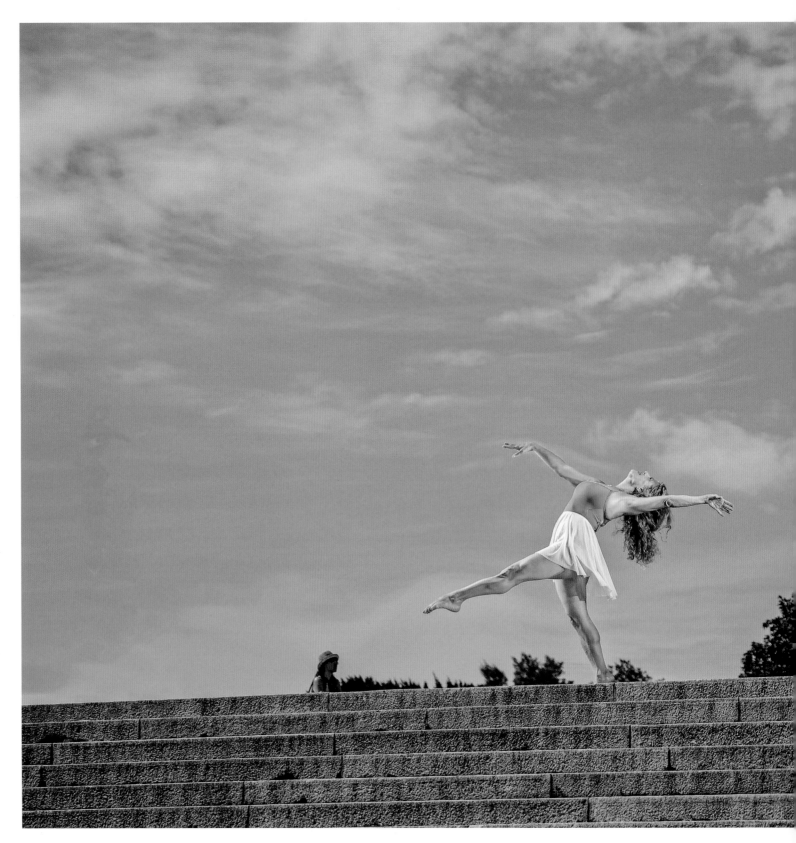

May Kesler - Age 61 **Lincoln Memorial, Washington D.C.**

"... freedom, connection, water, earth, air, history, pain and triumph. That is what keeps me dancing, along with some really good bodywork, a host of excellent teachers, and the courage to embrace my curves." ~ May Kesler

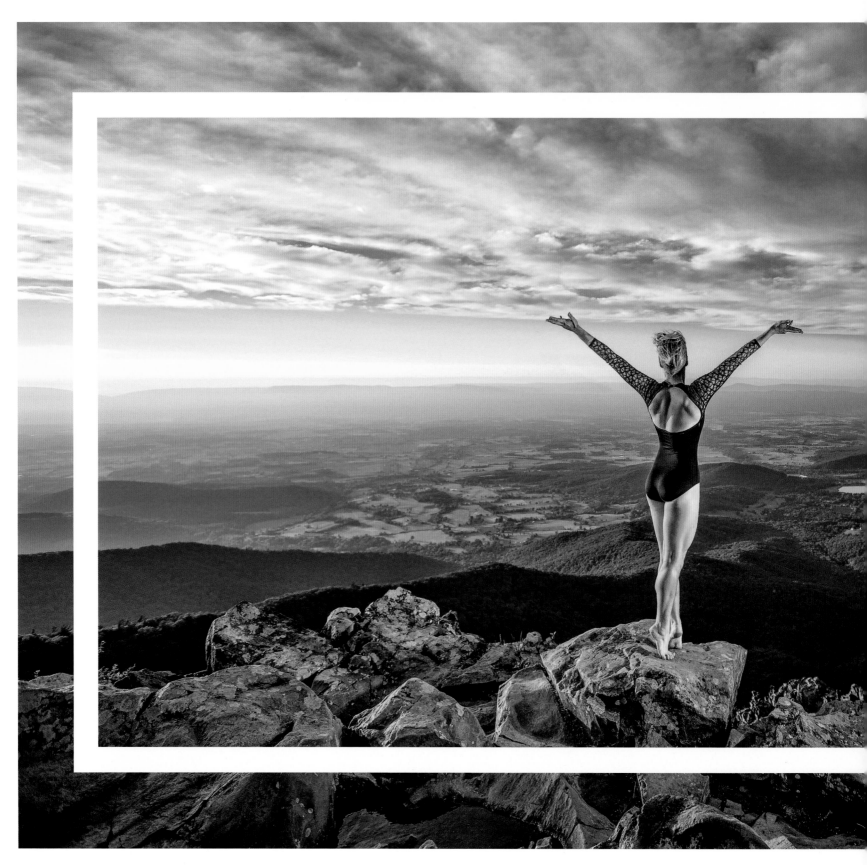

268 Chelsea Brown - Age 23 **Stony Man Mountain, Shenandoah National Park, VA**

VIRGINIA

Shenandoah National Park

DAY 85

LOCATION 52

SEPTEMBER 20, 2016

MILES ON BUFORD: 20106

"Oh beautiful, for spacious skies..." America the Beautiful. It is, isn't it? That song was written by Katharine Lee Bates, inspired by the view from the top of Pikes Peak. I've been there, it's stunning. But the view from Stony Man makes me think exactly the same thing. How beautiful is the country we live in? We are almost at the end of our trip, and this park seemed to tie it all up pretty well.

This area was heavily forested, with lots of homesteads and farms in the area. Naturalists fought hard to get this area set aside to preserve it for future generations. It took 20 years of effort to get Congress to make the designation, but another decade after that before the park was actually established.

The northernmost 4,000 foot mountain in the park is called Stony Man. Overlooking the Shenandoah Valley, it is an area often used for recreation. The trails here merge with portions of the Appalachian Trail, which we had seen before in New Hampshire, although it is not nearly as difficult here. These trails are more like leisurely afternoon strolls - beautiful, peaceful, energizing.

Just below our location was a sign showing a protected falcon's nest, who joined in our session a couple times as they flew the thermals coming up from the valley below. That was the icing on the cake for me, the falcon soaring over the horizon during our session.

Let me also say, that in addition to being a dancer, Chelsea is an avid explorer and climber. She has years of experience doing the things you see in these photos, and kept herself safe. Do not try things like this without the proper training!

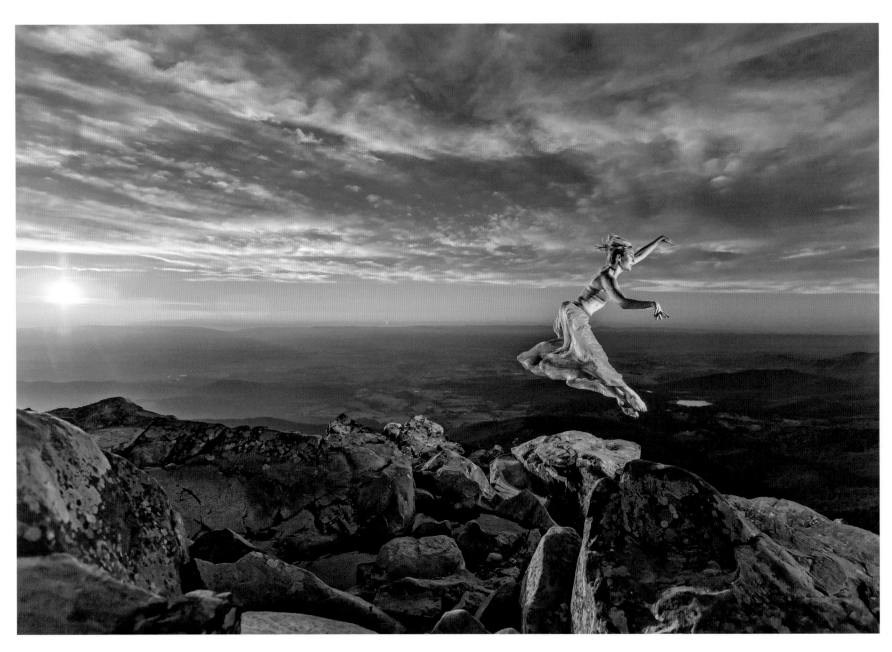

Chelsea Brown - Age 23 **Stony Man Mountain, Shenandoah National Park, VA**

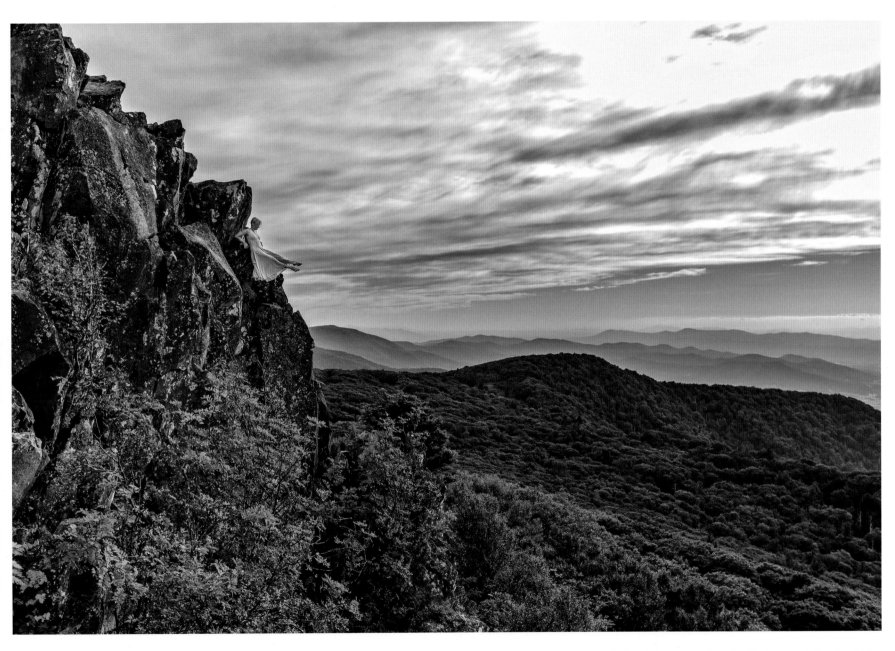

Chelsea Brown - Age 23 **Stony Man Mountain, Shenandoah National Park, VA**

Chelsea Brown - Age 23 **Stony Man Mountain, Shenandoah National Park, VA**

For me, dancing is a practice of re-wilding. I dance to feel close to nature; brave, strong, sensitive, and connected."
~ *Chelsea Brown*

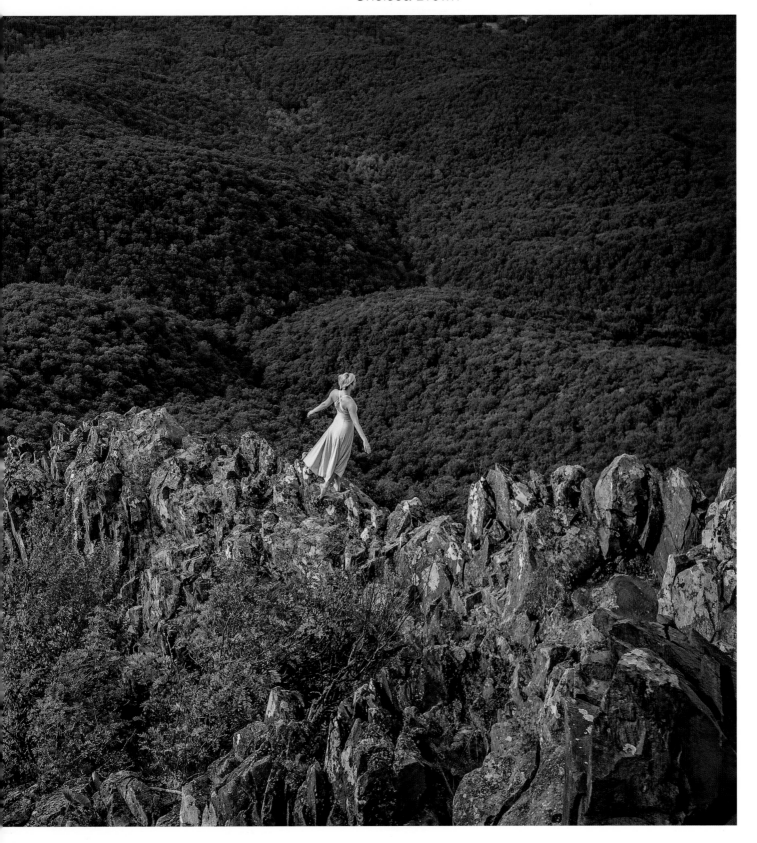

WEST VIRGINIA

Babcock State Park
Day 86
Location 53
September 21, 2016
Miles on Buford: 20394

One of the most iconic locations in all of West Virginia is Babcock State Park, home to the famous Glade Creek Grist Mill. I would be willing to bet that this mill has been photographed as much as the barns in Grand Teton.

When I was doing my research on where to shoot for West Virginia, I kept seeing images of this barn, and every time I did I thought of creating this image. This exact image. I am also a carpenter, and when I would envision a project and then build it, to stand back and see your vision realized was always so fulfilling. This was precisely the same thing.

This mill is a replica of one that stood nearby. To build it, the parts of three different mills were collected and put together here. The Stoney Creek Grist Mill and the Onego Grist Mill supplied the main building and stone floor. The giant water wheel was salvaged from the Spring Run Grist Mill after the remainder of that mill was destroyed by fire. This mill stands as a fully functioning monument to the more than 500 mills that once covered West Virginia.

This park covers a sprawling 4000-plus acres, and has cabins, camping, and over 20 miles of hiking trails. My time here was spent largely being up to my neck in the water, yelling over the sound of the waterfall "OK, NOW SOUS-SUS! PENCHÉ! SOUBRESAUT!" Which is a little different than the "HEY Y'ALL, WATCH THIS!!!" that I heard earlier in the day. There's a first time for everything, I guess.

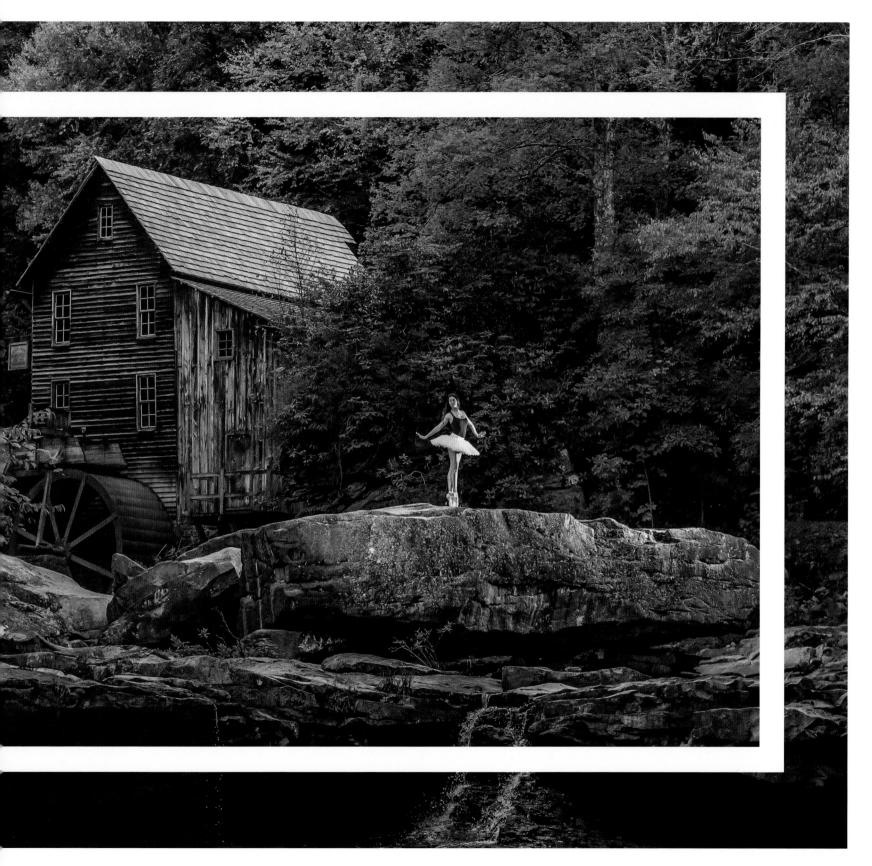

Alessandra Martinez - Age 15 **Babcock State Park, WV** 275

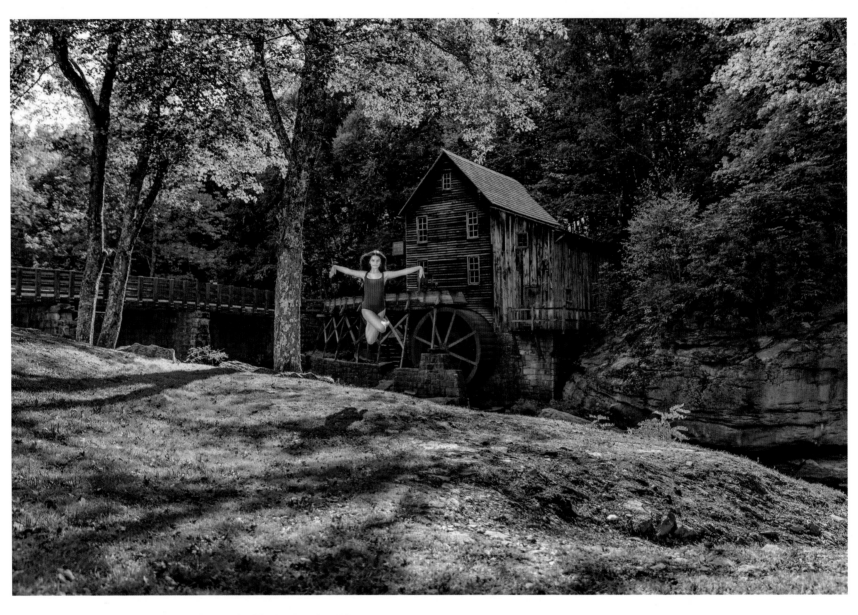

Natalie Butt - Age 14 **Babcock State Park, WV**

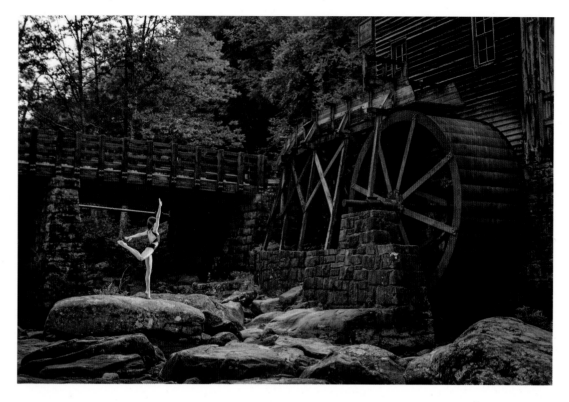

Avery James - Age 13 **Babcock State Park, WV**

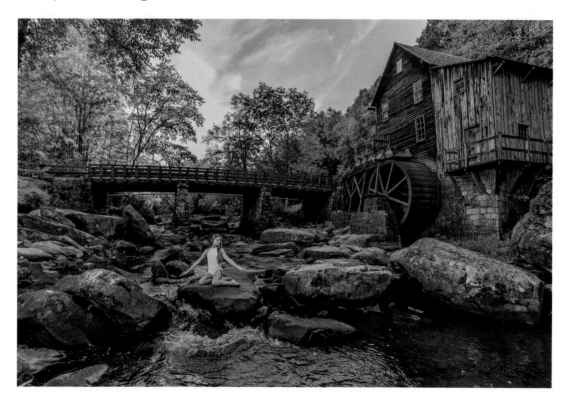

Rachel Burt - Age 13 **Babcock State Park, WV**

Alise Knight - Age 15 **Cape Hatteras National Seashore, NC**

NORTH CAROLINA

Cape Hatteras National Seashore

DAY 87

LOCATION 54

SEPTEMBER 22, 2016

MILES ON BUFORD: 20946

Cape Hatteras National Seashore was authorized by Congress in 1937, and was established as the first national seashore in 1953. This is one of the few national seashores where you can drive on the beach! So I just had to do that. We met up with our ranger, and drove from the visitors center all the way out, as far south as you are able to go, down to Cape Point. There is a wide variety of recreational opportunities here, from fishing and boating to windsurfing and even some excellent shelling.

The entire trip, I had been telling everyone about a $100 bet I had with my insurance agent that I wouldn't break anything. Over 20,000 miles of travel, and everything was still pristine. I take good care of my stuff.

After driving out to our spot, I was setting my lights up in the water (as I normally do for beach sessions) when out of nowhere, I got knocked on my face by a giant wave. As I went down, I rolled to the left to keep my camera dry, which ended up putting my flashes and their stand under me. Which I fell on. The stand sliced open my leg, which began gushing blood, and the lights went down hard into the water.

Now that the lights were wet, they were shocking me, over and over again, as I struggled to stand and get myself and my gear out of the water. I finally got my feet under me, and I dropped the flashes. They were toast, and I had been perforated. What to do? Gaff tape the wound shut, and keep going.

I replaced the flashes. I have a great scar from the wound. And I had to pay my insurance agent $100.

Alyssa Hall - Age 9 **Cape Hatteras National Seashore, NC**

"Never give up on your dreams. Always do your best and learn from your mistakes. My mistakes have helped me become the person and dancer that I am. No one is perfect and that is what makes us all unique."
- Alyssa Leigh Hall

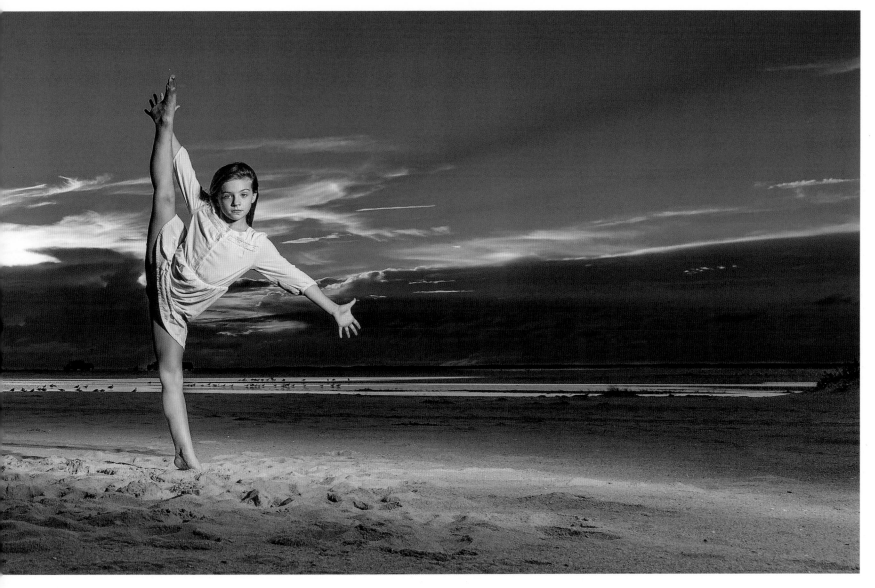

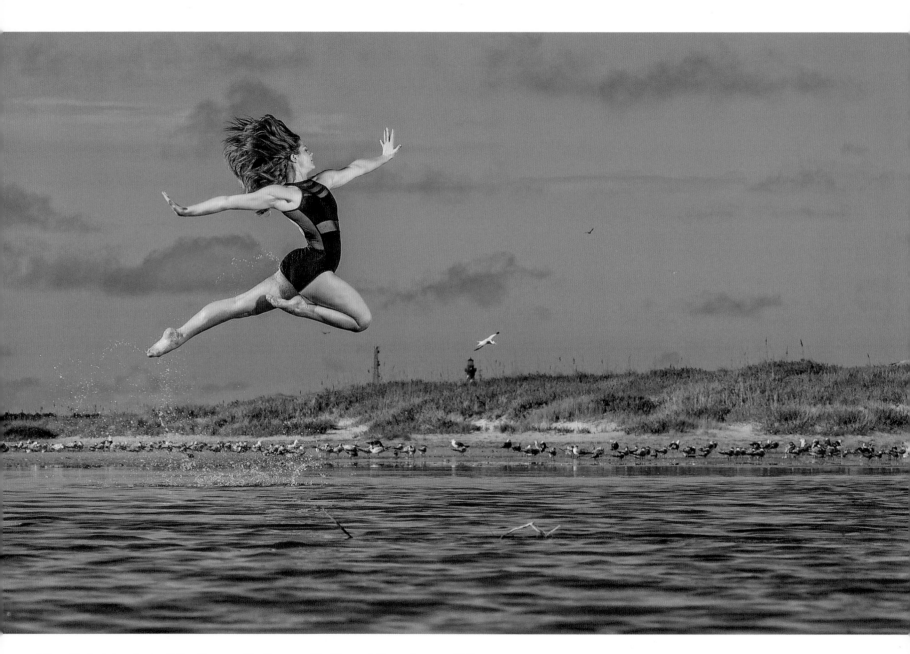

Alise Knight - Age 15 **Cape Hatteras National Seashore, NC**

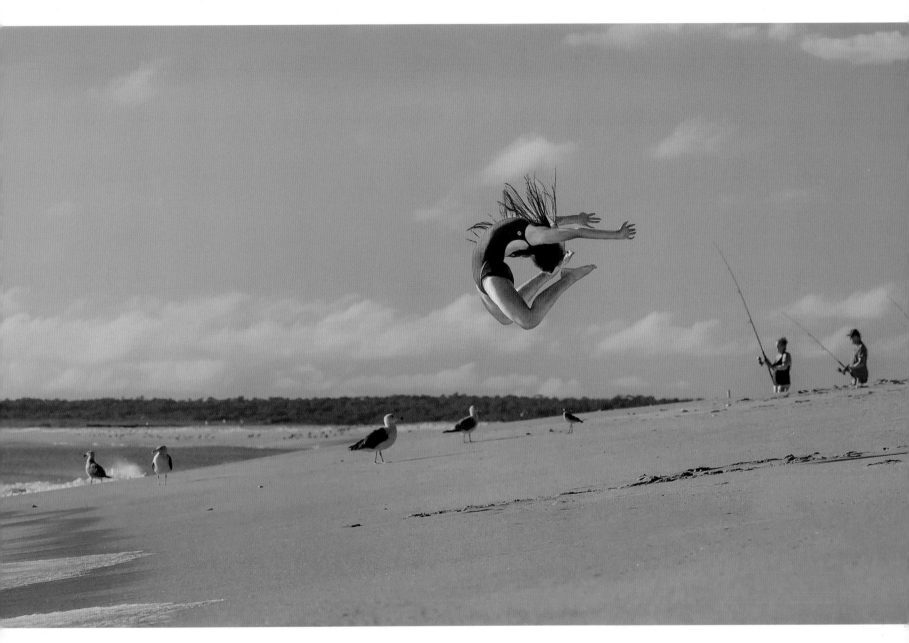

Vivianna Olander - Age 9 **Cape Hatteras National Seashore, NC**

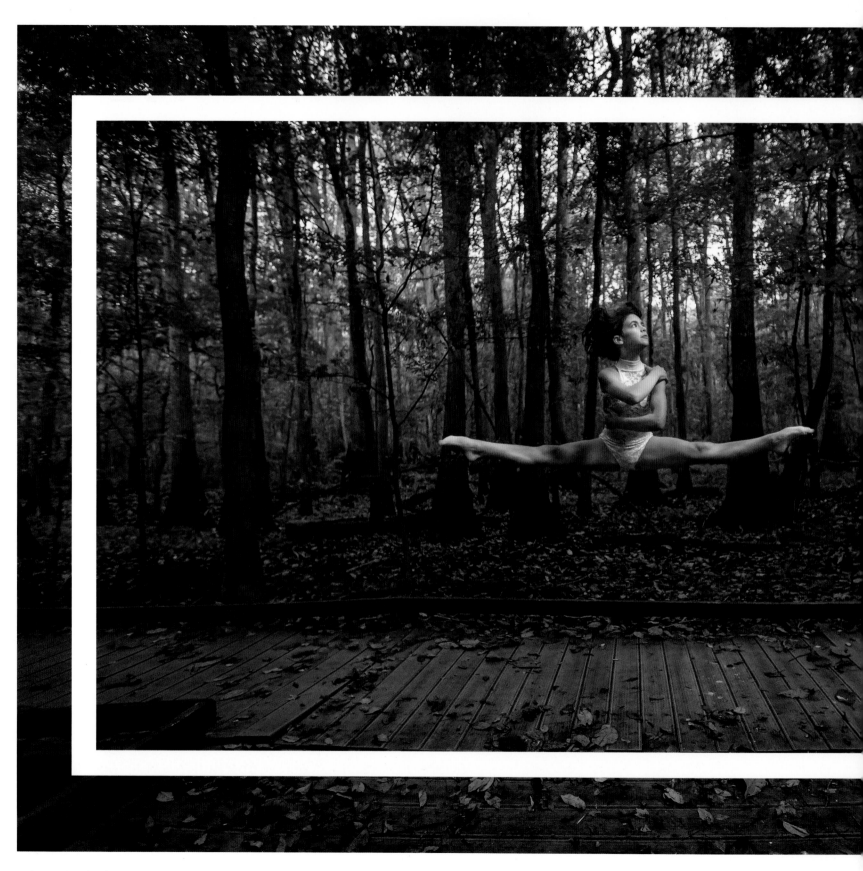

284 Miranda Saliva - Age 11 **Congaree National Park, SC**

SOUTH CAROLINA

Congaree National Park

Day 89

Location 55

September 24, 2016

Miles on Buford: 21488

This was the one that I was not sure was actually going to happen. Getting the permit here took weeks of back and forth. The ranger in charge of doing the permits for Congaree was off in Death Valley for some training I think, and between his work, our crazy schedule, and both of our lack of internet access, this truly came down to the wire. My wife had said we had gotten the approval, about five hours before I was meant to start the session. But, where I was in the woods, I had no kind of cell phone data. So I knew things were fine, but since I had not personally received the permit, I was a little nervous. Again, it is illegal to do professional photoshoots in national parks without a permit, and they take it seriously.

We arrived before sunrise, as per usual, but this location did not require a ranger to come with us. We hiked off into the woods in the dark, getting ready for first light, which was stunning! Watching the sun rise is always magical, even from in the middle of a forest. We got our shots, packed everything up, and started to head back to the visitors center.

As we were hiking, two LE Rangers (Law Enforcement, the ones with guns) came tearing down the trail. These folks are serious! The ones I met in other parks told me they had been SWAT, Green Berets, Navy Seals, and Night Stalkers, all elite forces you don't want to mess with. We stepped to the side to let them pass. They were looking for something, for sure! When we got to the visitors center, a ranger there asked me if I was the photographer from Dance Across the USA. "We've been looking for you. You don't have a permit." I told him I did, and he asked me to prove it. So out comes the phone, but again, no data. He said there was wifi in the center, and gave me access. Just like my wife had said, there was the permit, signed and authorized from the man in charge. "Oh, ok, you're good," he said. He had not seen the email, so they were out trying to stop us. So, again, make sure you ask for (and get) permission!

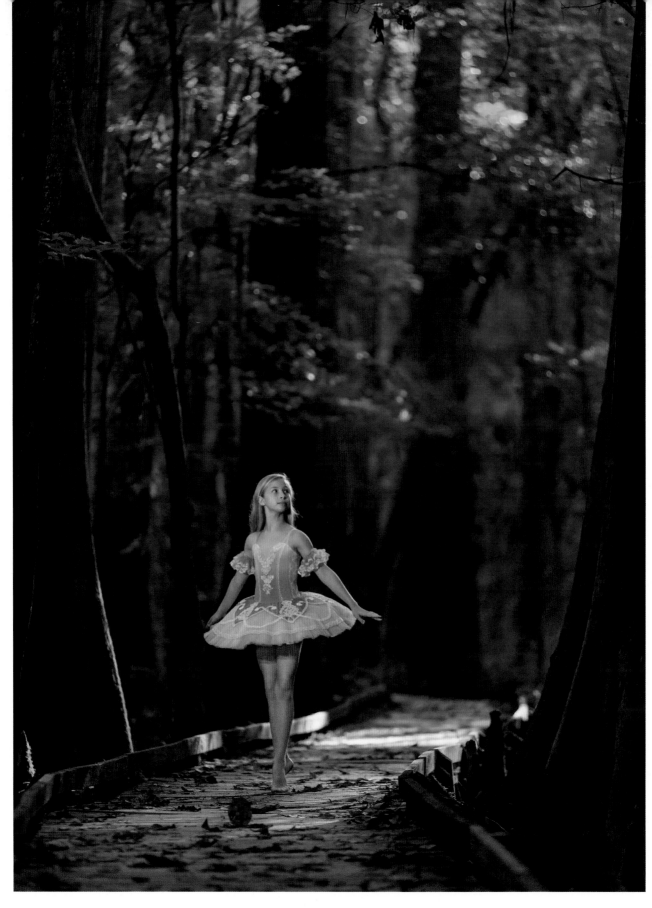

Anna-Katherine Risalvato - Age 11 **Congaree National Park, SC**

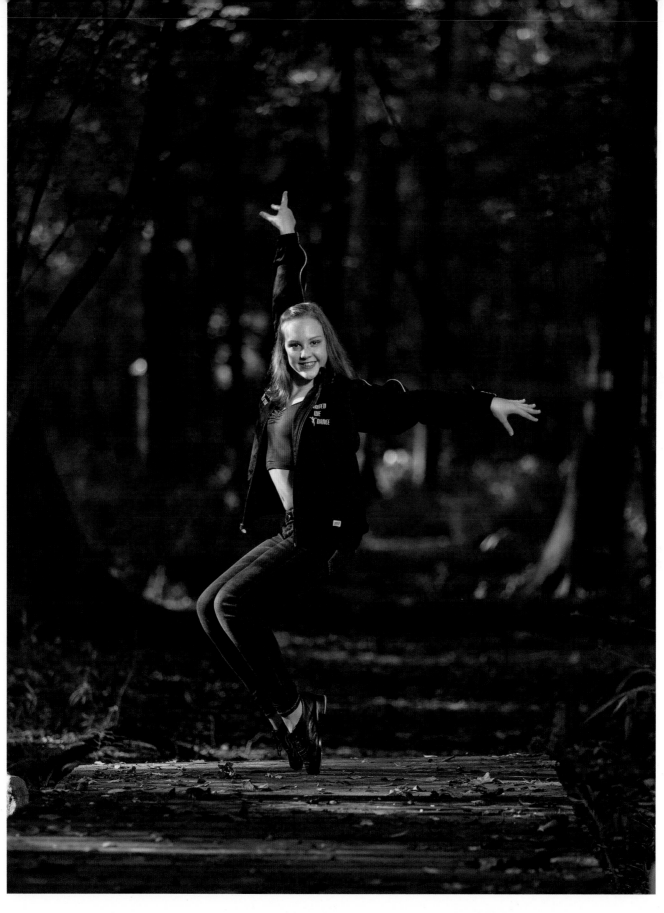

Kendra Brown - Age 12 **Congaree National Park, SC**

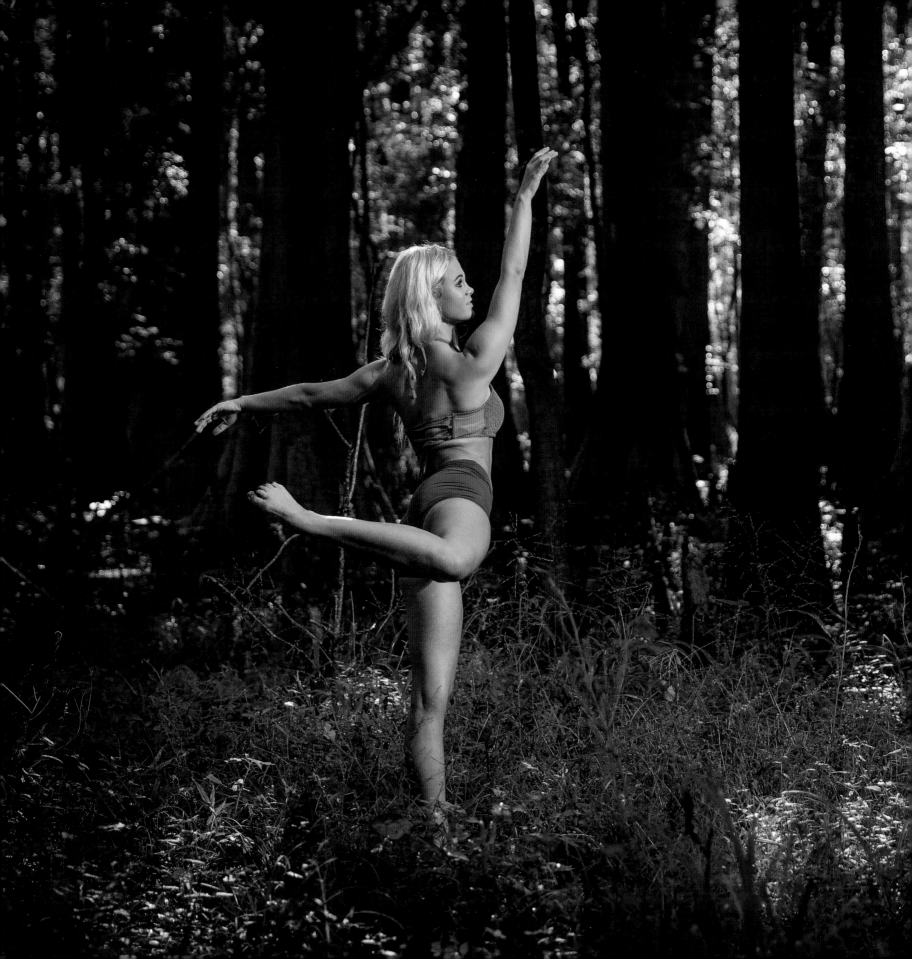

Congaree National Park, located just outside of Columbia, South Carolina, boasts the largest old-growth forest that remains in the American southeast.

There are several trails, some of which are boardwalks and therefore wheelchair accessible, and is an example of tremendous biodiversity. There are several national champion trees here, the most of any National Park. To be classified as a champion tree, that tree needs to be the largest of its species, under very specific guidelines.

Why does Congaree have so many champion trees? In part, it is due to the long growing season. Also, the fact that there have been many people who have fought to protect this area over the years, keeping it safe from logging or development. If you are a tree lover, then this is the park for you! In this park there are places for camping, backcountry exploration, canoeing, birding and of course photography!

Congaree has often been erroneously refered to as a swamp, although it is not. While Congaree does flood often, it does not contain standing water year round. Many visitors prefer to come here in the fall and early winter, when the temperatures are more mild and there is less humidity, as well as less mosquitoes.

Like many areas in the National Park system, insects abound, and can at times be a nuisance. You should make sure you plan accordingly, bringing repellent and covering up to keep the bugs away.

Also, there are quite a number of animals here that can pose a risk, so like anywhere else, make sure you stay aware and do not approach the wildlife. Alligators, wild hogs, and snakes (oh my!) live here, so just exercise good judgment, and you'll be fine.

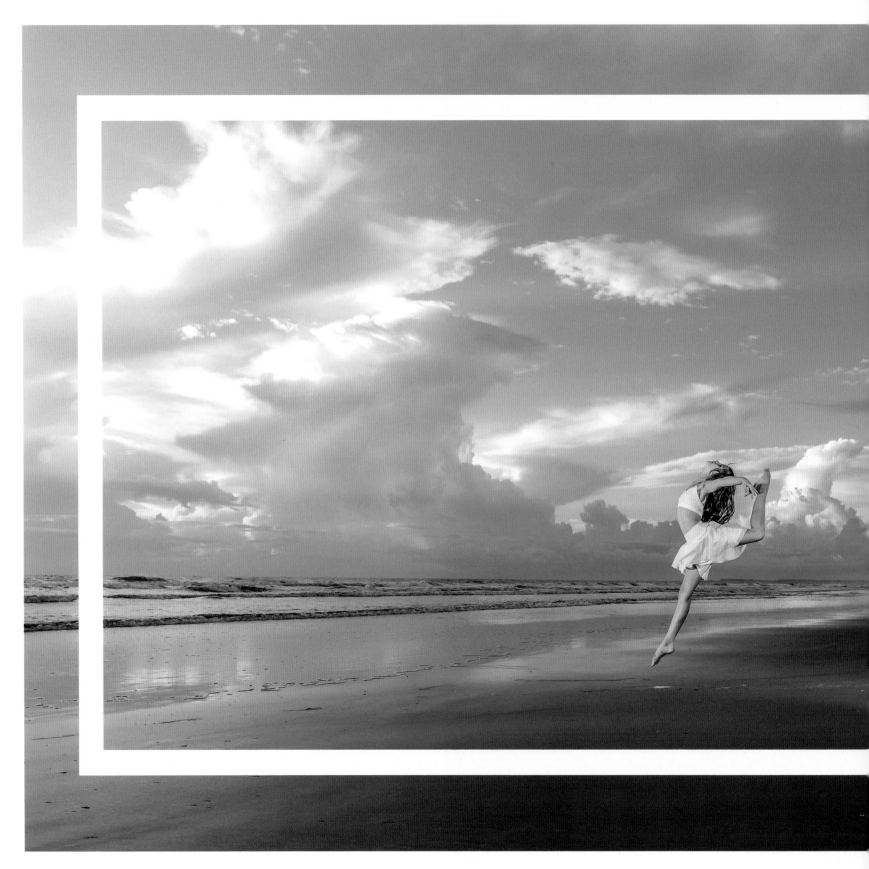

Arianna Gavrilas - Age 11 **Cumberland Island National Seashore, GA**

GEORGIA

Cumberland Island National Seashore
DAY 90
LOCATION 56
SEPTEMBER 24, 2016
MILES ON BUFORD: 21820

So here is it, the last location. Ninety days exactly, and I have now hit all 50 states. We sailed over to Cumberland Island on the ferry, and made our way to the campground to get ourselves settled. One last time setting up the tent, one last sunrise, one last drive. As I sat in the shade on this afternoon, I could not help but feel a little melancholy. Which only lasted for a moment, because there were things to do! We were shooting in the ocean, at the ruins of a mansion, random places around the island, and we had to get the ranger to on-board with my plans. Which did not take long, as when I met her, she was a photographer as well! She was super excited about the project, and was up for anything.

Using Cumberland Island for a location was incredible! This island has been used by several communities in its history, ranging from Native Americans as early as 4,000 years ago, Spanish colonies, English forts, American plantations, culminating in millionaire estates. The Carnegie family was at one point owner 90 percent of the island, and still owns a portion of it today.

Camping at the island is very quiet and peaceful, as long as you remember to lock up your food away from the raccoons. They are clever, quick, and not afraid of people in the least. While we were there, I watched a pair of raccoons walk up to a table, and take the food right off of a plate. If you stay here, remember that these are still wild animals, no matter how cute and cuddly they look. Remember, like Fezzik says, "You be careful. People (and animals) in masks cannot be trusted."

That quote is from the film *The Princes Bride*. If you knew that already, you win. If you did not, go watch that movie, NOW! Well, as soon as you are done reading this book.

Arianna Gavrilas - Age 11 **Cumberland Island National Seashore, GA**

Arianna Gavrilas - Age 11 **Cumberland Island National Seashore, GA**

294 Arianna Gavrilas - Age 11 **Cumberland Island National Seashore, GA**

Dancing to me is expressing my feelings. I breathe through my movement and forget everything else. There is always happiness in my heart when I dance, because to me dance is love! ~ Arianna Gavrilas

How we did it

Pulling off a project like this took an incredible amount of work, by lots and lots of people. The dancers, the rangers, companies that donated goods and services, strangers that left cash on Buford's windshield, they all played a part! I'll get to all of those people, but let me first start off with the equipment that I needed for this project.

I have always been the kind of guy who gets into a system, and deeply invests in it, both financially and emotionally. Like DeWalt tools. My wifes makes fun of me due to the amount of yellow and black tools I have at my disposal. As a carpenter / builder / welder kind of guy, I like great tools, and rely on them heavily. The same goes for my camera gear.

When I got my first "real" camera, I went to Best Buy, like most folks, and played around with the stuff they had out. Honestly, cameras are all more or less the same - they have similar specs, handle similar weather, obviously some are better than others in small ways, but you can create beautiful images with just about any camera. So the difference then becomes something less tangible - the camera has to choose the photographer.

You know how in Harry Potter, the wand picks the wizard? I think there is something that connects with the photographer when choosing their camera. For me, when I was messing around with all the different brands, I first picked up a Nikon. Light, small, nimble. But, it felt funny, and it didn't sound, well, tough. I held down the shutter button, and camera... *clickclickclickclickclick*. That's not the sound I wanted. So I picked up the Canon, and did the same thing... **CLICKCLICKCLICKCLICK.** Yeah, now that was a camera! (INSERT TIM "THE TOOL MAN" TAYLOR GRUNT HERE. Yes, I'm dating myself. No, I do not care.)

So that was it, I chose my camera system because of the sound of the shutter. From that sound, I decided Canon was tough, rugged, dependable, and it would take a beating. My Canon gear has been and done all of those things. On average, I am shooting 150,000 images a year, and my equipment is always ready for more. While you can make great images with any system, I can attest that with all the abuse I have thrown at it, my gear has stood up to it. Here's a small sampling of what my gear has had to withstand:

- Dropped down an ice cliff
- Lost in a snow drift
- Dunked into the ocean / lake / river / pool
- Thrown (accidentally) across a dance studio
- Kicked out of Buford to the road
- Cooked in the desert sun
- Chewed / drooled on by a German Shepherd
- Fumbled into a trash can by the TSA
- Frozen by sub-zero temperatures
- Drizzled with ketchup, mustard, syrup, Coke, honey, latex paint, hair gel, hydrogen peroxide, hand sanitizer, vanilla shake, and barbecue sauce
- Plopped into vomit, poo, chewing gum, various and sundry other unidentifiable substances
- Filled with sand from shooting on the beach / in the desert / near construction.
- Thrown across a creek
- Shoved off a table by a distracted photographer

I swear I'm careful with my stuff. but you know, life happens!

I also have to give a shout out to Canon Professional Services. I send them my dirty, disgusting gear, and it comes back to me looking and working like it is brand new. If you are a Canon shooter, I highly recommend you joining CPS. I get my gear back quickly, it is well cared for, and no one is going to do as good a job as they will when it needs to be fixed. Which it does, sometimes. Nothing is perfect. But for me and what I do, Canon comes really darn close!

For this trip, my camera kit consisted of:

- 2 Canon 5d mk III bodies
- Canon zoom Lenses 70-200, 24-70, 16-35
- Canon Prime Lenses 85, 50, 40
- Six Canon 600EX-RT flashes
- Eneloop Rechargeable batteries
- Powerex battery chargers
- Matthews Light Stands
- SanDisk CF and SD cards
- Apple Macbook Pro
- Apple iPad Pro
- Think Tank Airport Security Roller Bag

I very much subscribe to the theory if you buy great gear once, you only have to buy it once. If you buy cheap stuff, you will buy it 20 times.

In additional to the camera gear, I needed the stuff that was going to make the trip possible. While there is far too much to list everything, here are a few notable things that really made my life on the road not only possible, but pleasant -

Rinse Kit - this is a plastic box, that you fill with a hose, and becomes a pressurized water distribution system. I used it for my showers and cleaning myself / my gear. Found online, this was awesome. No gravity showers, and something with pressure, made for quite a lot of flexibility.

Engel Portable Refrigerator / Freezer - This wonderful little box was how I kept my food on the trip. I decided early on I didn't want to deal with coolers and ice, I needed a proper fridge. This little guy runs on 110v or 12v, so when I wired Buford up for power, I made a dedicated tie-in for this guy. With the same size as your typical beach cooler, this guy has been a great addition. Keep it in the car, and if you stop somewhere you can take it inside with you and still keep it running. Awesome!

Deuter ACT 40 +10 Backpack - Everytime I had a hike, this guy is what I carried all my photogear and supplies in. With the addition of a 3L camelback waterbottle, it was one stop shopping. When fully loaded, I had just under 80 lbs in this guy, and the pack took it like a champ. My back, well, that's another story.

Go Power Pure Sine Wave Inverter - This is how I had 110 power in Buford. For my computers, chargers, and other electronic equipment, I wanted to be sure the power I was creating was clean and safe. I used the heck out of this thing, and it is still in Buford, powering whatever I needed it to. In fact, one of the dance schools I work with lost power this year, and I ran the photo session directly off of this inverter! Extension cord from Buford to inside the building, and I powered all my lights and the computers for five hours until the power was restored. Awesome piece of gear!

There are so many other little things I got for this trip, there just isn't enough space to talk about them all. On the DATUSA website at www.danceatusa.com, there is a video tour of Buford and how I had him set up for the trip. I did this upon returning to Florida at the end of the project, so everything was a little battle scarred. There was nothing that I brought with me on the trip that I did not use at least once. Space was at a premium, so I wanted to be sure that whatever came with me, would be something that I needed. Again, prepare for the worst, and hope for the best.

The Mighty Buford

Obviously, I would have gotten nowhere if it were not for the Mighty Buford. Buford came to be in 2013. Prior to that, I drove a Ford Explorer for my business. He was the original Buford. How did he get his name? Beautiful Ford Buford. Spelled like the town in GA where I used to work at a Waffle House. That's another story, but Buford the original was a great vehicle, which I bought second-hand and drove all over the place. Eventually the time came when I needed to upgrade to something larger.

When I was looking for a van, I knew I wanted something that did not look like a kidnapper's vehicle from a crime tv show, and the boxy-yet-friendly-and-safe look of the Nissan was the winner. When I bought the Mighty Buford, I parked the original back to back with the Mighty, and had a little ceremony where I introduced them to each other. Thus the Mighty Buford was born.

The Mighty Buford is a Nissan NV 1500, to which I have made quite a few modifications, customizing him to be

ready for anything I might throw at him. Over the course of the project, we forded rivers, went off-roading through the mud and sand, climbed mountains, and braved Wal-Mart parking lots at 3am around the country. This is a great vehicle, with a great ride and has never faltered in the least. He's got a V6, gets about 15 miles to the gallon, and drives like a dream. If you are in the market for a van, I highly recommend this one.

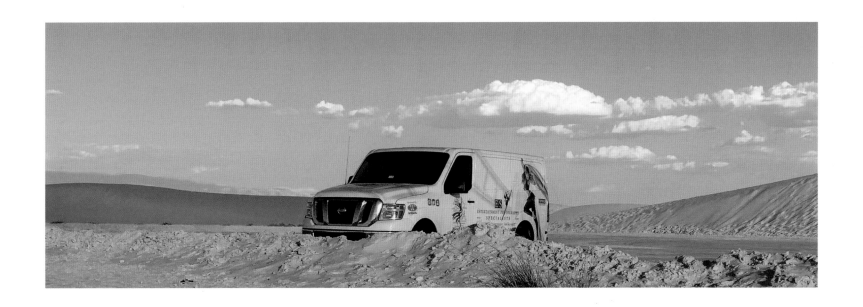

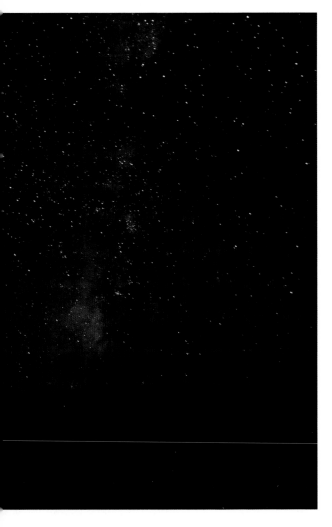

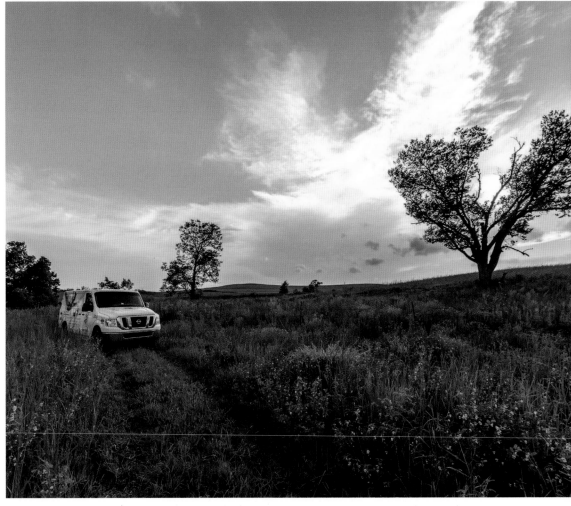

About the Author

My name is Jonathan Givens, and I'm a, well, I do a lot. It's really down to I have no idea what I want to be when I grow up, if I grow up. My wife says I'm 4. I think that's pretty accurate.

I have spent my whole life working in entertainment... first a performer, then a technician, then a designer. I've been a choreographer and a director. My career has spanned theater, film, television, circus, McDonald's, and Waffle House. Like many people I know in the arts, I have had to do lots of things to get by. Some pretty cool, others not so much.

I was born in Fort Worth, Texas, and I was adopted. I grew up in a military family, and we moved around every couple years. On my own, I kept moving around: following jobs, touring on shows, doing the "traveling entertainment professional" thing. Through everything, I have always kept learning stuff. How to do different things, how to be better than I was. It's like that both professionally and personally. I always want to be better tomorrow than I am today.

I never went to college, in fact, I barely graduated high school. That certainly does not mean that I stopped learning, or didn't like learning in the first place. Let's just say I followed a more non-traditional tract. All things considered, I'd say I did pretty well on my own.

How did I get into photography, you ask? It's Oprah's fault. I was the carpenter for her television show, and after she was shown something I had built, she turned and said, "I hope you are taking photos of these, because this work is beautiful!" So, I got a camera. But I learned pretty quickly that taking photos of scenery was really boring. General photographic wisdom is to "shoot what you know," and I know performers. So, that's what I did. All I photograph is dancers. I don't do weddings, or babies, or seniors, or anything else, just performers.

I am a dual-certified ETCP rigger (which means I safely hang heavy stuff and people in the air). I am a member of the Actor's Equity Association (AEA), and the International Alliance of Theatrical Stage Employees (IATSE). I am also an American Circus Educators Safety Consultant, and I teach about rigging, rigging safety, and how to be a safe aerialist. I design and build scenery and circus apparatuses. As a photographer, I am a Certified Professional Photographer, and have earned the degree of Master of Photography, both through the Professional Photographer's Association.

Much more importantly than any of that, I am a nice guy. I really like people, and doing nice things for them. I care about folks, even if I just met them. I'm shy, believe it or not, but I have no problem talking to a room full of people. I cry at movies, commercials, and (PLEASE DON'T TELL MY WIFE I SAID THIS) the Hallmark Channel. I hate the Hallmark Channel. I love my wife, and I adore my puppies. I like bread WAY more than I should. Bread, and gummy bears.

But if there was anything that I really wanted you to know about me, is that I'm just like you. I'm not anything special, TRUST ME. I'm just a boy, standing in front of a girl, asking her to... wait, sorry, wrong movie. Here's the thing: All the stuff I have done, anyone can do. You just have to jump in with both feet. Really, in a lot of ways, the only real obstacle people have is themselves. Sure, someone has to hire you, or give you your shot, or get you in the door. But how many opportunities have you passed up because you were nervous? Or unsure of yourself? Believe in yourself, and try. Try to do whatever it is you want to do. If you want to be the lead in the musical, go for it! If you don't make it, try again! Improve yourself, learn more, ask more questions. If you give up, you'll NEVER get there. But keep trying.

You'll never regret it.

Special Thanks

I would also like to thank the people who inspired and assisted me in this endeavor. They say to surround yourself with amazing people so you can learn and grow from them, and I have been incredibly blessed for all of these wonderful people in my life -

Heidi Kohz

Skip Cohen

Shari Malvin

Jorge Machado

Kris Arnold

Jane Kraemer

Becky Thomson-Foley

Kim and Howard Friedlander

Raul Guiterrez

Laura Carroll

Jerome Stucenski

Paul Wilson

Sydney Darling

Stacey and Richard Wichmann

Laura Given

Most of all, I again want to thank my wife, Leigh-Ann Givens. She laughs at my jokes, likes my cooking, listens to me sing, and loves me in spite of myself. She is my harshest critic and my biggest fan, the first thing I think of in the morning, and the last thing at night. She inspires me, impresses me, and has done more for me than anyone else on this planet, for no other reason than she wanted to. She literally saved my life, and for this, I trust her with my whole heart. I love you, always. Thank you for choosing me, Puddin' Pop.

Acknowledgments

Another thing that made this trip possible is the generous support we received from businesses and individuals in the way of donations. Using a site called Crowdrise, we were able to raise almost $44,000 to cover expenses - from permits and ranger fees to gasoline and groceries. If it were not for the efforts of those on this list, we could not have pulled off such an incredible journey. So, from the bottom of my heart, I want to thank you all for believing in this, and supporting it the way that you have.

CORPORATE SPONSORS

INDIVIDUAL SPONSORS

GOLD
Amy Flowers
Pro Tech Safety Consulting
Patrick and Cynthia Maloney
The Thaler Family
Sonja Giardina

SILVER
Richard Wichmann
Susan Virgilio
Century Plumbing
Charles and Laura Pearson
Crist, Krogh & Nord, PLLC
Debbie LeClair
Deborah Needle
James and Jennifer Biggs
Jeremy & Melanie Lyon
Kevin Wells
Angela Stocker

BRONZE
Stephanie Gonzalez
Alina Martinez
CheapCaribbean.com

Above the Barre Dance Academy
Christy & Richard Painter
Cumberland Dance Academy
Daddy, Mom & Hudson
Don Perkins
Miranda Siliva
Gram Herrington
Grandma & Grandpa Smith & Mom & Dad
Hollie Cappatocio
Jill & Christopher Caines
John Scott
Kay Family
Lindys Little One
Marcia Rosenfelt
Megan Sedita
Methods of Movement Dance & Performing Arts, Mountain Home, Idaho
MK Studios
Phyllis & Clarence Mullins
Pickett Family
Pincherry Grove Resort
Proud supporter
Pure Energy Dance, LLC
Sally Buller
Shockey Dance Company, LLC

Grassland Dance Academy
The Taylor Family
Rae & Tasha Price
Tanya Marderosian
Patience Stellmach
JoLynn Burt
Deana Hall
Darlene Krause
Kristen Parks
Laura Pearson

COPPER
Abuela Alodia and Ricardo
Abuelo Eduardo y Abuela Cruz
Adelaide Rooney
Alexandria Franklin
Alicia Rosa
Alise Knight
Amanda and Caroline Hampton
Amanda Eads
Amber Greenwood
Amy and Joe Luiso
Amy Welsh
Anca & Catalin
Angela Delyani
Angie Vazquez
Ann House
Anna Hines Manager, Arby's Waverly, Ohio

Anne-Marie Conn
Arianna's Uncle
Ashley Treasure
Aunt Sandra & Uncle Gil
Auntie Cherith
Babbette's Studio
Baga and Abie Peterson
Becky, Dave, & Lincoln Foley
Betty Dutton
Bill Boettcher
Bob Haring
Bob Schaar
Bradley Conn
Brian and Lisa Foster
Brian Puckett
Brittany Johnson
Brown Farms
Bryce Adams
Capt. Skip & Lisa Bradeen
Carl Stocker
Carla Puckett and Rick Forsythe
Carmen Loran
Carole Wiberg
Carolyn & Chelsea McNamara
Carrie Gorman
Charlie and Bobbie Holt
Charmion Performing Arts Center
Chee Lee
Chelsea Brown
Chelsea Dee Robinson
Cheryl and Jaymie
Chism Family
Chris Hollingsworth
Christian "Christy" Louque
Christine Callais
Christy Sykes
Ciara Harriman
Claire R. Fried Attorney at Law
Chillicothe, Ohio
Claudiu Gradea
Clearview Animal Hospital
Coffi and Yesenia Rodgers
Craig Conn
Cristin Nguyen
Crystal Eubanks
Cumberland Falls State Park
Daniel Kennedy
Danny & Ann Smith
Dawn & Pate - Keep dancing Jen! You're
 amazing!
Dean Goodwin
Debbie Parks
Deborah Newman
Deep Saving
Deeprock Energy Resources, LLC
Denise Gaggini-Mann
Dietz, Futrell & Walters Insurance, Inc.
Don and Judy Meilink
Donna Thibodeau
Duly Family
Dunyah Hudson
E.B. & Sammy
Eduardo Vazquez
Ela Gavrilas
Elaine James
Elizabeth Hort
Elizabeth Purdee
Elizabeth Shirey, Kelli Peters, Stacy
 Haden-Drum of Great Clips
Ellen Marie Gioia
Ellen Southerland

Emma Krauss
Eric Barnett
Eric Smith
Erica Franklin
Fabian, Claudia & Gianna
For the Reese Sisters Kiera and Audry
Fran & Al Alberghine
Frances Nelson
French, McDevitt & Schott Families
From Mama with Love from Chris Gabby
Gergely Family
Gerie Anderson
Gloria Teague / Bobs Bunz Inc.
Goodwill of Waverly, Ohio
Grammy & Grampy Gagnier
Grampa Jim McNally
Grandma and Grandpa Bickley
Grandma and Grandpa Smith
Grandpa Mar
Grandpa Richie
Grannie J.
Great American Jewelry: www.
 circlevillejewelry.com
Greg & Tess LeNoir
Gwen Parsons
Haven Massage and Esthetics Studio
Helene and Fred Voto
Henry DiLorenzo
Holly Miller Bachert
Holly Trujillo
Horizon Market, Bismarck ND
Infante Ohana
Jack and Marie Connors
Jane Comstock
Janet & David Goodwin
Janet & Richard Johnson
Janice Voto
Jason Scurlock
Jaye R Stein
Jeffrey Connors
Jenni & Sean DeWinter
Jennifer & Jim Bennethum
Jennifer Bangert
Jenny Montoya
Jill Ferguson
Jim & Judy Rae
Jimmy Hall
Jimmy Smith
Jo-Dee & Rich Giusti
John Francis
Jose Ramon Soto
Joseph & Marina Olander
Josh Fisher
Joy Kaufman
Judy Aubuchon
Julie's Shop On Paint Chillicothe, Ohio
Kaitlyn Webber
Keith and Jerri Svoboda
Kelsy Leyendecker
Ken Brass
Kendra Scott
Kenneth Harvey & Debra Slayton
Kerrington Nolte
Kim and Audrey Leonard
Kim Davis
Kim Haug
Kim Kochamba
Kimberly Kay
Kimberly Rae
Krystle & Cody
Lafayette Ford

Landrum School of Performing Arts
Lauren Mirandona
Laurie Clark
Lee Turner
Linda Doughty
Lindsey Smith
Linsey Battle
Lisa Wilensky
Live 2 Dance, Gillette WY
Love your Family, Grandparents & Uncles
LV Day School
Lynnette Hancock
Maggie Mondragon
Mamaw Connie
Marguerite Scott
Maria Bunning
Maria Rodrigues
Mary Beth Yocum
Mary Jo Zaccagnini
Marylisa Allen and family
Masha Balovlenkov
May Kesler
Meghal Vakil
Melanie Bickley
Melanie Huelsman
Melissa Torres
Melody Butt
Members Exchange CU
Merritt Engineering
Mihaela Gavrilas
Mikayla Scaife
Mike and Doris Anderson
Mike and Julie Lieberg & Family
Mimi and Bobo Scruggs
Mindy Rooney
Miss Tanya's School of Dance
Misty Lynn Ralphs
Misty Ralphs
Mom and Dad (Shanna Young)
Mom, Dad, and Brother
MomMom and Poppy
Mommy, Daddy and sister Lindsay
Mr. & Mrs. David Van Wart
Mrs. Gail Hornby
Nana & Papa Simmons
Nana and Papaw Payton
Nancy and Amber Greenwood
Nancy Bajer
Nathan & Christina Dulaney
Nicolas Gavrilas
Ninang Ping & Family
Nistor Mihai and Ely
Oma and Opa Buller
Oscar and Xixi
Paig and Chris Switalski
Paige Welsh
Pam Porter
Papaw, Granny & Aunt Kimmy
Pappy Mike
Patty Martina
Paul & Florence Esposito
Paula O'Connell
Peggy McCreary
Phyllis Mullins
Production Management Miami, LLC
R. Harrison
Rachel White, New Hampshire
Rebecca & Trevor Erickson
Reed & Lauren Estes
Regina Smith
River Cities Financial Services

Robert & Mrs Robert Ferguson
Robert, Lori, and Kendalyn Dudley
Roberts'
Robin Richie
Robin Scott
S. Richie
Sabrina Anderson
Sandie Payzant
Sarah Foster
Sarah Howe
Sarah Monahan
Sarah Risalvatos
Sarah Svoboda
Serena Simmons
Shanna Young
Shannon Butterfield
Shari Townsend
Shawn M. Wallin
SHE SAID YES.........Chillicothe, Ohio
Sheliah Roth
Sheri Lewis
Shirley Gonzalez and Family
So proud of you Mary Shea Love,
 Lucy & Jay
Srividhya Vijayakumar
Stacey Slackford-Barnes
Starstruck Academy of Dance
Step Ahead Gymnastics
Steve and Mary Beth Petti
Steve Lundin
Sue Anderson
Sue Campbell
Susan (Kaye) Daigneault
Susan Davis
Susan Edwards
Susan Marie Carlo
Suzanne Blake Gerety
Suzanne Young
TAME Dance Academy
Tammy & Edward Friedrich
Teresa Bonello
The Campbellettes
The Comstock Family
The Daniel Family
The Gutierrez Family
The Knights
The Kucera Family
The Schofield Family
The Weinsier Family
The White Family
The Wilkins Family
The Wood Family
Tia Kennedy and Staff at Dakotas in
 Waverly, Ohio
Tiffany Pulido
Tom and Brenda Weldon
Tony and Shari Johnson
Traci Tyler
Trinda Love
TUTC - The Ultimate Talent Connection
Uniquely Yours of Circleville, Ohio
United Way of Carbon County - Nord
 Kirkeeng
Verlane Franklin
Vicki Gergely
Virginia LeNoir
Walter G Grant
Wanda Chism
Wendy Eckrote
Wendy Winn
Yvonne Thomas

Ginger LeNoir - Age 15 **Everglades Wildlife Management Area, FL**

"Dancing gives you the ability to express yourself without saying a word" ~ Ginger LeNoir

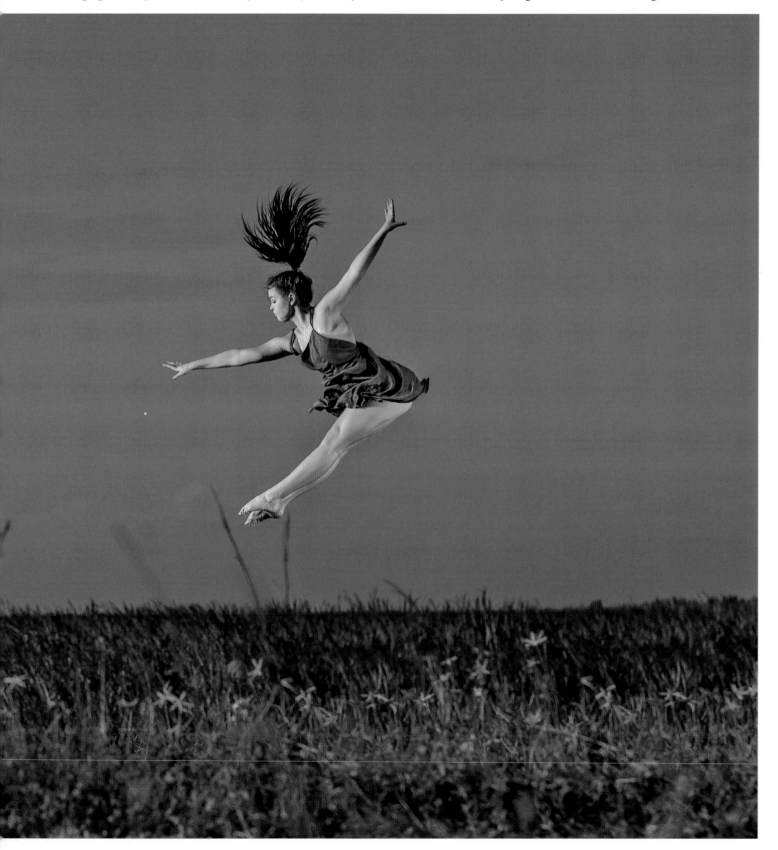

Index